global pop

is a thought-provoking consideration of what must rank among the most vital and significant artistic, media, and marketing phenomena of the later twentieth century. Through ecumenical source research (exploiting even Internet discussion groups), extended profiles of musicians, and close scrutiny of individual songs, Tim Taylor's study moves well beyond many of its predecessors, which stopped with a benumbed enumeration of the dizzying varieties of world beat or dampening suspicion of its mass-marketing and commodification. Taylor adroitly walks a fine theoretical line, analyzing the persistence of Western hegemonies even in musical gestures aimed against them at the same time as he describes the subtle force of hybrid musical styles to undermine Western conceptions and construct novel identities.

—Gary Tomlinson
University of Pennsylvania

global

World Music, World Markets

pop

Timothy D. Taylor

Routledge New York + London

Published in 1997 by

Routledge
29 West 35th Street
New York, NY 10001

Published in Great Britain by
Routledge
11 New Fetter Lane
London EC4P 4EE

Library of Congress Cataloging-in-Publication Data

Taylor, Timothy Dean.
Global pop : world music, world markets / by Timothy D. Taylor
p. cm.
Includes discography, filmography, bibliographical references,
and index.
ISBN 0-415-91871-5 (hb: alk. paper).
ISBN 0-415-91872-3 (pb: alk. paper)
1. World music—History and criticism. 2. Popular music—History
and criticism. I. Title.
ML3470.T4 1997
781.63'09 — dc21 97-4337
 CIP
 MN

To Sherry
my number only

PROUD music of the storm!

Blast that careers so free, whistling across the prairies!

Strong hum of forest tree-tops! Wind of the mountains!

Personified dim shapes! you hidden orchestras!

You serenades of phantoms, with instruments alert,

Blending, with Nature's rhythmus, all the tongues of nations;

You chords left us by vast composers! you choruses!

You formless, free, religious dances! you from the Orient!

You undertone of rivers, roar of pouring cataracts;

You sounds from distant guns, with galloping cavalry!

Echoes of camps, with all the different bugle-calls!

Trooping tumultuous, filling the midnight late, bending me powerless,

Entering my lonesome slumber-chamber—Why have you seiz'd me?

—Walt Whitman, *Leaves of Grass*

Contents

Lists of Tables, Figures, and Music Examples

Tables

Figures

Music Examples

Acknowledgments

Any book is merely a concrete node in a hugely complex web of friendships, libraries, scholars, meetings, teaching, email, the World Wide Web, and hard disc space. So it may well be that I will forget to offer proper thanks to some individuals who have helped along the way. If so, I apologize. With thanks.

Such thanks I can recall need to go out to various recording companies who provided me with much information: EMI/Angel, for its press kit for *Vision: The Music of Hildegard von Bingen*; Luaka Bop, for its press kits for Zap Mama and Djur Djura; Island/Mango, for its press kits for Angélique Kidjo and Apache Indian; Karen M. DiGesu at Ellipsis Arts . . . , for their press kits on *Global Meditation* and *Voices of Forgotten Worlds*; Susan Addy, for sending information on Obo Addy, and a score to *Wawshishijay*; Bob Haddad, of Music of the World, for information on Dumisani Maraire.

I would also like to thank Kat Egan and Jennifer Small at Luaka Bop for photos of Djur Djura and Zap Mama; Suzanne Hannema at Caroline Records for photos of Peter Gabriel and Sheila Chandra; The Pauline Oliveros Foundation for the photograph of Pauline Oliveros; and Bunty Hunter at Island for photos of Angélique Kidjo and Apache Indian.

While most of this study concentrates on musicians prominent in the world music scene, I have also tried hard to listen to music more on the margins, music often difficult, and sometimes impossible, to track down. I would like to thank my sister, Kristin Taylor, of Amadeus Music, Portland, Maine, for helping find some hard-to-find recordings and filling me in on some of the more arcane details of the music industry from a retailer's perspective.

Small portions of this book were originally parts of my Ph.D. dissertation in musicology at the University of Michigan; I would like to thank the members of my dissertation committee who provided important guidance and encouragement: Judith Becker, Richard Crawford, Jonathan Freedman, and Louise Stein. In particular, my committee chair, Glenn Watkins, was exceptionally helpful at every point. Other academic friends and colleagues I would like to thank for their direct and indirect input on the manuscript, and for inspiration in general, are Susan McClary, Robert Walser, Josh Kun, Deborah Wong, Hugh de Ferranti, and George Lipsitz.

Part of chapter 4 was revised from my "The Gendered Construction of the

Musical Self: The Music of Pauline Oliveros," which Oxford University Press has kindly given me permission to reprint.

My old friend Guthrie P. Ramsey Jr. of Tufts University read through the entire manuscript and offered incisive and practical comments that improved the book a great deal.

My oldest friend, John T. Canaday, also read through the entire manuscript. John is the best diagnostician of writing problems, great and small, that I know and, as in so many cases going back to our freshman year at Middlebury College in 1979–80, I owe him more than I can adequately thank him for.

Also, a great big thanks must go to the students in my "Popular Musics in the Global Postmodern" graduate seminar in the fall of 1995, who gamely read much of the manuscript and who offered extremely valuable suggestions; they are Susana Loza, Irene Nexica, Jasbir K. Puar, and Caroline Valverde. I miss you all.

I also need to thank my step-daughter, Gwen, for tolerating all kinds of strange music around the house, for her excellent teenager's knowledge of popular music, and for not minding too much when I reappropriated my CDs back into the public space of the house.

Several anonymous readers for different presses read and made comments on the manuscript. I would like to thank all of them. One, in particular, for another press, provided extremely trenchant and penetrating comments. I am deeply indebted to this person, who helped make this a better book.

William Germano at Routledge displayed early enthusiasm for the manuscript, and I am grateful to him for that, and for his unstinting good advice and guidance. Bill's assistant, Alan Wieder, was likewise helpful and supportive, as was their managing editor, Christine Cipriani, and the copy editor, Lorraine Kenny.

But my greatest debt is to Sherry B. Ortner: my wife, chief supporter, confidante, best friend, and only love. I hope that her wisdom, kindness, and generosity are imprinted on every page.

Introduction

Not very far from here sits one of my favorite restaurants. An Indian restaurant. A *south* Indian restaurant, no less, with a cuisine not very common in this part of the world. Often, in the evenings, they offer live Indian classical music (Hindustani, from north India). And a large outdoor banner advertises LIVE SALSA MUSIC! in the restaurant's "lounge," downstairs. (Recently, the sign changed: it advertised reggae and jazz for a while, now jazz and R&B.)

Such juxtapositions of forms from different places seem to me to capture the world in which we now live, whether we want to call it globalized, transnational, postmodern, or something else altogether. To my ears, though, the Hindustani and salsa musicians never picked up anything from each other. And yet, I would still argue that nothing better exemplifies this new world and the changes in it than music, for the very malleability of music makes possible local appropriations and alterations, particularly of North American and U.K. popular musics, resulting in all kinds of syncretisms and hybridities, which themselves continually syncretize and hybridize. Indeed, North American and U.K. popular musics have traveled far more widely than any other western idiom, resulting in what Simon Frith has called a "universal pop aesthetic."[1] This very pervasiveness means that popular musics help raise musical and theoretical issues better than other musics, even better, perhaps, than any other cultural form.

Some of the first business at hand concerns how we characterize this new global village. Probably the most influential formulations of the concept—following Immanuel Wallerstein's pathbreaking work positing the modern world-system in the 1970s[2]—has been Arjun Appadurai's version of the five -scapes that compose the intersecting, interlocking worlds most people inhabit today: finanscape, mediascape, ethnoscape, technoscape, and ideoscape.[3] What interests me the most is the "ethnoscape," defined by Appadurai as "the landscape of persons who make up the shifting world in which we live: tourists, immigrants, refugees, exiles, guest-workers, and other moving groups and persons. . . ."[4] Music resides in these -scapes as well, but on the surface it is this mixture of different sounds that catches most listeners' ears today.

Stuart Hall forwards another important conceptualization of this global (dis)order, arguing in two recent essays that we now live in what he calls a global post-modern, which, because of American hegemony, seeks to homogenize, though this can never happen totally; this hegemony also profits through disorder,

through difference.[5] And Hall reminds us, importantly, of Marx's crucially insightful argument in *Capital*, that capitalism only advances on contradictory terrain; or, as Marshall Berman put it in his analysis of *The Communist Manifesto*, Marx both seeks to bury the bourgeoisie and to praise it.[6] Hall continues by positing two forms of globalization: an older one, corporate, enclosed, increasingly defensive, nationalistic; and a new one, the global post-modern, "trying to live with, and at the same moment, overcome, sublate, get hold of, and incorporate difference."[7] For Hall, these two forms of globalization are competing, and their various facets appear in all kinds of situations and cultural forms.

Hall has since written that he hates the term "global postmodern" because of what it covers up, though what it reveals is just as important; he continues to use the term.[8] And it is easy to see how the phrase could be misleading; after all, Marx's potent description of modernity as a time of such momentous change that "all that is solid melts into air"[9] seems to be truer than ever, not a mode of existence that we are now post-. Anthony Giddens also writes of globalization in his *The Consequences of Modernity*, clearly viewing this process as one of these consequences, not something other than modernity altogether; arguing that modernity is inherently globalizing, his definition of globalization outlines a tension I hope to bear in mind in the following pages: globalization is "the intensification of worldwide social relations which link distant localities in such a way that local happenings are shaped by events occurring many miles away and vice versa."[10] Giddens helps us understand that modernity is alive and well as ideology and practice, though these ideologies and practices have changed (some more than others, some not at all), and some may even be gone.

All of these theoretical insights usefully recognize that the world has changed dramatically in the last few decades, that the ever-increasing global flow of capital and cultural forms are providing people virtually everywhere with new ways of looking at and living in the world. These and other theories present new models and call for jettisoning or rethinking older ones. Ideas of ethnicity, identity, subject position, and economic cores and peripheries are being examined in productive ways that are attempting to keep up with the complexity of life on the ground.

While much of this literature attempts to theorize the global flow of capital and forms, it rarely stops to take a look at concrete examples of people using what is in that flow. Giving up on (meta)narrativizing the current state of things does not mean that there isn't a current state of things, or that subjects on the ground aren't themselves trying to make sense of and narrate their own lives. Thus, many analyses of globalization more often than not fail to take into account experiences of real people. So Appadurai can argue that the globalization of technology has made available previously unimagined lives—as though everyone in the world had a television, a fax machine, or a computer connected to the Internet—and the economic opportunities to make these possible lives into real ones.[11]

How could an ethnography of globalization be conducted? Fieldwork in the

traditional sense can only be part of a larger set of tools to help us understand globalization as a general process. Instead of fieldwork in the traditional sense, our "commitment to the actual" (as Michael M. J. Fischer has eloquently described the ethnographic impulse[12]) can be accomplished in part through other means. "The actual" for my purposes here includes music, lyrics, and discourse on both, and discourse by musicians, fans, and critics, from which we can derive some ethnographic perspective on musicking and self-fashioning.[13] I also rely heavily on the Internet, for there reside newsgroups, user-maintained sites, and record-label sites, all of which contribute importantly to the web of discourses these musics inhabit. The Internet is like a giant word-of-mouth network, providing useful information of all kinds to whoever has access to it, but also allowing students of culture ways to eavesdrop on conversations by "natives" of all kinds, providing bits of virtual ethnographies.[14]

Although theorists of globalization have tended to stay away from ethnography or grounded textual analysis, musicologists and other scholars who write about music have occasionally looked at the issues raised by the globalization of music. The most salient discussions have centered on the "cultural imperialism" model, which assumes that local forms of all kinds around the world are being replaced by mass-produced, western ones, or being diluted into a homogenized cheap imitation of western pop/rock,[15] but an increasing number take on the music in more subtle and sophisticated ways, such as George Lipsitz's recent and compelling *Dangerous Crossroads* and the pioneering work of Steven Feld.[16] The most frequent contributor to debates on world music is the German anthropologist/ethnomusicologist Veit Erlmann, who has written recently that a theory of world music should "examine the ways in which world music constructs the experience of global communications and authenticity through symbolic means whose very difference depends so vitally on their sameness as transnational commodities."[17]

Global Pop hopes to live up to this injunction, at the same time as it charts double critical trajectories: it critiques the cultural studies methodologies that fail to examine real, on-the-ground forms and events; and it critiques musicology's traditional focus on strictly formal and stylistic features, an approach that has begun to change in recent years. I hope to make use of what the best of these fields have to offer; few disciplines manage to keep the big picture in mind as resolutely, or as profitably, in intellectual terms, as cultural studies does. And musicology's textual groundedness provides extremely sophisticated ways of listening. The point is to bring these approaches together.

One of the ways *Global Pop* will attempt this is to augment the work of those cultural studies scholars who too often talk about music without talking about music. It is possible to have great insights into cultural production, resistance, youth, or whatever, but I wonder how many people would accept, for example, discussions of literature that never actually engaged with how the given literature was put together, or how it worked to affect readers. Some scholars have theorized away the necessity for studying music as music. To give just one recent example,

Simon Frith writes that music "is both performance and story."[18] It is these, and more, as Frith outlines in his important essay. But music is also sound, and if we are to understand the ways that music affects the body and the way we feel and creates meanings, we have to attend to music as sound as well and seek significations that go beyond the discursive and verbal. This isn't an attack on Frith, whose work I greatly admire, or cultural studies in general; it is, rather, an attempt to point out what is missing in some cultural studies work on music, missing mainly because musicology has until recently left popular music to scholars outside of musicology. As Susan McClary writes, "the study of popular music should also include the study of popular music."[19]

Happily, this demand to bring together cultural studies approaches and musicological ones isn't entirely new in musicology and is being attempted by a growing number of musicologists. In popular music, an important book is Robert Walser's *Running with the Devil: Power, Gender, and Madness in Heavy Metal Music*, in which he writes "my interest is less in explicating texts or defining the history of a style than in analyzing the musical activities that produce texts and styles and make them socially significant."[20] Likewise.

And yet, talking about music as text and style is never easy, though it is frequently fun.[21] The following chapters make use of transcriptions of music, that is, versions in musical notation of music as sound. This is partly for practical reasons: there is no compact disc or cassette accompanying this book. (I have thus been assiduous in footnoting every disc so you can locate recordings yourself. I have also put some sound samples on the World Wide Web at http://www.columbia. edu/~tt327/Global_Pop/Global_Pop.html). But, also, the question of notation, particularly when the original music was not notated (as is the case for most of the music in this book) touches on larger issues. What is music? Is it the notation? Is it the sound? If so, what does notation do for us? I would say that music is the notation, the sound, the process, the performance, the talk about/around it, and more. Notation serves as a textualized representation of sound that isn't available any other way. If you don't read music, please try to hear the recordings. If you do read music, the transcriptions will mean something to you, but, of course, any transcription is only an approximation of the real sounds. In this book, transcriptions serve as a kind of placeholder, a cheap imitation of sound. Sound itself is invisible, so to spend many paragraphs discussing the invisible—but not intangible—seems pointless. For musicologists, though, transcriptions help illustrate the way a piece is put together. Unnoticed features may appear in notation that were taken for granted on hearing the work only. For that reason and that audience, I include transcriptions in the following chapters.

In keeping with the ethnographic spirit of *Global Pop*, some explanation of the other visual aids, included and not included, is necessary. In some ways, obtaining copyright permissions was the most difficult part of writing this book. Some publishers grant copyright permissions easily, and some grant them for free. Others demand fees, some of them high: One firm quoted a figure of $1,000; you will

not find the Rolling Stones lyrics here. Another firm asked a lower fee, but reserved the right to demand more if anyone else got a higher fee. Other publishers or record companies freely distribute publicity photos, others do so reluctantly. Without having seen the manuscript, Sheila Chandra wrote a very sweet letter saying she did not wish her music to be associated with this book and hoped this wasn't an inconvenience. Sony Music said, rather huffily, that they do not allow their publicity photographs to be reproduced in books, only in magazines or on posters or other kinds of promotional materials. They had no explanation for this anti-book stance and seemed to think it made perfect sense. Perhaps to them. So in the following you will see photos of some musicians, but not of others, lyrics to some songs, but not to others, and music to some songs, but not to others. If there was ever a lesson in learning that capitalism—at least as it is manifested in the music industry—is contradictory, inexplicable, irrational, and conflicted, putting the materials together for this book is it.

In all, *Global Pop* explores some of the new musics in the increasingly interconnected global village, addressing some current issues in cultural theory, such as the nature of hegemony, resistance, identity formation, and intercultural exchange. I hope that it will also bring to the table issues that have been circulating in academic debates, but that are not yet fully articulated: How are we to talk about globalization (or any large-scale cultural occurrence), real people, and their music?

Chapter 1, "Popular Musics and Globalization," examines the rise of the new genres/labels "world music" and "world beat," showing how these labels and the discourses surrounding them overlap with other discourses, and how concepts of authenticity and difference operate in discussions of this music. Although these categories were usually created to aid in marketing, many musics and musicians slip through the cracks, categorized not by their music but by their race or ethnicity: even if they make recognizably pop or rock musics, their music is labeled and marketed as "world music" if they aren't North American or British.

The second chapter, "'Nothin' but the Same Old Story': Old Hegemonies, New Musics," considers contemporary popular musics from western Europe and America and how these musics sustain western metropolitan notions of "the Other." At the same time, situations are more complex than a simple maintenance of hegemonic ideologies and practices; often, for example, local musicians don't speak of hegemonies at all, but are glad to have their music traveling further than ever before. A particularly complicated case is the English musician Peter Gabriel, who has worked with live and recorded musicians from other cultures, often in ways that could be viewed as appropriative. At the same time Gabriel has done more than any other western popular musician to bring musics and musicians of other cultures to the attention of mainstream rock fans. This chapter also

discusses the Kronos Quartet's *Pieces of Africa* (1992) that features contemporary music by African composers, black and white.

Chapter 3, "Strategies of Resistance," tackles the idea and practice of resistance and the ways that the colonialized and former colonialized present alternative points of view to the western metropoles. Musicians such as South Africa's Ladysmith Black Mambazo, and the Javanese pop star Rhoma Irama use various sounds and techniques from North American and U.K. popular musics to make their own music, lift themselves out of poverty, and combat the infiltration of western ideas that they view as threatening to undermine their own culture and practices. The final example is Djur Djura, a Berber woman from Algeria who escaped what she viewed as the horrors of Muslim patriarchy into the metropolitan feminisms of Paris in the 1970s.

Chapter 4 examines the unique cases of western women musicians in the global production of music, for the reality of these women's position is often hegemonic globally but not locally, resulting in some interesting strategies and alliances cross-culturally. "A Music of One's Own" examines the work of Pauline Oliveros, who makes a meditative music that draws on ritual and ceremonial conceptions of music from Tibetan Buddhism and Native American thought. Her goal is to help create an inner utopia by inspiring listeners to new introspective depths to discover their innermost, true selves, while at the same time making a music that is recognizably a woman's music, a kind of music that has little to do with contemporary "academic" composition, which she views as overly concerned with formal questions.[22] Another case is the all-women's band D'Cückoo, which appropriates sounds and ideas from all over the world to form their "neoclassical, post-industrial, cybertribal world funk"[23] music. The group uses extremely complex technology and sounds from other musics to promote ideas of equality across genders and cultures.

One of the main foci of *Global Pop* concerns the shifting assumptions that metropolitans have of peoples around the world. Chapter 5, "Strategic Inauthenticity," follows the careers of the Senegalese superstar Youssou N'Dour and the Beninoise singer Angélique Kidjo, both of whom have faced disapprobation from western critics and some fans who demand "authentic" music from the African and Asian continents. Saxophonist Branford Marsalis, who collaborated with Kidjo on her second solo album, *Logozo* (1991), asks, "When the world's greatest rhythms are in your own backyard, why use drum machines and sequencers?"[24] a comment that reveals as much about his perspective as her music. Again, issues of "authenticity" are central—and contested.

"Anglo-Asian Self-Fashioning" examines the shift from a kind of fashioning of the self through the other to alternatives to such fabrications. The modern impulse to make a singular self becomes, in postmodernity and postcoloniality, a kind of self-fashioning that results in mixes, blends, composites, more than juxtapositions and disjunctures; postmodernity attempts to melt the pot that never really melted in modernity. A central example for chapter 6 is Apache Indian, the son

of Punjabis but born in England. Apache makes an arresting blend of Jamaican dancehall, rap, and bhangra, a form of Punjabi traditional music popular among many South Asian youths in England. The result, Apache himself says, is "a very British sound," a music that helps project a new "Asian" identity in his native England while at the same time affiliating him with people of color around the world, in sound, lyrics, and even his name. I also examine the music of Sheila Chandra, who taps into the globalization of feminism to help solidify her identity as a contemporary Anglo-Asian woman in England.

Chapter 7, "Toward a More Perfect Union: Cross-Cultural Collaborations" discusses another mode of postmodern/postcolonial—even postidentity—politics in the form of collaborations in "world music." Such collaborations are popping up more and more; examples include collaborations between European women and women of color, as in Zap Mama; and interracial collaborations such as that between Johnny Clegg and Sipho Mchunu, who formed the first South African interracial group, Johnny and Sipho, later called Juluka. In America, Native and African Americans are coming together in bands such as the SongCatchers, whose "History 101" (on *Dreaming in Color* of 1994[25]) tells a now familiar story of European colonialism, but from the not so familiar vantage point of their combined perspectives. These collaborations reveal new ways of conceiving music making in the global ethnoscape. Collaboration, I argue, is a crucial way of suspending identities, and identity politics, focusing less on the resulting "work" than on the process of working together.

In concluding his essay "The Local and the Global: Globalization and Ethnicity," Stuart Hall writes that "the aesthetics of modern popular music is the aesthetics of the hybrid, the aesthetic of the crossover, the aesthetics of the diaspora, the aesthetics of creolization."[26] *Global Pop* attempts to examine such popular musics. In light of the music and musicians of the previous chapters, the concluding chapter, "We Are the World, and the World Is Us," explores what terms such as "hybrid" and "creolization" mean. This chapter also considers the different forms of "modernity" present in the global postmodern, for modernity as a concept occupies a central point of argument and community among many of the musicians discussed in this book. As such, "We Are the World, and the World Is Us" asks: Whose hybridity? Whose modernity? And, who's modern?

NOTES

1. Frith, Introduction, *World Music, Politics and Social Change*, ed. Simon Frith, Music and Society, ed. Peter Martin (Manchester and New York: Manchester Univ. Press, 1989), 2.

2. Wallerstein, *The Modern World-System: Capitalist Agriculture and the Origins of the European World-Economy in the Sixteenth Century*, Studies in Social Discontinuity, ed. Charles Tilly and Edward Shorter (New York

and London: Academic Press, 1974).

3. Appadurai, "Disjuncture and Difference in the Global Cultural Economy," *Public Culture* 2 (Spring 1990): 1–24.

4. Appadurai, "Global Ethnoscapes: Notes and Queries for a Transnational Anthropology," in *Recapturing Anthropology: Working in the Present*, ed. Richard Fox, School of American Research Advanced Seminar Series, ed.

Douglas W. Schwartz (Santa Fe: School of American Research Press, 1991), 192.

5. Hall, "The Local and the Global: Globalization and Ethnicity" and "Old and New Identities, Old and New Ethnicities," both in *Culture, Globalization and the World-System*, ed. Anthony D. King, Current Debates in Art History, no. 3 (Binghamton: Department of Art and Art History, State Univ. of New York at Binghamton, 1991).

6. Berman, *All That Is Solid Melts Into Air: The Experience of Modernity* (New York: Penguin, 1988).

7. Hall, "The Local and the Global," 33.

8. Hall, "What is this 'Black' in Black Popular Culture?" *Social Justice* 20 (Spring–Summer 1993): 105.

9. Karl Marx and Friedrich Engels, *The Communist Manifesto* (New York: Monthly Review, 1964), 7.

10. Giddens, *The Consequences of Modernity* (Stanford: Stanford Univ. Press, 1990), 64.

11. See Appadurai's "Global Ethnoscapes."

12. Fischer, "Ethnicity and the Post-Modern Arts of Memory," in *Writing Culture: The Poetics and Politics of Ethnography*, ed. James Clifford and George E. Marcus (Berkeley: Univ. of California Press, 1986), 198.

13. Some of these issues of music and ethnography surfaced in Robert Walser's "Rhythm, Rhyme and Rhetoric in the Music of Public Enemy," *Ethnomusicology* 39 (Spring 1995): 193–217.

14. In making use of so many texts of sources, I am continuing an argument forwarded in my "When We Think about Music and Politics: The Case of Kevin Volans," (*Perspectives of New Music* 33 [Winter and Summer 1995]: 504–36) in which I argue that a musical work, the practices of listening and performing, and what gets said/written about these all comprise one larger text, or metatext, and that any one of these possible sites of signification and interpretation can influence any other or combination of others.

By employing the term *metatext* I am deliberately setting it apart from the "metacommentary" posited and examined by Louise Meintjes in "Paul Simon's *Graceland*, South Africa, and the Mediation of Musical Meaning," *Ethnomusicology* 34 (Winter 1990): 37–73. The metacommentary, for her, exists apart from the text

(in this case, Paul Simon's *Graceland*). Furthermore, her metacommentary consists mainly of press reports, through which she intelligently discusses positionality and possible interpretations of *Graceland*. It is significant, though, that the metacommentary leaves out the musicians and herself, as if they have no positionality or play no role in shaping this metacommentary.

15. See Deanna Campbell Robinson et al., *Music at the Margins: Popular Music and Global Cultural Diversity*, Communication and Human Values, ed. Michael A. White and Michael Traber (Newbury Park, Calif., and London: Sage Publications, 1991). For a good introduction to cultural imperialism, see John Tomlinson, *Cultural Imperialism: A Critical Introduction*, Parallax Re-Visions of Culture and Society, ed. Stephen G. Nichols, Gerald Prince, and Wendy Steiner (Baltimore: The Johns Hopkins Univ. Press, 1991).

16. Lipsitz, *Dangerous Crossroads: Popular Music, Postmodernism and the Poetics of Place* (London and New York: Verso, 1994); Feld, "Notes on World Beat" and "From Schizophonia to Schismogenesis: Notes on the Discourses of 'World Music' and 'World Beat'," in Feld and Charles Keil, *Music Grooves: Essays and Dialogues* (Chicago and London: Univ. of Chicago Press, 1994). "Notes on World Beat" originally appeared in *Public Culture Bulletin* 1 (Fall 1988): 31–37; "From Schizophonia to Schismogenesis" in *Working Papers and Proceedings of the Center for Psychosocial Studies* No. 53, edited by Greg Urban and Benjamin Lee.

Other important contributions to the study of the globalization of popular music include Reebee Garofalo, "Whose World, What Beat: the Transnational Music Industry, Identity, and Cultural Imperialism," *World of Music* 35 (1993): 16–32; Andrew Goodwin and Joe Gore, "World Beat and the Cultural Imperialism Debate," *Socialist Review* 20 (July-September 1990): 63–80; Jocelyne Guilbault, "On Redefining the 'Local' through World Music," *World of Music* 35 (1993): 33–47; and Dave Laing, "The Music Industry and the 'Cultural Imperialism' Thesis," *Media, Culture and Society* 8 (July 1986): 331–41. Mark Slobin's *Subcultural Sounds: Micromusics of the West*, Music/Culture, ed. George Lipsitz, Susan McClary, and Robert Walser (Hanover and London: Wesleyan Univ. Press, 1993) is also

useful in theorizing the spread of music.

17. Erlmann, "The Aesthetics of the Global Imagination: Reflections on World Music in the 1990s," *Public Culture* 1996 (Spring 1996): 481.

18. Frith, "Music and Identity," in *Questions of Cultural Identity*, ed. Stuart Hall and Paul du Gay (London and Thousand Oaks, Calif.: Sage, 1996), 109.

19. McClary, "Same as It Ever Was: Youth Culture and Music," in *Microphone Fiends: Youth Music & Youth Culture*, ed. Andrew Ross and Tricia Rose (New York and London: Routledge, 1994), 38.

20. Walser, *Running with the Devil: Power, Gender, and Madness in Heavy Metal Music*, Music/Culture, ed. George Lipsitz, Susan McClary, and Robert Walser (Middletown, Conn.: Wesleyan Univ. Press, 1993), xiii.

21. Much of this terrain has also been profitably and elegantly gone over by Susan McClary and Robert Walser in "Start Making Sense! Musicology Wrestles with Rock," in *On Record: Rock, Pop, and the Written Word*, ed. Simon Frith and Andrew Goodwin (New York: Pantheon, 1990).

22. For my purposes, contemporary "academic" music is marked by a primary concern for formal issues rather than meaning, signification, communication, or pleasure. There are many contemporary composers in and out of academia to whom this label does not apply (a few examples are Robert Ashley, William Bolcom, Neely Bruce, Michelle Kinney, Meredith Monk, Carl Stone, Stephen Scott, Janika Vandervelde, and many others), but since Oliveros clearly operates against some sort of standard of contemporary music, this category of "establishment" music needs to be posited. For more on "academic" music, see my *The Rapacious Muse: Selves and Others in Music from Modernity through Postmodernity* (in preparation), and Susan McClary's "Terminal Prestige: the Case of Avant-Garde Music Composition," *Cultural Critique* 12 (Spring 1989): 57–81.

23. Liner notes to D'Cückoo's *Umoja*, RGB Records RGB 501-2, 1994.

24. Quoted by Brooke Wentz, "No Kid Stuff," *The Beat* 12 (1993), 43. *Logozo* is on Mango 162-539 918-2, 1991.

25. On Horizon/A&M 31454 0247 2, 1994.

26. Hall, "The Local and the Global," 38–39.

Popular Musics and Globalization

Foreign Music is where all the hipsters are.
—Stanley Goman, Head of Retail Operations,
Tower Records, 1995[1]

HASN'T WORLD MUSIC BEEN
AROUND FOR THOUSANDS OF YEARS?

One of the most notable trends in the music industry since the 1980s has been the rise in popularity of new music genres: world music, world beat, world fusion; in Germany, *Weltbeat* and *Weltmusik*[2]; in other parts of the world, ethnopop, Afropop, Afrobeat. Offshoots of these genres include: tribal, techno-tribal, and cybertribal, as well as ambient, trance, and new age. All of these categories overlap to some degree and with other categories I haven't mentioned. In 1988, Tower Records' international buyer told *Newsweek* that his section was "definitely the fastest growing part of the store," more than tripling in the previous three years.[3] By 1991 the market share of world music was equal to classical music and jazz,[4] two very small categories (according to the Recording Industry Association of America, in 1995, the market share of classical music was 2.9% and for jazz, 3.0%; they had no category for world music as of this writing).[5] A report in *Forbes* says that only about 2% of Tower Records' sales are of "foreign music."[6]

Two percent isn't much, but the visibility (audibility?) of world music is growing fast. For example, the Pakistani Qawwali singer Nusrat Fateh Ali Khan sang a duet with Eddie Vedder of Pearl Jam for the soundtrack to Tim Robbins's film *Dead*

Man Walking, which raised Khan's fame to the extent that he was recently signed by Rick Rubin's American Recordings, an eclectic label that records, among others, Johnny Cash, Jesus and Mary Chain, Donovan, Pete Droge, Sir Mix-a-Lot, and Slayer.[7] Plans are in the works for Khan to release two traditional albums and possibly one featuring more duets. "Nusrat is a powerful and charismatic performer," says label founder Rubin, "and in Pakistan, his singing is referred to as 'the voice of God'. I want to try and help him make the best records he can."[8]

So to what do these labels refer? The history of the world music designation isn't difficult to trace, though we should tease out an early academic meaning and a more recent, popular one. As early as the late 1970s and early 1980s some ethnomusicologists were using the term world music to describe all the musics of the world's peoples. No one then saw it as a phrase with potentially pejorative undertones; it was merely a shorthand way of separating the musics of west and the rest. So there were conferences with world music as the subject, and a book, by Bruno Nettl, examining *The Western Impact on World Music*.[9]

But the term did not really gain much currency until a little later. In *The Virgin Directory of World Music*, Philip Sweeney explains:

In the summer of 1987, a series of meetings took place in an upstairs room of a North London pub, the Empress of Russia. Present were about 25 representatives of independent record companies, concert promoters, broadcasters and other individuals active in the propagation in Britain of music from around the world. The objective was to discuss details of a modest promotional campaign for the autumn, and to boost sales of the increasing numbers of records being issued, as the boom in interest in African music continued and extended to other parts of the world. One of the obstacles to persuading record shops to stock much of the new international product was reported to be the lack of an identifying category to describe it, record shop managers didn't know whether to call it "ethnic", "folk", "international", or some other equivalent, and were inclined in the absence of an appropriate niche in their racks simply to reject it. It was decided, as part of a month-long promotion that October, to create such a tag and attempt to spread its use via one or two music press adverts, a cassette compilation of music on the various labels involved in the campaign, and the distribution to record shops of "browser cards" bearing the new appellation, to be placed in the sections it was hoped they would now create in their racks. After a good deal of discussion the term chosen was world music, other contenders such as "Tropical Music" being judged too narrow of scope. . . . Within months the term was cropping up in the British press, within a year it had crossed the Channel and was rivalling the existing French phrase "sono mondiale", coined three years earlier by the fashionable Paris glossy *Actuel* and its broadcasting subsidiary Radio Nova, and within three years it was in regular mainstream music industry use in Britain, the United States and northern Europe. [Probably less than three years, if the traditionally slow *Billboard* established a world music chart in

1990, the term was certainly in circulation before then.] This may be regrettable for those people, including myself, who dislike the term for its combination of a meaninglessly wide literal field of reference, with a capricious and subjective actual application, but it is also understandable. No better short phrase has yet been proposed, and thus the term World Music has taken on quite a sturdy life of its own, which is one of the reasons it forms the title of this book.[10]

I quote this story at length because it illustrates the kinds of drives that create markets and niches, how they came to being in the margins and moved into the mainstream (sometimes), and how creating a physical space to put the products in has much to do with how the product is labeled, marketed, and bought. In one gesture the old but not quite gone "international" label (which could include anything from Clancy and Makem Irish singalongs to polkas) is supplanted by a trendier, less musty, less your-grandparents'-music category that encompasses everything from field recordings made by ethnomusicologists to the latest in pop and rock from outside Europe and North America.

Sometimes, though, if this pop originates outside Europe and America, it might be labeled world beat, which is a term used more by listeners than the music industry. Steven Feld writes of the ways that the discourses surrounding world music and world beat began as mutually distinct categories but are getting less and less differentiated as time goes on.[11] This is probably true; world music has become an umbrella category for the musics of the world that are folk and/or traditional. World beat musics—more identifiably popular than folk or traditional—can fall into this all-inclusive label but more often refer to musics that are oriented more to North American and British pop and rock. And the world beat label hasn't enjoyed the success in the music industry that the more general world music has. "World beat," when used at all, usually applies to popular musics from non-European cultures, though there is some exclusivity, as well as much overlapping.[12] The term isn't usually applied to music by western popular musicians such as Peter Gabriel and Paul Simon—their music is, generally, "rock"—but rather is reserved for nonwestern musicians like Youssou N'Dour. As *Billboard*'s New Age and World Music chart manager Eric Lowenhar put it in 1991, "Warner [Warner Bros., Simon's record company] has asked why I won't put him [Simon] on the [World Music] charts. We need to give other artists their own place."[13] (Simon's music is usually on the Adult Contemporary charts).

Andrew Goodwin and Joe Gore provide an excellent discussion of this term in "World Beat and the Cultural Imperialism Debate," in which they identify a 1983 album of that title by an Austin, Texas musician Dan Del Santo as the origin of the term.[14] Del Santo's music on this album is a kind of funk/rock/jazz; the eponymous track is an instrumental in the same vein. His 1990 album *Off Your Nyash* features a photo of him on the cover over the caption: "The Undisputed Originator of World Beat."[15] And World Beat is the name of his band; World Beat Music is the name of his publishing company.

Later, the American independent record label Shanachie, which had previously concentrated on African and Irish musics, began a new series called "World Beat/Ethno-Pop" in 1988. This label appeared on the cover of several of their albums, but the company seems to have dropped the series title after only a few years for the simpler "World" designation.[16] In the meantime, many of the artists they introduced to American artists in this series achieved the kind of popularity most musicians dream of: they moved from this independent ("indie") company to a bigger one, as did, for example, Ofra Haza, Sheila Chandra, Dissidenten, and others.

On Shanachie's release of Ofra Haza's *Fifty Gates of Wisdom*, the company explained their series as follows:

> All around the globe new music is being made which takes the world's myriad musical traditions, with all their power and eloquence, and injects them with the intensity and urgency of Western pop, using the full palette of contemporary instruments and state-of-the-art recording techniques. . . . World Beat is a fascinating new mechanism which enables traditional music to again play the prominent role it historically has had in rejuvenating the world's popular music. Shanachie's World Beat/Ethno-Pop series presents many of the most impressive works of this provocative new movement.[17]

With this statement, Shanachie taps into many of the themes I will explore in these chapters: the mythification of nonwestern musics, rejuvenation, and a distancing of their series from the more traditional ethnomusicological ones associated with labels such as Folkways and the Nonesuch Explorer Series.[18]

SUBSIDIARY LABELS

Since the proliferation of world music, there has been an inevitable fracturing of this umbrella category into subgenres; Philip Sweeney's characterization of the world music label as marking a "meaninglessly wide literal field of reference" is quite correct.[19] New designations are cropping up all the time—I sometimes think my local record store has changed them every time I go in. So now there is ambient music, trance music, space music, world ambient, tribal music, ethnic fusion, ethno-techno, ethno-punk, techno-tribal, and doubtless others I haven't yet heard of, and still others that will appear after I have written this and before you read it.[20] Most of these musics overlap with each other and many overlap with the new age category, so that it is possible to find musicians without any world music experience or aspirations making acoustic/ambient/trance music that sounds to most listeners like some genericized "ethnic" music. And listeners to these musics overlap themselves. The proliferating newsgroups on the Internet that deal with new age and ambient musics talk about some of the same musicians and radio programs, for example.[21]

All of these labels possess an enormous currency in delimiting power. Their dispersal and their accompanying ideologies are perhaps best illustrated by two

examples. The first is a query of a puzzled Internet user in Hong Kong writing to the newsgroup rec.music.indian.misc (I have left the original spelling intact in this and all subsequent quotations of Internet postings unless otherwise indicated):

> I have never before been on this newsgroup. But I had to. In a local newspaper, a food journalist called the music in an Indian restaurant "definitely newage." I'm sure the music must have been Indian.
>
> Please tell me what is newage music and why would (if he did) the journalist call Indian music newage, when it has been around for thousands of years?

Stuart Hall's global post-modern was never more evident here: A Hong Kong Chinese person (judging by the name on his email address) inquiring about Indian classical music in an Indian restaurant in Hong Kong, addressing his question to the multinational users of the Internet.

The second example comes from a recent trip to Mexico City. I walked into the Tower Records and found all the usual U.S. and U.K. pop and rock music suspects on the ground floor, labeled "Pop" and "Rock." All the Mexican and other Latin American pop and rock musics were upstairs in the World Music section of the store, a bigger section, with a live karaoke singer performing the latest hits.

WELCOME TO THE MARKET

Steven Feld has written that "commodity capitalism, and particularly monopoly capitalism, promotes musical tokenism. And 'world beat' at this juncture is deeply about musical tokenism, especially in the way marketing strategies oppose it to 'world music'."[22] In order to track one of the forms of hegemony of this kind of musical tokenism, and explore further the ways that "world music" was a commercial construction, we should look at the music sales periodical of record, *Billboard* magazine and its charts. As the magazine itself writes in its advertisements, "It isn't a hit until it's a hit in *Billboard*," and they're quite right, for they publish the lists of hits and hitmakers.

CHARTS

Billboard heralded the debut of their World Music chart in May of 1990, with these words:

> *Billboard* introduces its World Music chart in this issue. . . .
>
> Based on reports from a panel of 40 dealers, the World Music chart lists the top 15 best-selling albums in this growing genre. The chart will run biweekly in the Retail section in tandem with the 25-position New Age chart under the heading Top Adult Alternative Albums. . . .[23]

The juxtaposition with the New Age chart and subsumption of both new charts under the heading "Top Adult Alternative Albums" tells much about how world

music has been positioned within existing music categories: it is designed to be music for grown-ups, music as wallpaper, music that does not, on its reasonably attractive and accessible surface, raise sticky problems about misogyny, racism, colonialism, what have you. And it is more than just a juxtaposition, for the same person manages both the World Music and New Age charts.[24]

A compilation of all the World Music charts from *Billboard* magazine gives some inkling as to who and what sells, in addition to revealing a few trends.[25] One is the huge portion of reggae musicians in the World Music chart, until *Billboard* began a reggae chart in the issue of 4 March 1994.[26] But one trend seems to come out of nowhere. In March 1995, the label Narada introduced *Celtic Legacy: A Global Celtic Journey*, which debuted at the number 2 position. It never attained number 1, though it remained on the charts for 52 weeks and appeared on *Billboard*'s list of the top ten World Music albums of 1995. This success was quickly followed (partly by accident and partly by design, it seems, given the dates) by more releases of albums with "Celtic" in the title, thirteen of which charted by August 1996. Several have sold quite well, though none as well as the first. This craze for things Celtic caused one of the major labels, Atlantic (part of WEA, one of the six biggest record companies in the world) to create a line called Celtic Heartbeat, which offers music by the Irish band Clannad, among others. I should also note that some of these albums appeared on the New Age charts as well. Atlantic/Celtic Heartbeat's promotional material pulls together features of the discourses and imagery of authenticity, new age and more, to hook potential listeners. For example, a promotional postcard issued in 1995, features text, partly in a "Gaelic" font, superimposed over a stormy seaside sunset seen behind a castle tower halfway in view that is faded into the water so that it appears not quite real.[27]

> Over the Miles
> Over the Centuries
> Celtic Heartbeat
> Music with Resonance

> Celtic music is as unique as Ireland itself:
> its people, their history, their future. It encompasses wonder,
> mysticism and tradition. And now there is a label
> dedicated to bringing the best of Celtic music to the world:
> Celtic Heartbeat.

Another indicator of the success of "Celtic" music is the response to a 1993 Volkswagen television ad that included background music by Clannad. The company received so many calls about the music that a revised version of the spot included the band's name and song title, which anyone who watches television advertisements will know is unusual.[28] This ad propelled the album *Anam* (the Irish word for "soul"), originally released in 1982, onto the World Music charts

beginning on 17 April 1993 where it remained for 55 weeks, making it one of the best-selling World Music albums of 1993. This belated boost also raised sales from the original 45,000 to over 250,000 and helped make Clannad one of the top-selling World Music bands since the charts began and the number one World Music band in 1993 (the album itself was no. 5). Sales of the Volkswagen Passat also increased by 25%.

The reason for this surge of interest in things "Celtic" isn't entirely clear, though I would propose it has something to do with the increasing consciousness of ethnicity in contemporary American life and the concomitant commodification of ethnicity in music, even white ethnicities: European Americans are loath to be left out. In making this point, I am rehearsing a widely made argument in studies of ethnicity in the United States concerning some members of the dominant culture's perceptions of themselves as lacking an ethnic identity. The issue of dominant middle-class envy of ethnic communities surfaced, for example, in *Habits of the Heart*, where the authors explicitly oppose the middle-class emphasis on individuality with lower-class concern for group solidarity and relationships. This contrast, the authors suggest, "is expressed by middle-class Americans themselves when they entertain envious fantasies about more 'meaningful community' among lower-class racial and ethnic groups or among (usually European) aristocracies."[29] Enter the craze for the Celtic, a word sufficiently vague that almost any white American could claim to have some Celtic ancestry. Also, as usual in discussions of world music, the new age isn't far away, for Celtic beliefs form an important part of some new age beliefs and practices.

Another trend worth noting is the rise of collections; there were none on the charts until early 1993, when Ellipsis Arts . . .'s 4-CD *Global Meditation* arrived, where it stayed for 33 weeks. This success, combined with the lesser success of their *Global Celebration* (also 4 CDs), helped make Ellipsis Arts . . . a player in the world music market, for it appeared on *Billboard*'s list of the top-five world music labels in 1993; they are also expecting to increase their annual earnings by about 25% from 1995 to 1996.[30] The success of such collections isn't difficult to understand, since they are mostly compilations of previously released material and are thus relatively inexpensive to assemble, especially if the company already owns the rights to the recordings. Further, as musical *hors d'oeuvres*, they don't tax listeners' attention spans.

My compilations of all the charts contain no surprises: western musicians dominate.

Position	Artist	Years on Top Chart	Region/Music
1.	Gipsy Kings	1990, 1991, 1992, 1994, 1995, 1996	France: Flamenco
2.	Clannad	1993, 1994, 1995, 1996	Ireland: Celtic
3.	Strunz & Farah	1991, 1992, 1996	fusions

Table 1.1
Billboard's Best-Selling World Musicians.

Table 1.1 (continued)

Position	Artist	Years on Top Chart	Region/Music
4.	Boukman Eksperyans	1991, 1993	Haiti
5.	The Chieftains	1995, 1996	Ireland: Celtic
6.	Ry Cooder	1994, 1995	North America
7.	Cesaria Evora	1995, 1996	Cape Verde
8.	Angélique Kidjo	1992, 1994	Benin
9.	Lebo M	1995, 1996	South Africa: pop
10.	Loreena McKennitt	1995, 1996	Canada: Celtic
11.	Youssou N'Dour	1991, 1992	Senegal
12.	Ali Farka Toure	1993, 1994	Mali
13.	Zap Mama	1993, 1994	Africa/Europe: fusions
14.	3 Mustaphas 3	1991	England: fusions
15.	Altan	1994	Ireland: Celtic
16.	Mary Black	1995	Ireland: Celtic
17.	Cirque du Soleil	1995	French-Canadian
18.	Sheila Chandra	1993	England: fusions
19.	Johnny Clegg and Savuka	1990	South Africa
20.	Ry Cooder and V. M. Bhatt	1993	North America/India: fusions
21.	James Galway	1996	Ireland: Celtic
22.	Mickey Hart	1992	North America: fusions
23.	Ofra Haza	1993	Israel
24.	Henry Kaiser and David Lindley	1992	North America/Africa: fusions
25.	Salif Keita	1994	Senegal
26.	Kronos Quartet	1992	North America/Africa: fusions
27.	Ladysmith Black Mambazo	1990	South Africa
28.	Baaba Maal	1993	Senegal
29.	Hugh Masekela	1994	South Africa
30.	Mahlathini and the Mahotella Queens	1990	South Africa
31.	Thomas Mapfumo	1991	Zimbabwe
32.	Sergio Mendes	1992	Brazil
33.	Margareth Menzes	1990	Brazil
34.	Mouth Music	1991	Scotland: Celtic
35.	Le Mystère des Voix Bulgares	1990	Bulgaria
36.	Nightnoise	1995	Ireland: Celtic/new age
37.	Outback	1992	Australia/Africa: fusions

Position	Artist	Years on Top Chart	Region/Music
38.	Keali'i Reichel	1996	Hawai'i
39.	Ravi Shankar and Philip Glass	1990	India/North America: fusions
40.	Sweet Honey in the Rock	1994	African-American: gospel
41.	The Tahitian Choir	1993	Tahiti
42.	Bill Whelan	1996	Ireland: Celtic

Table 1.1 (continued)

Since *Billboard* compiles its charts based on sales, it is no surprise that, for the most part, fairly unchallenging music appears at the top of these lists.[31] In particular, there is never any music from the far east, which most western listeners find the most foreign, despite the spate of press coverage of such albums as the Okinawan Shoukichi Kina's *Peppermint Tea House* on Luaka Bop.[32] Even with the popularity of some African musicians, western European and North American musicians still sell the most. "If it isn't Celtic or the Gipsy Kings, it's very hard to get on the *Billboard* World Music chart," says Suzanne Hannema, U.S. product manager for Real World, the English label founded by Peter Gabriel.[33]

Artist	Album Title	Debut date	500,000 date	1,000,000 date
Gipsy Kings	*Gipsy Kings*	5/19/90	5/19/90	6/10/95
The Chieftains	*The Long Black Veil*	2/18/95	3/18/95	
Lebo M	*The Lion King: Rhythm of the Pride Lands*	3/18/95	5/13/95	
Gipsy Kings	*Mosaique*	5/19/90	5/27/95	
Gipsy Kings	*The Best of the Gipsy Kings*	4/15/95	5/25/96	

Table 1.2
Billboard's Best-Selling World Music Albums.

As western musicians dominate the charts, the biggest and most powerful recording companies dominate: ten of the sixteen companies represented are one of the six majors (CEMA, EMD, PolyGram, Sony, UNI, WEA), and five of nine of these are in the top two thirds.

Label	Years	Owned By
Mango	1990, 1991, 1992, 1993, 1994	PolyGram
Elektra	1990, 1991, 1992	WEA
Shanachie	1991, 1992, 1993	independent
Warner Bros.	1990, 1995, 1996	WEA
Atlantic	1993, 1994	WEA

Table 1.3
Labels with charted albums.[34]

Table 1.3 (continued)

Label	Years	Owned By
Hannibal	1992, 1994	Ryko-independent
Nonesuch	1995, 1996	WEA
RCA Victor	1995, 1996	BMG
Ryko	1991, 1992	independent
Walt Disney	1995, 1996	independent
Capitol	1990	EMD
Elektra Musician	1994	WEA
Ellipsis Arts. . .	1993	independent
RCA	1995	BMG
Triloka	1994	independent
Windham Hill	1996	BMG

GRAMMY AWARDS

If *Billboard* keeps track of the day-to-day affairs of the music industry, the annual Grammy awards presented by the National Academy of Recording Arts and Sciences (NARAS) recognizes those who sell and excel. Not long after *Billboard* introduced its World Music chart, NARAS added a new Grammy award category for world music in the summer of 1991. NARAS president Michael Greene employed some unmemorable press-conference speak to justify this: "We noticed activity connected to these specific forms of music. We realized these genres were growing and more young artists were getting involved."[35] Greene also announced at the time, NARAS's decision to limit the fields of Latin, new age, folk, blues, reggae, polka, bluegrass, children's, comedy, spoken word, and engineering/nonclassical as album-only categories, meaning that only whole albums can be considered, not single songs. Greene's comment on this decision contrasts with the world music Grammy winners thus far: "We wanted to keep pop singers from doing one song with a reggae beat and being included in that category. This is a purification process, it creates a more mature category as opposed to having pop artists dabbling in our specialized fields."[36]

The creation of charts and awards doesn't mean that world music was previously ignored, but that it showed up—albeit rarely—in other categories. The first in the Grammys was the "Best Performance, Folk" category introduced in 1959, the year after the Grammys began. Appendix 2 contains a complete list of this designation and its spinoffs from their inceptions, and a perusal of it clearly indicates changing tastes in the "exotic" as well as the increase in diversity of the kinds of music represented. What is at first obvious is that whatever passed for "folk" music in the 1950s and 1960s would not fall in these categories today. For example, Harry Belafonte, the biggest winner in the '50s and '60s, followed by Peter, Paul, and Mary, was usurped by the mid-1960s, by hipper, urban musicians. Belafonte, the most frequent winner in the first half of the 1960s, was never again nominat-

ed for another Grammy in any of these categories. In 1970, the name of the award was changed again to "Best Ethnic or Traditional Recording (Including Traditional Blues)," so many African-American blues singers begin to take over the awards in this category. In 1974, the name was changed again to "Best Ethnic or Traditional Recording (Including Traditional Blues and Pure Folk)," indicating a recognition of a kind of authenticity. No matter the title, though, throughout the 1970s, Muddy Waters and Doc Watson took almost all the awards, so that by 1982, a "Best Traditional Blues Recording" Grammy was added, and in 1986, the name of the ethnic/traditional category was changed to "Best Traditional Folk Recording." Still, despite a few nominations along the way (for Miriam Makeba, Ravi Shankar, and Ali Akbar Khan), no non-U.S. musician (except Canadian Joni Mitchell, who won in 1969 for *Clouds*) ever won an unshared Grammy in any of these categories until 1987, when Ladysmith Black Mambazo earned the award for *Shaka Zulu*, their first album after working with Paul Simon on *Graceland* in 1986. The Grammy nominees and awards have pretty much tracked *Billboard*'s World Music charts, for nearly all Grammy nominees appeared on the *Billboard* charts, and three of the five winners attained the number 1 position on the chart.

The Grammy awards in World Music thus far have gone to:

1991	*Planet Drum*	Mickey Hart and guests
1992	*Brasileiro*	Sergio Mendes
1993	*A Meeting by the River*	V. M. Bhatt and Ry Cooder
1994	*Talking Timbuktu*	Ali Farka Toure and Ry Cooder
1995	*Boheme*	Deep Forest

Table 1.4
Grammy Winners for
Best World Music Album.

What is interesting about this list is that most of the primary musicians come from the realm of U.S. popular musics, and that most of the awards went to collaborations: between Grateful Dead drummer Mickey Hart and a number of other percussionists from around the world; between rock/folk/jazz/roots/blues guitarist Ry Cooder and two world music stars, Indian musician V. M. Bhatt (who plays a *Mohan vīnā*, a kind of south Indian slide guitar) and Malian singer-guitarist Ali Farka Toure. None of these albums makes it into *World Music: The Rough Guide* (the most comprehensive guidebook of world music, which I'll discuss below), which helps point out the difference between the "pure" world music focus of that guide and the syncretic, popular, crossover world music favored by NARAS and *Billboard* and reflected in relatively high sales; this makes it clear that their president's claims of purification concerned album style and consistency, not musical style.

If we look at the nominations for the Grammys we find a little more range than the list of winners might lead us to expect. The 1994 Grammy nominations for "Best World Music Album" (obtained from the Internet,[37] reproduced below as Table 1.5) included musicians and entire bands from outside the North American and British popular music hegemony: the Gipsy Kings are from southern France;

Milton Nascimento is a black Brazilian; Youssou N'Dour is Senegalese and sings mainly in his native Wolof (I will discuss him in chapter 5); and Zap Mama (whom I'll discuss in chapter 7) is an African-Belgian group of women who sing in a variety of languages and styles from the African and European continents.

Angelus	Milton Nascimento
Love & Liberté	Gipsy Kings
The Guide (Wommat)	Youssou N'Dour
Sabsylma	Zap Mama
Talking Timbuktu	Ry Cooder with Ali Farka Toure

Table 1.5
1994 Grammy Nominees for Best World Music Album.

Ry Cooder and Ali Farka Toure eventually won, the second year in a row for Cooder and a nonwestern collaborator, thus showing that, as Paul Simon demonstrated with his Grammy-winning *Graceland* in 1986, hiring musicians from outside the west helps establish (or reestablish, in Simon's case) U.S. musician's visibility with the general public.

Boheme	Deep Forest
Cesaria Evora	Cesaria Evora
Firin' in Fouta	Baaba Maal
Raga Aberi	Shankar with Zakir Hussain and Vikku Vinayakram
The Splendid Master Gnawa Musicians of Morocco	The Splendid Master Gnawa Musicians of Morocco featuring Randy Weston

Table 1.6
1995 Grammy Nominees for Best World Music Album.

Not much changed in 1995; there was, again, a fairly wide variety of musics and musicians represented, but the award went, predictably, to Deep Forest's *Boheme*, a danced-up, sample-heavy, highly manipulated treatment of a range of musics, mainly from Eastern Europe, and the Hungarian folk singer Márta Sebestyén.[38] This album won after a well-publicized campaign by NARAS to make the Grammy choices hipper,[39] but as we have seen, there was little chance that any of the nonwestern nominees for 1995 would win, since there was no precedent for such a victory.[40] Even more plainly than the folk and blues categories, no world music Grammy has ever gone to a non-American musician or group exclusively (except for *Brasileiro*, and even that album was largely made in the U.S., where Mendes has lived since 1964).

The accompanying notes to the winning *Boheme* feature the same kind of new-ageifying and naturalizing evident from their earlier, popular *Deep Forest*; here is a sample from *Boheme*'s liner notes by the two principal musicians, Eric Mouquet and Michel Sanchez:

The enchanting timbre of a strange woman's voice unmistakably marked Transylvania as our new destination in that stationary journey which gives our music mean-

ing. Echoes of deep forests, ancient legends and buried tales still resounded there. The voice revealed a name—Márta [Sebestyén], and she seemed to be singing directly to us. She would be the guide, thread and bird of good omen on our Bohemian wanderings.[41]

And the album's cover continues this natural theme with lovely, sunlight-filtered leaves.

Figure 1.1
Deep Forest:
Boheme, cover.

Perhaps more interesting—or at least, less predictable—at the 1995 Grammys, the master *sarod* player Ali Akbar Khan was nominated for a Grammy in the folk music category for his 2-CD album *Then and Now*; he lost to Ramblin' Jack Elliott's *South Coast*. There is nothing "folk" about Khan's music, of course; he plays Hindustani (North Indian) classical music, though it has become occasionally tinged by new age influences after his many years of living in San Rafael, California, where he has operated the Ali Akbar College of Music since 1967.[42] Also, the Los Angeles-based Chicano/roots/rock band Los Lobos won the Best Pop Instrumental Performance Grammy for their soundtrack to the film *Desperado*. These two examples show the slipperiness of the categories and the ways that musicians, particularly musicians outside the most prestigious categories, can be made to fit anywhere, no matter what their music may sound like.

Comparing the musics and musicians on *Billboard*'s world music charts to those of the Grammy awards', we find that NARAS is clearly more interested in world music not made in Europe or America (though some Europeans and Americans do appear). But the Celtic fringe is gone, and any recording that might be a blockbuster (such as Lebo M's sound track to Disney's *The Lion King: Rhythm of the Pride Lands*) is absent as well. NARAS's concerns may be more centered on "pure" world music than *Billboard*'s, but, even so, the awards thus far have

always gone to American or European stars who collaborate with or appropriate other musics and musicians and who show little long-term interest in these other musics and musicians.

The practices of marketing and labeling of world music and world beat continue an old binary of "the west" and "the rest," putting hugely diverse bodies of musics into the same box, while Gabriel, Simon, and other western musicians are allowed the more prestigious and general "rock" (or more specific "Adult Contemporary") label. Part of the impetus behind such labeling is that record stores need to put things in their place. If you go to a record store you find "rock" music as its own category, subdivided by the musician's names, whereas the nonwestern music section would be subdivided by country (or region or continent), then, perhaps, further subdivided by the musicians' names. Furthermore, all kinds of musical traditions from these cultures would be lumped together. It would be difficult to ask Tower Records or other national retailers to change their categories; but such commercial practices point out, yet again, the limitless ways capitalism constructs centers and margins, and how the margins, no matter how diverse, are nonetheless undifferentiated almost beyond recognition. Record stores' approaches to marketing, labeling, and selling help demonstrate the contradictory and conflicted nature of capitalism, which Lawrence Grossberg has described as a "difference-making machine," but a machine that, as he knows, also seeks stability and predictability. In this case, stability is achieved through the establishment of standard, homogeneous categories such as "world music" that are in the end neither stable nor homogeneous at all.[43]

CROSSOVER DREAMS

Even though marketing strategies try to lump diverse musics into single categories, they also frequently use multiple music categories at one time. Probably the best illustration of this trend is the recent release of *Vision: The Music of Hildegard von Bingen* by Angel Records, obviously an attempt to follow up on the success of Angel's *Chant*, a recording of Gregorian chants by Benedictine monks from Santo Domingo de Silos in Spain, an album that went gold and platinum in 1994, the first ever platinum album for Angel (selling 3 million copies thus far), reaching the number 1 position on *Billboard*'s classical chart and number 3 on the pop charts.[44] The monks refused to make a second album for EMI/Angel, saying they had been underpaid for the first one, so Angel scrambled to recreate the success of *Chant*.[45] Hence, the cover art of *Vision* is remarkably similar to *Chant*; even the font is the same.[46] *Vision* was heralded with a full-page ad in *Rolling Stone*, two issues running, in late 1994, with three different toll-free numbers for listening, ordering, and more information. Dial the "Touchtunes™" number, punch in the 3-digit code for *Vision*, and you hear a stereotypically sexy woman's voice: "'There is the music of heaven in all things, and we have forgotten how to hear it until we sing.' Twelfth-century mystic and prophet Hildegard von Bingen lived in a heavenly world of music. Now, Hildegard transcends time, so *you* can

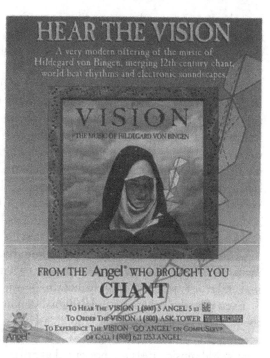

Figure 1.2
Angel/EMI advertisement
for *Vision: The Music
of Hildegard
von Bingen.*

hear the *Vision*. From the Angel that brought you *Chant*, hear the *Vision*, exclusively on Angel Records." It sold 200,000 units in its first four months, very good sales indeed.[47]

The description in the ad, "a very modern offering of the music of Hildegard von Bingen, merging twelfth-century chant, world beat rhythms and electronic soundscapes," caught my attention. Angel seemed to think that using the marketing buzzwords "chant," "world beat," and "soundscapes" would catch the eyes of different portions of the market and that they would have successfully concocted another hit (marketers used a similar strategy to sell "Teenage Mutant Ninja Turtles"—throw some buzzwords together and hope they strike home; this is what one might call the splatter effect). It is true that late capitalism has produced niche markets,[48] but just as true that by attempting to combine those markets, companies can attempt to turn a marginal product into a major one by bringing some of the contradictory strands of discourses together. *Vision* has indeed made the *Billboard* Classical Crossover charts (it was number 1 for 14 straight weeks), though by its sound it ought to be on the New Age chart. The press release from Angel continues the mixture of discourses, beginning by invoking new age sentiments—"CHANT brought you inner peace. VISION will illuminate that inner peace"—but continuing only a sentence later with the authenticity discourse familiar to listeners to early music: "Using two unique vocalists for authenticity, Sister Germaine Fritz, a Benedictine nun, and Emily Van Evera, a world renowned early music vocalist and historian. . . ."[49] Even though the wording isn't

entirely clear, here we have two different authenticities being invoked: the "early music" authenticity of Van Evera and the authenticity of Sister Germaine Fritz, prioress of St. Walburga Monastery in Elizabeth, New Jersey. Angel obviously wanted a nun to participate in the recording.[50]

At the same time, the world music aspect of the album isn't authentic in this way at all. The promised world rhythms turn out to have been available on a CD collection entitled *Supreme Beats: A Percussion Library by Bashiri Johnson*. Bashiri Johnson has worked for Madonna, Whitney Houston, and others and oversaw a staff of several additional percussionists for *Supreme Beats*. This 4-CD set reportedly took six months to complete and contains 650 grooves in four hours, in four categories: "contemporary," "dance/hip-hop," "African," and "world"; subcategories include Mozambique, Charleston, cha-cha, tribal vocal, and more. *Supreme Beats* is described by its label's chief executives as "a working tool for people who make music," saying that the collection is for people who use sampling as a creative tool, adding that one should "consider this collection an invitation to apply Bashiri's grooves to your own music. Use these sounds. Be original and true to yourself. Make wonderful music."[51] For $350.

Even though world music was originally an industry-sponsored term, people in the industry have differing opinions about just what world music is. Most people agree that there has been a shift away from ethnomusicological purism, so that now, world music artists are presented as artists, as individuals, instead of nameless "natives." So, for example, Peter Siegel, founder of Henry St. Records, says that the Chinese musician Sisi Chen's *Tides and Sand* album featuring the yangqin (a hammered zither-type instrument) would have been presented before as a yangqin album, "now it is designed to highlight Sisi Chen as a very expressive artist."[52]

WORLD MUSICIANS

The world is based on this system of labels and it's difficult to be successful if you don't slot nicely into a certain category. I think people regard me as a bit of a UFO!
—Sally Nyolo, formerly of Zap Mama[53]

While world music and world beat are putatively labels for musics, they are more often used to label musicians. The most exhaustive guide to world music, *World Music: The Rough Guide* looks at "ethnic" musics in particular places; here, the editors are concerned mainly with what they perceive to be "indigenous," "authentic" musics.[54] And they are marketing their book primarily to those western consumers who want to buy what they believe to be the authentic, the real. While the contributors to *World Music* detail musics that might be called popular, they only do this when the makers are "exotic."[55] So the authors will talk at length about aboriginal rock in Australia but not, say, the Pogues (Irish folk/rock/punk musicians). And they will look at rock in Asia but

avoid Cantopop and other soft-rock and pop genres, softer sounds, to be sure, but also far more lucrative and popular than the few rebel rockers still beloved by the west; these Cantopop stars (such as Jacky Cheung, Aaron Kwok, Leon Lai, Andy Lau, Faye Wong, and many others) sell millions of albums in China, southeast Asia and in other Cantonese-speaking communities around the world.[56] There is also no mention in *The Rough Guide* of any guide of karaoke, one of the biggest ways of making money through recorded music and one of the most popular forms of musical entertainment in Asia.[57]

If it seems that the world beat category refers to music that is somehow exotic, different, fresh, and North American/British pop/rock oriented, it is also true that musicians who make this—or any—music that sounds mainstream will be categorized by their ethnicity rather than music. For example, Banig (Josephine Banig Roberto), a Filipina teenager now living in Los Angeles who sounds like a Madonna wannabe, is nonetheless commonly classified as a world music figure, even though she sings in English in a totally recognizable mainstream pop/dance style.[58] Her record company, Del-Fi—not a world music specialty label—printed a full-page ad in *Rhythm Music Magazine* (the only magazine devoted to world music in the U.S.), half of which advertised her recording, *Can You Feel My Heart* (the other half dealt with several different releases).[59]

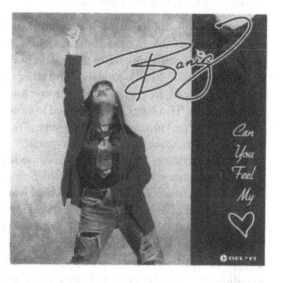

Figure I.3
Banig: *Can You Feel My Heart*, cover.

Can You Feel My Heart went to the top of the charts in Hawaii and Illinois, and was number 8 at the Virgin Megastore in Los Angeles.[60]

WORLD MUSIC LISTENERS

In addition to what academics, critics, retailers, and musicians say, listeners have their own ideas about what the music is and how it should be

treated. The spread of the Internet gives us a glimpse at some of these sentiments. Late in March 1996, a seemingly innocent posting appeared on alt.music.world:

> Subject: Sitar Music
> I'm not sure if that's how you spell it, but Rachel insists that it is. Who's that, you ask? Nobody important. Anyway, does anybody know anything about sitar music? (You know, the weird stuff in the background of Beatles movies) Thanx a lot :)

(In this and all subsequent quotations from the Internet, I have left the original spelling intact unless otherwise indicated.) Responses to this post quickly moved into a discussion of the politics of world music. South Asian posters (one in particular) were angered that an important instrument in Indian classical music could be referred to in this unknowledgeable, offhand way.

In the many subsequent postings, which appeared over a couple of weeks, several issues emerged. Many users felt guilty about the kinds of music they make or like:

> As a North American (several generations, very white), I am in the position of being a cultural rapist when I take instruments and styles from other cultures and use them for my own entertainment. Yet there is so much beauty in those elements, that I cannot help but want to play them myself.

Posts following this one largely fell along two lines. If you respect the borrowed music, it's permissible to use it. For these users, intentionality played a key role. If a western musician approaches the music to be appropriated with respect and good intentions, then all is forgiven. The other main argument was the belief that music is universal, free, available to anyone and everyone who wants to put it to their own uses. This latter group seemed to view music as having a life of its own: "Music *is* free," proclaimed one posting, "regardless of the *recording industry's* attempt to make you think otherwise."

One polarization among netters became increasingly clear and ultimately caused such rancor that the thread ended. Some posters (including the principal South Asian poster) clearly possessed what I would call a "culture concept": they had some kind of understanding of the workings of culture and the transmission of cultural forms; they knew about hegemony and were familiar with Left politics. Others subscribed to the more Enlightenment view that everyone is an individual, and music is an object and therefore not connected to any social space. The globalization of North American culture and North American music is minimal, according to these users: "No American anywhere forces anything cultural on anyone at anytime, particularly musical," wrote one. Then, in another post, this same person wrote, "I would like to hear how young people around the world are marched into record stores and forced to buy Madonna or Michael Jackson records." These discussions lasted nearly four weeks and finally fizzled. Presumably most users lost interest or deliberately stopped reading and posting out of anger.

Clearly, there are divergent ideas among these and other fans about what con-

stitutes world music and which strands of discourse around world music are the best or the true ones. If capitalism is conflicted and contradictory, so are listeners. As we will see in a moment, there are plenty of world musics to go around, whether one likes the authentic, the hybrid, the crossover, or some kind of combination.

THE DISCOURSES OF WORLD MUSIC

Thus far we have examined the rise of world music and the discourses contributing to its growth, including musicians' and listeners' positions on the subject. But these discourses did not just spring up out of nothing. What I want to do next is investigate some of the representations and commodifications of this new music to show how contemporary constructions of "nonwestern" musics betray underlying, old sensibilities about Others and their cultures. Several common strands emerge: rejuvenation, novelty, authenticity, originality, the "real," and the spiritual. All of these are intertwined, but I will attempt to separate them here.

SONIC TOURISM: THE GOOD, THE BAD, AND THE *NEW*

One of the most salient discursive strategies is the use of language that emphasizes the diversity of the music, its freshness; the image of the "happy native" is not far from this kind of rhetoric. Of the three guidebooks currently available (*World Music: The Rough Guide*, Philip Sweeney's *The Virgin Directory of World Music*, and Peter Spencer's *World Beat*), Spencer's is the briefest and most revealing in its introductory comments, sounding something like a how-to guide for hip dinner parties. He writes,

> Nowadays the music you play needs to be sophisticated but not obtrusive, easy to take but not at all bland, unfamiliar without being patronizing.
>
> World music gives the American listener a sense of freedom from the constraints of standardized Anglo-American pop, without the arid, over-intellectual pomposity of much "progressive" music. World music is both entertaining and different. It takes the listener to a place where the world's various cultures meet happily and in the spirit of festival. It is a force for understanding and goodwill in an increasingly dark world.[61]

Spencer goes on to offer his own selection criteria, which, like those in *World Music: The Rough Guide*, amount to criteria of authenticity and novelty: "Basically, anything that sounds too familiar will be left out."[62] Such a statement indicates that the growing interest in world music isn't just a search for authentic sounds but *new* sounds, musics and musicians unpolluted by the market system of the late capitalist west, and sounds more accessible and ignorable than the insistent and in-your-face and under-your-skin popular styles of the 1990s rap, hip-hop, grunge, punk, pop-punk, and others.

Similarly, j. poet's guide to "worldbeat" in the *All-Music Guide* on the Internet continues many of the same ideas. A notion of consumption-as-health underlies much of his language.

> Cats and chicks will always need to boogie, and as rock 'n' roll slowly dies of boredom and cultural irrelevance (according to several recent *Billboard* surveys, rock currently accounts for less than 40% of the records sold in the U.S.) we're going to have to expand our horizons to find our minimum daily requirement of musical satisfaction. When you listen to the music of Latin America, Africa, Jamaica, Algeria, Java and other foreign climes you'll hear the kind of raw energy and hungry enthusiasm that's been missing from most pop music in this country for almost a decade. Most of the (white) world may suffer from an advanced case of xenophobic blindness (and deafness), but that's no reason to deprive yourself of some of the richest musical rewards our planet has to offer.[63]

Spencer's and poet's concern for novelty is echoed in the compact disc accompanying *The Virgin Directory of World Music*:

> The collection of songs . . . hopefully demonstrates that at a time when rock has become far too responsible to drop its trousers and most jazz couldn't be further from the "sound of surprise", a whole lot of stuff the marketeers confine to the World Music rack has at least one common denominator: its sheer freshness. If young people have been walking around into record stores and buying armfuls of Salif Keita and Milton Nascimento albums, then it's probably because they want to hear something NEW.[64]

There are several notions floating about in these excerpts. One centers on an old concern in rock music: the intellect versus the body.[65] Steven Feld has written cogently of the "beat" part of the world beat label, making much the same point.[66] It is therefore important to note that the most frequent way of describing the nature of the nonwestern music is to talk about rhythm. Watch for this in the musicians' quotations on their music in what follows. Rock music, we understand, which used to be pure sex, has lost its grinding energy; musics by others (read: people of color) still have something to do with sex. It is no accident, then, that Spencer's two examples, Salif Keita (from Mali) and Milton Nascimento (from Brazil), are both black. And jazz, we are supposed to think, while it used to be black and sexual, is now so academicized that it too has become sterile, whether the cerebral, abstract improvisations of Cecil Taylor, the studied, historically-informed work of Wynton Marsalis, or the new music musings of Anthony Braxton.

Another reason for the rise in the popularity of world music is that, as Spencer indicates, many listeners are looking for something out of the mainstream. If, in contemporary late capitalist culture, consumers continue to define themselves by their tastes, to be an individual one must have increasingly individualized tastes, increasingly non-mainstream tastes, increasingly eclectic or unusual tastes. American (and other) consumers who go to Wal- or Kwik-E- or K-Mart or wherever,

know, whether they admit it or not, that necktie, those socks, that automobile, they are buying is virtually identical to hundreds, thousands, hundreds of thousands of others. It may be impossible to ensure one's own subjectivity in a world in which everything is mass-produced, bought, and sold. But advertisers constantly tell contemporary consumers that it is possible and that the authentic is within reach of everyone who wants it.

AUTHENTICITY

Had Raymond Williams lived a little longer, "authenticity" would surely have been one of his keywords, for few ideas have surfaced more noticeably and more subtly than this one in the last decade. I have already touched on the "authenticity" with which most regular listeners to music are familiar: authenticity as historical accuracy (in "art" music) or cultural/ethnographic accuracy in world musics. Increasingly, though, there is confusion over these authenticities and an authenticity that refers to a person's positionality as racialized, ethnicized, subaltern, and premodern. Lionel Trilling[67] and Charles Taylor analyze a third authenticity: a sincerity or fidelity to a true self. Taylor explains: "There is a certain way of being human that is *my* way. I am called upon to live my life in this way, and not in imitation of anyone else's life" (emphasis in original).[68] But even this authenticity operates under various guises: sincerity as credibility, or being true to the emotions represented in the work, and sincerity as commitment to one's art.

Let me attempt to present all of these authenticities together as a whole, first, before teasing out the various strains.[69] First, I should note that all these authenticities have at bottom an assumption about an essential(ized), real, actual, essence. For Trilling and Taylor this essence is the modern, bourgeois, individual; in music it is an assumption of original, untainted ways of musicking and sounding. The problem is that there are multiple subject positions available to anyone and multiple interpretations and constructions of those positions. Those that are thrown into relief most frequently in music are the public/private conceptions of stars, and the artistic/personal existences of musicians. But the west, while it views its citizens as occupying many different subject positions, allows "natives" only one, and it is whatever one the west wants at any particular moment. So constructions of "natives" by music fans at the metropoles constantly demand that these "natives" be premodern, untainted, and thus musically the same as they ever were. Even more thoughtful critical discourse cannot escape these old binaries and expectations. Authenticity is jettisoned and hybridity is celebrated, but it is always "natives" whose music is called a hybrid (and you can tell this by the use of the natural metaphor to describe supposed "natural" peoples, cultures, and processes of hybridizing[70]). Musicians at the metropoles rarely make musics that are heard as hybrids (even if they are every bit as hybridized as musics from the peripheries) but instead are placed in more prestigious categories and praised, as was Paul Simon for *Graceland*: Simon reinvented himself artistically and successfully engineered a "creative rebirth."[71]

The discourse surrounding the Simon and *Graceland* case helps get at some of these issues.[72] Along with the theme of rejuvenation, which constantly surfaces in the rhetoric of western musicians who work with musicians and musics from around the world, there are the multiple subject positions available to metropolitans in late capitalism. "It's hard to know if you're being attacked as an artist or as a person,"[73] said Simon about the *Graceland* controversy, and that is the point: as a person he was resolutely anti-apartheid, as an artist, his western, voracious aesthetic allowed him to appropriate anything and do anything with it.

Capitalist structures that protect western subjects, with the most visible of these being, stars, allow western culture to emerge as simultaneously always mongrel and always pure. "Culture flows like water," says Simon, defending his work with black South African musicians. "It isn't something that can just be cut off."[74] Note yet another natural metaphor. Simon means, though, the "natural" culture of "natives"; his "culture" isn't culture in this anthropological sense at all: it is civilization, intellectual property. So *his* culture *can* be cut off: he has copyrights, agents, lawyers, publishers, record company executives at his disposal. And Simon's hybrids, appropriations, syncretisms—supported by these capitalist music-industrial structures—are conceived as nothing other than his individual creations, meaning they are only thought of as his original works. Western culture is neither pure nor impure because it is owned. It is constructed as outside the purview of such ideas as authenticity. But other cultures' forms are available to be constructed as pure or impure when they are not owned, and even, sometimes, when they are.

I would like to make it clear that the "authenticity" I am attempting to describe here is a real thing, not just a marketing tool or, as Martin Stokes has written, "a discursive trope of great persuasive power,"[75] or, as Iain Chambers has argued, on the wane.[76] But "authenticity" is something that many musicians and listeners believe in *and* use as a discursive trope. An example from my own experience might help make the highly contradictory nature of this concept a bit clearer. While as a scholar in using the term authenticity I am well aware of the problems that arise (as I hope this discussion demonstrates), with my other hat on, that of a player of Irish traditional music, I have a firm, inflexible idea about what is "authentic" in that music and attempt to play not merely in an authentic style but also seek out players with similar attitudes and pick as favorites bands that play in ways that conform to my conception of authenticity.

Authenticity of Positionality

Notions of what we can call "authenticity" seem to be increasingly common in the global postmodern. Consumers at the traditional metropoles look toward the former margins for anything real, rather than the produced. They want "real" gangsta rap musicians—black, poor, from the hood—not middle-class ones, and certainly not white ones. Time and again I see this in teaching (and in my own house with our teenager). The most important criterion for my students and

daughter in listening to a band isn't whether they are good, meaningful, or interesting, but if they have sold out to money, to commercialism. To "sell out" means to: 1) appear on MTV, or appear on any other major television network; 2) sign with a major label.[77] In that order, it seems. Prince Be of the hip-hop group P.M. Dawn says "a sell-out is someone who does shit that they can't fuckin' stand doing just to make money."[78]

If world musicians depart from their assumed origins they run the risk of being labeled as a sellout and/or perhaps losing their world music audience, which for many nonwestern musicians, is the only audience they have outside their immediate locale and circles. The discourse of selloutism applies far and wide, not just to world musicians. An example from the world of "alternative" rock will help make some of this clearer. A recent letter to *Spin* magazine, which had named Smashing Pumpkins the Artists of the Year in 1994, captures this disdain of the sellout, or the popular: "Kudos-plus to your Artist of the Year, Smashing Pumpkins. It's about time this band got the recognition it deserves. I've held the Pumpkins deep and close to my flaccid, hollow heart for so long it rather irks me that they have become mainstream and are not only mine anymore, but half of America's."[79] So, it would seem, owning a CD or a concert ticket here and there isn't enough: today's listeners/consumers seem to view themselves as owners of a piece of a band (or bands as owners of a piece of each of their earliest fans), a piece that gets smaller as the band gets bigger. And so if a band becomes nationally popular, they cease to "belong" enough to any individual.

By definition, world music musicians cannot be sellouts, since the structures of the music industry exclude virtually all world musicians from the venues, visibility, and profits that might make them appear to be sellouts to their fans. But listeners can construct these musicians as sellouts if their music seems to be too much like North American and U.K. popular musics: their betrayal is of music and place, not of anticommercial values. It is important to underscore this point: North American and British musicians can make whatever music they want and only be viewed as sellouts if they try to make money; any other musician is constrained by the western discourse of authenticity to make music that seems to resemble the indigenous music of their place and is cast as a sellout if they make more popular-sounding music, and/or try to make money. (I will unpack this dynamic as it relates to Youssou N'Dour and Angélique Kidjo in chapter 5.)

Authenticity of Emotionality

The discourse of emotionality and experience perhaps owes much to the rise of folk music, as outlined intelligently by Simon Frith in *Sound Effects*. It was, according to Frith, this demonstration of one's own emotional experience that gave folk music its power in the 1960s.[80] This concept in world music is often bound up with constructions of spirituality (hence one of the ways that the world music and new age music categories overlap). So, for example, Paul Simon was drawn to his collaborators on the album *The Rhythm of the Saints*, he says,

because he found it "real and emotional."[81] But mostly, listeners' demands for authentic spirituality apply to Others, whose perceived enigmatic qualities are often interpreted as spiritual.

The best illustration of this phenomenon is the improbable success of the Tibetan monks of Gyuto, whose polyphonic vocalizing has catapulted them into international fame, which they translate into support for Tibetan refugees and Free Tibet activities. Their record company, Rykodisc, maintains a World Wide Web page on the Internet. Listen to the ways this music is marketed.

> The sobering, otherworldly sounds of the Monks have been developed over hundreds of years, ever since the Gyuto Tantric University was founded in 1474. Their monastic training includes a type of multiphonic chanting, in which each monk sings a chord containing two or three notes simultaneously. This remarkable, transcendentally beautiful sound, thought to arise only from the throat of a person who has realized selfless wisdom, is like nothing else on this earth.[82]

And on the same Web page:

> Their voices come from a place largely unknown to other humans, lifting three-note chords from individual throats to produce a sound that is awesome and quite literally cosmic. They are the Gyuto Monks, once of Tibet and now of Dharmsala, India. They chant to set the human race and the planet free. Seeing and hearing them is a very special experience, for in addition to their multiphonic chanting, the audience is feasted with the brilliant colors of their costume, the graceful movement of ritual activity, and a panoply of unusual instruments: mountain horns, bells, and drums.[83]

The quasi-spiritual words describe a "music" that is actually fairly dull, the Tibetan equivalent of a group of Christian clerics communally reciting prayers. This isn't an aesthetic judgment, however; rather, I am trying to point out that the western presentations of these Tibetan Buddhist chants leave them so decontex-

Figure I.4
Mickey Hart checking
the microphone of a
Gyuto monk.

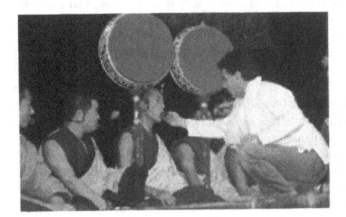

tualized and deritualized that they are evacuated of the meanings of their own surroundings, and of little interest to a western listener as music. But these sounds are made interesting in the way they are packaged for consumption as the essence of ancient, eastern spirituality, and the fame-value that rubs off of Mickey Hart and other western stars who associate with them.

The spiritualization that western listeners impose on this decontextualized and deritualized music is also indicated by the monks' first recording: not for Mickey Hart and Rykodisc (noted world music preservationists) but, rather, Windham Hill, a label that first became known for virtually creating the new age genre in the early 1980s.[84] Still, I don't think it is necessarily the spiritual nature assumed by western listeners that gives this music an audience; the famed throat singers of Tuva are no less popular, but they are secular, and their music sounds much the same to most westerners.[85]

Australian Peter Parkhill has commented cogently on the tendency of western listeners to impose gut-level, romantic ideas and feelings to musics they might not otherwise be able to respond to at all, except with puzzlement. Parkhill notes that the press coverage of the 1992 WOMAD (World of Music and Dance) Festival in Adelaide was mainly concerned with the reviewers' perceptions of the raw emotion of the nonwestern musicians. "The term most commonly used was 'feeling', unlimited resources of which were credited to all visiting performers: they all played with great feeling, no one had ever heard music played with such feeling, and so on."[86] It seems that if the feelings presented and evoked are so real, they must therefore also be deep, or spiritual.

The boldest attempt to capture the spiritual angle has been the successful collection discussed earlier, *Global Meditation: Authentic Music from Meditative Traditions of the World*, a snazzy 4-CD release by Ellipsis Arts . . . in 1992. (Their companion collection, the 4-CD *Global Celebration: Authentic Music from Festivals & Celebrations Around the World*, shows the other side of the common emotional binary allowed native peoples by the west: authentically spiritual on one hand, authentically joyful and celebratory on the other).[87] On the outside of the box so potential buyers can see it before buying, appear the words:

> Rhythm, melody, harmony and song are as natural to human beings as are breathing and talking. We create music around our work, celebrations, and folklore. Through music, we express the vast range of our emotions and ideas. Music also exists universally as an integral part of our spiritual lives. It is the meditative, sacred, and spiritual music, existing for thousands of years in all parts of the world, which is the inspiration behind *Global Meditation*.[88]

Note how this statement uses the first person plural to universalize. Some of this sounds like wishful thinking, as if the writers are forgetting that it was the supposed death of rock music and bankruptcy of western culture that led most listeners to this music in the first place. Such marketing unfortunately obscures the value of the anthology, for it is a well-chosen and -presented collection, culled

from previously released recordings, some made in the field. There is much to like in the music, if not the packaging.

Because there are some field recordings, the company's claim to authenticity works. Some of the songs are authentic in the purist sense; but this authenticity is overlain/juxtaposed with the full new age treatment. Each disc in each collection gets its own title (*Global Meditation*'s four CDs are called "Voices of the Spirit," "Harmony and Interplay," The Pulse of Life," and "Music from the Heart"; *Global Celebration*'s are "Dancing with the Gods," "Earth Spirit," "Passages," and "Gatherings"). The point is that the marketing of these and many other recordings sells by bringing to bear on the impressionable consumer several powerful discourses, any one of which will sell some recordings, and all of which, together, sell even more, putting Ellipsis Arts . . . on the best-selling label list in 1993 as noted earlier. Further, they sell only about a third of their recordings in record stores; the rest are in new age stores, museum shops, and bookstores.[89]

Even those who admit the marketing origins of the term world music cling to the spiritual undertones. Philippe Constaint, director of Mango, the Island Records world music subsidiary, says,

> World music has existed commercially since the industry began seeing it as a source of profit. It is a market category. As long as the producers of this music do not forget its spiritual dimension, as long as they are not too obsessed by the desire to get into the top 50 . . . all will go well. This music has existed as long as the human race. It is not intended to conquer the market, and that is good. It is just intended to be heard by more people.[90]

Constaint's comment demonstrates the multiple bind faced by many subaltern musicians: stay spiritual, stay authentic, don't try to be too popular. We shall see how several musicians deal with this tension in subsequent chapters.

Authenticity as Primality

Another facet of the authenticity issue concerns origins; this is perhaps the oldest assumption made by westerners of musics from outside the west.[91] What is of concern to listeners is that the world music (or alternative rock or what have you) they consume has some discernible connection to the timeless, the ancient, the primal, the pure, the chthonic; that is what they want to buy, since their own world is often conceived as ephemeral, new, artificial, and corrupt. This isn't a new sentiment; it goes back to the nineteenth century, at least, as far as music is concerned, and probably earlier still. At any rate, early modern instances of western European discontent with western Europe are abundant, demonstrating European disaffection for the "modern," "civilized" world and celebrating the pure and natural existence of the noble savage. Italian Peter Martyr,[92] court chaplain and philosopher to Queen Isabella and King Ferdinand, wrote in his *Decades* (1511) that the recently "discovered" indigenous Americans lived without

pestiferous moneye, the seed of innumerable myscheves. So that if we shall not be ashamed to confesse the truthe, they seem to lyve in the goulden worlde of the which owlde wryters speake so much: wherin men lyved simplye and innocentlye without inforcement of lawes, without quarrelling Iudges and libelles, contente onlye to satisfie nature, without further vexation for knowledge of things to come.[93]

The point is that the earliest European observers viewed the unspoiled, unmodern "savage" as living lives that modernized Europeans could only envy: natural, innocent. And lives in which music was made, not manufactured.

Even the names of the new labels specializing in these new genres help connote the primal, the original, the authentic, the unfettered, the real: City of Tribes, EarthBeat!, Earthworks, GlobeStyle, Original Music, Real World, Redwood Cultural Work, Rhythm Safari, Roots Records, Soundings of the Planet, and, in German, Erdenklang ("Earthsound"), and many others. Recently, another curious logism has found favor: the adjective "cultural" is beginning to be used as a code for "ethnic" and/or "authentic." Some critics and musicians speak of "cultural music" as a category congruent, it would seem, to world music. For example, an interviewer paraphrased David Byrne by writing that "all popular U.S. music . . . is a synthesis of African, Latin, Celtic, and other cultural music."[94] In a similar example noted earlier, a representative of a "space music" label describes the didjeridu as a "cultural instrument" (see footnote 21). And a recent advertisement in *Vibe* magazine (which chronicles hip-hop music and culture) displayed several muscular young African American men wearing brightly colored clothing with bold patterns. The company? Cultural Clothing.

This imputation of spirituality and primality to world music occasionally slips into universalist discourse, some examples of which we have already encountered, as if something so spiritual must also be ancient, primal, and therefore timeless and universal. For example, Peter Spencer writes, blithely stepping over issues of cultural relativism, that "the bond that a vernacular music has with its particular subculture is something that can be felt even by those outside of the subculture. . . . And for the American listener who defines his or her taste by its unorthodoxy, discovering music that expresses that distance . . . is one of the moments that makes life real."[95]

Immanuel Wallerstein suggests that, historically, the concept of the universal was

propagated by those who held economic and political power in the world-system of historical capitalism. Universalism was offered to the world as a gift of the powerful to the weak. The gift itself harboured racism, for it gave the recipient two choices: accept the gift, thereby acknowledging that one was low on the hierarchy of achieved wisdom; refuse the gift, thereby denying oneself weapons that could reverse the unequal real power situation.[96]

We shall see in later chapters how some musicians accept the gift and use it to

their own advantage (such as Ladysmith Black Mambazo), while other musicians have more conflicted ideas about it.

The central problematic in such marketing and labeling revolves around the necessity for demonstrating that world music and world beat are both timeless and new at the same time. This results in some odd linguistic juxtapositions in all arenas of the marketplace. For example, the recipe of my favorite pancake mix was altered recently, the new but familiar box proclaiming both "Original Recipe" and "New and Improved." World music is timeless, but fresh; fresh, but timeless. You have heard it before (almost), but you haven't heard anything like it before.

BROUGHT TO YOU BY . . .

Often, the discourses of authenticity or spirituality distance the makers of other musics so far that to bring them back for consumption by westerners an intermediary is required. So one final area related to authenticity concerns who brings us this music, and how; recall the photograph of Mickey Hart and the Gyuto Monks in Figure 1.4 above. This publicity photo captures a "Brought To You By—" feeling, as though this music, taken out of its original context, cannot be presented without a western interpreter/guide who is a master of technology. The curatorial aspect of much of the production of world music and world beat should not be underestimated. In the realm of the visual arts, the notion of curatorship and presentation have become hot topics but have gone largely unremarked in music, except by the typically astute Steven Feld.[97] And the major crisis in anthropology in the last decade has been the ways that the ethnographer can—or should—(re)present the "native."[98]

There is indeed a burgeoning growth in the recordings of musicians like Hart who have become passionate about certain musics from around the world and who have done much to preserve and promote them.[99] Often, these westerners who become involved with recording remote musics tap into the explorer narrative: they are heading off to mysterious places looking for mysterious music. The best illustration of this is ex-Police drummer Stewart Copeland's *The Rhythmatist*, a recording made in 1985, which he said, ten years later, is the album of which he is proudest.[100] The cover, reproduced as Figure 1.5, shows a virile, dressed all in black, hat-clad Copeland dramatically holding a huge microphone in the air, a microphone more phallic, if possible, than a gun: Copeland is a hunter for a new age.[101]

Copeland's note inside, preceded by two paragraphs attributed to Thomas Aquinas (an impossible attribution since the "quotation" mentions a cassette recorder) about a ritual rock/instrument, makes the explorer narrative and the "natural culture" assumption clear.

"Rhythmatism" is the study of patterns that weave the fabric of life; with this speculation in mind a black clad figure is on his way across the so-called dark continent. He meets lions, warriors, pygmies and jungles before stumbling across the **rock**.

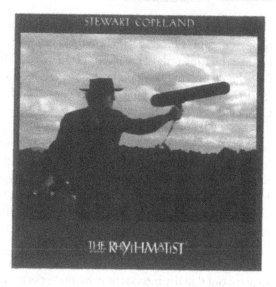

Figure I.5
Stewart Copeland: *The
Rhythmatist,* cover

This record is a curious blend of musical snatches from Tanzania, Kenya, Burundi, Zaire, the Congo and Buckinghamshire.

With all this recording of African music I couldn't help but add some drums of my own and a little electric guitar even.[102]

There is much to unpack here: the politically correct questioning of Africa as the "dark continent," the continuation of the explorer narrative, and the self-effacing remark about his own contribution, which is not at all modest or insubstantial and serves to undermine the aggressiveness signified on the album's cover. Copeland's interview comments on these issues are unfortunately no more thoughtful.

I've recently heard an expression: cultural mining. It's a term of derision, although I proudly assume this term for my own work. Because I think the term itself is only used by intellectual journalists who are very ignorant of the mind-set of the indigenous people in exotic places. That mind-set is very open and giving of its culture and proud to have people from across the world listening to it. And appreciating it. The idea that someone goes to an African village, records their music, and takes the tape away—it's not like, suddenly, "Where's all the music gone? Must've been that white guy with his microphone! He stole it and took it away with him!" Nothing could give them greater happiness than the idea that some people in a faraway land are dancing to their beat.[103]

It is sometimes true that "natives" don't mind western musicians taking their music, but, as in the case of Ladysmith Black Mambazo and the other black South African musicians who worked with Paul Simon on *Graceland,* they wanted something in return: international recognition.[104]

But on *The Rhythmatist*, as usual in such albums, no musicians are credited by name, except western ones (or famous nonwestern ones); African musicians are credited by tribe only. The album cover states, "All music composed by Stewart Copeland" except two selections, one credited to the "world music fusionist"[105] (and *The Rhythmatist* collaborator) Zairian Ray Lema, and another to Lema and Copeland.

Many of these world music recordings feature photographs of the sound technician/host/explorer with audio equipment.[106] Often the accompanying photographs show a bedraggled western musician with his or her nonwestern collaborator(s), always photographed to look less scruffy and more at home, and usually looking as exotic as possible: in traditional dress, with an instrument or weapon. Or sometimes, the emphasis is placed on the collision of the (post)modern western technocrat with the premodern native, who is wearing headphones, or somehow using audio or video equipment.

All of this isn't so much to criticize Copeland, Mickey Hart, or anyone else, as to point out that the intersecting discourses of authenticity, exploration, emotionality, universalism, spirituality, and others have an immense inertia, which even the most reflexive and sensitive musician would find difficult to overcome, and which most of us as listeners succumb to in one way or another. This durability of old western notions about the African continent and premodern cultures everywhere is also perpetuated by the fact that the flows of power in the music industry overlap in complex ways; musicians can produce recordings (Paul Simon), own or head record companies or divisions of companies (David Byrne, Peter Gabriel, Mickey Hart); music journalists can oversee series and anthologies (Brooke Wentz, for example, compiled *Global Meditation* and *Voices of Forgotten Worlds*, and co-compiled *Global Celebration*).[107] Even academics occasionally foray into the production side, with some ethnomusicologists compiling and annotating anthologies (Veit Erlmann, Steven Feld, Jocelyne Guilbault, Christopher Waterman, and Philip Yampolsky spring first to mind).[108]

In his important study *The Black Atlantic*, Paul Gilroy quotes Jean Baudrillard on the process of commodification to buttress his argument that listeners of black music reinject commodified performances with a politicized memory of slavery, a process that turns the object into an event. Here is Baudrillard's passage:

> The work of art—a new and triumphant fetish and not a sad alienated one—should work to deconstruct its own traditional aura, its authority and power of illusion, in order to shine resplendent in the pure obscenity of the commodity. It must annihilate itself as familiar object and become monstrously foreign. But this foreignness is not the disquieting strangeness of the repressed or alienated object; this object does not shine from its being haunted or out of some secret dispossession; it glows with a veritable seduction that comes from elsewhere, having exceeded its own form and become pure object, pure event.[109]

Here Baudrillard rewrites Walter Benjamin's idea of the aura inherent in art-works: aura is not something intrinsic and unique that *may* be lost in the mechanical reproduction of artworks but something that *must* be destroyed in an era of mechanical, electronic, and digital reproduction.

Baudrillard's process of transformation is reversed in the consumption of world music: the music is not familiar-made-monstrous, but the monstrous-made-familiar: noise transformed into music. This transformation occurs by aestheticization, the unfamiliar music harnessed for western consumption by its incorporation into the interlinked realms of the commodity and the aesthetic. There is some irony in the fact that to "understand" or "appreciate" world music, it has not only to be presented by an intermediary but commodified as well, as if commodification somehow refines world music into a familiar and intelligible consumable item.

But we have gone too long without music. The following chapters will examine the voices and sounds of musicians, fleshing out some of the theoretical issues and observations already made, always remembering that there are people who make and listen to music. It is to all of these voices that I now turn.

NOTES

1. Quoted by Robert La Franco and Michael Schuman, "How do you say rock 'n' roll in Wolof?" *Forbes* 156 (17 July 1995), 103.

2. See Peter Niklas Wilson, "'Zwischen 'Ethno-Pop' und 'Weltmusik'," *Neue Zeitschrift für Musik* 148 (May 1987): 5–8.

3. Quoted by Jim Miller, "Pop Takes a Global Spin," *Newsweek* 111 (13 June 1989), 72.

4. Brooke Wentz, "It's a Global Village out There," *Down Beat* 58 (April 1991), 22.

5. *Annual Report of the Recording Industry Association of America* (Washington, D.C.: Recording Industry Association of America, 1996).

Examination of the growth of the global music industry isn't my goal in this volume, except to the extent that the industry manufactures meanings. Fortunately, there are several excellent sources on the industry, beginning with Roger Wallis and Krister Malm's classic *Big Sounds from Small Peoples: The Music Industry in Small Countries*, Communication & Society Series, ed. Jeremy Tunstall (London: Constable, 1984). See also their subsequent *Media Policy and Music Activity* (London and New York: Routledge, 1992); and Robert Burnett's *The Global Jukebox: The International Music Industry*, Communication and Society, ed. James Curran (London and New York: Routledge, 1996). Finally, *Rock and Popular Music: Politics, Policies, Institutions*, ed. Tony Bennett et al., Culture: Policies and Politics, ed. Tony Bennett et al. (London and New York: Routledge, 1993) contains several essays that examine issues of the music industry and the globalization of popular musics.

6. La Franco and Schuman, "How do you say rock 'n' roll in Wolof?"

7. *Dead Man Walking* is on Columbia CK 67522, 1995.

8. "American Recordings owner Rick Rubin is pleased to announce the signing of Pakistani singer Nusrat Fateh Ali Khan," *Entertainment Wire* (25 June 1996), available on the Internet at http://newspage.yahoo.com/newspage/yahoo2/960625/003005.html.

9. Nettl, *The Western Impact on World Music: Change, Adaptation, and Survival* (New York: Schirmer Books, 1985).

10. Sweeney, *The Virgin Directory of World Music* (London: Virgin Books, 1991), ix. See also Anthony Wall's introduction to *Rhythms of the World*, eds. Francis Hanly and Tim May, (London: BBC Books, 1989). For a similar definition and history, see Simon Broughton et al., eds., *World Music: The Rough Guide* (London: Rough Guides, 1994).

11. Feld, "From Schizophonia to Schizmogenesis," in Feld and Charles Keil, *Music Grooves: Essays and Dialogues* (Chicago and London: Univ. of Chicago Press, 1994), 267.

12. For this succinct definition I am indebted to Tony Mitchell, "World Music and the Popular Music Industry: An Australian View," *Ethnomusicology* 37 (Fall 1993): 310.

13. Quoted by Wentz, "It's a Global Village out There," 23.

14. Goodwin and Gore, "World Beat and the Cultural Imperialism Debate," *Socialist Review* 20 (July–September 1990): 63–80. Del Santo's album appears on Pleasure Records PLP 1002, 1983.

15. Dan Del Santo, *Off Your Nyash*, Flying Fish Records FF 70551, 1990.

16. I don't see "World Beat/Ethno-Pop" on their current releases, and their web page, at http://www.dmn.com/Shanachie/ uses the "World" category only.

17. Quoted in the liner notes to Ofra Haza, *Fifty Gates of Wisdom*, Shanachie 64002, 1989, and reproduced in their catalogues.

18. A more detailed history of world beat and world music and record labels can be found in Herbert Mattelart, "Life as Style: Putting the 'World' in the Music," *Baffler* (1993), 103–9.

19. Sweeney, *The Virgin Directory of World Music*, ix.

20. For more on these musics, see Josh Kun, "Too Pure?" *Option* 68 (May/June 1996): 54; Mark Prendergast, "Background Story," *New Statesman & Society* 6 (29 October 1993), 34–35, and "The Chilling Fields," *New Statesman & Society* 8 (13 January 1995), 32–33; Dom Phillips, "U.K. fray: Trip or Trance, Tech or Tribal, House Rules," *Billboard* 105 (25 September 1993), 34; Dominic Pride, "U.K.'s Nation of 'Ethno-Techno'," *Billboard* 105 (16 January 1995), 1.

21. To be sure, some listeners make fine distinctions between genres that to outsiders would be indistinguishable. There is, for example, a good deal of argument concerning the use of acoustic instruments versus electronics in ambient music. A leading electronic ambient musician and president of Silent Records, an ambient specialty label, Kim Cascone, calls the didjeridu—an Australian Aboriginal instrument often featured in acoustic/world ambient musics also spelled "didgeridoo"—"the kazoo of the '90s," while defenders of the instrument and other acoustic instruments locate their arguments in the perceived primal origins of their music and instruments. Says Shawn Bates of the Hearts of Space label, "the didgeridoo has been around a lot longer than this kind of [electric] music, and will be around long after we're gone. It's a perfect example of a cultural instrument brought into the mainstream that will survive all these trends" (quoted by Colin Berry, "The Sound of Silence: San Francisco's Ambient Music Labels find their Groove," *SF Weekly* 14 [17–23 May 1995], 17).

22. Keil and Feld, *Music Grooves*, 319.

23. "*Billboard* Debuts World Music Album Chart," *Billboard* 102 (19 May 1990), 5.

24. The best coalescence of new age and world music is the World Music Festival (in progress as of this writing), which has lined up almost exclusively new age musicians, and whose position statement, "The Effect of Music on Society," is probably the clearest short introduction to the importance of music in new age philosophy I have seen. See their web page at http://wmf.oso.com/.

25. This compilation is Appendix 1.

26. See "*Billboard* Bows Reggae Albums Chart," *Billboard* 106 (5 February 1994), 7.

27. From a promotional postcard issued in 1995. I would like to thank Irene Nexica for passing this on to me.

28. See David Gates, "The Marketing o' the Green," *Newsweek* 121 (5 April 1993), 60.

29. Robert N. Bellah et al., *Habits of the Heart: Individualism and Commitment in American Life* (Berkeley: Univ. of California Press, 1985), 152.

Space doesn't permit an exhaustive discussion of this topic here. See Richard Alba, *Ethnic Identity: The Transformation of White America* (New Haven and London: Yale Univ. Press,

1990), and Mary C. Waters, *Ethnic Options: Choosing Identities in America* (Berkeley and Los Angeles: Univ. of California Press, 1990).

30. See "More Americans Listen to Exotic Beat of World Music," Reuters, (18 September 1996), from http://newspage.yahoo.com/.

31. *Billboard* does not publish actual sales figures (unless an album reaches a particular sales milestone, such as 500,000 or 1,000,000 units, which happens to few world music albums) so compiling all charts can be confusing. One solution is to compile by number of weeks on the charts, which says something about popularity and longevity, but an album can linger near the bottom for weeks and not sell as much as the number 1 album does in a week. *Billboard* does offer annual rankings of sales, though not with actual sales figures, however, compiling these gives some indication of sales and popularity. (In Table 1.1 I have removed the reggae musicians, as they now appear on their own chart.)

32. Asia Classics 2: *The Best of Shoukichi Kina: Peppermint Tea House*, Luaka Bop/Warner Bros. 9 45159–2, 1994.

33. Quoted by Richard Henderson, "Dead Men Walking, Tibetans Chanting & Cubans Smoking Cigars," *Billboard* 108 (25 May 1996), 36.

34. From "The Year in Music, 1990," *Billboard* 102 (22 December 1990), YE-36; "The Year in Music, 1991," *Billboard* 103 (28 December 1991), YE-34; "The Year in Music, 1992," *Billboard* 104 (19 December 1992), YE-45; "The Year in Music, 1993," *Billboard* 105 (25 December 1993), YE-45; "The Year in Music, 1994," *Billboard* 106 (24 December 1994), YE-63; "The Year in Music, 1995," *Billboard* 107 (23 December 1995), YE-78; and "World Music: Year to Date Charts," *Billboard* 108 (25 May 1996), 44.

35. Quoted by Karen O'Connor, "Grammy adds 3 Categories: World Music among new Awards," *Billboard* 103 (8 June 1991), 87.

36. Ibid.

37. http://www.grammy.com/.

38. *Boheme* is on 550 Music/Epic BK 67115, 1995.

39. See Steve Pond, "Grammys Look for Hipness in New Rules," *New York Times* (25 February 1996), H34.

40. For more on Deep Forest and their best-selling eponymous album, see the "Deep Forest FAQ," located on the Internet at ftp://ftp.best.com/pub/quad/deep.forest/DeepForest-FAQ.txt. See also Carrie Borzillo, "U.S. ad use adds to commercial success of *Deep Forest*," *Billboard* 106 (11 June 1994): 44; and my own "Free Samples: Ghosts in the Tape Machine," in preparation.

41. Mouquet and Sanchez, notes to *Boheme*, 550 Music/epic BK 67115, 1995.

42. Listen to, for example, *Garden of Dreams*, on Triloka/Worldly Music 7199–2, 1993.

43. In *We Gotta Get Out of This Place: Popular Conservatism and Postmodern Culture* (New York and London: Routledge, 1992).

44. On Angel/EMI CDC 7243 5 55138 2 3, 1994. This was actually a compilation of recordings made between 1973 and 1982 and previously released.

45. Meanwhile, the Monks released a new recording, *The Soul of Chant*, for a smaller label, Milan Records 35703, 1994. See Larry Blumenfeld, "Promo Item of the Week Department," *Rhythm Music* 4 (August 1995), 59; and David E. Thigpen, review of *The Soul of Chant*, *Time* 145 (22 May 1995), 72.

46. For a history of the phenomenal success of *Chant*, see Katherine Bergeron, "The Virtual Sacred: Finding God at Tower Records," *New Republic* 212 (27 February 1995), 29–34; Don Jeffrey, "Monks Lift EMI Music to Double-digit Gains," *Billboard* 106 (3 September 1994), 6; Howell Llewellyn, "Meet the Monks: EMI's Next Hit?" *Billboard* 106 (29 January 1994), 1; and "Monk's New Chant: 'Get Off Our Cloud'," *Billboard* 106 (25 June 1994), 11, and "Timeless Success Story: New Age Music Experiences Growing Gains in Popularity," *Billboard* 106 (9 July 1994), 54; and "Music Man," *Forbes* 155 (13 March 1995), 164.

47. It's on Angel CDC 7243 5 55246 21, 1994.

48. On this, see most importantly Scott Lash and John Urry, *The End of Organized Capitalism* (Madison: Univ. of Wisconsin Press, 1987).

49. Angel, press kit for *Vision*.

50. Jim Montague, "Sister Act," *Hospitals & Health Networks* 69 (20 May 1995), 54.

See the profile on Fritz and her success on *Vision*, Michael Pollak, "Medieval Mystic and a Nun Ascend the Music Charts," *New York Times* (11 June 1995), 21.

51. Havelock Nelson, "Ice Cube, K-Dee Launch Lench Mob Label; Grand Street Releases a Big Box of Beats," *Billboard* 106 (25 June 1994), 36. See also the lengthy, positive review of the set by Greg Rule in *Keyboard* 21 (March 1995), 97–98.

52. Quoted by Henderson, "Dead Men Walking," 38.

53. Quoted by Lois Darlington, "Solo Nyolo," *Folk Roots* 156 (June 1996), 51.

54. Broughton et al., eds., *World Music*.

55. See also Martin Stokes's review in *Popular Music* 15 (May 1996): 243–45.

56. See Mike Levin, "Cuttin' Loose in Concert," *Billboard* 105 (27 November 1993), 83, and "Southeast Asia Talking up Chinese Music," *Billboard* 105 (30 January 1993), 1. See also a Cantopop World Wide Web page at http://sunsite.unc.edu:80/pub/multimedia/pictures/asia/hongkong/hkpa/popstars/; Tower Records in Singapore posts weekly sales information at http://www.singnet.com.sg/~skyeo/tower.html. A good introduction to Cantopop is available at http://siegelgate.com/~hsa/cantopop.html.

57. See Andrew Tanzer, "Sweet Chinese Siren," *Forbes* 152 (20 December 1993), 78.

On the rise and popularity of karaoke, see Larry Armstrong, "What's That Noise in Aisle 5? Karaoke may be Coming Soon to a Supermarket or Mall Near You," *Business Week* (8 June 1992), 38; Charles Keil, "Music Mediated and Live in Japan," reprinted in Keil and Feld, *Music Grooves*; Heather McCaw, "The Origins, Use and Appeal of Karaoke" (Department of Japanese Studies, Monash University, 1990); Chris McGowan, "Market Report: Can Karaoke Take Root in America?" *Billboard* 104 (30 May 1992), K1; Shuhei Hosokawa, "Fake Fame Folk: Some Aspects of Japanese Popular Music in the 1980s," *Art & Text* 40 (September 1991): 78–81, and *Japanese Popular Music of the Past Twenty Years—Mainstream and Underground*, translated by Larry Richards (Tokyo: Japan Foundation, 1994). Finally, there is a magazine devoted to karaoke in the U.S., *Karaoke USA NewsMagazine*, and an Internet newsgroup, alt.music.karaoke.

58. I have read that she sings songs in Tagalog at events designated for Filipinos. See Reynaldo G. Alejandro, "Fil-Ams Troop to AC for Banig's Concert," *Filipino Reporter* (9 November 1995), PG.

For more on Banig see Wilma B. Consul, "Brave and Beautiful Banig," *Filipinas Magazine* 3 (30 June 1995), 15, and "Filipino Americans in the U.S. Music Industry," *Filipinas Magazine* 3 (31 July 1994), 38; and "Singer 'Banig' Relocates to Los Angeles," *Heritage* 8 (June 1994), 22.

59. Banig, *Can You Feel My Heart*, Del-Fi 70013–2, 1994.

60. According to Marites Sison-Paez, "The Banig Invasion," *Filipino Express* (12 November 1995), PG.

61. Spencer, *World Beat: A Listener's Guide to Contemporary World Music on CD* (Pennington, N.J.: A Cappella Books, 1992), 2–3.

62. Ibid., 4.

63. j. poet, "Worldbeat," *All-Music Guide*, http://www.allmusic.com/.

64. Simon Hopkins, liner notes, *The Virgin Directory of World Music*, Virgin Records VDWM1, 1991.

65. See Susan McClary and Robert Walser, "Start Making Sense! Musicology Wrestles with Rock," in *On Record: Rock, Pop, and the Written Word*, ed. Simon Frith and Andrew Goodwin (New York: Pantheon, 1990).

66. Feld, "From Schizophonia to Schizmogenesis," 266–267.

67. Trilling, *Sincerity and Authenticity* (New York: W. W. Norton, 1969).

68. Taylor, *Multiculturalism: Examining the Politics of Recognition*, ed. Amy Gutmann (Princeton, N.J.: Princeton Univ. Press, 1994), 30.

69. See also Charles Hamm's important intervention "Modernist Narratives and Popular Music," in *Putting Popular Music in its Place* (Cambridge: Cambridge Univ. Press, 1995). Hamm's concerns are somewhat different than mine, yet, as usual, there is some overlap between his two modernist narratives of authenticity: the first, that subalterns produce music authentic to their culture; the second that popular musics are besmirched by their relationship to capitalism.

Sarah Thornton has also tackled questions of authenticity in *Club Cultures: Music, Media and Subcultural Capital*, Music/Culture, ed. George Lipsitz, Susan McClary, and Robert Walser (Middletown, Conn.: Wesleyan Univ. Press, 1996). Her concerns also differ somewhat from mine. In particular, she views racial/ethnic/national authenticity as an "inflection" of what she calls "subcultural authenticity." This is one of the central authenticities for my discussion and not an inflection at all.

70. For a particularly lucid examination of hybridity, see Robert Young's *Colonial Desire: Hybridity in Theory, Culture and Race* (London and New York: Routledge, 1995).

71. Quoted by Patrick Humphries, *The Boy in the Bubble: A Biography of Paul Simon* (London : Sidgwick and Jackson, 1988), 121.

72. It is not my goal here to offer a detailed discussion of this album, which I examine at length in "Paul Simon, *Graceland*, and the Continuation of Colonialist Ideologies" (in preparation). Crucial discussions of Paul Simon and *Graceland* include Robert Christgau, "South African Romance," *Village Voice* (23 September 1986), 71; Steven Feld's "Notes on 'World Beat'," in Keil and Feld, *Music Grooves*; Charles Hamm's *Afro-American Music, South Africa, and Apartheid*, ISAM Monographs, no. 28 (Brooklyn: Institute for Studies in American Music, 1988), and his *"Graceland* Revisited," *Popular Music* 8 (October 1989): 299–304 (both of which are reprinted in his *Putting Popular Music in its Place*); and Louise Meintjes, "Paul Simon's *Graceland*, South Africa, and the Mediation of Musical Meaning," *Ethnomusicology* 34 (Winter 1990): 37–73.

73. Quoted by Jennifer Allen, "The Apostle of Angst," *Esquire* (June 1987), 212.

74. Quoted in Denis Herbstein, "The Hazards of Cultural Deprivation," *Africa Report* 32 (July–August 1987): 35.

75. Stokes, "Introduction: Ethnicity, Identity and Music," in *Ethnicity, Identity and Music: The Musical Construction of Place*, ed. Martin Stokes, Berg Ethnic Identities Series, ed. Shirley Ardener, Tamara Dragadze, and Jonathan Webber (Oxford and Providence: Berg, 1994), 7.

76. Chambers, *Migrancy, Culture, Identity*, Comedia, ed. David Morley (London and New York: Routledge, 1994). See especially "The Broken World: Whose Centre, Whose Periphery?"

77. See also David Schiff's report of similar experiences with his students, "Scanning the Dial: Searching for Authenticity in High-Art and Popular Music," *Atlantic* 272 (November 1993), 138–44.

78. Quoted by Michael Azerrad, "P.M. Dawn gets Real," *Option* 65 (November/December 1995), 65.

Fans construe the motivation to make money in myriad ways, though. These can include using electric rather than acoustic instruments in order to be heard by more people, which means, of course, selling more tickets. For discussions of this issue, see Simon Frith's "Art versus Technology: The Strange Case of Popular Music," *Media, Culture and Society* 8 (July 1986): 263–79. See also Chuck Eddy's provocative discussion of sellouts on the Internet "Rock and Madison Avenue," http://www.glyphs.com/millpop/95/inbed/html #chuck.

79. *Spin* 10 (March 1995), 16.

80. Frith, *Sound Effects: Youth, Leisure, and the Politics of Rock 'n' Roll*, Communication and Society Series, ed. Jeremy Tunstall (London: Constable, 1983). See especially chapter 2, "Rock Roots."

81. Quoted by Wentz, "It's a Global Village out There," 23.

82. From http://www.well.com/user/gyuto/.

83. Ibid.

84. Gyuto Monks, *Tibetan Tantric Choir*, Windham Hill WD-2001, 1987. Their Rykodisc recording is *Freedom Chants from the Roof of the World*, Rykodisc RCD 20113, 1989.

85. Try *Huun-Huur-Tu*, Shanachie 64050, 1993, which was the first Tuvan recording to take off. See also Warne Russell, "The Throat Singers of Tuva," *RMM* (February 1994), 10–12. There is also a massive Tuvan culture FAQ on the Internet, available at http://www.lib.ox.ac.uk/Internet/news/faq/archive/tuva-faq.html, much of which is devoted to discussions of the music. See also the newsgroup alt.culture.tuva.

86. Parkhill, "Of Tradition, Tourism and the World Music Industry," *Meanjin* 52 (Spring 1993), 504.

87. *Global Celebration: Authentic Music*

from Festivals & Celebrations Around the World, Ellipsis Arts. . . CD 3230, 1992.

88. *Global Meditation: Authentic Music from Meditative Traditions of the World*, Ellipsis Arts... CD 3210, 1992.

89. Henderson, "Dead Men Walking," 41.

90. Quoted by Laurent Aubert, "The World Dances to a New Beat," *World Press Review* 39 (January 1992), 25. This article originally appeared in *Le Monde*.

91. See also Bruno Nettl's *Folk and Traditional Music of the Western Continents*, 2d ed., Prentice-Hall History of Music Series, ed. H. Wiley Hitchcock (Englewood Cliffs, N.J.: Prentice Hall, 1973).

92. Martyr (1457–1526) is also referred to by his Italian name, Pietro Martire d'Anghiera, and his Latinized name, Petrus Martyr de Angleria.

93. Quoted by J. H. Elliott, *The Old World and the New: 1492–1650* (Cambridge and New York: Cambridge Univ. Press, 1970), 26.

94. Rebecca Carroll, "Rodriguez Meets Byrne," *Mother Jones* 16 (July/August 1991), 9.

95. Spencer, *World Beat*, 5.

96. Wallerstein, *Historical Capitalism* (London: Verso, 1983), 85.

97. See his "From Schizophonia to Schismogenesis" and "Notes on 'World Beat'," in Keil and Feld, *Music Grooves*. My discussion on the curatorial aspects of world music owes much to Feld's.

Useful writings on the visual arts include Robert Baron and Nicholas R. Spitzer, eds., *Public Folklore* (Washington, D.C. and London: Smithsonian Institution Press, 1992); James Clifford's *The Predicament of Culture: Twentieth-Century Ethnography, Literature, and Art* (Cambridge, Mass. and London: Harvard Univ. Press, 1988) and "On Collecting Art and Culture," in *Out There: Marginalization and Contemporary Cultures*, ed. Russell Ferguson et al. (Cambridge, Mass., and London: MIT Press, 1990); Sally Price, *Primitive Art in Civilized Places* (Chicago and London: Univ. of Chicago Press, 1989); Deborah Root, *Cannibal Culture: Art, Appropriation, and the Commodification of Difference* (Boulder and Oxford: Westview Press, 1996); and Marianna Torgovnick, *Gone Primitive: Savage Intellects, Modern Lives* (Chicago and London: Univ. of Chicago Press, 1990).

98. See James Clifford and George Marcus, eds., *Writing Culture: The Poetics and Politics of Ethnography* (Berkeley and Los Angeles: Univ. of California Press, 1986).

99. See Banning Eyre, "Bringing it All Back Home: Three Takes on Producing World Music," *Option* (November 1990): 75–81. The double issue of *Rhythm Music Magazine* vols. 3 (1994) and 4 (1995) featured an entire section called "Tracking the Music to its Source," and included two articles by Banning Eyre, "Microphone in Hand: David Lewiston's World Recordings," pp. 36–39, and "Becoming an Insider: Louis Sarno's Life Among the Pygmies," pp. 40–43; and Erik Goldman's "Get Innuit!" about recordings made in Greenland, pp. 44–46. Finally, see Louis Sarno's *Song from the Forest: My Life Among the Ba-Benjellé Pygmies* (Boston and New York: Houghton Mifflin 1993).

100. This comment was in a live Internet conversation on 12 June 1995, now archived at http://rocktropolis.com/sting/stewartchat.html.

101. Copeland, *The Rhythmatist*, A&M CD 5084, 1985.

102. Copeland, liner notes to *The Rhythmatist*.

103. Quoted by David N. Blank-Edelman, "Stewart Copeland: The Rhythmatist Returns," *RMM* 3 (February 1994), 38.

104. This desire surfaces repeatedly in interviews by Black Mambazo and the other musicians. See the video *Paul Simon: Born at the Right Time* from 1992, in which Ray Phiri, the arranger for *Graceland*, says, "Here we were, isolated from the world, and trying really hard to get involved in the international community. And it wasn't happening. And suddenly here was this guy who was known, and was writing beautiful words."

105. Broughton et al., eds., *World Music*, 322.

106. See Baka Beyond, *Spirit of the Forest*, Rykodisc HNCD 1377, 1993, for a memorable photo, as well as Steven Feld's *Voices of the Rain Forest*, Rykodisc RCD 10173, 1991.

107. *Voices of Forgotten Worlds* Ellipsis Arts. . . CD 3252, 1993.

108. See Feld's "From Schizophonia to Schizmogenesis" for a history of the *Voices of the Rain Forest* recording. Erlmann compiled

Mbube Roots: Zulu Choral Music from South Africa, 1930s–1960s, Rounder CD 5025, 1988; Guilbault, *Musical Traditions of St. Lucia, West Indies: Dances and Songs from a Caribbean Island*, Smithsonian/Folkways SF 40416, 1993; Waterman, *Jùjú Roots: 1930s–1950s*, Rounder

CD 5017, 1993; and Yampolsky compiled many recordings for Smithsonian/Folkways of Indonesian musics.

109. Quoted by Gilroy, *The Black Atlantic: Modernity and Double Consciousness* (Cambridge: Harvard Univ. Press, 1993), 105.

2

"Nothin' but the Same Old Story"

Old Hegemonies, New Musics

There are no bands anymore . . . There are projects. . . .
—Michael Whitaker
(Director of Marketing, A&M Records)[1]

The title of this chapter comes from a song by Paul Brady, a singer/songwriter/guitarist from Northern Ireland, who sings in this song of a fictitious Northern Ireland man who travels to live in England, finding himself constantly angered by English assumptions that because he's from Northern Ireland, he is a premodern bigot.[2] The musicians in this chapter, too, make assumptions about the subalterns they work with, or whose music they appropriate, assumptions that are deeply rooted in metropolitan and colonial ideologies, so deeply rooted that these musicians are for the most part unaware of them. At the same time, Peter Gabriel and the Kronos Quartet attempt to advocate the preservation of world musics and the empowerment of peoples from around the world. But their positionality as westerners, and, in Gabriel's case, a male star in the music industry, means that their resulting musics are always appropriative in some ways.

Much of the theoretical foundation of this chapter relies on Antonio Gramsci's concept of hegemony, which has proved extremely influential in the last couple of decades. Gramsci derived his theory of hegemony from Marx and Engels, who posited two kinds of dominance: a class that was both the ruling material as well as intellectual force. Gramsci borrowed from this idea and theorized two super-

structural levels of society, which he termed "civil society" or, he writes, "The ensemble of organisms commonly called 'private'"; he labeled the other level 'political society,' that is, the State.[3] The tensions I am going to outline in this chapter in the music of Gabriel and Kronos help point out that hegemonies of the intellect and hegemonies of the material are intertwined and interdependent, even in the practices of a single musician or band, and even if those musicians try to work around them.

Another one of the most lively and provocative bodies of theory to emerge in recent years is the study of postcolonialism; it too will be important in this chapter and, indeed, throughout this book. One feature of postcolonial theorizing is that its practitioners appear to be more interested in the colonialized nations and subjects than the colonializing powers and colonializers' subject positions.[4] Part of the reason for this is that much of this theory is written by the former colonialized, principally Indians and Africans. Rather than focusing on colonialism as historical fact, I will attempt to tease out the threads of colonialist ideologies that are still evident in cultural practices as Gramscian hegemonies in a more globalized world. These ideologies inform the ways in which the formerly and currently colonialized peoples and/or nations attempt to reform their culture and identities. Fernando Coronil makes a similar claim about the historicity implied by the term "postcolonial," writing that "postcoloniality appears as something of a euphemism, one that at once reveals and disguises contemporary forms of imperialism."[5] When western musicians appropriate music from somewhere else and use it in their music, or even work with nonwestern musicians, the old subordinating structures of colonialism are often reproduced in the new music, though in complex ways that need to be analyzed carefully.

Appropriation is rarely just appropriation. As Steven Feld reminds us, any sort of cross-cultural musical interaction is an appropriation with multiple implications. "Musical appropriation," he writes, "sings a double line with one voice." According to Feld one of those lines is admiration, respect; the other is appropriation.[6] This observation leads us to ask how such appropriations are enacted, and in what kind of political framework they occur. Stuart Hall's two globalizations, the older corporate model that attempts to distance and contain difference and the more recent one that evinces a more ambivalent attitude toward difference, are both exemplified in the following examples by Gabriel and Kronos.[7] These musicians openly speak of their attractions to musics from other cultures and attempt to treat those other musics and musicians with equanimity and respect. At the same time, however, they benefit from their positionality as westerners.

Some writers on world beat have noticed that most discussions of this music tend to be polarized around issues of authenticity and appropriation, or tend to be excessively focused on the personal politics of the western musicians.[8] While I would agree with these criticisms, at the same time it is necessary to point out that authenticity, appropriation, and positionality *are* some of the key issues, as we

have already seen: fans care about these themes, as do the musicians from whom the appropriated musics are taken. Writing around these concepts without oversimplifying or mistaking a particular musician's subject position for the more general positionality of stars in the music industry is the tack I hope to maintain in what follows.

PETER GABRIEL: *US*

In a recent interview on National Public Radio, Daniel Lanois, Peter Gabriel's (1950–) producer on his 1992 album, *Us*,[9] indicated that in part Gabriel treats borrowed music by recording over it.[10] "Come Talk to Me," the first track on *Us*, features Gabriel's improvisations over an African drumming field tape of the Babacar Faye Drummers he recorded in the early 1980s.[11] The prerecorded material is prominent throughout the song but subservient to Gabriel's music. Gabriel at the same time treads new aesthetic/technical ground, for the resulting texture is extremely thick: musical lines piled on lines on lines on lines. Rather than some sort of hierarchical structure as found in most western music,[12] Gabriel instead makes a kind of deep sandwich without the bread: it is all one good thing on top of another. But Gabriel's music makes up the top layer. William P. Malm used to employ the term "polystylistic polyphony" to describe a polyphonic texture that wasn't any other kind (not homophony, heterophony, or contrapuntal),[13] but the word seems to me to be a bit of a misnomer, since most western music until fairly recently did not use noticeably different styles within one work. The term "polystylistic polyphony" would work well, however, to describe the texture used by Gabriel, and other musicians who layer sounds of different origins on top of one another. And Gabriel himself says that he is interested in hybrids, not entering a particular style or genre entirely. "In my own work, I've tried to take elements and integrate them into a sort of no-man's land that isn't England or Africa."[14]

Gabriel also made use of borrowed music in this way for his sound track to *The Last Temptation of Christ*,[15] the controversial film directed by Martin Scorcese. The first track from *Passion* (the sound-track album), "The Feeling Begins," is based on Armenian doudouk music,[16] a sound that Gabriel has said in several places he finds enormously moving.[17] This music—unmetered, *parlando* (free)—begins the track. But after about 22 bars, a percussion track begins, and from that point on the presence of the western drums regularizes the *parlando* quality of the Armenian music into an unchanging 4/4 meter. This repackaging of time marks one of the most salient impositions of western concepts on the musics of other cultures.[18]

Us, though, is more eclectic than *Passion* (which, incidentally, is a favorite among listeners to "ambient" music, showing again the overlap of music categories).[20] The list of additional musicians provided after the lyrics in the album shows a remarkable array of musics and instruments from around the world:

Example 2.1
Peter Gabriel: "The Feeling
Begins." opening.[19]

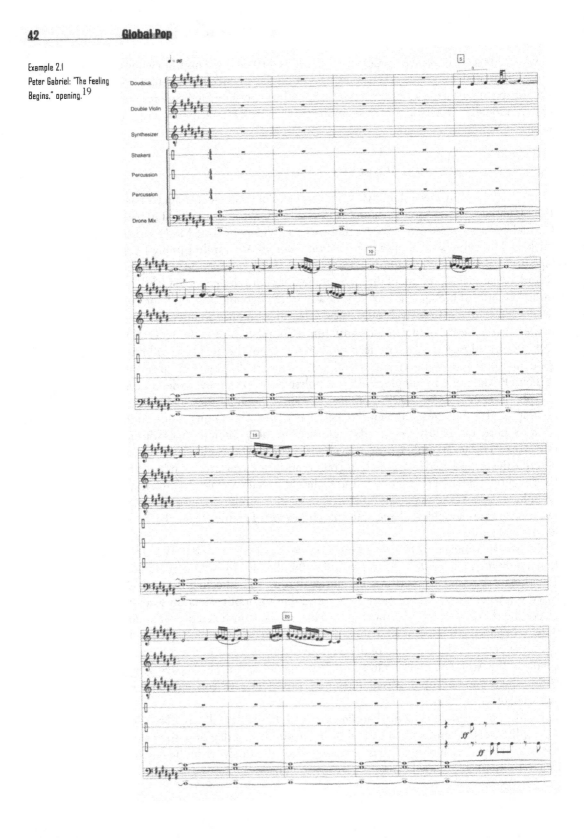

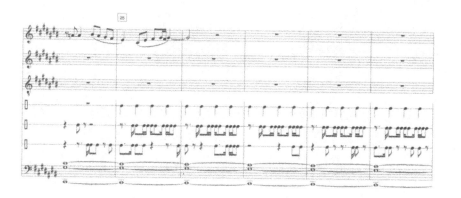

Example 2.1 (continued)

Drums, Manu Katche; Sabar drums, the Babacar Faye drummers; Drum loop, Doudou N'Diaye Rose; Programming, David Bottrill; Bass [chorus], Tony Levin; Guitar, David Rhodes; Shaker, guitar [telecaster], and additional vocals, Daniel Lanois; Additional verse keyboards, Richard Blair; Bagpipes, Chris Ormston; Doudouk, Levon Minassian; Vocals, Sinéad O'Connor, Dmitri Pokrovsky Ensemble; Programming, triangle, keyboard bass, keys, PG. All these musicians—from Russia, Ireland, Senegal, England, Armenia, France, and Canada—contribute to the audible ethnoscape of "Come Talk to Me" and the entire *Us* album. But the resulting sound is Gabriel's: he sings over everybody, and he owns the copyrights. His notes accompanying the album *Plus from Us* make his proprietary stance clear. "I have an extraordinary band who provide the foundation of my records and at the same time I am very lucky to be able to work with musicians from all over the world. They make an enormous contribution to the sound of my work."[21]

And they do, as the following transcription of the opening to "Come Talk to Me" demonstrates. The line marked "Drums" contains all the drum sounds on the track, so a single line of transcription cannot convey the different kinds of sounds the drums make. Also, the upper synthesizer line becomes increasingly distorted by the end of the excerpt transposed, so that the last pitch is really more of a flash of electronic fuzz than a distinct pitch.

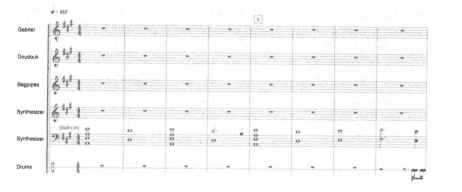

Example 2.2
Peter Gabriel: "Come Talk to Me," opening.

Example 2.2 (continued)

While the sounds in "Come Talk to Me" come from many different peoples and places, this and other songs like it should not be thought of as pastiche, or postmodern. The polystylistic lines are indeed polystylistic *in toto*, but because of meter, harmony, rhythm, and Gabriel's orchestrations, all the parts come together to form a unified whole, one that Gabriel uses to promote the messages of the song's lyrics, which I've included below with simplified harmonies.

Table 2.1
Peter Gabriel: "Come Talk to Me," form, lyrics, and harmonies.

Form	Text	# of measures	Key
intro. [fades in]		4	A-D-A-D
		4	A-D-E-f♯
		4	A-D-A-D
		4	A-D-E-f♯

Table 2.1 (continued)

Form	Text	# of measures	Key
		4	D-D-A-A
		2	A
verse 1	The wretched desert	1	A
	takes its form,	1	D
	the jackal proud and tight	2	A
	In search of you	1	D
	I feel my way,	1	D
	through the slowest heaving night	2	A
	Whatever fear invents,	2	D
	I swear it makes no sense	2	A
	I reach out through	1	b
	the border fence	1	G
	Come down, come talk to me	2	A
verse 2	In the swirling, curling,	1	A
	storm of desire	1	D
	unuttered words hold fast	2	A
	With reptile tongue,	1	A
	the lightning lashes	1	D
	towers built to last	2	A
	Darkness creeps in	1	D
	like a thief	1	A
	and offers no relief	2	A
	Why are you shaking	1	b
	like a leaf?	1	G
	Come on, come talk to me	2	A
chorus	Ah please	2	A
	talk to me	2	D
	Won't you please	2	A
	talk to me	2	D
	We can unblock this	2	A
	misery	2	D
	Come on, come talk to	2	E
	me	2	f♯
	I did not come to	2	A
	steal	2	D
	This all is so	2	A
	unreal	2	D
	Can't you show me how you	2	A
	feel now	2	D
	Come on, come talk to	2	E
	me	2	f♯
	Come talk to me, come talk to	2	D

Table 2.1 (continued)

Form	Text	# of measures	Key
	me	2	A
instrumental break	[bagpipes, drums, synthesizer]	4	A
verse 3	The earthly power sucks	1	A
	shadowed milk from	1	D
	sleepy tears undone	2	A
	From nippled skin as	1	A
	smooth as silk the	1	D
	bugles blown as one	2	A
	You lie there with your eyes half closed like	2	D
	there's no-one there at all	2	A
	There's a	1	b
	tension pulling on your face	1	G
	Come on, come talk to me	2	A
chorus	Won't you please talk to	2	A
	me	2	D
	If you'd just talk to	2	A
	me	2	D
	Unblock this	2	A
	misery	2	D
	If you'd only talk to	2	E
	me	2	f#
	Don't you ever change your	2	A
	mind	2	D
	Now your future's so	2	A
	defined	2	D
	And you act so deaf so	2	A
	blind	2	D
	Come on, come talk to	2	E
	me	2	f#
	Come talk to me, come talk to	2	D
	me	2	A
break	[Dmitri Pokrovsky Ensemble; drums; synth]	8	A
bridge	I can imagine the moment	1	A
	Breaking out through the silence	1	D
	All the things that we both might say	2	A
	And the heart it will not be denied	1	A
	'Til we're both on the same damn side	1	D

Form	Text	# of measures	Key	
				Table 2.1 (continued)
	All the barriers blown away	2	A	
chorus	I said please talk to	2	A	
	me	2	D	
	Won't you please come talk to	2	A	
	me	2	D	
	Just like it used to	2	A	
	be	2	D	
	Come on, come talk to	2	E	
	me	2	f♯	
	I did not come to	2	A	
	steal	2	D	
	This all is so	2	A	
	unreal	2	D	
	Can you show me how you	2	A	
	feel now	2	D	
	Come on, come talk to	2	E	
	me	2	f♯	
	Come talk to me, come talk to	2	D	
	me	2	A	
break	[doudouk, drums, synthesizer]	16	A	
chorus [fades out]	I said please talk to	2	A	
	me	2	D	
	If you'd just talk to	2	A	
	me	2	D	
	Unblock this	2	A	
	misery	2	D	
	If you'd only talk to	2	E	
	me	2	f♯	
	Don't you ever change your	2	A	
	mind	2	D	
	Now your future's so	2	A	
	defined	2	D	
	And you act so deaf so	2	A	
	blind	2	D	
	Come on, come talk to	2	E	
	me	2	f♯	
	Come talk to me, come talk to	2	D	
	me	2	A	

Clear here is Gabriel's artsy sensibility, producing lines such as "The earthly power sucks shadowed milk from sleepy tears undone/From nippled skin as smooth as silk the bugles blown as one." These words and the song as a whole concern problems of communication, the assumption of guilt rather than innocence. Gabriel sings the words with his famously intense vocal style, so the song takes on the feeling of an estranged lover pleading with his ex. This may well be the case. Rumors circulated about the breakup of Gabriel's 20-year marriage and a new relationship. When Elysa Gardner of *Rolling Stone* asked Gabriel about this, he replied, "This record follows the breakup of a marriage and the breakup of another quite intense relationship. I had a five-year period of going to therapy, first as part of a couples' group, then with a singles' group. I think it was a period when I was trying to understand what was going wrong and, in doing so, recognized bits in me that I didn't want to look at, that I didn't like."[22]

Figure 2.1
Peter Gabriel: *Us*, cover.

The album's cover, which depicts Gabriel straining, alone, against unknown forces, contributes to this interpretation of estrangement, as does Gabriel's interactions with the other singers on the album. Sinéad O'Connor's backing vocals are mixed so far into the background that the distance Gabriel sings about isn't overcome.[23] And the one time Gabriel's plea does seem to be answered—by the Dmitri Pokrovsky Ensemble singing in the background after the second chorus—it is sung in Russian and mixed so far into the background it is more of an instrumental line than a lyric. Further, note from Table 2.1 that the parts marked "break" grow increasingly longer throughout the song—from 4 bars to 8 to 16—as if these growing parts without words stand for the growing chasm between Gabriel and whomever he addresses.

If we get a little more musically technical we can discover other ways that

"Come Talk to Me" works affectively, for the song's use of harmony further adds to the estrangement theme.[24] Gabriel makes frequent use of the subdominant (evident in the transcription), which for centuries has carried connotations of the church (it's the same chords as in "Amen"). It is as if Gabriel is attempting to bring in the sounds of an elemental spiritual dilemma. Also, the chorus line that gives its title to the song is often harmonized with a deceptive cadence (on f♯ minor)—you may think you know where the music is going, but it doesn't go there. This deceptive cadence, which serves to signify the futility of ever achieving any kind of communication, is only part of a larger tonal structure in which the dominant, usually the harbinger of a cadence (or a momentary cadence itself called a half-cadence) is bypassed in favor of a ii-♭VII-I progression (b to G to A in verses 1–3). Such harmonic motion, rather than giving a sense of tonal closure, sounds more like a modal cadence (since many of the ancient church modes conclude with a flatted seventh rather than the raised seventh as in the major and minor modes), as if Gabriel, along with the instruments such as the bagpipes and drums, is attempting to make his cry seem primordial.

Figure 2.2
Peter Gabriel, Secret World
Live tour, during "Come
Talk to Me."

Lyrics, harmonies, and eclectic instrumentation all contribute to a sense that "Come Talk to Me" grows out of Gabriel's life. At the same time, however, Gabriel has ensured that the meanings of the lyrics are universalized: he may as well be talking about classes, races, ethnicities, genders, and nations that aren't communicating. This more general theme of estrangement bears an important relationship to the appropriated musical materials. The uses of musics and musicians from around the world on this album provide a kind of remedy for this distancing, perhaps illustrated by the album's title *Us*, not, say, *Us and Them*. In answer to an email question from a fan, Gabriel himself says, that the title

means us as in two people, a relationship, and us as in all of us. I read somewhere that the measure of man's [sic] civilization is where he [sic] places the line between

them and us. When you put people in the box marked them, you can kick them around a lot more easily than you can when they're in a box marked us. So I think it's useful to try and empty the box marked them and fill up the box marked us.[25]

Gabriel's political activism bears out this position. But the music of "Come Talk to Me," instead, builds and builds and builds, clearly indicating that there has been no rapprochement, or that there can never be one. Even though the song fades to conclude, "Come Talk to Me" seems to build toward crisis, not communication. The video, included on *All About* Us,[26] reinforces this interpretation. Seemingly drawing on the famous "morphing sequence" from Michael Jackson's 1991 *Black or White* video, Gabriel's disembodied face undergoes numerous alterations, through makeup, lighting, and probably other kinds of technology. Interspersed with these shots are views of Gabriel performing with a band in a powerful blue light. The video is all about Gabriel, cut off from the rest of the world as his face is cut off from his body.

Gabriel's practice of distancing the original drummers—described by Steven Feld as "schizophonia"—a practice becoming increasingly widespread as world beat music becomes more popular, is the way in which traditional music can be wholly appropriated or modified, without the permission or collaboration of those who originally made the music.[27] Rather than problematizing this situation, Gabriel dramatizes it nearly to the point of irony.

Gabriel is sensitive to issues of appropriation, clearly having thought about what is at stake:

> I know all the arguments concerning appropriation, but at the end of the day, providing you try and balance the exchange and allow for the promotion of the collaborating artist and their own music, rather than just taking, I feel very comfortable with this idea of dialogue. . . . So, given these parameters, more is gained than is lost . . . it is possible now for artists from different cultures and countries to reach a limited audience worldwide, making a living from it, and there is much more focus now than there was ten years ago.[28]

Even though Gabriel speaks intelligently and sensitively about the issues at stake, better, perhaps, than any other rock star, he also employs an aesthetic discourse that threatens to override the political: He likes the tunes; he was looking for rejuvenation. For example, *Us* "has a wonderful selection of players and colors. Once you get to know the musics, it's almost impossible not to incorporate them. I got interested in world music as a failed drummer; I was able to look for fresher rhythms. It just seemed fresh, wonderful, more live and spiritual than most pop."[29] Aesthetics—and I do mean "high" culture aesthetics—and the economic underpinnings such as copyright make possible the incorporation of all sounds under the name of a single creator, just as colonialism itself made peoples from around the world subjects of this or that western European empire.[30]

Gabriel probably doesn't intend some sort of appropriation that could be con-

sidered as colonialist. His interest in world music appears to be deep, and he records and promotes much of it with the organization he helped found in 1982, WOMAD (World of Music Arts and Dance[31]), and the record company that records many musics by musicians from around the world, Real World.[32] He is also a well-known activist for Amnesty International. WOMAD and Real World Records will ensure that the musicians with whom Gabriel works (and more) will be heard on their own; "it is a vehicle," Gabriel says. "An artist can come from another country and get onto a circuit that they will find very hard to achieve any-where else—and get visibility, get heard, and hopefully find an audience that will allow them the following year to come back and tour under their own steam."[33] Elsewhere, Gabriel discussed the loftier goals of WOMAD, employing a kind of "natural culture" view of nonwestern peoples we will see throughout this study. "There are two jobs to be done," he says. "One is to protect and preserve the seed stock of as wide and varied a base as you can keep alive. The other is to try out as many hybrid possibilities as you can that will give you the most vibrant, pulsating new life forms. Hopefully, the WOMAD festivals in America will reflect this mix-ture of ancient and modern."[34]

Bringing Gabriel's intentionality into the picture isn't a mistake or theoretical lapse; even though contemporary theoretical discourse privileges interpretation as the primary site of the creation of meaning, not creation, or the creators' utter-ances, it is nevertheless the case that members of the "rock aristocracy" (as Simon Frith calls it[35])—musicians who enjoy particularly privileged positions in the music industry and thus the culture at large—need to be scrutinized, for they have some power to shape how their works are received.[36] I want to conclude this section by theorizing the idea of intentionality with relation to Gabriel's music.

In discussing what happens in collaboration's as represented in albums such as *Us*, Michel Foucault's notion of the "author function" would work well; he writes that "we could say that in a civilization like our own there are a certain number of discourses that are endowed with the 'author function' while others are deprived of it."[37] And certain people, such as the members of the rock aristocracy, are endowed with the author function, or author authority, as we have seen in the production of *Us*.

Useful as this concept is, Foucault goes too far in denying authors any author-ity or agency. So I am less willing to give up the author as person, or, perhaps bet-ter, persona who is capable of shaping interpretation of her own work. I would argue that in some cases, the makers of cultural texts do matter, particularly when they are stars or when they occupy strategic points in the web of late capitalist relations. Partly this is because these makers of contemporary texts are still around, able to inflect, even direct to some extent, interpretations of their texts. In this short space of contemporary cultural production, many of the deconstruc-tionist/poststructuralist ideas about the role of the author must be limited.[38] Edward Said writes that "it is probably correct to say that it does not finally matter *who* wrote what, but rather *how* a work is written and *how* it is read" (emphasis in

original).[39] The key word is *finally*. But in the contemporary world—which, after all, is the only world we have—it *does* matter who wrote it and what they said about it. When authors are still around, when they go on talk shows, give interviews published in internationally distributed magazines, newspapers, and broadcasts, their utterances on their works inevitably shape the way those works are received, even though they cannot shape reception totally. Most people who listen to popular music still believe in authors as people and in the authority afforded those who produce these widely consumed cultural forms.

THE WORK OF ART IN AN
ERA OF MINIMAL REPRODUCTION

Art is a grant proposal.
 —Ian Sholes

In 1995, U.S. sales of recorded music were nearly $11 billion. That's recordings only (not money paid for concert tickets, sheet music, instruments, lessons, copyright permissions, anything or else). And the Recording Industry Association of America (RIAA) claims that nearly $1 million in revenue is lost *per day* in piracy, that is, sales of illegally produced recordings.[40]

But very few of those recordings, or sales, are of classical music. According to the RIAA, only 2.9 % of sales in 1995 were of classical recordings. Moreover, many of those bestsellers in the classical category are souped-up versions of classics—such as *Vision: The Music of Hildegard von Bingen* discussed in chapter 1, not more conventional classical recordings. Nearly 86% of all sales are of nonclassical musics; in order: rock, country, urban contemporary, pop, rap, gospel, and jazz. Classical music is followed by soundtracks, then children's. (RIAA doesn't say in what genres the remaining 11% of sales occur).

From these figures, one might reasonably conclude that classical music doesn't much matter. And in some ways it doesn't. But while we live in a culture that values economic power, there are other values, other kinds of hegemonies and dominance. Classical music, while selling very little, nonetheless commands the most prestige of all musics. And this prestige is power. For example, the engineers involved in the development of the compact disc decided upon the seventy-minute (or thereabouts) maximum time of the disc because they wanted to be able to put all of Beethoven's 9th symphony on one disc. (Previously, recordings of that symphony were spread over three sides of LPs, or, the second movement would be broken in the middle so the disc could be flipped over, Beethoven having inconveniently written a long first movement that nearly occupied the entire first side of a disc). Classical music does matter; it just doesn't sell.

One terminological note is necessary before we continue. Musicologists, lacking a term such as "literature," sometimes use the somewhat confusing phrase "art music" instead of "classical music" to label the same kind of rarefied forms.[41] It's

a problematic term in some ways, but better than "classical," which, to musicologists, refers to the classical period (the latter half of the eighteenth century). Within art music there is an important subdivision in contemporary music, academic music, or music largely composed by academics and primarily concerned with formal issues. Despite their highfalutin nature, though, I would say that "high" and "low" cultural forms can be explicated using much the same methodologies. The problem is that there are, at the same time, different audiences, different marketing strategies, different ideologies, and different sounds. Earlier I talked about the ways in which the institutional structures inhabited by popular music and musicians allowed them to override local musics, musicians, and practices. Much the same processes happen with art music, but they are also different: There are hegemonies of dominance and hegemonies of prestige (among many others), and while these two could not exist completely independently, they do lead somewhat different lives. The music played by the Kronos Quartet exists in the realm of where prestige is greatest, but where, also, there is virtually no audience relative to popular musics. Even so, art and popular musics raise many of the same issues of appropriation and positionality considered earlier, but the forms of hegemony are somewhat different.[42]

The power of the "art music" label is that like "rock," it can override anything else. So even though few would call the music of the composers here "world music," these musics exist in much the same kinds of ideologies and practices as the musics earlier in this chapter.

KRONOS QUARTET:
PIECES OF AFRICA

The Kronos Quartet (David Harrington, first violin; John Sherba, second violin; Hank Dutt, viola, Joan Jeanrenaud, cello) is one of the most visible and groundbreaking chamber groups of the last twenty years. While they sport mod haircuts and clothes and make occasional forays into musics unusual for string quartets, most of what they play fits well within the mainstream of contemporary composition, even though most string quartets don't specialize in contemporary musics. It might be fair to say that Kronos's position in contemporary culture is its willingness to present itself as a new kind of string quartet, which may or may not help them find a new audience for difficult contemporary music.

"I never wanted to be a string quartet, per se," says founder and violinist David Harrington. "I suppose we've never actually been one."[43] Harrington acknowledges that the quartet's unconventional image has harmed them in some quarters. "No matter what you're doing, there's always gonna be somebody telling you 'you shouldn't do it' or 'you can't do it,'" he says. "So what? Why should that deter us from doing our own thing?"[44]

Their departures from contemporary academic music are worth noting. Perhaps most significant of these is the 1992 release, *Pieces of Africa*, which features

Figure 2.3
Kronos Quartet
(Jeanrenaud, Sherba,
Dutt, Harrington).

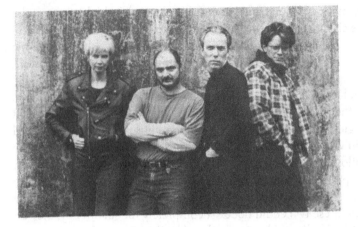

works by composers from all over the African continent, all black except for the white South African Kevin Volans, whose *White Man Sleeps* Kronos recorded in 1987 (two movements only), and which they realize in its full five-movement version on this newer recording.[45] What is noteworthy about *Pieces of Africa* isn't only the music but the many composers who appear with the quartet on the recording and in live performances.

Harrington, who acts as the group's spokesperson and artistic leader, says that he had been interested in African musics for years. "It started when I was in high school. I had these old 78s of African drumming. I was aware that there was something . . . beautiful about them. I remember just filing away in my head the idea that one day I'd do something about this."[46] Elsewhere he said that

> *Pieces of Africa* was never meant to be a record. It started as a piece—*White Man Sleeps*, by Kevin Volans, in 1984. Slowly, over the years since then, we met various composers from all over Africa, like Hamza el-Din, Dumisani Maraire and Obo Addy. We enjoyed their music, getting inspired by it. By 1990, it occurred to us that we had a body of music that just belonged together on one record.[47]

And, "Volans brought into our music images and rhythms and a sound that we'd never had before," Harrington says.

The compositions on *Pieces of Africa* are:

Table 2.2
Kronos Quartet: *Pieces of Africa*, contents.

Obo Addy	*Wawshishijay* (1991) [realized by Chris Baum]	Ghana
Hamza el-Din	*Escalay* (1989) [realized by Tohru Ueda]	Nubia
Hassan Hakmoun	*Saade* (1991) [realized by Itaal Shur and Richard Horowitz]	Morocco

Dumisani Maraire	*Mai Nozipo* (1990)	Zimbabwe	Table 2.2 (continued)
	Kutambarara (1990)		
Foday Musa Suso	*Tilliboyo* (1990)	Gambia	
Justinian Tamusuza	*Ekutundu Ekisooka* (1988)	Uganda	
Kevin Volans	*White Man Sleeps* (1985)	South Africa	

Harrington's discussion of the album and its title indicates that, among other things, authenticity is important—this is clear also from the cover art and internal artwork, all taken from, we are told, *African Canvas*, a coffee-table book of photographs of African textiles by Margaret Courtney-Clarke; we aren't told where these particular textiles were made, however, or who made them.[48] At the same time, by treating "Africa" as a monolith, the title of the recording continues the western mythologizing and inventing of the African continent that has gone on for centuries. But while some of the dark underbelly of postcolonial positioning is evident, the musicians are partly admitted to the rarefied world of classical music, where a composer's every thought is important. Thus, each composer is allotted one to two paragraphs to explain his work in comments "taken from interviews, correspondence and conversations with the composer," according to the liner notes. In other words, the quartet culled together a few tidbits, a strategy they haven't employed on any other recording (with liner notes, if any, by a third party). Here, more than on any other Kronos recording, the quartet acts as a curator situating itself between the composers and audience, as if the album's real title is "Pieces of Africa, Brought to you by. . . ." Though there the composers have a palpable presence, to be sure, the album is more performer-mediated than anything Kronos has ever done, and it is more mediated than any other classical recording I can think of. These four intrepid U.S. musicians have journeyed to darkest Africa and come back with a few pieces, a few ethnographic goodies, and some great images of authentic African textiles.

Now, instances of the performers enjoying bigger billing than composers are common in the world of classical music. What is different here is the way the quartet carefully stage-manages the presentation of the composers by partly relying on fairly recent marketing strategies in the classical music world, where performers more and more are trying to be like rock stars, and responding to the fact that these composers, after all, are contemporary Africans, not dead Europeans.[49]

The curatorial stance adopted by the quartet silences the musicians, however, who are allowed to speak only through their works, themselves brought to you by the performers. Because the liner notes have no author as such and no bibliography, the printed statements of the musicians serve as ethnographic tidbits as well. But if we dig a little bit, we find that there is a heavy hand of premodernization operating, such as I will examine in depth in chapter 5 with regard to Youssou N'Dour and Angélique Kidjo. For example, the Nubian musician Hamza el-Din (1929–) is quoted as saying: "I am from the Aswan High Dam area [on the Nile]. I was in New York when the dam was finished [in 1970]. I lost my village. When

I went back and saw my village and my people in a different place I saw in their eyes the loss. I saw my people were lost. They had moved to an almost semi-desert place. When I came back I was lost myself."[50]

This is a frightening and all-too-familiar story: the lean, mean, modernization machine destroying a timeless village, destroying entire ways of life, the villagers powerless to stop it. Yet a recent interview with el-Din discloses that he has a university education in engineering and music and is a cosmopolitan citizen of the world (having lived in New York, Rome, and now Tokyo). Here he tells the same dam story, though quite differently. While studying in engineering school (because his parents thought he might be able to get a job near his village working on the existing dam), he heard of the plans for a new dam. "I tried to tell my people to be ready. I told them such a thing will happen and they should be aware of it, not lose the chance to prepare themselves. . . . But people refused to understand what I was talking about. They refused to accept the idea that the water will get that high above the hills." Eventually, however, the villagers "built ports on the river to receive the steamboats who came to take them away. They stood as one man to help themselves and to help the government to move. We are farmers, we live in semi-desert and we know how important the water is. So we were very helpful."[51] In other words, it sounds as though el-Din and his fellow villagers welcomed the continuing modernization. The older dam, built in 1902, prompted many families to attempt to educate their children, as did el-Din's. (I should also note that the liner notes indicate that *Escalay* was written for Kronos, but it is well known that the work was written by el-Din in 1969, was recorded, and introduced him to the listeners of "world music" on the indispensable Nonesuch Explorer Series).[52]

Despite these observations, which again demonstrate the power in positionality that we clearly saw with Peter Gabriel, I intend this critique of *Pieces of Africa* to be a generally sympathetic reading. For while it is clear that U.S. musicians possess a lingering colonialist ideology, they do collaborate in important ways with their colleagues from the African continent. Kronos clearly learned from the African musicians, and the collaborating composers clearly wanted to participate in the project.

All of the composers on the album have had a good deal of exposure to and experience with western musics of all kinds, and most have been concerned with various kinds of fusions with the traditional musics they grew up with and the musics they found in western Europe and America (Hamza el-Din, for example, appeared in concert with the Grateful Dead as early as the late 1970s; today he regularly appears with that band and with Mickey Hart, one of the band's drummers who has done much to publicize, preserve, and record musics from around the world).[53] Still, most of the musicians on *Pieces of Africa* were not trained in the western sense; some, it appears, have little or no facility with western notation, and so their works were realized in notation by others.

Space doesn't permit a discussion of all of these composers; and for most of

them, scores and information are hard to come by.[54] Instead I want to focus on just two, Obo Addy and Dumisani Maraire, for these two pursued radically different musical paths that help delineate the range of musics and practices on the album. Addy has tried to make musical fusions throughout his career, while also preserving traditional ways of musicking; Maraire, who has stayed resolutely within traditional Shona mbira techniques, was still willing to venture into this partnership with the Kronos Quartet.

OBO ADDY: *WAWSHISHIJAY* (1990)

While psyching himself up for a gig in Juneau, Alaska, David Harrington walked by a small record store where he bought a cassette of music by Obo Addy (1936–), a Ghanaian-born drummer who now lives in Portland, Oregon. Harrington evidently liked what he heard, and he called Addy's manager, whose number was listed on the cassette. "I rang him up and we got talking about how Obo might write a piece," Harrington says.[55] That piece eventually became *Wawshishijay*, which means "Our Beginning," because, Addy says, the music was neither western classical nor Ghanaian traditional drumming. "I didn't know what to call it," Addy says. "They [Kronos] asked me, 'What do you call it?' and I said, 'Well, I don't know yet.' And they say, 'Well, this is a beginning, how do you call 'this is our beginning' in your language?' So that's what I called it."[56]

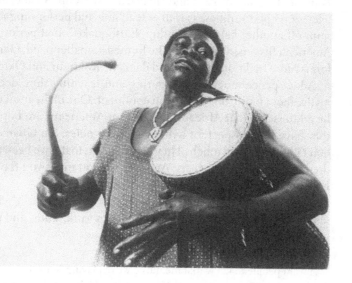

Figure 2.4
Obo Addy.

Of all the musicians represented on *Pieces of Africa*, Obo Addy may be the most experienced with cross-cultural collaborations and fusions, although he at the same time maintains strong ties to the traditional music of Ghana. His first professional musical experience wasn't with traditional musics in Ghana, but pop-

ular: in 1954 he joined Joe Kelly's big band in Accra, Ghana, as a drummer but eventually became a singer as well. The rise to power of Kwame Nkrumah and independence from the U.K. in 1957 revitalized interest in traditional African musics, and so Addy quit the big band (growing tired, his official biography tells us, of "reproducing the music of Frank Sinatra and Tom Jones when so much African music was going unheard in the cities"[57]) and worked for the National Arts Council of Ghana, becoming a member of the Builder's Brigade Band, one of Nkrumah's state ensembles in 1959. In 1961 Addy joined the Farmer's Council of Ghana, a band that helped educate farmers across the nation by using a combination of music, cinema, and drama, which taught Addy how to package and present traditional music in a multimedia context to live audiences. Addy became the Farmers' Band's deputy leader in 1962.

With the overthrow of Nkrumah in 1966, Addy had to find work on his own, so he formed a band to headline at the newly opened Continental Hotel, again blending traditional drumming and contemporary music. After working briefly with the Ghana Broadcasting Band, Addy decided he wanted to save and publicize older drum and dance traditions. He took a job at the Arts Council, honed his compositional skills, and continued exploring fusions of the old and the new. Addy helped form Anansi Krumian Soundz, a band that exclusively used traditional instruments. In 1972, Addy joined with his brothers to form Obuade ("Ancient"), a band that gained some acclaim and popularity. Addy emigrated to Portland, Oregon, in 1978 and created a new group, Ablade, that led to radio and television opportunities, as well as teaching and performing jobs. In 1981, Addy spun off another band, Kukrudu ("Earthquake") that performs Addy's African/American fusions, and in 1988, he formed a smaller band, Okropong, which performs more traditional music and dance.[58] Kukrudu and Okropong now coexist.

Addy spends much of his touring and teaching time debunking American myths about music on the African continent. One of the most pervasive ideas that he addresses is that Africans and African Americans are born improvisers, that they have little respect for written words or notes. "In Ghana," he says, "people don't improvise very much. They play rhythms that have been prescribed for hundreds and hundreds of years. And for every 50 miles you travel, you'll find that both the language and the instruments change."[59]

Another myth Addy addresses concerns the "natural" rhythmic and musical abilities of Africans. Making music requires work, study, and practice, no matter what one's race.

> I want people to know that the music we're playing is not a music that any Ghanaian or any African can just sit down and play. He's got to learn it, too. See, American audiences are a little funny about me playing African music with white people in the band. But you can get a white person who is more rhythmic than an African. When I first came here, I didn't know that, because I had been brainwashed a long time ago in Africa. But when I began teaching, I found out. Even the Ghanaians

that I brought here, some of them left because the music was too hard. So whoever comes and says, "I want to play with you," I will teach that person.[60]

Addy, like several of the composers whose works appear on *Pieces of Africa*, doesn't compose in the western sense: in particular, he does not use notation.

My father [a medicine man, or *woncher*, "the father of the spirit"] taught us how to play the drums for him; his work was to be possessed and then dance to the music, to raise a healing song. We just watched and listened, and then we knew how to do it by ourselves. That's how I teach: I always tell them, watch me carefully and listen carefully, try and put it in your head, and then play it and play it and play it.[61]

Instead of notation, Addy sings into a tape recorder, and a colleague transcribes this into notation. "When I was a kid, we were taught to listen and watch. It's a completely different way of learning from here. You can't write these sounds down on music paper; you have to put them inside the person. You cannot learn it unless you are associated with the people who do it all the time, or you are born into the house where the music is done all the time."[62] So in the case of *Waw-shishijay*, Chris Baum provided the transcription, of which I've included the opening below.

Example 2.3
Obo Addy:
Wawshishijay,
opening.[63]

Example 2.3 (continued)

To my ears, *Wawshishijay* isn't the most musically successful work on *Pieces of Africa*, appearing (and sounding) too confined by notation, which, after all, cannot capture the subtleties of rhythm and inflection characteristic of Addy's music (and which one can hear in the drumming that accompanies the strings). Comparing the score with the recording can be confusing, for the score regularizes rhythm and meter in ways that Addy does not in performance. But I would argue that the success of cross-cultural collaborations cannot and should not be measured solely by the quality or popularity of the resulting musical work, but additionally by what the participants learn about each other and each other's culture and how they relate musically. While some of the tracks on *Pieces of Africa* do not make any unusual demands of the string players, Harrington tells of how Addy's music stretched them in ways that might not be audible on the recording or noticeable in the score. "One of the scariest things we've done in the studio was playing shakers with him. Obo's a great teacher, and a very encouraging person, but the idea of doing this with a master drummer was really something! We also joined him on some vocal tracks, which was something very new for us."[64] Elsewhere, he states,

> One of the things that we noticed right away when performing with a great drummer like Obo—and there are many others on *Pieces of Africa*—was that each person has a very individual sense of the beat. So what we did was play together in the studio and try to get a sense of the collective beat. Obo was great on that. The idea that you might have a contest to find where the center of the beat is made us realize how wide the center of the beat can be, particularly when you're there with someone

who has spent his whole life dealing with this issue. So deciding on the center of the beat was a very revealing moment. . . .

Rhythm is such an individual thing. Yet it takes on an incredible sense of pulse, and that's something we worked on a lot with Obo, too. We also had a lot of suggestions about different aspects of the music, such as voicings, adding double stops and different textures to the notes that were already there in the score. And certainly articulation.[65]

Addy engages in many kinds of musicking, working both with old and new sounds that he mixes and matches, while at the same time pursuing a more traditional sound. As has much of the music in this study, Addy's music shows us ways out of the polarized thinking in which language itself frequently entraps us. He is both traditional and not, he operates two different musical groups simultaneously,[66] and he helps educate audiences about the music of Ghana.[67]

DUMISANI MARAIRE: *KUTAMBARARA* (1990)

Dumisani Maraire (1943–) comes from a family of musicians. Unlike Addy, however, Maraire's creative impulses are directed less at fusion than education and preservation; he has published a songbook for children,[68] and many traditional recordings of mbira music.[69] Paul Berliner, in his classic *The Soul of Mbira*, lists Maraire as his teacher, and Maraire earned a Ph.D. in ethnomusicology from the University of Washington, writing a 1990 dissertation on mbira music.[70] After that, he returned to Zimbabwe to teach and play, founding the first school to teach traditional Shona music in Zimbabwe. He now is affiliated with the University of Zimbabwe Department of African Languages and Literature.

Maraire's relationship to the mbira constitutes his relationship to music itself: it is a give-and-take process, the mbira and music living entities that can give back whatever a skilled musician puts into them, and more. "To me an mbira is a lively [in the sense of "living"] instrument," he told Berliner. "It amazes me whenever I hear all these different things coming out without any changes in my way of playing. This is not because I am playing different patterns without knowing what I am doing, but because, as I give the mbira more, I get more from it."[71]

Maraire also cultivates a strong political sense of his music. His notes to *Kutambarara* on *Pieces of Africa* are the most political of all the musicians represented on *Pieces of Africa*. *Kutambarara*, he tells us, means "spreading," using the same metaphor that Ladysmith Black Mambazo and George Clinton use in "Scatter the Fire" (which I'll discuss in the next chapter): African cultures, philosophies, and musics are moving around the world. After throwing into doubt the notes "by" Hamza el-Din, above, I'm inclined to give credence to Maraire's, for they are consistent with his other published statements.

What is spreading is African concepts, perspectives, philosophies, traditions and cultures through African music. This is now being done by Africans themselves. It is true that African traditions, cultural norms and aspects have been spread for years all

over the world. However, this spreading was by non-Africans which in some ways was an interpretation of Africa by non-African scholars, writers, film makers and so on. Africa and Africans have been suppressed for a long time. It was only around the 1950s that Africans resisted and fought for their rights in their own land and started gaining the political power of rule themselves and try to determine their own future.

The other message of the song is that not all non-Africans oppressed Africans. Actually, there were and still are non-Africans who fought and fight to free Africa from oppression financially, educationally and political-ly. Music can help dismantle cultural, political, and racial barriers.[72]

Maraire's (and Addy's and Ladysmith Black Mambazo's) words clearly demon-strate the ways that contemporary musicians from the African continent are attempting to forge alliances with anyone of like mind, not necessarily anyone who shares an essentialized identity. Given the kind of identity politics in the United States today, which seem increasingly mired in a debilitating essential-ism—something Maraire may well have encountered in his years here—state-ments such as Maraire's offer a timely reminder that to change the world, we must work together.

Maraire's approach to music and words seems quite serious, leaving the listen-er unprepared for the sheer joy and pleasure of the two selections included on *Pieces of Africa*, which have proved to be the most popular on "alternative" radio stations. I've chosen an internal excerpt from *Kutambarara* that shows the kind of unflinching repetitive pleasure in straightforward harmonies and joyful rhythms, and Maraire's soaring vocals (left untexted here since no words are included in the liner notes, on this or Maraire's more traditional version on mbira for the album *Chaminuka*[73]; I have also omitted Maraire's mbira, which is inaudible by this point in the performance). The chorus is the Oakland Interfaith Gospel Choir, adding another layer to this collaboration between Zimbabwean and African and European Americans. Maraire says that "I believe the most important elements of Shona culture are respect, love and sharing, especially when extend-

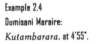

Example 2.4
Dumisani Maraire:
Kutambarara, at 4'55".

ed toward strangers. Shona music, with its multi-part texture, is especially conducive to sharing."[74]

It is not a mistake that this music looks and sounds like a Christian hymn. Maraire has said that in writing music for string quartet, he recalled the only western music with which he had prior personal experience. "When I was writing I was not thinking about, I am writing for the string quartet. I didn't like that to intimidate me, because I'd never done it before. But again, before I even studied playing a lot of African instruments, I did a lot of church music, because my parents, you know, were Christians, so we sang a lot of hymns. So all I just did is I saw the string quartet as voices, I just said, I am writing for the voices."[75]

Kutambarara starts slowly, with mbira and strings playing the kind of complex, interlocking, polyrhythmic/polymetric (to western ears) patterns typical of mbira music. But it isn't very long before the celebratory music excerpted above kicks in, these four bars repeating over and over and over. It isn't minimalist; it is not repetitive in a way that could be construed as simplistic. It is more like the music of B. B. King or Muddy Waters, music that seems to start with or achieve a musical and emotional climax right from the beginning, rather than putting it off toward the end, which is the trajectory of much western European music. Maraire's music, like these great African American musicians, lives in the moment, avoiding what a composer friend calls the "magic carpet" effect sought by most western European art music, an effect that removes the listener from the here and now. Which, after all, is the only place to be.

NOTES

1. Quoted by Johnny Angel, "Born to Lose: Fear and Self-Loathing in the Ostrich Generation," *San Francisco Bay Guardian* (17 August 1994), 43.

2. The song appears on the collection *Bringing It All Back Home*, BBC CD 844, 1991.

3. Gramsci, *Selections from the Prison Notebooks*, ed. and trans. Quintin Hoare and Geoffrey Nowell Smith (New York: International, 1971), 12.

For useful discussions of Gramsci and the influence of his writings on the study of culture, see, in particular, Tony Bennett's "Popular Culture and 'the turn to Gramsci'," in *Popular Culture and Social Relations*, ed. Tony Bennett, Colin Mercer, and Janet Woollacott (Milton Keynes and Philadelphia: Open Univ. Press, 1986); and Stuart Hall's "Culture, the Media and the 'Ideological Effect'," in *Mass Communication and Society*, ed. James Curran, Michael Gurevitch, and Janet Woollacott (Beverly Hills: Sage, 1979).

4. I use the word "colonialize" and its related forms rather than "colonize," for the former term implies not only physical colonization but ideological as well. The first anticolonialist writers well understood this. See, for example, Aimé Césaire, *Discourse on Colonialism*, trans. Joan Pinkham (1995; reprint, New York: Monthly Review Press, 1972), and Frantz Fanon, *The Wretched of the Earth*, trans. Constance Farrington (New York: Grove Weidenfeld, 1968). See Benjamin B. Ringer and Elinor R. Lawless, *Race-Ethnicity and Society* (London and New York: Routledge, 1989), for useful discussions of this and related terms.

5. Coronil, "Can Postcoloniality be Decolonized? Imperial Banality and Postcolonial Power," *Public Culture* 5 (Fall 1992): 102.

6. Feld, "Notes on World Beat," in Steven Feld and Charles Keil, *Music Grooves: Essays and Dialogues* (Chicago and London: Univ. of Chicago Press, 1994), 238.

7. Hall, "The Local and the Global: Global-

ization and Ethnicity," in *Culture, Globalization and the World-System*, ed. Anthony D. King, Current Debates in Art History, no. 3 (Binghamton, N.Y.: Department of Art and Art History, State Univ. of New York at Binghamton, 1991).

8. See Feld, "Notes on World Beat"; Andrew Goodwin and Joe Gore, "World Beat and the Cultural Imperialism Debate," *Socialist Review* 20 (July–September 1990): 63–80; and Tony Mitchell, "World Music and the Popular Music Industry: An Australian View," *Ethnomusicology* 37 (Fall 1993): 309–38.

9. Peter Gabriel, *Us*, Real World GEFD 24473, 1992.

Lanois is a musician in his own right, who also makes use of many musics from around the world on his recordings. For example, *Acadeie*, WEA/Warner Bros. 7599 25969 2, 1989, and *For the Beauty of Wynona* WEA/Warner Bros. 7559 45030, 1993.

10. Peter Gabriel, interview with John di Liberto, National Public Radio, *Morning Edition*, 29 September 1992.

Useful articles on Gabriel's interest in world music that I do not discuss but are worth reading include Tom Cheyney, "The Real World of Peter Gabriel," *The Beat* 9 (1990), 22–25; Banning Eyre, "Bringing it All Back Home: Three Takes on Producing World Music," *Option* (November 1990), 75–81; David Fricke, "Peter Gabriel: the Ethnic Shocks the Electronic," *Musician* 51 (January 1983), 20; and Jon Pareles, "Music Without Frontiers: Peter Gabriel," *Musician, Player & Listener* 27 (September/October 1983), 40–44.

11. Paul Simon reports that his album following *Graceland*, *The Rhythm of the Saints*, was made in much the same way: he recorded the percussion ensemble Olodum in a town square in Brazil, then took the tapes back to New York where he improvised music and words over them and added other layers of music (interview with Bob Edwards, National Public Radio, *Morning Edition*, 18 October 1990).

12. For discussions of hierarchies in western music, see John Shepherd's *Music as Social Text* (Cambridge: Polity Press, 1991), and Christopher Small, *Music • Society • Education* (London: John Calder, 1980).

13. Malm used this term in his lectures to freshman music majors in an introductory course he taught for years at the University of Michigan and for which I was a teaching assistant for four years. I would like to thank him for that time, and this term.

14. Quoted by Thomas Brooman, "Peter Gabriel in Conversation," *RMM* (September 1993), 12.

15. Peter Gabriel, *Passion: Music for* The Last Temptation of Christ, Geffen Records M5G 24206, 1989.

16. A doudouk (also spelled "duduk") is a large double-reed instrument of Armenia and Georgia.

17. "If played properly, it can make you cry," he said (quoted in *Vox* 25 [October 1992], downloaded from http://www.cs.clemson.edu/~junderw/pg/interviews/vox).

Gabriel used a doudouk on *Us* and recounts the story of trying to find a player (since the doudouk playing on *Passion* was prerecorded). "Trying to find a doudouk player is a little more difficult than I thought—you try Yellow Pages and the doudouk column is very empty. So we then tried for any Armenian contacts we could find; in other words, people selling carpets or jewelry or whatever it is. We had a lot of interesting avenues trying to find someone, and eventually got hold of Levon [Minassian], who actually works as a jeweler in Marseilles. He's a wonderful player. He was quite suspicious of us, and rock and roll at the beginning, but then I think really had a great time and jumps at the chance to do anything ever since" (interview with Bob Coburn, transcribed by Wendy Katz and available on the Internet at http://www.cs.clemson.edu/~junderw/pg/interviews/swl.html).

18. Max Weber wrote about the rationalization of pitch organization in western music in *The Rational and Social Foundations of Music* (ed. and trans. Don Martindale, Johannes Riedel, and Gertrude Neuwirth [Carbondale: Southern Illinois Univ. Press, 1958]), and his argument, that musical tone organization was rationalized into something calculable, could easily be extended to time organization. See also Shepherd, *Music as Social Text*, and Small, *Music Society Education*.

19. Transcribed from Gabriel, *Passion:*

Music for The Last Temptation of Christ. Gabriel writes in the liner notes that the doudouk melody is a traditional Armenian melody entitled "The Wind Subsides." All transcriptions are by the author unless otherwise noted.

20. *Passion* appeared, for example, on the Internet's Ambient Mailing list as the sixth most recommended ambient album in a recent call for top-ten nominations.

21. Peter Gabriel, liner notes to *Plus from Us*, Real World Carol 2327–2, 1993.

22. Gardner, "Peter Gabriel's 'Us'," *Rolling Stone* 639 (17 August 1992), 27. For more interpretations of Gabriel's personal life and *Us*, see Jon Pareles, "For Peter Gabriel, This Time it's Personal," *New York Times* (27 September 1992), H30, and Divina Infusino, "Singer Peter Gabriel Reveals his Inner Journey," *Christian Science Monitor* (3 August 1993), 13.

23. For this observation I am indebted to one of my students, Jeff Rhode.

24. Thanks are due to one of my students, Bennett Brecht, for pointing out the significance of Gabriel's use of harmonies here.

25. From Real World's web page at http://realworld.on.net.pg/tina/pgfaq4.html.

26. *All About Us*, Michael Coulson, 1993. There is also a CD-ROM version with four selections from *Us* (*Xplora1: Peter Gabriel's Secret World* [London: Real World MultiMedia, 1993]). See Fred Davis, "I want my Desktop MTV," *Wired* (July/August 1993), 4–11.

27. Feld, "Notes on World Beat." In addition to copyright problems and questions of appropriation and ownership, this practice results in a new genre: "ethnotechno." See Erik Goldman, "Ethnotechno: a Sample Twist of Fate," *Rhythm Music* 6 (July 1995), 36–9. While this label is new, appropriative practices involving tape manipulation go back several decades in both "art" and popular musics. For a collection, see *Ethnotechno: Sonic Anthropology*, vol. 1, Wax Trax! Records TVT 7211-2, 1994.

28. Quoted by Brooman, "Peter Gabriel," 14.

29. Gabriel quoted in Peter Watrous, "The Pop Life," *New York Times* (23 September 1992), C14.

30. For a discussion of the role of aesthetics in cross-cultural appropriations and representations, see my *The Rapacious Muse: Selves and Others in Music from Modernity through Postmodernity* (in preparation).

31. For more on WOMAD, see Stuart Cosgrove, "Music Global Style?" *New Statesman & Society* 1 (9 September 1988), 50; David Sinclair, "World Music Fests Flourish in U.K.," *Billboard* 104 (8 August 1992), 12; Peter Jowers, "Beating new Tracks: WOMAD and the British World Music Movement," in *The Last Post: Music After Modernism*, ed. Simon Miller, Music and Society, ed. Peter Martin (Manchester and New York: Manchester Univ. Press, 1993); Dominic Pride, "WOMAD's Future Appears Wobbly," *Billboard* 105 (16 January 1993), 87; Stu Lambert, "The Angel Gabriel," *New Statesman & Society* 6 (25 June 1993), 34; Paul Sexton, "WOMAD Back for 2nd U.S. Tour; Western, World Music Acts Team Again," *Billboard* 106 (21 May 1994), 1; and Larry Blumenfeld, "My Week in the Real World," *Rhythm Music* 4 (October 1995), 30–35.

32. For more on Real World, see John Bridger and Susan Nunziata, "Real World Project Boasts Wide Universe of Talent," *Billboard* 103 (21 September 1991), 41.

33. Radio interview with Bob Coburn.

34. Quoted by David Sinclair, "Peter Gabriel's Secret World," *Rolling Stone* 663 (19 August 1993), 85.

While almost all of the press about Gabriel and WOMAD has been positive, there is some grumbling here and there. In "Real World Problems and Otherworldly Music" [*Georgia Straight* (1–8 October 1993)] Alexander Varty recounts a story told to him by Henry Kaiser, a major producer/collector/guitarist active in world music, about a musician who was not getting his promised payment. Other musicians told similar stories. Kaiser told Varty he was "certainly in doubt of Real World's good intentions" (downloaded from the Internet at http://www.cs.clemson.edu/~junderw/pg/reviews/real.world).

35. Frith, *Sound Effects: Youth, Leisure, and the Politics of Rock 'n' Roll*, Communication and Society Series, ed. Jeremy Tunstall (London: Constable, 1983). Keith Negus also discusses the power afforded to stars: "They can

use their considerable material assets to directly influence the production and consumption of popular music; through their ownership of companies, labels, song catalogues and studio recording facilities; by directly or indirectly admitting or excluding lesser known performers from certain prestigious events and tours; and by using their commercial clout to influence record company acquisition policies" (Negus, *Producing Pop: Culture and Conflict in the Popular Music Industry* [London and New York: Edward Arnold, 1992], 139).

Celebrity, as a kind of powerful currency in late capitalist cultures plays a role here too, though I don't have the space to explore it in this volume. See Joshua Gamson, *Claims to Fame: Celebrity in Contemporary America* (Berkeley: Univ. of California Press, 1994).

36. Susan McClary also suggests that it is important to examine intentionality when the musician is popularly perceived to have no ideas or control over his/her own work; in her example, Madonna. See "Living to Tell: Madonna's Resurrection of the Fleshly," in *Feminine Endings: Music, Gender, and Sexuality* (Minneapolis and Oxford: Univ. of Minnesota Press, 1991).

37. Foucault, "What Is an Author?" in *The Foucault Reader*, ed. Paul Rabinow (New York: Pantheon, 1984), 107.

38. See Roland Barthes, "The Death of the Author." Barthes's argument is widely influential in poststructuralist and deconstructionist thought and holds that since we can never know *exactly* what the author intended, meanings are made in interpretation, not creation. So readers and the texts themselves became the primary forces behind making meaning. In Barthes's words, "The birth of the reader must be at the cost of the death of the Author" (in *Image-Music-Text*, translated by Stephen Heath [New York: Noonday, 1977], 148). For a typically shrewd analysis of the situation, see Salman Rushdie's "In Defense of the Novel, yet Again," *New Yorker* (24 June and 1 July 1996), 48–55.

39. Said, "The Politics of Knowledge," *Raritan* 11 (Summer 1991): 31.

40. All figures from the 1995 *Annual Report of the Recording Industry Association of America* (Washington, D.C.: Recording Industry Association of America, 1996).

41. Some musicologists employ the terms "cultivated" and "vernacular" to describe the two main divisions of music, but the binarized pairing of the terms implies pejoratively that vernacular music is uncultivated. For that reason I don't use the terms.

42. In outlining this cultural hierarchy between "high" and "low" I am not endorsing or accepting this divide, except as an ethnographic reality. The construction and development of these hierarchies has been well documented, most importantly in Paul DiMaggio, "Cultural Entrepreneurship in Nineteenth-Century Boston: The Creation of an Organizational Base for High Culture in America," in *Rethinking Popular Culture*, ed. Chandra Mukerji and Michael Schudson (Berkeley: Univ. of California Press, 1991); the indispensable Lawrence W. Levine, *Highbrow/Lowbrow: The Emergence of Cultural Hierarchy in America* (Cambridge: Harvard Univ. Press, 1988); Stephanie Sieburth, *Inventing High and Low: Literature, Mass Culture, and Uneven Modernity in Spain* (Durham and London: Duke Univ. Press, 1994); and Peter Stallybrass and Allon White, *The Politics and Poetics of Transgression* (Ithaca: Cornell Univ. Press, 1986).

For discussions of cultural hierarchies in popular music, see Robert Walser, "Highbrow, Lowbrow, Voodoo Aesthetics," in *Microphone Fiends: Youth Music and Youth Culture*, ed. Andrew Ross and Tricia Rose (New York and London: Routledge, 1994), and *Running with the Devil: Power, Gender, and Madness in Heavy Metal Music*, Music/Culture, ed. George Lipsitz, Susan McClary, and Robert Walser (Middletown, Conn.: Wesleyan Univ. Press, 1993).

43. Quoted by Andy Carvin, "Classical Aghast: The Avant-Garde Musings of Kronos Quartet," downloaded from the Internet at http://k12.cnidr.org:90/kronos.html.

44. Ibid.

45. *Pieces of Africa*, Elektra Nonesuch 9 79275-2, 1992.

46. Quoted in "Are Friends Eclectic? *Q* Magazine (March 1992), downloaded from http://nwu.edu/music/kronos. Ellipsis in original.

47. Carvin, "Classical Aghast."

48. Courtney-Clarke, *African Canvas: The Art of West African Women* (New York: Rizzoli, 1990).

49. The quartet's attitude is also made clear by their use of the unrevised version of Kevin Volans's *White Man Sleeps*, instead of the revised version, something Volans was quite upset about when I interviewed him in 1992, around the time of the album's release.

50. Liner notes to *Pieces of Africa*.

51. Quoted by David N. Blank-Edelman, "Hamza el-Din: Looking out from the Inside," *RMM* (May/June 1994), 16–17.

52. El-Din, *Escalay*, Nonesuch Explorer Series, Nonesuch H 72041, 1971.

53. See Hart's *Drumming at the Edge of Magic: A Journey into the Spirit of Percussion*, with Jay Stevens (San Francisco: HarperSan-Francisco, 1990), and *Planet Drum: A Celebration of Percussion and Rhythm*, with Fredric Lieberman (San Francisco: HarperSanFrancisco, 1991).

54. I have discussed Kevin Volans at length elsewhere; see my "The String Quartets of Kevin Volans," M.A. thesis, Queen's University of Belfast, 1990; "The Voracious Muse: Contemporary Cross-Cultural Musical Borrowings, Culture, and Postmodernism," Ph.D. diss., University of Michigan, 1993; "When We Think about Music and Politics: The Case of Kevin Volans," *Perspectives of New Music* 33 (Winter and Summer 1995): 504–36; and *The Rapacious Muse* (in preparation).

55. Quoted in "Are Friends Eclectic?" downloaded from http://www.nwu.edu/music/kronos.

56. Quoted by David Stabler, "Different Drummer," *Oregonian* (1 March 1992), D2. I would like to thank Susan Addy for providing me with this and other material related to the music of Obo Addy and Kronos Quartet's *Pieces of Africa*.

57. From the press kit for Obo Addy. I suspect there is some creative license being exercised here, for Tom Jones did not become famous until 1964 when he recorded "It's Not Unusual."

58. Biographical information compiled from Addy's press kit; Rick Vanderknyff's "Beating a Path from Village to City to Globe," *Los Angeles Times* (22 July 1995), 3; and Ron Wynn's entry on Addy in the *All-Music Guide* on the Internet, http://www.allmusic.com/.

59. Quoted by Diane Gordon, "African

Music for String Quartet," *Strings* (July/August 1994), 30.

60. Quoted by Lynn Darroch, "Obo Addy: Third-World Beat," *Northwest Magazine* (20 August 1989), 4.

61. Ibid.

62. Ibid.

63. The score provided by Addy's manager is different than the version that Kronos performs. *Wawshishijay* is composed in sections; Kronos omits the first section and begins with the second, presumably at the instigation of (or at least the cooperation of) the composer. They return to the opening of the work later in their performance. I am excerpting here the opening as the quartet has recorded it, although without the drums and singing, which do not appear in the written score.

64. Quoted by Gordon, "African Music," 30.

65. Ibid., 30–31.

66. See his recordings *Let Me Play My Drums*, Burnside Records BCA-0010-2, n.d.; *Okopong*, EarthBeat! 42508, 1990; and *The Rhythm of which a Chief Walks Gracefully*, Earthbeat 42561, 1994.

67. I wish I could report that Obo Addy's cross-cultural musical and educational experiences were as positive as one might hope. In 1991, Addy and Kukrudu were scheduled to perform at Diamond Valley School in Lake Tahoe, California. Some parents objected: Since Addy is the son of a Ghanaian medicine man, they feared he would teach the children witchcraft and voodoo. Addy had distributed a video to the school prior to the performance, which included a call-and-answer game with the audience using foreign words, words that some parents thought were meant to worship the devil (actually, they were the words for "thank you" and "you're welcome"). The show went on as planned, but some parents kept their children away. (This incident was reported by FileRoom, which keeps track of incidents of censorship; their archive is available on the Internet at http://fileroom.aaup.uic.edu/FileRoom/documents/Mmusic.html).

68. Abraham Kobene Adzinyah, Dumisani Maraire, and Judith Cook Tucker, eds., *Let Your Voice be Heard! Songs from Ghana and Zimbabwe: Call-and-Response, Multipart, and*

Game Songs (Danbury, Conn.: World Music Press, 1986).

69. See *The African Mbira: Music of the Shona People of Rhodesia* on the classic Nonesuch Explorer Series, Nonesuch H 72043, 1971; *African Story-Songs*, Univ. of Washington Press UWP 901, 1969; and *Mbira Music from Rhodesia*, University of Washington Ethnic Music Series. Seattle: Univ. of Washington Press, UWP-1001, 1971.

70. Maraire, "The Position of Music in Shona Mudzimu (Ancestral Spirit) Possession," Ph.D. diss., University of Washington, 1990.

71. Quoted by Paul Berliner, *The Soul of Mbira* (Berkeley and Los Angeles: Univ. of California Press, 1981), 129.

72. Maraire, liner notes to *Pieces of Africa*.

73. Maraire, *Chaminuka: Music of Zimbabwe*, Music of the World CDC-208, 1989. Thanks are due to Bob Haddad at Music of the World for sending me a copy of this recording.

74. Quoted by Banning Eyre, "Shona Spirit: Passing on the Ancestral Music," http://kiwi.futuris.net/rw/motw/shona.html.

75. Maraire, interview with Julie Burstein, National Public Radio, *Morning Edition*, 10 June 1992.

Strategies of Resistance

Strategies of Resistance

We live in a society where you're either innocent or you're black.
—Caller to CBC Radio's *As It Happens*, 18 January 1996

In the previous chapter, I examined the ways in which hege-
monies are perpetuated by those whose positionalities as western metropolitans
continue different kinds of dominance, even though many of these same musi-
cians or music-industry people may attempt to avoid doing just that. Additionally,
I showed that there are different kinds of dominance. As hegemony takes different
forms, so does resistance, perhaps even more myriad and diverse than hegemony.
Since one of the goals of these chapters on hegemony and resistance is to point
out what is hidden by binary oppositions such as "hegemony/opposition" or
"dominant/subordinate," it's thus crucial to analyze music by musicians outside of
Europe and the United States, musicians whose approaches and syncretisms
move in the opposite direction of those of the musicians considered thus far. At
the same time, I think it is important to identify and examine the ways that local
resistances are not necessarily resistances to "the state" or former state, as in post-
colonial situations; otherwise, we are only assuming that disempowered peoples
are totally caught up in resistance, not totally caught up in leading their lives, only
part of which may involve resistance. I will start with the now-famous black South
African men's chorus, Ladysmith Black Mambazo, and their genre of music, *isi-
cathamiya*, then consider music by Java's biggest pop star, Rhoma Irama, and con-
clude by discussing the work of Djur Djura, an Algerian Berber woman living in
France.

LADYSMITH BLACK MAMBAZO:
TWO WORLDS ONE HEART

Isicathamiya is one of many kinds of music produced by migrant laborers in South Africa's major cities and is "inseparable from the history and struggles of the Zulu-speaking working class."[1] As the apartheid government reduced the area of homelands so that fewer people could live on them, black South Africans were forced to migrate into the cities to work as cheap laborers. The government granted all of the homelands a form of political independence, so the political status of the migrant workers in the Republic of South Africa under apartheid was like that of guest workers in many European countries: they were second-class citizens at best. And usually worse.

Figure 3.1.
Ladysmith Black Mambazo

The name *isicathamiya* refers to choreography and means literally "to walk stealthily or on one's toes."[2] *Isicathamiya* is unaccompanied and performed by men, and these men's choirs are usually named for their leaders' or members' homelands. Ladysmith is leader Joseph Shabalala's hometown in the Natal province; black, Shabalala says, refers to beautiful skin color[3]; and "mambazo" is Zulu for "ax," which is meant as a symbol of power.

Men's a capella choirs, a long-standing tradition in Zulu culture in South Africa, originally performed only for themselves and their friends and families.[4] During the apartheid days, Sundays were usually the only days off, so *isicathamiya* contests began on Saturday night and often lasted until Sunday morning so that every group could be heard. Judges for the contests were usually whites, for it was thought that the most important quality a judge should have is impartiality. Singers believed that a black judge would be related to or friendly with other singers, so the only way to ensure neutrality was to select a white judge.

Usually judges were chosen at the last minute and were pulled off the street and forced to remain the entire night, listening to each group before picking the winner. Jeremy Marre and Hannah Charlton's *Beats of the Heart* contains an extraordinary story of their attendance at one of these events, in which a judge was virtually kidnapped out of a doughnut shop.[5]

But choosing white judges poses problems. First, hardly any white South Africans know any Zulu, the primary language of the *isicathamiya* musicians. Second, judges know none of the stylistic conventions of the music itself. Third, what white would relish the opportunity to spend a sleepless night in unfamiliar surroundings? Some of these constraints have resulted in changes in *isicathamiya*. English is often incorporated into the Zulu songs so that the judge may have some idea of what is happening. The adjudicators picked are often those who don't have anything better to do, so those recently released from prison (as was the judge witnessed by Marre) and the homeless are most often chosen.

Ladysmith Black Mambazo became so polished and adept that their victories at these song contests were virtually assured. Other groups eventually refused to compete with them. Therefore, in order to continue to perform and supplement their incomes and food supply—the usual prizes offered at these contests—Black Mambazo had to seek other venues. They decided to go professional, and thanks to Paul Simon and *Graceland*, they are now well known all over the world.

AFRICAN AMERICAN AND AFRICAN FERTILIZATION

Most of the songs on Black Mambazo's 1990 album, *Two Worlds One Heart*, are in their familiar *isicathamiya* style, but two are not: "Leaning on the Everlasting Arm," an old gospel hymn arranged by the famous Detroit gospel musician Marvin Winans; and a rap, "Scatter the Fire," written and arranged by the also famous American funk and soul musician, George Clinton.[6] Such collaborations and syncretisms are only the most recent examples of Africans borrowing African American and American music, a practice that has a long history. These borrowings might not have been possible in the first place if *isicathamiya* music had not been originally influenced by missionaries' gospel hymns. The quasi-tonal harmonic language of *isicathamiya* music gives it a connection to the west that allows *isicathamiya* musicians to appropriate and re-appropriate western musical forms continually.

Appropriations of dominant cultural forms by marginalized groups always involve some changes by the appropriators, changes that bend the dominant culture's values and remake them into the subordinate group's own values, aesthetics, and ideologies. *Isicathamiya* music is no exception. Such reworkings of hymns has a long history all over Africa. The Kenyan author Ngũgĩ wa Thiong'o explains that most national liberation movements begin by dialectically opposing everything of the former colonializer: religion, class, educational system. "Often," he writes, the decolonialized "take the songs of the colonizer and give them an entirely different meaning, interpretation and emphasis."[7] Ngũgĩ provides exam-

ples from the Mau Mau rebellion in Kenya, in which the revolutionaries took Christian hymns and rewrote the lyrics.[8] Celestial battles became local ones.

Aanake ukiraai	Young men arise
Muugwitwo ni Jesu	Jesus calls you to
Muoe matimu na Ngo	Take up spears and shields and to
Mute guoya wanyu	Throw away your fears.
Ukiri wake guoya	For what's the point of fear?
Thiii na ucaamba;	Go ye with bravery;
Mutwariitwo ni Jesu	Led by Jesus
No mukaahootana.	You'll be victorious.

Ngũgĩ says that the above example is a Gikuyu version of "Stand up! Stand up for Jesus! Ye Soldiers of the Cross" and says that the Mau Mau revolutionaries changed the words of the hymn, so that the spears and shields were used for their own revolution.

Aanake ukiraai	Young men arise
Muugwitwo ni Mbiu	Mbiu calls you to
Muoe Matimu na ngo	Take up spears and shields
Na mutigaikare.	And don't delay.
Umaai na Ihenya	Get out quickly
Ukaai Muteithanie	Come help one another
Ageni ni Nyakeeru	The white people are foreigners
Na ni njaamba neene.	And they are very strong.

Perhaps a more striking example is the national anthem of the African National Congress, made one of the official national anthems of the new South Africa in 1994, "Nkosi Sikelel' iAfrika."[9] This hymn does not feature changes of words, but its generic identity as a hymn and its use of western four-part harmonies make its apparent lack of nationalistic sentiment striking. "Nkosi Sikelel' iAfrika" was composed in 1897 by Enoch Sontanga, a teacher in a Methodist mission in a black section of Johannesburg. The title translates as "Lord Bless Africa." This hymn looks and sounds as though it could appear in a Methodist hymnal in America.[10]

Example 3.1
"Nkosi Sikelel' iAfrika."[11]

Nkosi, sikelel' iAfrika,[12]	Lord, bless Africa
Malupnakanyisw' udumo lwayo;	May her spirit rise high up
Yizwa imithandazo yethu	Hear thou our prayers
Nkosi sikelela,	Lord bless us,
Nkosi sikelela.	Lord bless us.
Nkosi sikelel' iAfrika,	Lord, bless Africa
Malupnakanyisw' udumo lwayo;	May her spirit rise high up
Yizwa imithandazo yethu	Hear thou our prayers
Nkosi sikelela,	Lord bless us
Nkosi sikelala.	Your family.
Chorus	*Chorus*
Woza Moya (woza, woza),	Descend, O Spirit
Woza Moya (woza, woza),	Descend, O Holy Spirit
Woza Moya, Oyingcwele.	Lord bless us
Usisikelele,	Your family.
Thina lusapho lwayo.	
(Repeat)	(Repeat)

"LEANING ON THE EVERLASTING ARM"

> From the native quarters came the soft beat of a drum and the sound of plaintive barbaric chanting that was doubtless a free rendering of a Church of England hymn.
>
> —Elspeth Huxley, *The African Poison Murders*

"Leaning on the Everlasting Arm" was originally written by European Americans, Reverend Elisha A. Hoffman and A. J. Showalter, and published in 1887 by Showalter's music company in *The Glad Evangel*. "Leaning on the Everlasting Arms" (plural, as the hymn was originally called) is popular in gospel hymnals in both white and black churches and has been recorded by a number of white musicians, including versions by Merle Haggard and George Jones.[13]

Example 3.2
"Leaning on the
Everlasting Arms."[14]

Example 3.2 (continued)

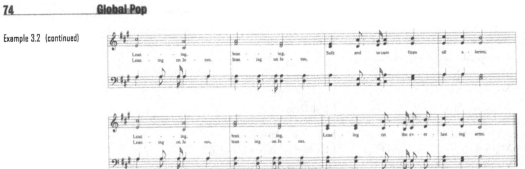

Winans and Black Mambazo's version makes a deliberate hybrid textually with the insertion of Zulu words:

Leaning on the Everlasting Arm

Introduction (instrumental)

Zulu chorus

Ladysmith Black Mambazo:	Qamela engalweni engunaphakade. Qamela kuJesu Qamela engalweni engunaphakade. Qamela kuye
Shabalala: *verse 1*	What a fellowship What a joy divine Leaning on the everlasting arm.
Winans:	What a blessedness What a peace of mind Leaning on the everlasting arm.
	[bridge]
Winans: *verse 2*	What have I to dread What have I to fear Leaning on the everlasting arm.
Shabalala:	Nothing can hurt me now With my Lord so near Leaning on the everlasting arm.
	[bridge]

English chorus

Leaning, I'm leaning
Safe and secure from all alarm
Leaning, I'm leaning
Leaning on the everlasting arm.

English chorus

[bridge]

All: His arm is reaching
Across the ocean.
Let us go across the ocean
To see the resting place
Of our forefathers.

English chorus

[bridge]

Zulu chorus to fade

The kind of appropriation made by Black Mambazo (and simultaneously, their African American collaborators) continues the history of African uses of other cultural forms. The process resembles "signifyin(g)," the tradition of African American constant improvisation and re-improvisation on various forms.[15] The process of taking white gospel hymns and improvising black gospel versions of them, and then making versions of those versions and still *more* versions, is central to African American culture and indeed fundamental in any orally transmitted culture. Christopher Ballantine writes that this process prominently figured in South African popular musics from the beginning: "If there is one concept which is fundamental to any understanding of urban black popular music in South Africa, it is that this music as a fusion—vital, creative, ever-changing—of traditional styles with imported ones, wrought by people of colour out of the long, bitter experience of colonisation and exploitation."[16]

Arranger Marvin Winans performs along with Black Mambazo on "Leaning on the Everlasting Arm," and while they kept the original lyrics, they also added some: the last passage, about God's arm reaching across the ocean, is a clear reference to the collaboration this song demonstrates. In adding this section Winans omitted the original second verse of the hymn, the most dated and most religious of all the verses to contemporary ears:

O how sweet to walk in this pilgrim way,
Leaning on the everlasting arms;
O how bright the path grows from day to day
Leaning on the everlasting arms.[17]

Additionally, in the passages marked "bridge," Shabalala and Winans speak (once addressing each other as "Brother Joseph" and "Brother Marvin"), adding to and amplifying the message of the song's text, a practice observed in America by African American gospel singers.

"Leaning on the Everlasting Arm" highlights the juxtapositions of African and African American approaches to music and musicking. Winans's voice is superbly controlled and clear, always hitting each pitch accurately, but still employing the pitch bending and inflections characteristic of gospel music and African American vocal music generally. Black Mambazo uses a much rougher voice quality, and their approach to pitch is much looser than Winans's. Where he aims at and hits a pitch, they sidle up to it, every bit as accurate but existing on a completely different trajectory, a practice as rooted in their traditions as Winans's are in his.

Approaches to rhythm are similar: Winans offers a rocking rhythmic track that features a strong backbeat throughout. The line "leaning on the everlasting arm" is syncopated after the first time, an effect that Winans executes flawlessly and precisely. Black Mambazo, however, with their freer rhythmic approach, are less effective in the syncopated sections; perhaps this is why Shabalala doesn't syncopate it the first time this line is heard. All of these differences and layers stand out in relief, rather than being backgrounded as in Peter Gabriel's "Come Talk to Me."

Black Mambazo, in addition to demonstrating the ways that hegemonies and resistances coexist even in the practices of a particular group, also illustrate that the widespread commodification of musical forms allows distant solidarities to be fashioned, even "across the ocean." Paul Gilroy's influential *The Black Atlantic* centers these solidarities on transatlantic communication, between blacks in the U.K. and the U.S., but even some of his own examples (such as Apache Indian, whom I'll discuss in chapter 6) show that the circulation of commodified musics and identities is pervasive and multidirectional.[18]

Moreover, Charles Hamm has written of African American music traveling to South Africa as early as 1858, based on the records of a minstrel troupe in Durban. The American Christy Minstrels visited there in 1865.[19] By the advent of recorded music, South Africa was literally inundated with African American (and other) musics, many of which left their traces in black South African musics, as we learned with the case of hymns.[20] In the 1950s and 60s, rock 'n' roll found a home in South Africa, but it was soul music that ultimately emerged as the biggest African American music yet among blacks in South Africa. This music, combined with African American styles of dress, became increasingly common by the 1960s and 1970s, all of which helped provide solidarity among all urban South African blacks, regardless of tribe or social class.[21] Today there are now black South African rap groups, such as Prophets of da City, who were prominent in getting out the vote before the 1994 election; rap may be the most influential of all African American musical forms in South Africa today among young urban blacks.[22]

"SCATTER THE FIRE"

The African American funk musician George Clinton, now enjoying something of a comeback, wrote "Scatter the Fire" for Black Mambazo. While the song

has some musical elements common to contemporary African American raps, it sounds more like a vehicle for Black Mambazo and sidesteps political issues.

Scatter the Fire

Scatter, scatter the fire, spread the music all over the world
Scatter, scatter the fire, spread the music all over the world
Scatter, scatter the fire, spread the music all over the world
O yeyi yeyi yeyi yeyi yeyi yeyi wema
wo yeyi yeyi yeyi yeyi yeyi yeyi wema
wo hansi ingoma wethu

Sampled voice: Yo! Check this out man!

Shabalala: Yabo! You check this out!
 Mhlakaza, mhlakaza nhlantsi Zibashise
 Mhlakaza, mhlakaza nhlantsi Zibashise
 wethu Galajaomasondosondo
 Mbilaobomvana kamahulula Mabhajwa
 azikhumule kubobonke abakwa shabalala
 Kungazange kubekhona umabhajwa
 khumule nake wethu, Untombi
 zimcela Umendo noma usupheile
 Xola nyanga uhlala ukwenza kukulungela ungeke usayithola
 Nkunzi ekhonye ubusuku bonke kwandonga ziyaduma
 Kuthe kusa yabe isithamele ilanga phansi egagsini
 Ji om, Ji om!
 Hey! Listen to the band!
 Yes, this is zulu dance!
 Keep the faith! Bafna Ba Sehkya!
 Spread the music and scatter the fire!
 Music is Love! And Love is Power!
 Spread the music and scatter the fire!
 Music is Love! Love is Power!
 Spread the music and scatter the fire!
 Scatter, scatter the fire, spread the music all over the world
 Scatter, scatter the fire, spread the music all over the world
 Scatter, scatter the fire, spread the music all over the world
 Scatter, scatter the fire, spread the music all over the world
 Uyayizwa ingoma yakithi
 Awuyazi wena
 This is zulu dance

In "Scatter the Fire," Clinton and Black Mambazo have taken the most explicitly political contemporary African American musical genre and thoroughly

tamed it; the line "Music is Love! Love is Power!" is a fairly mild one compared to the anger and violence of much contemporary rap in America. At the same time, however, Black Mambazo continues their dialogue with African American musicians, since this rap was written by Clinton, and a clearly African American sampled voice contributes a shouted line, "Yo! Check this out, man!"

RESISTANCE

Given the pervasiveness of power, it is thus important to examine Black Mambazo's apparent apolitical nature, as well as our own assumptions: Why would we require them to perform a rap that says "Down with apartheid!"? And so I want to bring in a discussion of forms of resistance. Is resistance only direct and overt, or can it take other forms, even transcend the oppression of everyday life? With the exception of the work of political scientist James C. Scott, this question was probably undertheorized in cultural theory until recently (although there have been a few extraordinary histories written, such as LeRoi Jones's classic *Blues People*, Lawrence W. Levine's *Black Culture and Black Consciousness*, Américo Paredes's *With his Pistol in his Hand*, George P. Rawick's *From Sundown to Sunup*, and others).[23] Perhaps the evident pleasure Black Mambazo takes in their music could be considered a form of direct opposition to whites since it defies the subservient position white South Africans made for blacks. According to Veit Erlmann, *isicathamiya* music does have a history of offering political protest songs, although he (and most writers on this music) tend to write about *isicathamiya* as emphasizing the more quotidian experiences of migrant workers, particularly the differences between "here" (city) and "home."[24] Christopher Ballantine, however, writes that *isicathamiya*'s roots in the Zulu-speaking working class mean that it is usually political and that Black Mambazo is exceptional in this regard; for this reason, he argues, they were championed by the South African Broadcasting Corporation because their lyrics tend not to criticize the social order.[25]

In discussions of power and resistance, the work of Michel Foucault must be central. While considerations of power pervade much of his work, it is in *The History of Sexuality* that Foucault sets out what he means by the term and its implications:

> power must be understood in the first instance as the multiplicity of force relations immanent in the sphere in which they operate and which constitute their own organization; as the process which, through ceaseless struggles and confrontations, transforms, strengthens, or reverses them; as the support which these force relations find in one another, thus forming a chain or a system, or on the contrary, the disjunctions and contradictions which isolate them from one another; and lastly, as the strategies in which they take effect, whose general design or institutional crystallization is embodied in the state apparatus, in the formulation of the law, in the various social hegemonies.[26]

Foucault's conception of power is supple and complex, allowing for all kinds of manifestations, deployments, and resistances. Power isn't merely located in the state; it is everywhere, embedded in social relations. "Power is not something that is acquired, seized, or shared . . . power is exercised from innumerable points, in the interplay of nonegalitarian and mobile relations."[27] Elsewhere he writes,

> Power must be analyzed as something which circulates, or rather as something which only functions in the form of a chain. It is never localized here or there, never in anybody's hands, never appropriated as a commodity or piece of wealth. Power is employed and exercised through a net-like organization. And not only do individuals circulate between its threads; they are always in the position of simultaneously undergoing and exercising this power. They are not only its inert or consenting target; they are always also the elements of its articulation. In other words, individuals are the vehicles of power, not its points of application.[28]

Foucault is also careful to set out his thoughts on resistance. "Where there is power, there is resistance, and yet, or rather consequently, this resistance is never in a position of exteriority in relation to power."[29] But, taking the long view historically, he is rather pessimistic. Resistances

> are inscribed in [power] as an irreducible opposite. . . . Are there no great radical ruptures, massive binary divisions, then? Occasionally, yes. But more often one is dealing with mobile and transitory points of resistance, producing cleavages in a society that shift about, fracturing unities and effecting regroupings, furrowing across individuals themselves, cutting them up and remolding them, marking off irreducible regions in them, in their bodies and minds."[30]

It is this apparent pessimism—or, perhaps, refusal of optimism—that has led some critics to view Foucault's position as totalizing: one can never escape power, all resistance stems from the power relations that any particular resistance is attempting to critique.[31] It is true that Foucault allows for resistances in his discussions of power, but it is also clear that he isn't much interested in them, or that he is even unable to articulate how they might occur. Foucault isn't totalizing in his theory, but he is in his explication of it. For example, in a discussion between Foucault and a couple of "Maoist militants" in June of 1971, Foucault speaks at length of the necessity of not reinstating bourgeois structures of power after the citizenry has been proletarianized. One of the Maoists asks him where the new bureaucracy is going to come from, and Foucault admits he doesn't know—"it remains to be discovered."[32]

In the case of Black Mambazo, the question of what constitutes resistance leads us to other questions: If a people who are uncolonialized become colonialized overnight, do all of their practices and cultural forms become forms of resis-

tance overnight? Or, now that the apartheid system has been dismantled, have traditional South African musics ceased to be resistant? Or does resistance depend on the intent of the actors? The binarization of responses to oppression as "complicity" or "opposition" results in questions that are every bit as polarized and not very relevant to the lived situations of black South Africans.

Black South Africans offer defenses of Black Mambazo that run the gamut from those who say they were oppositional to those who say they did not have to be. Marre and Charlton quote an unnamed exiled black South African poet who claims that Black Mambazo's music is oppositional mainly because the blacks were dominated.

> It seems strange perhaps that black South Africans can sing, can dance, can still create music that is an expression of life in the face of violence and oppression. Even the man who is walking to his execution, for example, sings. But these songs that are created and played by black musicians throughout South Africa are songs of opposition, of rejection of the apartheid system that makes a black person a fourth-class person in his [sic] own country. Music created by black South Africans is a direct response to the apartheid system under which we are forced to live. In that way it is uniquely South-African music. It is defiant. It expresses the determination that every one of us will win freedom one day. It cannot be explicitly political, so it is subtle. It expresses in its tone, in the sound of the voice and sound of the instruments, the soul of the black South African.[33]

This poet doesn't see the problems inherent in such a stance. If everything is resistant or oppositional, then black South African cultural forms are thus limited to expressing nothing but resistance. Whites can view Africa as Europeans once viewed the Orient: they know it, and believe they know it totally. African culture is seen as monolithic, while western culture (expressed in South Africa as white South African culture) is diverse, wide-ranging, and ineffable.

So the question of what constitutes resistance makes more sense as, what forms can resistance take? James C. Scott formulated one extreme position on resistance in his critique of Gramscian hegemony theory, which Scott thought was too totalizing: Hegemony infiltrated every aspect of the lives and minds of the hegemonized. For Scott, Gramscian hegemony theory "ignores the extent to which most subordinate classes are able, on the basis of their daily material experience, to penetrate and demystify the prevailing ideology."[34] His solution to the problems of the Gramscian model was to propose a concept of "everyday forms of resistance" that holds that practically everything is, or can be, resistance. Scott begins with a definition of class resistance as "*any* act(s) by member(s) of a subordinate class that is or are *intended* either to mitigate or deny claims . . . made on that class by superordinate classes . . . or to advance its own claims *vis-à-vis* those superordinate classes."[35] But Scott concludes that resistance can be intentional, nonintentional, individual, coordinated, and in fact just about anything members

of a subordinate group do to help themselves. Thus, as many have pointed out, Scott's idea of resistance is as totalizing as his version of Gramsci's hegemony: Hegemony was total, Scott feared, but now resistance is total.[36]

Nonetheless, Scott's concept of everyday forms of resistance teaches us that resistance can work in ways other than direct confrontation, explicitly oppositional to a particular regime or viewpoint, and in that respect it remains a crucial intervention. Perhaps Black Mambazo "resist" apartheid because they sometimes refuse to engage with it, refuse to allow apartheid to infiltrate every corner of their consciousnesses. Their lives are made by their music, their church (Christian), and their friends and families, as Scott might argue.

Ashis Nandy offers important insights on this issue, writing that the apparent lack of resistance by Indians to British imperialism should not be confused with capitulation or complicity. He offers a subtle and compelling analysis of western and Indian values, concluding that the Indian sense of self, informed by Hinduism and other aspects of Indian culture, allowed Indians a highly fluid self-conception that enabled them to retain their old concepts of self while at the same time accommodating new one(s) imposed by British imperialism.[37] He further argues that Indians could find solace and strength in their culture and its forms and that the act of participation in Indian culture alone was a way of combating imperialism. Nandy discusses Gandhi's achievement in pointing out the inherent inconsistencies of imperialism, noting that Gandhi "recognized that once the hegemony of a theory of imperialism without winners and losers was established, imperialism had lost out on cognitive, in addition to ethical, grounds."[38] Nandy concludes by noting the sorts of polarities that drive western culture and suggesting that by refusing to participate in the two positions established by the west — complicity or resistance — the oppressed can exist outside of them, or, as he puts it, perhaps the oppressed can "transcend the system's analytic categories and/or stand them on their head."[39]

We should also be mindful of who might be able to practice an armed resistance. Direct, physical opposition, historically a radical kind of resistance, privileges the few who can practice this kind of resistance, generally young men without families or pressing family obligations. Black Mambazo existed in a highly politicized environment, but there are still practices available to them that are less informed by politics. Joseph Shabalala has described at length his quest to attain the fine art he achieved with Black Mambazo and characterizes this quest as a powerful desire to make the best music possible, while never mentioning politics. Shabalala's efforts to conceive and realize a music based on his dreams and desires appear to be a way of operating *outside* the political. Ladysmith Black Mambazo's music is neither an example of resistance nor complicity, but an attempt to escape the very grounds of the oppressor/oppressed paradigm that European colonialism imposed on them.

As Shabalala himself said in a recent interview,

From the beginning when you talk about the politician to our country, it was something that can lead you to jail. But I was very happy because I was singing my language, and then the white people don't understand what was the meaning. My people were very happy because they know exactly what is this, it gives them power to work very hard and to do whatever they want to do. And I consider that my music was *everything*, as I say our nation is to spread the culture and its tradition to encourage musicians and composers that their music should remain as close as possible to their roots. When we talk about roots, it's more than politician[s], but it's food for those people. That's why our people at home, they were very happy with Black Mambazo, because the music itself, it's universal.

There were people [who asked us to denounce apartheid with our music], but especially those who don't understand the language. But those who understand the language, they said, "Carry on, this is wonderful." Because they understand. I think it's universal. . . . But to me when I was listening to people, they said, "Carry on."[40]

The white South African musician Johnny Clegg (whom I will discuss in chapter 7) makes the point that black South African music is supposed to be humanizing, it is supposed to help people restore themselves and forget. This was Clegg's and others' response to some of the more radical black militants and understanding of the role of music in the anti-apartheid struggle.

When you have experienced apartheid, then you don't risk going out in the townships to see a band in order to be told about that experience. You don't need that. You've gone there to be reconstituted as an individual, a human being. The weekends are for reconstitution. . . . "Good time" music is reconstitutive because it says, climb inside and I'll make you whole, get up off your chair, don't feel so bad, let's move together, a bit more strongly with each repeated cycle of the song.[41]

Whether or not Ladysmith Black Mambazo's actions and music fall under the umbrella of resistance as it is currently theorized, the importance of their accomplishment cannot be overemphasized: making your own music for your own pleasure under apartheid constitutes a triumph over apartheid, even as this victory is defined by apartheid.

RHOMA IRAMA: "QUR'AN DAN KORAN"

I want to turn now to Rhoma Irama (1947–), an Indonesian popular musician who provides another example of a musician outside the west who uses western musics, demonstrating other complex kinds of resistance.[42] William Frederick, who has followed Irama's career for many years, writes that early in his career Irama turned away from western pop and rock and to Melayu music, a genre of western/Arabic/Indian-influenced popular music in Indonesia. Still not satisfied with this music, Irama envisioned a new musical style with the

Figure 3.2
Rhoma Irama,
publicity photograph.[45]

following criteria: it had to be popular to Indonesians of different classes and backgrounds; it must be modern; it must carry a message that was intelligible to young people everywhere; and it mustn't bear too close a relationship to western styles. Irama's goal, Frederick writes, was "an unmistakably 'Indonesian' or at least an 'Eastern' sound," and not merely "imitate the existing Melayu-Deli style with its Arab and Indian flourishes."[43] The new style was called *dangdut*, named onomatopoetically for the sound of the beat, a low drumbeat on the fourth beat of the measure followed by a high drum stroke on the first beat on the next measure: dang—*dut*.[44]

Irama has marketed himself as a western-style rock star, even changing his original name; "Rhoma Irama" means "Father Rhythm." Irama is a superstar in Java, appearing in many films that feature him and his music and that tap into a rags-to-riches story that approximates Irama's own. The publicity photograph above features Irama dressed all in black, with a "Flying V" guitar, popular in the last twenty years or so.

"Qur'an dan Koran" ("The Qur'an and[46] the Newspapers") proves a striking song for analysis; indeed, since I first started this project, the song seems to have become a canonical work in world music, thanks to its inclusion on a Smithsonian collection. The lyrics (English only) appear in *World Music: The Rough Guide*, one of very few songs to be granted this much space.[47] Here are the complete lyrics, in Indonesian (with a couple of lines in Javanese) and English.[48]

Qur'an dan Koran	The Qur'an and the Newspapers
Dari masa ke masa manusia	From age to age
Berkembang peradabannya	Man's civilization develops
Hingga di mana-mana manusia	By now everywhere
Merubah wajah dunia	Man is changing the world
Gedung-gedung tinggi	Tall buildings scrape the sky
mencakar langit	
Nyaris menghiasi segala negeri	They adorn almost every country
Bahkan tehnologi di masa kini	In fact technology in this day and age
Suda mencapai kawasan samawi	Can reach into outer space
Tapi sayang disayang manusia	But it's sad to say
Lupa diri tinggi hati	Men have forgotten who they are and
	become arrogant
Lebih dan melebihi tingginya	They think they're even taller
Pencakar langitnya tadi	Than those skyscrapers
Sejalan dengan roda pembangunan	As progress marches on
Manusia makin penuh kesibukan	People get so busy
Sehingga yang wajibpun terabaikan	That they forget their duty
Sujud lima waktu menyembah Tuhan	To pray to God five times a day
Karena dimabuk oleh kemajuan	They are so drunk with progress
Sampai komputer dijadikan Tuhan	They think the computer is God
(yang bener ajé!)	(you're kidding!)
Kalau bicara tentang dunia	When they talk about the world
Aduhai pandai sekali	They're wonderfully clever
Tapi kalau bicara agama	But talk to them about religion
Mereka jadi alergi	And suddenly they're allergic
Membaca koran jadi kebutuhan	Reading the newspaper is a necessity
Sedang al-Qur'an cuma perhiasan	The Qur'an is just there for decoration
Bahasa Inggeris sangat digalakkan	Everybody's crazy to learn English
Bahasa Arab katanya kampungan	But Arabic is considered backward
(ngaak! salah 'tuh!)	(they're wrong!)
Buat apa berjaya di dunia	What good is success in this world
Kalau akhirat celaka	If it brings disaster in the next?
Marilah kita capai bahagia	Let us try to be happy
Di alam fana dan baka	Not only for today but for eternity

Judging by the lyrics alone, "Qur'an dan Koran" seems to be a song about the negative influence of the west, but the way Irama achieves this message is instructive. Just as he markets himself like a western rock star while at the same time critiquing the west, Irama uses western music and words to help him make the same

critique: In other words, he takes western and other forms to make a statement that opposes the west. One example from the lyrics is the use of the word "alergi" ("But talk to them about religion/And suddenly they're allergic"). A. L. Becker says that this is a word derived from English, but it is used here in a way to help Irama denounce western culture, just before he criticizes the "crazy" desire to learn English.[49]

The lyrics and music appear to center clearly upon the hegemony/resistance binary; this is a song about Islam versus the west (as exemplified by newspapers and skyscrapers). Irama, whose forbears were the victims of European colonialism is exerting his local identity and religion. The main local religion in Java is Islam, although not usually the more aggressive brand advocated by Irama.[50] It turns out that Irama isn't so much opposing a distant land with a colonialist past as promoting a certain view of his homeland. Becker says that young Muslims' antiwestern sentiments represented here by Irama are due less to an anticolonial stance and more from their own experiences and understandings of the west.[51] Further, Becker says that what antiwestern feelings there are in Java tend to be directed not at the west, but Hong Kong, the port of entry and disembarkation for much western culture in southeast Asia.

The critique that Irama does offer of the west isn't so much of the west as geography or as former colonializer, but of one of the most cherished aspects of western bourgeois ideology: progress. But as Irama reminds us, progress to what? The trappings of modernity are not very salutary, he warns, particularly when they are imposed on cultures that did not introduce them.

Below is a transcription of the melody of the song's first verse.

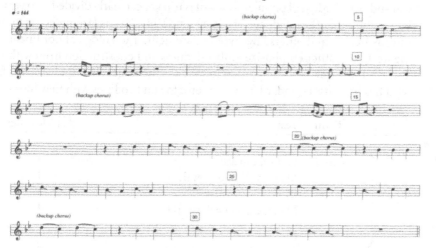

Example 3.3
Rhoma Irama: "Qur'an dan Koran," first verse.

The vocal music itself owes little to western popular music, but the guitars, the rhythm, the clear 4/4 meter do. The western pop sound has become so internationalized, however, that Irama himself probably would not acknowledge any debt to the west.

Although much of "Qur'an dan Koran" consists of borrowed musical styles (from western popular music, Indian film music, Middle Eastern music), it provides musical clues to Irama's difference. His vocal style owes much more to the fluid singing style of Indonesian music than to North American and U.K. popular music, and is only crudely captured in the notation used in the transcription.

This song again helps illuminate the problems contained in a simple hegemony/resistance or colonializer/colonialized polarization. A simplistic application of this model would argue that Irama's use of a western idiom is itself oppositional and nothing else, or, conversely, that Irama's use of western pop sounds demonstrates the extent to which he has been westernized. But what we have here is more complex: Irama not only borrows western pop music sounds but Indian film music as well. Constructing appropriation as always embedded in a critique of the appropriated culture can never be the whole story. Irama also uses some instruments from the Middle East as a way of marking solidarity with other Muslims. Music can contain these disparate sounds and different critiques and affiliations in ways that no other cultural form can.

Irama borrows from the west to aid him in a struggle for recognition of his brand of Islam in his own country as well as protesting westernization. The multiple meanings in "Qur'an dan Koran" and the nature of the resistance it offers provide a good example of Sherry B. Ortner's recent complaint about resistance studies that wash out politics: resistance is defined in terms of dominant and subordinate, not with regard to "local categories of friction and tension," such as "struggles for primacy between religious sects."[52]

The form of this particular song, while it follows to some extent North American and British ideas of popular song—it is tripartite, clearly divided into verses—is nonetheless further evidence of a local sensibility. Javanese approaches to structure, as Becker and others have written, are neither teleological nor linear as in the west, but rather emphasize embeddedness and construction from within, as Table 3.1 illustrates.[53] The portion to watch is the largest B, which departs from what has become a standard four-line verse to add two lines with new music.

Table 3.1
Rhoma Irama: "Qur'an dan
Koran," formal diagram.

	Form	Text	# of Measures
		a	
	verse 1	From age to age	4
		Man's civilization develops	4
		By now everywhere	4
		Man is changing the world	4
A		**b**	
	verse 2	Tall buildings scrape the sky	4
		They adorn almost every country	4
		In fact technology in this day and age	4
		Can reach into outer space	4

Table 3.1 (continued)

Form		Text	# of Measures
A		[transition]	2
		a	
	verse 3	But it's sad to say	4
		Men have forgotten who they are and become arrogant	4
		They think they're even taller	4
		Than those skyscrapers	4
		[instrumental]	8
			8
			6
		c	
	verse 4	As progress marches on	4
		People get so busy	4
B		That they forget their duty	4
		To pray to God five times a day	4
		d	
		They are so drunk with progress	4
		They think the computer is God (you're kidding!)	4
		[transition]	2
		a	
	verse 5	When they talk about the world	4
		They're wonderfully clever	4
		But talk to them about religion	4
		And suddenly they're allergic	4
		b	
	verse 6	Reading the newspaper is a necessity	4
		The Qur'an is just there for decoration	4
		Everybody's crazy to learn English	4
		But Arabic is considered backward (they're wrong!)	4
A		**a**	
	verse 7	What good is success in this world	4
		If it brings disaster in the next?	4
		Let us try to be happy	4
		Not only for today but for eternity	4
		[close]	2

The portions labeled **A** in the large font refer to the largest subdivision of the form. The smaller, lower-case letters refer to melodic repetitions. Although the

formal qualities of western popular music have continually expanded, the most common and tried-and-true form, **AABA**, isn't used in "Qur'an dan Koran." Instead the most interesting formal characteristic of this song is that it appears to be telescoped: the overall structure is **ABA**, with the **A** parts consisting of **aba** parts. An instrumental section appears after the second verse, as in much western popular music. The fourth verse offers new musical material. All of this new music occurs in the fourth verse (marked **cd** above), which is two lines longer than any earlier verse in the song. In other words, while the formal behavior of western popular music would lead one to expect new musical material at some point in the middle of the work, this material is collapsed into one verse, which itself is extended. So while "Qur'an dan Koran" may sound western in many ways, and while Irama presents himself as a western rock star might, formal and other musical clues clearly point to a different aesthetic at work.

The point I'm attempting to underline here is that, while it may look as if Irama is critiquing the west, there are more local concerns and local musical approaches evident. He is involved in more local politics: identifying Hong Kong as the gateway for western ideas and forwarding a local version of Islam. To assume that such a critique could only be of the west is Euro-Americocentric. There are multiple and layered resistances at work, as well as multiple and layered hegemonies.

DJUR DJURA: WOMEN OF THE (THIRD) WORLD, UNITE!

Ladysmith Black Mambazo and Rhoma Irama help point out the ways that there can be many kinds of resistances, and these need not always be directed primarily at the usual suspects: former colonial powers. And we have seen the ways that these musicians have been able to critique the west by using western cultural forms. From Djur Djura, we learn that it is difficult to critique hegemony as total; her resistances to patriarchy are greatly aided by her familiarity with ideas from feminist movements.

Djura Abouda (1949–), is a Kabyle (an Algerian Berber) who takes feminist ideas to make powerful statements against patriarchy in Algeria, using musics and musical sounds from all over. Born to a traditional family whose culture undervalued women as equal members of society, she moved to Paris with her family when she was five, leaving behind her grandmother, the only person who cared for her. Djura's autobiography, *The Veil of Silence*, stunningly recounts her life, from being ignored by her mother to various atrocities committed against her by members of her family because she refused to live the traditional life of a Berber woman.[54] It is, to my mind, the most compelling memoir by a woman musician since Billie Holiday's *Lady Sings the Blues*.[55]

Since Djura left Kabylia when she was quite young, her music is more European pop/folk/eclectic than traditional Algerian or Berber. She journeyed back

Figure 3.3
Djur Djura.

with her brother and sister-in-law while a young woman and there relearned the language and some traditional music. The music of Djur Djura (the name refers to the mountains of Kabylia) reflects her desire to reconcile Algerian and French musics. The earliest members of the group were various instrumentalists, some Algerians, some not, with vocals by Djura and her sisters. The sisters proved unreliable, and all eventually joined a vendetta against her and her French husband—Djur Djura's producer, Hervé Lacroix—for marrying a non-Muslim. The most recent Djur Djura recordings feature vocalists unrelated to Djura.

Djura's writings in *The Veil of Silence* are overwhelming. Tales of crimes against women (murdered merely because of their gender or family negligence, murdered because they refused to participate in arranged marriages). As remarkable as her family's stories are Djura's stories of her rebellious nature and desire for independence. The book is replete with her desire to emancipate women of her country, and around the world, and preach this belief through her music; she consciously gave up a promising film directing career to write songs and lyrics, which she thought would more powerfully aid her political message.

I was a young Algerian, in love with Berber traditions, but equally concerned about women's place in modern society. I had suffered, like my female compatriots, from the social, political and family constraints which still persisted, in spite of claims to progress. . . .

Well, I'd broaden the debate! I'd attempt to drag all Algerian girls into my struggle, and those from all North Africa, the whole of Africa, girls and women from other Arab countries, and even some from the West whose light was still hidden under a bushel. I would be like Kahina [a seventh-century Berber priestess who resisted the conquering Arabs' new religion, Islam]: with my songs I would raise a veritable army, loyal to the cultural wealth of our countries and yet rebelling against the omnipotence of an outdated patriarchy.[56]

Although she misses her home, she realizes that growing up in France allowed her feminist consciousness to flourish.

> I had the luck to be brought up in a Western country; I was at the crossroads of two cultures, I could draw the inspiration for my compositions from these two sources. Not denying the past nor my origins, but making them shine with the light of a brighter future.
>
> For that, it would not be enough to perform as a 'folksy' group: we would have to compose new songs, inspired by the old ones, with added suggestions for future developments.[57]

Perhaps Djura's most succinct statement about her mission is that "our slogan for Djur Djura would be, 'We sing aloud what our mothers hummed under their breath.'"[58] And she reports, "When I'm playing somewhere, there are these groups, almost committees of women who come together, and often they tell me backstage, 'Our husbands are taking care of the children. And it's thanks to you that we're able to bring that about.'"[59]

It is clear that the global movement of music and culture is creating new, complicated political and subject positions all the time. The case of Djur Djura is particularly complex in this regard, for she, in her dual cultural roles as colonialized person and inhabitant of a European metropole, finds herself in the position of criticizing her ancestral home from the vantage point of her new one, criticisms that have spawned violence. This is the Salman Rushdie problem, the problem of being *of* a culture but not *in* that location, of having to make an in-between life that may or may not find you a community of similarly positioned people. So have Djur Djura and Rushdie become "westernized"? This is a poor way of asking the question, it seems to me, for it implies that in becoming western they have lost something else. It would be more fruitful to view them from the vantage point of Appadurai's "ideoscapes"—they inhabit a historical and cultural moment in which many ideologies and positions are simultaneously possible, and this particular one happens to be associated with the west, but at the same time these musicians are not giving up aspects of their ancestral cultures.

Djura believes in music as a de-culturalized, universal form and uses appropriate rhetoric to support this position. First, she invokes the familiar notion of a universal language of emotions, which she has "experienced . . . all over the world." She also looks for commonalities in the body. "In some cultures, the body is shown, in others it is completely hidden. But in both cases, it is the body of the woman that is exploited. A woman's body hardly ever belongs to her, it belongs to the society."[60]

Critics have commented on the "universal" appeal of her music collected on *The Best of Djur Djura*,[61] but some have commented on the flip side, claiming that it's too universal, too popular. The most scathing criticisms have accused Djura of being too pop, too slick, too produced. "The melodies inched embar-

rassingly close to 'Frère Jacques'"; "occasionally cheesy electronics (we're talking video games)"; "treacly pop"; "saccharine Euro-pop"; and more.[62]

As one might guess, some of the criticism of Djura's music slips into sexist language; often her music is described as "innocent" in the same breath as it is described as too popular. Her music is praised mainly on the grounds of her autobiographical experiences, which are recounted in virtually every review; and when her music is praised as music, it is usually compared favorably to Bulgarian women's choirs and to *rai*, an Algerian popular music that can boast of very few women stars.

Djura's music, while it refers to traditional Berber musics, also relies heavily on western musical traits. It demonstrates a familiarity with popular and folk styles from all over, as well as a sense of European "art" music of the past. So the styles on the album run a broad gamut. For example, "Nura," below.

Example 3.4
Djur Djura: "Nura," melody.

Djura sings this song in the Berber language, but the liner notes are in English only, as is usually the case with world music/world beat recordings.

Nura

Nora, this letter I must write
Although it cannot reach your eyes
Where your buried body lies
But thanks to you, we now unite
To defend the future's youth.
We never case to hear your cries
Repeated still from mouth to mouth
East to west, north to south.
Your memory shall endure
By this our song kept ever green.
Killed by your brothers, just sixteen.
Hard as it is to tell this truth . . .

To justify their crime
They invoked the usual claim:
"Ancestral law her death decreed.
She went too far, she brought us shame."

What we fear does come to pass
You die for a word, an idea, alas!

You were a flower in its prime
Nora, of beauty pure
Victim of a wicked deed.
And in your heart: the beauty of the world . . .

For you and our sisters we shall sing
Mountains we shall move
Our words will be sharp and cutting
They will uphold our dignity
Which many seek to disprove
Truth is a clear refreshing spring.

That "Nura" (translated into English as "Nora") takes its form as a letter from Djura to her fictitious sister allows the song to continue a long-standing tradition of women writers: barred by patriarchal cultures from participating in the production of public cultural forms such as books, women who want to write can still write letters. Alice Walker's *The Color Purple*, which won the Pulitzer Prize in 1983 may be the best example of a private genre made public to attack patriarchy.[63]

Djura's letter writing calls to mind Lauren Berlant's "female complaint," which "serves in particular to mediate and manage the social contradictions that arise from women's sexual and affective allegiance to a phallocentric ideology that has, in practice, denied women power, privilege, and presence in the public and private spheres."[64] For Berlant, the female complaint operates as an admission of both privilege and powerlessness, recognizing patriarchal oppression, while at the same time employing a mode of discourse that is always already delegitimized. "The *a priori* marking of female discourse as *less serious* is paradoxically the only condition under which the complaint mode can operate as an effective political tool" [emphasis in original].[65] The female complaint thus becomes, in Berlant's words, "an aesthetic 'witnessing' of injury," a way of expressing rage, injustice, frustration, uttered in the only space women have, a space between the sexual politics that threatens patriarchy, and powerless sentimentality.[66]

Another of Djura's songs, "Azemmur," sounds like fourteenth- or fifteenth-century European art music, though with updated harmonies. The voices that move in a generally homophonic way (that is, the voices move roughly together, in the same rhythm), the pauses between measures, the changes in meter, all point to a musical sensibility far from the present, but also far from Kabylia. Along with art music, Djura is linking up with more recent traditions of singing, such as the "girl" groups of American pop in the 1950s, but also such groups as Zap Mama, an African Belgian women's vocal sextet I'll discuss in chapter 7.

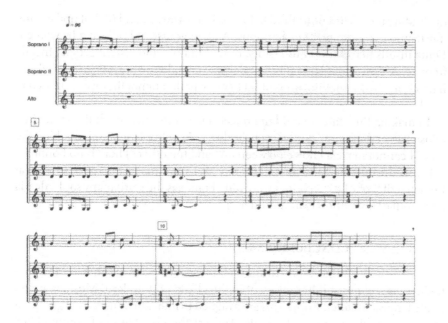

Example 3.5
Djur Djura: "Azemmur,"
opening.

Azemmur

Gather our olives
Black and ripe,
Beloved Land!
Olive trees of our ancestors!

Gather our olives
In the cold of winter,
Beloved Land!
From dawn to dusk, we
defend you.

Today, like tomorrow,
In rain or in shine
You remain our land, our sister,
our poetry . . .

Gather our olives
With their leaves and branches.
The beauty of the Kabylia
Is not meant to be hidden.

In "Azemmur," Djura takes a kind of music in which women were rarely permitted to be active—premodern western European art music—keeps some conventions (such as the Landini cadence, in which the tonic is approached not from

the leading tone, but from a third below, as in measures 2 and 6), but updates the music into common practice harmony. And, of course, it is all sung by women. Djura inserts herself into this history, distant in time and distant geographically from her Algerian roots, demonstrating that women have always been around and have always had something important to say, whether or not they were allowed to speak.

In making this statement, Djura rejects racial essentialism, at the same time refusing to embrace an aesthetic of hybridity. "My native language is double," she says. "I cannot make a choice between one and the other. There is no boundary between this one and that one. This is why I have made reference to a great French writer of Algerian origin who said: 'France is the spirit of my soul; Algeria is the soul of my spirit.' (Jean Amrouche)"[67]

CONCLUSIONS

What we learn from all these musicians emphasizes the contradictions and possibilities inherent in the global postmodern. Music is appropriated, music is stolen, copyrights are assigned to individuals instead of groups or sometimes to the wrong individuals. And yet the circulation of commodified musics provides more ways of resistance, and dominance, than ever before.

One of the most noticeable features of these musicians is their operative conceptions of "the global" and "the local," what Roland Robertson has called "the interpenetration of the universalization of particularism and the particularization of universalism"[68]; these musicians negotiate these ideas in startlingly clever and innovative ways. New technologies and modes of musical production allow these musicians to occupy different subject positions in a kind of simultaneity never before possible; they don't move from one to the next but rather employ and deploy several at once. So even if musicians of color around the world seem to eschew a local identity for a global one, they do, at the same time, maintain their old identities as locals: as Zulus in South Africa, Javanese in Indonesia, and Kabyls in France, looking ahead toward the next century.

NOTES

1. Christopher Ballantine, *Marabi Nights: Early South African Jazz and Vaudeville* (Johannesburg: Ravan Press, 1993), 5. Ballantine's is a fascinating history of black music and musicians in South Africa early in this century.

2. Helen Q. Kivnick, *Where is the Way: Song and Struggle in South Africa* (New York: Penguin, 1990), 114.

In an interview on National Public Radio, Shabalala said that the word means "tiptoe guys" (Ladysmith Black Mambazo, interviewed

by Ray Suarez, National Public Radio, *Talk of the Nation*, 12 January 1995).

3. In a 1989 interview with Veit Erlmann, Shabalala said that the word "black" referred to a kind of span of oxen in his homeland that was particularly strong (Erlmann, "A Conversation with Joseph Shabalala of Ladysmith Black Mambazo: Aspects of African Performers' Life Stories," *World of Music* 31 (1989): 41. The shift demonstrates a kind of politicization and awareness of African American sentiment

that black is beautiful, a shift that belies Shabalala's claims that Black Mambazo is not political.

4. This is only the briefest of histories of this genre. For more comprehensives ones, see David B. Coplan's *In Township Tonight! South Africa's Black City Music and Theatre* (London and New York: Longman, 1985); and Veit Erlmann's many publications, particularly *African Stars: Studies in Black South African Performance* (Chicago and London: Univ. of Chicago Press, 1991), and *Nightsong: Performance, Power, and Practice in South Africa*, Chicago Studies in Ethnomusicology, ed. Philip Bohlman and Bruno Nettl (Chicago: Univ. of Chicago Press, 1996). Erlmann's relevant articles include "Migration and Performance: Zulu Migrant Workers' *Isicathamiya* Performance in South Africa, 1890–1950," *Ethnomusicology* 34 (Spring/Summer 1990): 190–220, and "'The past is far and the future is far': Power and Performance among Zulu Migrant Workers," *American Ethnologist* 19 (November 1992): 688–709.

5. Marre and Charlton, *Beats of the Heart: Popular Music of the World* (New York: Pantheon, 1985). Marre's film about South African music, *The Rhythm of Resistance* (Harcourt Films, produced by Jeremy Marre, directed by Chris Austin and Jeremy Marre [Newton, N.J.: Shanachie, 1988]), includes this scene described in their book.

A more recent description of these contests can be found in Helen Q. Kivnick's *Where is the Way*.

6. *Two Worlds One Heart*, Warner Bros. 9 26125-2, 1990.

7. Ngũgĩ wa Thiong'o, *Writers in Politics*, Studies in African Literature (London: Heinemann, 1981), 27.

8. The Mau Mau was a guerrilla group formed in 1952 that attempted to wrest back some lands taken by the British during their imperial administration. By 1963 Kenya had gained independence from Britain.

9. The other anthem is "Die Stem van Suid Afrika" ("The Call of South Africa").

10. A recording can be found on *This Land is Mine: South African Freedom Songs*, Folkways FH 5588, 1965.

11. From Coplan, *In Township Tonight!*

12. Several different versions of the words can be found online at http://www.polity.org.za/misc/nkosi.html. This is the Zulu version and the current English version.

13. Thanks to my sister Kristin Taylor of Amadeus Music, Portland, Maine, for unearthing this information for me.

14. From V. E. Howard and Broadus E. Smith, eds., *Church Gospel Songs & Hymns* (West Monroe, Louisiana, and Texarkana, Texas: Central Printers and Publishers, 1983).

15. "Signifyin(g)" has been most influentially theorized by Henry Louis Gates Jr. in *The Signifying Monkey: A Theory of African-American Literary Criticism* (New York: Oxford Univ. Press, 1988).

16. Ballantine, *Marabi Nights*, 4.

17. Howard and Smith, *Church Gospel Songs and Hymns*.

18. Gilroy, *The Black Atlantic: Modernity and Double Consciousness* (Cambridge: Harvard Univ. Press, 1993). I would like to thank Donald Moore for suggesting this critique.

19. Hamm, *Afro-American Music, South Africa, and Apartheid* (Brooklyn: Brooklyn College, Institute for Studies in American Music, 1988), 2.

20. Much has been written about the influence of African American musics (or representations of them in minstrel shows) on South African musics. In addition to Hamm's valuable book, see Coplan's *In Township Tonight!*, and Erlmann's work on *isicathamiya* already cited. See also Dale Cockrell, "Of Gospel Hymns, Minstrel Shows, and Jubilee Singers: Toward Some Black South African Musics," *American Music* 5 (Winter 1987): 417–32; Erlmann, "A Feeling of Prejudice: Orpheus M. McAdoo and the Virginia Jubilee Singers in South Africa, 1890–1898," *Journal of Southern African Studies* 14 (April 1988): 1–35; and Peter Larlham, *Black Theater, Dance, and Ritual in South Africa* (Ann Arbor: UMI Research Press, 1985).

21. This unity through identification produced paradoxical political problems, which Hamm examines on pp. 32–33 of *Afro-American Music*.

22. Try their *Never Again*, Nation NAT 45T, 1994, and *Universal Souljaz*, Nation Records NATCD 54, 1996. See also Linda Vergnani, "Rapping for Democracy in South Africa,"

Chronicle of Higher Education 40 (3 November 1993), A43.

23. Jones, *Blues People: Negro Music in White America* (New York: Morrow, 1963); Levine, *Black Culture and Black Consciousness: Afro-American Folk Thought from Slavery to Freedom* (Oxford: Oxford Univ. Press, 1977); Paredes, *With His Pistol in His Hand: A Border Ballad and its Hero* (1958; reprint, Austin: Univ. of Texas Press, 1971); and Rawick, *The American Slave: A Composite Biography*, vol. 1, *From Sundown to Sunup: The Making of the Black Community*, Contributions in Afro-American and African Studies, no. 11 (Westport, Conn.: Greenwood, 1972).

At a conference at the University of California, Berkeley in October 1996, George Lipsitz recommended George P. Rawick's work in the course of his presentation, and I would like to thank him for drawing my attention to this important book.

24. Erlmann, *African Stars*.

25. Ballantine, *Marabi Nights*, 5.

26. Foucault, *The History of Sexuality: An Introduction,* trans. by Robert Hurley (Harmondsworth: Penguin, 1987), 92–93.

27. Ibid., 94.

28. "Two Lectures," in *Culture/Power/History: A Reader in Contemporary Social Theory*, ed. Nicholas B. Dirks, Geoff Eley, and Sherry B. Ortner, Princeton Studies in Culture/Power/History, ed. Nicholas B. Dirks, Geoff Eley, and Sherry B. Ortner (Princeton, N.J.: Princeton Univ. Press, 1994), 214.

29. Foucault, *The History of Sexuality*, 95.

30. Ibid., 96.

31. See, for example, Marshall Berman's *All That is Solid Melts Into Air: The Experience of Modernity* (New York: Penguin, 1988), especially pp. 34–35.

32. Foucault, "On Popular Justice: A Discussion of Justice," in *Power/Knowledge: Selected Interviews and Other Writings, 1972–77*, ed. Colin Gordon, trans. Colin Gordon et al. (New York: Pantheon, 1980), 27–28.

33. Marre and Charlton, *Beats of the Heart*, 44.

34. James C. Scott, *Weapons of the Weak: Everyday Forms of Peasant Resistance* (New Haven and London: Yale Univ. Press, 1985), 317.

35. Ibid., 290.

36. Scott pursued his thesis in *Domination and the Arts of Resistance: Hidden Transcripts* (New Haven and London: Yale Univ. Press, 1990).

37. Nandy's assumption that it was Hinduism that allowed Indians to accommodate new ideas of selfhood during the Raj is somewhat limited, for there are of course other religious groups in India.

38. Nandy, *The Intimate Enemy: Loss and Recovery of Self under Colonialism* (Delhi: Oxford Univ. Press, 1983), 79.

39. Ibid., 113.

40. Ladysmith Black Mambazo, interviewed by Ray Suarez.

41. Quoted by David B. Coplan, "A Terrible Commitment: Balancing the Tribes in South African National Culture," in *Perilous States: Conversations on Culture, Politics, and Nation*, ed. George E. Marcus, Late Editions: Cultural Studies for the End of the Century, no. 1 (Chicago and London: Univ. of Chicago Press, 1993), 347.

42. Thanks are due to Judith Becker who first told me about the music of Rhoma Irama.

43. William H. Frederick, "Rhoma Irama and the Dangdut Style: Aspects of Contemporary Indonesian Popular Culture," *Indonesia* 34 (October 1982): 109.

44. Martin Hatch, "Popular Music in Indonesia," in *World Music, Politics, and Social Change*, ed. Simon Frith, Music and Society, ed. Peter Martin (Manchester and New York: Manchester Univ. Press, 1989).

45. I would like to thank Susan Walton for tracking down this (and other) photographs for me. And I would like to thank Rhoma Irama for giving them to Susan.

46. Philip Yampolsky, in his translations accompanying the recording, translates this as "versus"; Judith Becker says that the word should be "and," and that is what will be used here.

47. Simon Broughton et al., eds., *World Music: The Rough Guide* (London: Rough Guides, 1994).

48. *Music of Indonesia 2: Indonesian Popular Music: Kroncong, Dangdut, and Langgam Jawa*, Smithsonian/Folkways SF 40056, 1991.

A. L. Becker was kind enough to provide a

literal translation that matches fairly well the smoother one by Phililp Yampolsky. The one major difference is that Becker translates "manusia" as "humanity," whereas Yampolsky uses "man" throughout. Many thanks to A. L. Becker for his help with this song.

49. Becker, personal communication, Ann Arbor, Mich., 20 October 1992.

50. R. Anderson Sutton writes that although Irama supported militant Islamic politicians in the early 1980s, he has now switched allegiances and thrown his support to the current government. ("Asia/Indonesia," in *Worlds of Music: An Introduction to the Music of the World's Peoples*, 2d ed., ed. Jeff Todd Titon [New York: Schirmer Books, 1992]), 311–312.

51. Becker, personal communication, Ann Arbor, Mich., 20 October 1992.

52. Ortner, "Resistance and the Problem of Ethnographic Refusal," *Comparative Studies in Society and History* 37 (January 1995): 177.

53. See Becker, "Text-Building Epistemology and Aesthetics in Javanese Shadow Theatre," in *The Imagination of Reality: Essays in Southeast Asian Coherence Systems*, ed. A. L. Becker and Aram A. Yengoyan (Norwood, N.J.: Ablex Publishing, 1979).

54. Djura, *The Veil of Silence*, trans. Dorothy S. Blair (London: Quartet, 1992).

55. Holiday, with William Dufty, *Lady Sings the Blues* (London and New York: Penguin, 1992).

56. Djura, *The Veil of Silence*, 111.

57. Ibid., 112.

58. Ibid., 114.

59. Quoted by Ty Burr, "From Africa, Three Female Rebels With a Cause," *New York Times* (10 July 1994), H26.

60. Quoted by Amy Linden, "Djura: Making Gorgeous, Liberating Music out of a Brutal Past," *Mirabella* (April 1994), 66.

61. See, for just one example, Daisann McLane, "The Global Beat," *Rolling Stone* 670 (25 November 1993), 108, who writes that "this music translates itself." *The Best of Djur Djura*, Adventures in Afropea 2, is on Luaka Bop/Warner Bros. 9 45211-2, 1993.

62. Joe F. Compton, review of *The Best of Djur Djura, Dirty Linen* 50 (February/March 1994), included in the press kit from Luaka Bop; Dean Olsher, review of *The Best of Djur Djura, (Raleigh, N.C.) News and Observer* (16 January 1994), included in the press kit from Luaka Bop; Stephen Davis, "The Wild Woman of the Barbary Coast," *The Beat* 12 (1993), 42–45; and John Baxter, review of *The Best of Djur Djura, Option* (March/April 1994), 98.

63. Walker, *The Color Purple* (San Diego and New York: Harcourt Brace Jovanovich, 1982).

64. Berlant, "The Female Complaint," *Social Text* 9 (Fall 1988): 243.

65. Ibid.

66. Ibid.

67. Quoted by David Byrne, interview with Djur Djura, *Bomb* 47 (Spring 1994), 10. I would like to thank Irene Nexica for giving me a copy of this interview.

68. Robertson, "Social Theory, Cultural Relativity and the Problem of Globality," in *Culture, Globalization and the World-System*, ed. Anthony D. King, Current Debates in Art History, no. 3 (Binghamton, N.Y.: Department of Art and Art History, State Univ. of New York at Binghamton, 1991), 73. See also Appadurai's "Disjuncture and Difference in the Global Cultural Economy," *Public Culture* 2 (Spring 1990), especially p. 17.

A Music of One's Own

> Men have had every advantage of us in telling their own story. Education has been theirs
> in so much higher a degree; the pen has been in their hands. I will not allow books to
> prove any thing.
>
> —Anne Elliot (Jane Austen, *Persuasion*)

————————

While much of this book thus far is concerned with the complex ways that hegemonies and resistances occur culturally and musically in a context in which the realities of "global" and "local" are increasingly blurred, many western women musicians present even more complicated cases. Western women are in a dominant group globally as westerners but, generally, do not enjoy many positions of power themselves in their own cultures. And, of course, this group "western women" is extremely heterogeneous. Women musicians making something we could call world music explore diverse paths through the various discourses and issues I have been examining, forging some expected and some unexpected alliances in their attempts to make new musics. Picking up the thread of art music left at the end of chapter 2, I will continue with another composer, Pauline Oliveros.

PAULINE OLIVEROS

> Mind like a floating White cloud
> Sunset like the parting of old acquaintances
> Who bow over their clasped hands at a distance.
>
> —Rihaku

Figure 4.1
Pauline Oliveros.

Oliveros's music doesn't easily fit into the many categories in which it is often placed: "experimental," "ambient,"[1] "women's," "new age," or, as is my purpose here, "world." But her music—however it is categorized—and her compositional strategies, rely heavily on musics and ideas about music from other cultures. At the same time, her aesthetic has been powerfully driven by a feminist consciousness. My goal in this portion of this chapter is to outline this consciousness and examine the ways that it developed along with a construction of nonwestern Others.

FEMINISM

Oliveros tends not to present herself as a composer of woman's music in her writings, although a case could be made that she is; it is possible to argue that the entire trajectory of her career has been an attempt to define and then shed the established norms of postwar composition, which she sees as overwhelmingly male.[2] Much of her music actively goes against conventional notions of contemporary music, norms such as an overriding concern for form, size, unity, and complexity.[3] Oliveros instead emphasizes values that western culture has coded as "feminine" as perhaps the most important. There is a recurring danger here that aesthetic qualities historically constructed as masculine or feminine could be construed as being "naturally" masculine or feminine. If the dominant aesthetic in a patriarchal culture values some ideas over others, are those ideas somehow inherently masculine? This question has generated a good deal of theoretical debate among feminists, many of whom believe that women's art should emphasize values currently underappreciated by the dominant culture, such as intuition or the unconscious.

Oliveros's many writings demonstrate her interest in cultivating a kind of music that emphasizes characteristics she views as feminine, though she seldom discusses her own work in these writings. In an essay entitled "The Contribution of Women Composers," Oliveros discusses analytical versus intuitive modes of thought and argues that western culture seems to have emphasized the former over the latter. This, for her, is a problem. Like many feminists, Oliveros links analytical modes of thought with masculinity and intuitive modes with femininity, writing that the phenomenon of women becoming composers "may well represent the primary meaning of the liberation movement in the world today. That is, the recognition and reevaluation of the intuitive mode as being equal to and as essential as the analytical mode for an expression of wholeness in creative work. Oppression of women has also meant devaluation of intuition, which is culturally assigned to women's roles."[4] She goes on to argue that

> the emergence of women in male dominated fields means a move towards the inclusion of intuition as a complementary mode of activity. Women's emergence is a significant evolutionary development towards synthesis or wholeness. Neither mode is exclusively the province of one sex or the other. The two modes must be available in any human being, making a more complete expression available in any field.[5]

Oliveros's particular brand of feminism is generally known as cultural feminism, a label that is something of a misnomer, since cultural feminists assume that differences between the sexes are biological, not cultural. The term was coined in 1983 by Alice Echols, who chose the qualifier "cultural" because such feminists believe that they should actively make a separate, female culture that seeks to revalue underappreciated "feminine" traits[6]; in this it is much like the demands for authenticity I will examine in chapter 5. Later, Linda Alcoff defined cultural feminism as "the ideology of a female nature or female essence reappropriated by feminists themselves in an effort to revalidate undervalued female attributes."[7] This kind of feminism locates gender and sexuality as natural components of biology that necessarily inform a particular subject's world view. We should thus remember Echols's insight that cultural feminists who want to emphasize what they believe are female traits buy into the patriarchal culture that defined those traits as feminine in the first place. Donna Przybylowicz also argues this point, writing that essentializing sexuality consolidates patriarchal power.[8] Her observation might be more powerfully illustrated if the component of identity were shifted from gender to, say, race. If persons with a different skin color were naturally different, then the dominant culture could (and did) construct those with nonwhite skin colors as inferior.[9]

Cultural feminists tend to believe that they should make an environment free of masculine values as they perceive them and that specifically female body experiences are powerful forces in constructing a female ideology. Thus, art not only can, but should, represent what is thought to be feminine. In an interview, I asked

Oliveros if she thought that a woman's experience in the world is different from a man's and could or should be represented musically. She replied somewhat evasively. "Well, that's a hard one. Certainly I think women's experiences are different. Because of the hierarchy and power structure . . . women don't have the power and privilege that men have. It's not the same for women in this society as it's structured now."[10]

This equivocation points out Oliveros's current ambivalence to the cultural feminist position. But Oliveros's earlier statements and some of her music in the 1960s and 1970s do represent a conscious rejection of many of the tenets of contemporary music, embracing values that patriarchal culture has coded as "feminine." Alice Jardine offers a term for this sort of revaluation, "gynesis," which she says is "a search for what has been 'left out,' de-emphasized, hidden, or denied articulation within Western systems of knowledge."[11]

In other writings, Oliveros makes clear her goals, following a provocative question by interviewers:

> *How do you respond to the criticism that your music advocates a preoccupation with the self to the exclusion of political issues?*
>
> I think there's a real misunderstanding on the part of that critic, because I consider a work like, say, *Sonic Meditations* to be deeply political in that it challenges certain premises in the musical establishment, that it opens the way for people to participate who aren't musicians. That's pretty political, pretty subversive![12]

HER MUSIC

Now let's turn to an examination of some of Oliveros's music and see how she charts her way through these issues. What I want to do in this section is demonstrate the ways that Oliveros constructed musical and self identities and show that her new musical identity was made largely in opposition to the official, academic music of the university. Oliveros constructed her aesthetic from an essentialized vision of femininity, but her music is a result of both this feminism and her use of musical ideas from cultures other than her own. While Oliveros's current discourse on her music shows less allegiance to a cultural feminist position than it had in the 1960s and 1970s, her music still clearly owes much to these ideas.

Oliveros was born in 1932 in Houston. Evidence of her choice of a different musical path appeared early, since as a girl she chose the accordion as her major instrument. Before completing college she moved to San Francisco to study with Robert Erickson, who was an important mentor to many composers in the Bay Area in the 1960s. Oliveros's compositional career was similar to many contemporary composers in the 1950s and 1960s: she began by writing conventionally notated works, but gradually changes crept in, particularly an interest in improvisation.

In the mid-1960s Oliveros began searching for new ways of composing. Electronic music served her for a time, but the decisive move came with her turn to

writing meditative or intuitive music.[13] She writes in *Software for People*—her collected writings—of her doodling during department meetings at the University of California at San Diego.[14] She saved those doodles and gradually realized that there were recurring images, particularly one of a circle with a dot in the middle, which she calls an image of the "proper relationship of attention and awareness," the dot representing attention and the circle awareness.[15]

Oliveros realized that this figure was an archetypal mandala—a Tibetan Buddhist ritual symbol—and came to believe that this figure was therapeutic.[16] And she thought that the mandala figure could help solve a musical problem. As she writes, "After recovering my childhood meditation ritual through these drawings, I began to make mandala-like sketches hoping to find a way of organizing musical materials which would be free of the conventional staff notation. At the time I was only vaguely aware that such notation could no longer serve my music; but I felt trapped by it."[17]

Oliveros's feeling of being trapped by notation was an important realization, for western musical notation has facilitated the musical ideas of complexity, virtuosity, and large-scale formal structure at the expense of others. By homology, Oliveros and others have viewed these values as patriarchal, part of the social and political systems under which they developed. Further, notation left little room for intuition or the input of the performer, and, as musical scores became increasingly complex throughout the twentieth century, the control of the composer over the notes in the scores, and thus the performers, became more pronounced, causing some composers voluntarily to relinquish some control.

Oliveros's aesthetic shift away from academic music was driven as much by a search for a music that would reflect "feminine" values as much as a search for music that did not adhere to contemporary musical norms. But while Oliveros's public support for women composers is well known, she seldom discusses her music in relation to feminism. In an interview, I asked her if the focus of her career had to do with writing a woman's music. She replied,

> I think that [feminism] is inherent in what I've chosen to do, really. I don't have the conception that women should write like me, or anybody should do that. It feels to me that what I'm doing is what I need to do in this time, and that I want to draw on all the resources that I have or that I've learned or that have come to me through my experience to express myself and my values. And if it's helpful to others then I'm happy. But the best I can do is set an example.[18]

The ways that Oliveros chose to make this new music are tied up in questions of identity and modern western constructions of the self and Other. Oliveros seemed to want to create a new sort of musical self outside of the identity allowed by the academy; she also wanted to try to create community and ritual meanings in her music, feeling that such meanings have increasingly disappeared in much contemporary music, as composers generally pay more attention to formal issues

within the music rather than to the relationship of the work to its larger social context. In *Software for People*, Oliveros quotes (but doesn't discuss) a passage from W. Y. Evans-Wentz's translation and commentary on the Tibetan *Book of the Dead*, in which he describes in detail the musico-sacred rituals practiced by Tibetan lamas. There is much in Evans-Wentz's description that seemed to appeal to Oliveros: the ideas that music can cause certain states of mind, such as veneration and faith; that performed music should replicate the sounds of the body; and that such musical representations of human noises is a way of interpreting truth.

An important compositional milestone was Oliveros's *Sonic Meditations* of 1971. Oliveros writes in *Software for People* that she intends the word "meditation" to mean concentration in a secular sense. Oliveros said in a recent interview that part of the impetus for these pieces was that "at the end of the Vietnam War, I felt a need for calming kinds of activities. So I used to play long tones on my accordion and sing, observing the effect on me psychically and physically. Then I began to get other people involved in it. I . . . studied some tai chi, and began to think about breath and physical coordination. So I started making those *Sonic Meditations*."[19]

Sonic Meditations was dedicated to Amelia Earhart and the ♀ Ensemble, and reflects Oliveros's growing belief in the importance of making music a community activity, not the province of an elite group of the talented. And these are compositions of ritual as much as music, abandoning the more traditional modes of contemporary academic composition. The introduction to *Sonic Meditations* is the most succinct statement of her new aesthetic:

> Pauline Oliveros has abandoned composition/performance practice as it is usually established today for Sonic Explorations which included everyone who wants to participate. She attempts to erase the subject/object or performer/audience relationship by returning to ancient forms which preclude spectators. She is interested in communication among all forms of life, through Sonic Energy. She is especially interested in the healing power of Sonic Energy and its transmission within groups.
>
> All societies admit the power of music or sound. Attempts to control what is heard in the community are universal. For instance, music in the church has always been limited to particular forms and styles in accordance with the decrees of the Church Fathers. Music in the courts has been controlled through the tastes of patrons. Today Muzak is used to increase or stimulate consumption in merchandising establishments.[20]

Oliveros expands some of these ideas in *Software for People*, making clear her emphasis on awareness, as well as the effect that music has on the mind and vice-versa. Conspicuously absent, however, is any mention of talent, genius, or virtuosity, for Oliveros instead attempts to make a music that can be for and by everyone. She writes,

While one's attention is focused to a point on something specific, it is possible to remain aware of one's surroundings, one's body, movement of all kinds, and one's mental activity (in other words remain aware of inner and outer reality simultaneously). Attention is narrow, pointed and selective. Awareness is broad, diffuse and inclusive.

My *Sonic Meditations* . . . are "sonic" in the sense that sound and hearing, both active and receptive, are the foci of attention and stimuli of awareness. The enhancement and development of aural sensation is one of their goals. Synchronization of attention and awareness, keeping them balanced and conscious, is necessary. Also, the synchronization of voluntary and involuntary mental or physical activity is explored. The ear is the primary receptor or instrument; sound, both inner and outer, real and imaginary, is the stimulus of *Sonic Meditations*.[21]

Later, she concludes,

How and what does one hear? In order to answer this question, the mind must relax, as a muscle must relax. The appropriate state of expectation must be present in body and mind in order to become receptive to both internal and external stimuli.[22]

She goes on to explain that her earliest interest in sonic meditation resulted in long-held notes and that this technique can be found in the music of Terry Riley and La Monte Young, two U.S. composers who also came to prominence in the 1960s.[23] She writes that "drones of all kinds (such as motors, fluorescent lighting, freeway noise) are ever present. The mantra of the electronic age is *hum* rather than *Om*. These constant soundings influence everyone, whether consciously or unconsciously."[24]

The *Sonic Meditations* are all prose, and all direct the participants to make, imagine, listen to, or remember sounds. They are usually aphoristic and gentle, reminiscent of Buddhist religious tenets. Prose as a musical score didn't originate with Oliveros—many composers preceded her, most importantly John Cage. But perhaps Oliveros's turn toward prose as a means of storing and imparting musical information stems from her desire to escape the emphasis upon formal considerations, by which she felt confined in contemporary composition.

The first of the *Sonic Meditations* is entitled "Teach Yourself to Fly":

Any number of persons sit in a circle facing the center. Illuminate the space with dim blue light. Begin by simply observing your own breathing. Always be an observer. Gradually allow your breathing to become audible. Then gradually introduce your voice. Allow your vocal cords to vibrate in any mode which occurs naturally. Allow the intensity to increase very slowly. Continue as long as possible naturally, and until all others are quiet, always observing your own breath cycle.

Variation: Translate voice to an instrument.[25]

Example 4.1
Pauline Oliveros: *Sonic Meditations,* "Teach Yourself to Fly."

Anyone who has attempted Buddhist meditation will recognize these directions, which begin the same way novice meditators do, by paying attention to one's breathing.[26] Also interesting in this meditation is the absence of self or will: the participants do not cause anything to happen; instead, they "observe" — "Always be an observer" — "allow," and "continue." Agency is in the sounds themselves, not in the composer or performer, which indeed is another binary Oliveros tries to break down with her music. Oliveros discusses this particular sonic meditation in *Software for People*, writing that the demand to focus on one's breath in "Teach Yourself to Fly" makes one aware of drones, textures, and other details one usually isn't aware of when breathing. The effect, she believes, is restful, even though the practitioner is aware of sounds and ideas perhaps previously unknown. The sonic meditator is also able to tap into the energies of others when "Teach Yourself to Fly" is performed in a group.[27]

Oliveros's instructions show a familiarity with the ideas of some Native American tribes, whose cultures she began studying in the 1970s. Many tribes believe that songs exist in the world and are not composed, but rather caught, or captured. And even after this, they continue to live lives somewhat independent from the singers.[28] Oliveros's prose directions clearly indicate that sounds have lives of their own and that people and sounds are inseparable. In giving up some of her compositional agency, she nonetheless stipulates that this agency be transferred to everyone, and every sound.

Beginning with the *Sonic Meditations*, Oliveros avoids traditional compositional value, that of authority or authorial control. Her intuitive music gives performers more creative freedom than intuitive music by other composers. It may seem that writing scores using prose rather than notation is a significant enough departure, but other composers who chose similar means of realizing musical ideas have not been as ready to relinquish their control. A good example is Karlheinz Stockhausen, a composer whose career has paralleled Oliveros's in some ways, as Heidi Von Gunden has noted.[29] Von Gunden discusses the interesting parallels in Oliveros's and Stockhausen's careers: working first with conventionally notated music, then electronic music, and then intuitive music. Sometimes Oliveros preceded Stockhausen in her innovations, sometimes not. Oliveros herself has commented on the "curious relationship" to Stockhausen's music her own work has had since the 1950s and 1960s.[30]

Some of Stockhausen's intuitive scores, while appearing on the surface to abandon concerns for form, nonetheless continue his interest in form. Stockhausen has maintained throughout his career that his intuitive pieces are still part of a highly developed structural plan; in other words, he always seems to want to be considered the master architect. His statement about *Es* (*It*), from *Aus den Sieben Tagen* (1968), reveals this structural conception of his intuitive music.

I have compared numbers of different performances of the same texts, and have found that they often share very similar characteristics. All the different versions of

IT have started with very brief, short, sound actions; then gradually you get here and there a longer sound, which stops as soon as another sound starts, which shows that sounds are cutting off each other. Later in all the versions there is a gradual super-imposition of sustained sounds: you have one musician playing, then another starts playing a sound or a certain pattern, and the first is able to keep going. Then it builds very quickly, in every version I had heard: all of a sudden there is a situation reached where they are obviously taken all together by something that is in the air, and are completely absorbed by the sound and react instantly, without thinking. I mean, they just do it, and then very dense structures come about.[31]

Connection, from *Aus den Sieben Tagen*, tells the player to "play a vibration in the rhythm of your enlightenment"; *It*, in its entirety, tells its performers to:

Example 4.2
Stockhausen: *Es*, from
Aus den Sieben Tagen,
excerpt.

think NOTHING
wait until it is absolutely still within you
when you have attained this
begin to play

as soon as you start to think, stop
and try to reattain
the state of NON-THINKING
then continue playing

It's important to note that Stockhausen's goals in these intuitive works and others are to move toward a kind of transplanetary aesthetic. In his article entitled "World Music," Stockhausen sets out this view in very explicit terms: "Every human being encompasses all of humanity," he writes. "A European can experience Balinese music, a Japanese the music of Mozambique, a Mexican the music of India."[32] Yes, but who has access to which musics, and what does listening to them do for the listeners? Elsewhere, Stockhausen remarked that "it's wrong to say, 'He's influenced by the Japanese.' What I've actually experienced is that I came to Japan and discovered the Japanese in me."[33] And he sidesteps political considerations by insisting that one should look at the "underwater currents" that connect all cultures and that one must learn to hear the "*vibrations, the waves, which take form in a thousand different ways*" [emphasis in original].[34] These musics can be experienced as sounds and forms, but Stockhausen's viewpoint relies not on perceptions of structure and unities, or culture (in the anthropological sense), but rather on a kind of transcultural mysticism grounded in bourgeois aesthetics: music is pure form and, as such, can enter our consciousnesses unimpeded by such everyday concerns as politics and power, or, even, authorship.[35]

Oliveros touched on this notion of control in a 1991 interview.

> I think [my sonic meditation pieces] are very different as well. [Stockhausen] retains the control and power in his work, whereas I try to give it up. I feel that his work remains authoritarian, whereas what I've tried to do with the *Sonic Meditations*, and I worked very, very hard to do that, was to take the commands out of the language, so that it's more of an invitation to people than a command. They are very different [from Stockhausen's pieces] and not only that, each piece is representative of a strategy and process of attention that are disciplines, if they're practiced and not dismissed as too simple. They really do lead somewhere—they lead to a greater understanding, an awareness of how the mind works, or how one's mind works.[36]

All of Oliveros's *Sonic Meditations* reflect an interest in music and ritual, a belief that musicking should be practiced by everyone, and a conscious rejection of many of the established aesthetic standards. Her intuitive music follows none of the academic contemporary compositional tenets, for it is nondevelopmental, nonclimactic, nongoal-oriented, nonvirtuosic, and not complex, unified, or formal in the ways that much contemporary music is. At the same time, it is important for Oliveros that her music is perceived as meditative and ceremonial, not political, although it can be used in political ways.[37]

Oliveros's prose writings from this time help illuminate the aesthetic position of the *Sonic Meditations*. They show a growing belief in the ritual role of music and a ritual role in life. A brief excerpt from *Software for People*, entitled "Dialogue with Basho,"[38] (which Oliveros calls a meditation and which had its first presentation as a performance) helps explicate Oliveros's growing mystical view of the use and power of music.

> Each sound must have its own life. Express the inner generative power of its being. The relationship to other sounds and sights is not imposed. Parallels exist. There will be no musical syntax. . . .
>
> Each sonic image, though possibly taking a suggestion of the preceding sonic image, opens a world of its own. The listener will be carried through the whole series as through an exquisite arrangement of rooms in a building "always entertained by delightful changes but never arrested by sudden contradictions."[39]

By the mid-1970s Oliveros's studies of Native American cultures, as well as eastern religions, began to inform her conceptualization of new musical and perceptual ideas, and her work started integrating meditative practices within larger ritual or ceremonial works. She began writing pieces that encompassed her newfound beliefs about music and the self, and which incorporated all kinds of nonmusical elements. *Crow Two* (1975) is an example and I will spend some time with it. Although Oliveros has not said anything that could be construed as feminist about *Crow Two*, its feminist orientation is clear. *Crow Two* as a text score is longer than most of Stockhausen's, but most of the directions refer to spatial organization and other nonmusical activities. She rarely offers more musically specif-

ic directions in *Crow Two* than these: "The task of the meditation for each [flute] player, is to allow single pitches, intervals or chords to come to mind. The player then must determine whether he or she is a sender or receiver of a pitch, or of one of the pitches of an interval or chord."[40]

The score consists entirely of prose, with one drawing showing the stage layout, a mandala figure reproduced below as Figure 4.2. The characters give strong indications about the gendered aspects of the work.

Much of the characterization and drama of the score appears to be derived from Lakota beliefs, which Oliveros had been studying. One character, perhaps the most important, is the Crow Poet, who sits in the center of the circle. Oliveros doesn't indicate in the score that this person should be a woman, but she does name the Crow Poet of the first performance, Margaret Porter. The Crow Poet's poem is supposed to be distributed to the members of the audience before the performance along with the program notes. From the opening lines of Porter's poem, entitled "Crowlogue," the feminist slant is clear: "A crow is not a crow is a crow," a line that recalls the famous one — "rose is a rose is a rose" — by Gertrude Stein from her poem "Sacred Emily."

Outside this innermost circle containing the Crow Poet, another circle marks the positions of the Crow Grandmother, Crow Stepmother, Crow Mother, and Crow Godmother. Presumably (although Oliveros doesn't say so), these figures

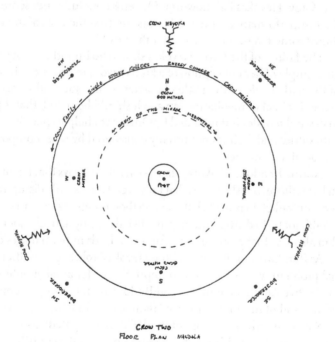

Figure 4.2
Pauline Oliveros: *Crow Two*, stage diagram.

have all attained enlightenment, or whatever the ultimate goal of her meditations is. She writes in the score that "their meditation is simply being. They personify natural order." That, is, they are beyond meditation and are indistinct from nature. The Meditators, occupying the center, are evidently attempting to attain this state, and it is interesting that their gender isn't specified, probably because this aspect of the score allows for audience participation; anyone from the audience is allowed to join the meditation onstage.

Important players include the Crow Heyokas. Oliveros doesn't specify their gender either, but she does provide the names of the first performers and they are all male. And the role that Oliveros has the Crow Heyokas play corresponds to roles that cultural and other feminists have coded as masculine in western culture in general: they are aggressive, violent, and disruptive. Oliveros writes in the score that

> the Crow Heyokas are personifications of natural disturbances. Their purpose is to test the meditators through mockery and distracting behavior. "He is an upside down, backward-forward yes-and-no-man, a contrary wise" [according to John Fire Lame Deer, a Sioux[41]]. They appear at will 15 to 20 minutes after the meditation has begun. The human mandala is taken over as their playground. They cannot actually touch a meditator, but may try in any way to break the meditation.[42]

The Crow Heyokas fail, however; Oliveros concludes her score by noting that in the first performance, "the meditators survived the tests of the Heyokas and continued some ten minutes or so after their exit."

The failure of the Crow Heyokas shows the importance of Oliveros's music as an example of her conception of a kind of woman's music. These representations of the darker side of the male character do not succeed in disrupting the more "feminine" act of meditation, an act, it should be noted, that is practiced by both males and females but intended by Oliveros to help its practitioners make contact with values and feelings not usually considered by most composers of contemporary academic music.

Norma Rendon, a Lakota, offers a caveat. She says that heyokas play male roles in her culture, but she warns that they aren't necessarily disruptive. Their function is to contradict, to provide balance. So their traditional role in Oliveros's *Crow Two* would not be to disrupt, but to provide balance by actively *not* meditating.[43] Rendon also says that crows are not important birds in her nation's culture.[44]

As Rendon's qualification of the Heyokas' role suggests, there are some potential problems with Oliveros's appropriations. Her amalgamation of several different Native American cultures and Buddhism, for example, demonstrates her use of the kind of monolithizing (or "nativizing") in which many of the anthologies of Native American writings of the 1970s participated: portraying Native Americans as a unitary culture, rather than as many different tribes with different languages, cultural practices, and mores.[45]

Crow Two and Oliveros's other works based on mandalas are examples of her

turn toward an essential feminine as she saw it, an attempt to write a music that eschews the many masculine values she believed were encoded in conventionally notated contemporary music. Oliveros wanted to write a music that emphasizes ritual, community, and intuition above all, going against many of the ideas and practices of contemporary academic music, and indeed, of western European post-Enlightenment art music.

More recently, Oliveros has perhaps realized that the problems posed by a cultural feminist approach to composition were insurmountable, and since writing her most overtly feminist statements, she has shifted somewhat from this standpoint, a shift evident in some of the more recent quotations we have seen. In our interview, it was difficult to pin her down on her position as a woman composer. Part of this may have been an attempt to avoid a label: Oliveros, understandably, wants to be considered a composer instead of a "feminist composer" or "woman's composer."

To call Oliveros's music simply "feminist" or "oppositional" or "resistant" would be to put it in another box, a smaller one with less prestige. Oliveros wants to write a new kind of music, where aesthetics drives her as much as her desire to write music that she views as representing feminine ideals; indeed, in Oliveros's system, aesthetics would appear to be inseparable from her other concerns. Oliveros recognizes the ambivalence of this position. In our interview she said, "I didn't mean to oppose the mainstream so much as to express the inner values that I have and that I feel have to come from the inside, rather than taking the imposition of structures from the outside which tend to suppress what's going on inside." Sounding like a heyoka herself, she continues, "And I'm looking not necessarily to oppose or overthrow but to balance out, and come to a different understanding of what can be done."[46]

Oliveros is currently cultivating a new kind of musicking and listening that she calls "deep listening," her "life practice" that embodies many of the concerns that she demonstrated in her music of the 1960s and 1970s and the writings collected in *Software for People*: a deeply personal concern for the constitution of the self and an interest in improvisation. All of these impulses came together with the formation of the Deep Listening Band in 1988.[47] Oliveros is also committed to teaching everyone that we are all musical. In one of the most animated and vehement statements of our interview she called the western ideas of talent and genius "a crock" and said that they have disempowered many people. Empowering people to make music is what Oliveros's mission is about.

> [M]y purpose and my goal is to encourage creative expression, because that's what has been suppressed by this society. And that's where we need to work. I mean, no wonder there's no audience or a relatively smaller audience for contemporary music: because no one has had any cues or encouragement that it was even worth doing. And it feels to me that it's my job to encourage that. It's a responsibility and mission that I feel to make my work in such a way that it will cue others to do it. Not

to be like me, but to do something for themselves. Because I also feel that it's been a great pleasure in my life to make music, so why shouldn't other people have that experience?[48]

As a woman, the ideologies of patriarchy and modernity had positioned Oliveros as an Other, and she thought that the only means available to her to redefine herself were outside Euro-American ideologies of modernity: in nonwestern musics and different modes of consciousness. And yet it was modernity itself that had commodified these other cultural forms and made them available to her, that had construed cultural forms of other cultures as available to be used, and that had required, in Oliveros's mind, a new sense of self from within instead of without. Further, although Oliveros says she wanted to define herself apart from patriarchal culture, she was nonetheless participating in reinforcing patriarchal structures, since she accepted patriarchal values of "the feminine" and voluntarily allied herself with other cultures in her quest for a new music. As many feminist scholars have pointed out, patriarchy constructs the categories Woman and Other and puts them in the same box. These contradictions can't be immediately escaped by anyone, but, as Oliveros and other musicians demonstrate, they can be called into question, and, one hopes, eventually dislodged.

D'CÜCKOO: *UMOJA*

If Oliveros chose to make a music that emphasized what she believed patriarchal western culture to have left out, the four American women who comprise the core of D'Cückoo—Tina Blaine, Patti Clemens, Jennifer Hruska, and Candice Pacheco—took more than one approach at the same time. They not only turned to other musics in making their own but, perhaps more importantly, like Oliveros, cultivated notions of the value of music in ritual, encouraging everyone to make music themselves.[49] Linda Jacobson, a technologist involved with the founding of the band in 1992, says that

> what is real important to me is the notion that everybody is an artist. Sure, some people are born with more innate talent than others, but everyone is able to express ideas and emotions artistically. It's important to me that VR [virtual reality] attain its lofty status as an artist's tool, an artistic medium, one that will allow the view or participant to become co-creator in the art. That alone affects our self identity. With VR you're no longer just a consumer. . . . [T]hat's what D'Cückoo's trying to do—give the audience new ways to react with graphics and sound.[50]

But, even though they are not in nearly as privileged a position in the music industry as, say, Peter Gabriel, their positionality as westerners nonetheless allows them to engage in appropriative practices, though they attempt to put these appropriations to positive political good: empowering women, and, indeed, helping everyone realize their creativity.

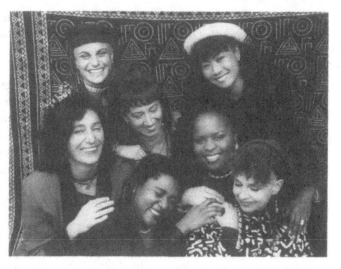

Figure 4.3
D'Cückoo (clockwise
from top left to right: Tina
Blaine ("Bean"), Shalonda
Smith, Susan Jette, Patti
Clemens, Janet Koike,
Candice Pacheco and
Terrie Wright).

The short promotional blurb on the back of their album *Umoja* reads: "D'Cückoo • An all-women multimedia, techno-arts ensemble that blends musical styles from around the globe, defining the groove of the future • D'Cückoo has opened for the Grateful Dead and recorded with Brian Eno and Mickey Hart."[51] Inside the album, the musicians write that the title is Swahili for "unity," and they use it "because it reflects our global perspective and interest in people and issues beyond our own geographical borders. UMOJA represents the union of musical ideas and styles that characterize and inspire our music."[52]

Elsewhere they write:

D'Cückoo has been developing their unique synthesis of music and technology since 1985. They design and build their instruments, inventing unusual electronic marimbas and drum controllers that trigger a vast array of custom digital sounds.

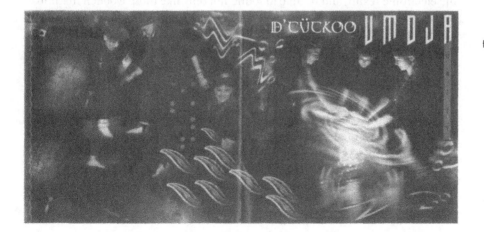

Figure 4.4
D'Cückoo: *Umoja*,
front and back covers.

Extremely varied musical influences—African, Asian, pop, funk, instrumental—
converge in a style that has been described as "neoclassical, post-industrial, cyber-
tribal world funk."[53]

These notes demonstrate the difficulties contemporary groups have position-
ing themselves in the growing world music market: they are new but they make
links to the past, and they have had brushes with fame (opening for the Grateful
Dead). And some of the language used to describe the band, which they quote in
the last excerpt, is remarkable in its extravagance of adjectives, particularly the
word "cybertribal." The band clearly identifies with this characterization, though,
for they use it all the time; the title of their homepage on the World Wide Web
reads: "The World's Only Neo-Classical, Post-Industrial, Cybertribal World Funk
Ensemble."[54]

D'Cückoo's extremely sophisticated use of technology underscores one of
their main messages: that women can do anything.[55] This is further emphasized
by the band's name, the "ü" recalling the randomly umlauted names of many
heavy metal bands (such as Blue Öyster Cult, Mötley Crüe, Motörhead, Queens-
srÿche, and others); *Umoja* also features the band's name in semigothic lettering,
as do many heavy metal band albums. Heavy metal is probably the most male-
dominated genre of popular music, so in calling it up, D'Cückoo appropriate
some of the male associations with that genre.[56]

But D'Cückoo's main engagement is with technology, which they use not
merely for show, or for its own sake. After traveling in west Africa and viewing
music and musicking as everyday activities in peoples' lives, the members of
D'Cückoo became interested in encouraging everyone to make music. In Africa,
they learned to play the Shona (of Zimbabwe) version of the marimba, and their
earliest, self-designed technology was built much like this instrument. Tina
Blaine, better known as Bean, said in an interview that "we came together and
decided that we wanted to expand the idea of playing acoustic instruments into
the electronic realm, and be able to sound not only like those wooden marimbas
that we had made, but to be able to broaden the sound palette to . . . any sound in
all the world."[57] So Blaine and Pacheco invented a wireless, helium-filled ball
connected to a MIDI (Musical Instrument Digital Interface) synthesizer onstage
that controls both sounds and visuals. At concerts, they toss the midiball into the
audience, and whenever it is touched it sends signals to the MIDI unit onstage
that alters the sound of the music.[58]

Another piece of technology affects their performances: "Bliss Paint," which
they say was "invented by computer graphics whiz, Greg Jalbert, also known as
Imaja. Bliss Paint is actually a screensaver program modified for live performance
so that audience members may play a musical keyboard (off-stage!) to trigger visu-
al imagery and affect the visual environment at D'Cückoo shows."[59]

The band's—or at least, the founding members', Pacheco and Blaine's—deci-

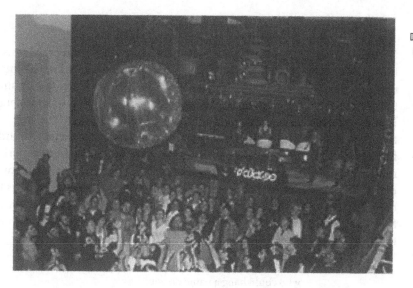

Figure 4.5
D'Cuckoo and the Midiball
at the Oakland Coliseum.

sion to move into the multi-adjectived music they now play represents a blend of
their interests in traditional musics—mainly African—and technology. As
Pacheco says, "the blend of just the global music plus the electronics was just a
natural thing that happened."[60]

The text in the liner notes about the group being all women makes the femi-
nist orientation of D'Cückoo clear; this is also evident from the accompanying
artwork, which shows the three members all holding their hands, as if they are
warming them over a swirling light; other hands grasping toward this light are in
the blurry foreground. Colorful geometric shapes surround these central images.
The photo at the back of the booklet depicts the three women dancing as a globe
flits across the frame, as though this was the circular object—the midiball, per-
haps—that they had been holding their hands over before. The other images with
the recording introduce us to the musicians, and the colorful geometric figures
recur; a mask motif also enters, masks that look as though they are from Southeast
Asia.

D'Cückoo's artwork, words, and music are among the kinds of pastiches
increasingly common in the global ethnoscape. No one musical style stands out,
other than D'Cückoo's; the world musics (really world musical instruments) add
to rather than define D'Cückoo's music. D'Cückoo, however, make a political
point of view prominent throughout their album, so it appears that the world
music sounds are harnessed for other reasons. Most of the songs use languages
other than English (we aren't told which ones they are, and since translations
aren't provided, it is probably the case that these languages are used for their
phonemic/phonetic qualities rather than signification); and some of the words
they use are made up for their sound value.

D'MUSIC

Rather than just creating a musical space ignored by patriarchal music cultures, D'Cückoo also mount a full frontal assault on patriarchal stereotypes. This message of empowerment is not surprisingly the theme of the entire album, from the title through the songs. Space doesn't permit a discussion of all the songs, but I want to spend a little on two, beginning with "Ruby Tuesday," the only song on the album that isn't original. It is, in fact, by Mick Jagger and Keith Richards, and first appeared on the Rolling Stones's album *Between the Buttons*, originally released in 1967.[61] In the Jagger/Richards lyrics, Ruby emerges as that rare creature, a liberated woman, someone who has power, wields it, and refuses to bow down to patriarchy: she is free; she refuses to say where she's from; she is uncontrollable by others. And, therefore, she is leaving, though whether of her own volition or because she has been rejected we aren't sure. As the chorus goes:

> Goodbye Ruby Tuesday
> who could hang a name on you
> when you change with every new day
> still—I'm gonna miss you

But the Stones perform all the lyrics in a way that compromises their meaning. The use of eclectic instrumentation (a stringed bass, recorders), Mick Jagger's occasional exploitation of a lower part of his vocal range that he doesn't ordinarily use, in addition to a more precise, even "classical," approach (Jagger, the consummate rock stylist, sounds strangely like he's struggling to get the notes right) make it possible to hear their "Ruby Tuesday" as ironic, as though Ruby has indeed lost her mind, as the end of the song warns when it employs another classicism in inverted word order, "life unkind." Additionally, the Stones's version is slow and balladlike. It uses what musicologigists still call a "feminine ending," that is, a cadence on a weak beat, in the lines "still—I'm gonna miss you." Such a weak ending further ironizes the performance.[62]

D'Cückoo's version, while unmistakably a cover of the Stones's original, goes off in a completely different direction. Unlike the Stones's version, D'Cückoo's grooves: it's faster, and it uses a drum track with a backbeat throughout.[63] They change the "feminine ending" to a "masculine" one; the word "you" concludes on a downbeat instead of an upbeat as in the Stones's version. What began as an eclectic, classicalized Stones song subtly satirizing a woman who could not be controlled evolves into a celebration of this same woman. It is probably no accident that none of the musical elements that have resulted in D'Cückoo being labeled as "neoclassical, post-industrial, cybertribal world funk" appear audibly in this song; it is as straight a rock song as D'Cückoo perform on the entire album, eschewing—at least in any discernible sense—the technological wizardry pervading the other tracks on the album, all as a way of meeting and contradicting the Rolling Stones on their own ground: straight ahead rock.

This empowerment comes at a price, of course: the appropriated sounds and languages and musical instruments are removed from their own musics and put to the use of western musicians. But since capitalism is conflicted and contradictory, so is any kind of cultural production, particularly in the global ethnoscape. It would be possible to tease out every strand, every musical component of Peter Gabriel's music or D'Cückoo's music, for example, and show which is western and hegemonic, which isn't, and make a tally. But culture doesn't work in these kinds of quantifiable ways. Gabriel and D'Cückoo do good, and they appropriate, and there is no way around this contradiction.

But in most of their music, D'Cückoo bring in sounds, images, and languages from other cultures in order to posit a sisterhood with all the world's women, coupled with a distrust of the world's men. Their song "King of the Jungle" on *Umoja* helps illuminate this.

King of the Jungle

> When the boys come in . . . what starts happening?
> Roll up their sleeves, they're playing to win
> crusades, campaigns, the atomic bomb
> inventing new ways to cause us harm
> War of the worlds, no winning side
> ethnic cleansing is genocide
> They take all the power, but won't take the blame
> when will they realize this isn't a game?
> They're heads of nations, they run the corporations
> now they're trying to control creation
> They make the rules, they pull the strings
> they call the shots, they think they're kings
>
> We're looking at the future taking lessons from the past
> at the rate we're going, none of this can last
> We're talking about control of our destiny
> not giving it up to dude density
> We've got to share the power, work hand in hand
> we've got to share the love all across the land
> Stop thinking about profits, start learning to care
> take the next step and do what's fair
>
> *Chorus*
>
> Before you came in, things were good
> Before you came in, I had an opinion
> Before you came in, I had an opinion
> Oh things were good

Watch your footsteps ■ we're watching you
Watch your footsteps ■ we know what you do
Watch your footsteps ■ what are you up to
Watch your footsteps ■ we're watching you
Watch your footsteps ■ it's not too late
Watch your footsteps ■ we'll have our own say
Watch your footsteps ■ we're on the way

We won't be silent now ■ we're gonna raise our voice
We will be heard ■ we'll make our own choice

The title, "King of the Jungle," signifies that it is men who ought to be considered "uncivilized," akin to nature, not women. To convey their message, the musicians use a mind-boggling array of sounds. "King of the Jungle" begins with sampled "jungle" sounds—monkeys, mainly shrieking and laughing—then moves to rap groove with a woman rapper articulating the opening lyrics of the song: "When the boys come in. . . ." This vocalist continues through the second stanza. But with the chorus, the music becomes more lyrical, so that by "Watch your footsteps," instead of rapping the lyrics, the singer soars above the mix.

And it is a complicated mix, a densely layered one, further complex in the way that the sounds pan from one side of the stereo landscape to another and back again. Generally, however, there is a trajectory from the rap opening through the chorus into the final section, which gets louder, denser, more complicated, until the singer wails at her loudest and highest. The song ends with a loud, harsh tonic in octaves, which reverberates for several seconds.

The jungle trope has for the better part of this century, and perhaps more, been an important site of contestation between the dominant culture and its various subalterns. Some jazz musicians in the 1920s and 1930s, usually black musicians employed in clubs that catered to white clienteles, made use of many sounds that were characterized as jungle style, sounds that were guttural, grinding, "primitive," and that used growls, tom-toms, and wah-wah mutes. African American musicians took this term, and instead of letting it describe them, turned it around, ironized it, and turned it into a musical style with specific effects. As students of hegemony (Gramsci, Stuart Hall) and language (V. N. Vološinov), have taught us, however, there is never any final victory in such cultural battles. Members of the dominant culture still use the term pejoratively, as a covertly racialized term of derision. So in declaring war on Iraq in 1991, then-President George Bush could state that the U.S. was going to forge a "new world order" in which the "rule of law, not the law of the jungle" prevailed.[64] But there are hip hop groups and other African American musical groups that purposely take on the name; James Brown's band is popularly known as the "J.B.s," or the "Jungle Brothers." One of the earliest big hip hop bands, Grand Master Flash & The Furious Five, had a hit with "The Message" (with Melle Mel and Duke Bootee) in 1982, which featured the recurring line "It's like a jungle out there/It makes me wonder how I keep

from goin' under."[65] Another popular hip hop group in the 1980s was called the "Jungle Brothers," and they had an important rap called "Straight Out the Jungle," which also took on the urban jungle theme.[66] In these and other raps, the jungle metaphor isn't used as irony but to decry the deteriorating conditions of urban life brought on partly through Ronald Reagan and the Federal Government's declining support for U.S. cities, particularly the poorest parts of cities where the least politically heard people live. More recently, an entirely new genre of music has arisen, first among urban blacks in the U.K. but is now spreading all over. It's called "jungle" and is a blend of house, hip hop, reggae, and techno. Jungle's most noticeable feature is it's incredible speed, which is much bragged about by musicians; BPMs (beats per minute) appear on the covers of many jungle albums, as if those dancing to it are supposed to dance themselves into oblivion.[67] There are plenty of other examples, in and out of music, but the point is not to enumerate them all, but rather to demonstrate that the metaphor of the jungle still circulates and has meanings that people fight for, over, and against.

D'Cückoo's jungle is the ironized one used by earlier African American musicians and current musicians of color in the U.K., but rather than just taking back the metaphor, they historicize it by pointing out that it is men who made this jungle in the first place, and it is now women who are going to be in the roles of the vigilant, even the victors.

Oliveros and D'Cückoo make use of a vast array of sounds, musics, and technology, but the most salient feature of their music and discourse is their commitment to a liberationist view of women in contemporary culture. D'Cückoo accomplish this not just through their lyrics but in their construction of themselves as agents, as masters of technology, and, in the end, masters of many kinds of music. The final ambivalence of their message marks the polyvocal, polysemic nature of the movement of music, signs, and images, all of which can be harnessed for whatever use the musician wishes.

NOTES

1. See David Toop, *Ocean of Sound: Aether Talk, Ambient Sound and Imaginary Worlds* (London and New York: Serpent's Tail, 1995).

2. Heidi von Gunden's recent paper on Oliveros makes a similar claim, that Oliveros's music can serve as a model for feminist criticism of music ("The Music of Pauline Oliveros: a Model for Feminist Criticism," paper given at the Music and Gender Conference, London, July 1991). Thanks are due to Professor von Gunden for sending me a copy of this paper.

See also Von Gunden's *The Music of Pauline Oliveros* (Metuchen, N.J. and London: Scarecrow Press, 1983); and Elisabeth LeGuin, "Uneasy Listening," *Repercussions* 3 (Spring 1994): 5–21. A recent extended interview appears in Cole Gagne, *Soundpieces 2: Interviews with American Composers* (Metuchen, N.J. and London: Scarecrow Press, 1993).

3. See my *The Rapacious Muse: Selves and Others in Music from Modernity through Postmodernity* (in preparation), for a discussion of

the valorized aesthetic norms of western music.

4. Oliveros, *Software for People: Collected Writings 1963–80* (Baltimore: Smith Publications), 135.

5. Ibid., 136.

6. Alice Echols, "The New Feminism of Yin and Yang," in *Powers of Desire: The Politics of Sexuality*, ed. Ann Snitow, Christine Stansell, and Sharon Thompson (New York: Monthly Review Press, 1983).

7. Linda Alcoff, "Cultural Feminism versus Poststructuralism: The Identity Crisis in Feminist Theory," *Signs* 3 (Spring 1988): 408.

8. Donna Przybylowicz, "Toward a Feminist Cultural Criticism: Hegemony and Modes of Social Division," *Cultural Critique* 14 (Winter 1989–90): 259.

9. See Stephen Jay Gould's *The Mismeasure of Man* (New York: W. W. Norton, 1981) for a devastating critique of this kind of racial essentializing, which continues, most recently with that execrable book, *The Bell Curve: Intelligence and Class Structure in American Life*, by Richard J. Herrnstein and Charles Murray (New York: Free Press, 1994). See, more importantly, Steven Fraser, ed., *The Bell Curve Wars: Race, Intelligence, and the Future of America* (New York: Basic Books, 1995); and Russell Jacoby and Naomi Glauberman, eds., *The Bell Curve Debate: History, Documents, Opinions* (New York: Times Books, 1995).

10. Oliveros, telephone interview by author, 20 December 1991.

11. Quoted by Przybylowicz, 292.

12. Interview with Geoff Smith and Nicola Walker Smith, *New Voices: American Composers Talk about their Music* (Portland: Amadeus Press, 1995), 209.

13. "Intuitive music" is a termed coined by Karlheinz Stockhausen to describe his music that does not use conventionally notated scores.

14. Oliveros writes of her time at the University of California, San Diego, in an email from 15 November 1995 that circulated widely on the Internet among people interested in questions of gender and music. Typically, Oliveros is neither sexist nor biased, instead praising those men whom she felt helped her and quietly criticizing those who stood in her way.

15. Oliveros, *Software for People*, 140–41.

16. Oliveros's understanding of mandalas — and Buddhism in general — most importantly seems to derive from Carl Jung, who passed on this description of the mandala. Jung authored a book on mandalas that Oliveros may well have consulted: *Mandala Symbolism*, trans. R. F. C. Hull, Bollingen Series (Princeton: Princeton Univ. Press, 1972). But archetypal mandalas have squares internally, not dots, as will be seen in Oliveros's *Crow Two*, which seats figures at four points within the circle. For a good introduction to mandalas, see Giuseppe Tucci's *The Theory and Practice of the Mandala*, trans. Alan Houghton Brodrick (London: Rider & Company, 1961).

17. Oliveros, *Software for People*, 229.

18. Oliveros, telephone interview by author, 20 December 1991.

19. Oliveros, interview with William Duckworth, *Talking Music: Conversations with John Cage, Philip Glass, Laurie Anderson, and Five Generations of American Experimental Composers* (New York: Schirmer Books: 1995), 171–72.

20. Oliveros, *Sonic Meditations*, Introduction (Baltimore: Smith Publications, 1974).

21. Oliveros, *Software for People*, 139.

22. Ibid., 141.

23. See, for example, Young's *Composition 1960 #7*, in which he notates a perfect 5th and instructs the performer to play "for a long time." (Contained in La Monte Young and Jackson Mac Low, eds., *An Anthology of Chance Operations*, 2d ed. [New York, N.Y.: Heiner Friedrich, 1970]). For a statement of Young's aesthetic (which differs in important ways from Oliveros's), see La Monte Young and Marian Zazeela, *Selected Writings* (Munich: Heiner Friedrich, 1969).

24. Oliveros, *Software for People*, 147.

25. Oliveros, *Sonic Meditations*.

26. Oliveros herself talks about this as a beginning exercise, saying that "that piece is an entry level and an experience for, say, people who have not had any music training" (interview with Geoff Smith and Nicola Walker Smith, *New Voices*.)

27. One of the anonymous reviewers of the manuscript for this book wrote, however, that "having attended one of her workshop sessions, I know that at least some of the participants find 'deep listening' exercises (such as whispering

fragments of a person's name at them) embarrassing and coercive."

28. I will talk about this idea at greater length with regard to the SongCatchers in chapter 7.

29. Von Gunden, *The Music of Pauline Oliveros.*

30. Oliveros, telephone interview by author, 20 December 1991.

31. Stockhausen, *Stockhausen on Music,* compiled by Robin Maconie (London and New York: Marion Boyars, 1989), 121.

32. Stockhausen, "World Music," trans. Bernard Radloff, *Dalhousie Review* 69 (1989): 318.

33. Quoted by Jonathan Cott, "Talking (Whew!) to Karlheinz Stockhausen," *Rolling Stone* 86 (8 July 1971), 38.

34. Stockhausen, "World Music," 319.

35. Stockhausen's former pupil, the English composer Cornelius Cardew (1936–1981) made a similar critique of obfuscation through mysticism in *Stockhausen Serves Imperialism and Other Articles* (London: Latimer, 1974).

36. Oliveros, telephone interview by author, 20 December 1991.

37. See the interview with her in William Duckworth's *Talking Music,* 175.

38. Zen poet (1643–1694) largely responsible for the development of the *haiku.*

39. Oliveros, *Software for People,* 56.

40. Reprinted in Walter Zimmermann's *Desert Plants: Conversations with 23 American Musicians* (Vancouver: A.R.C. Publications, 1976).

41. "Sioux" is the white word for this tribe; their own name for themselves is "Lakota" and I will use it instead. Bracketed passage in original.

42. The Lame Deer description of a heyoka appears on p. 225 of *Lame Deer: Seeker of Visions,* by John (Fire) Lame Deer and Richard Erdoes (New York: Washington Square Press, 1971).

43. Oliveros, however, insists that her understanding of heyokas is accurate (personal communication with author, 15 February 1993).

A collection of tales describing the transformation of Siddhartha to the Buddha includes one that strongly echoes the role the Crow Heyokas play. Joseph Campbell recounts this story in *Hero With a Thousand Faces,* a book that Oliveros may well have seen in her researches into world myth. "[Siddhartha] placed himself, with a firm resolve, beneath the Bodhi Tree, on the Immovable Spot, and straightway was approached by Kama-Mara, the god of love and death. The dangerous god appeared mounted on an elephant and carrying weapons in his thousand hands. He was surrounded by his army, which extended twelve leagues before him, twelve to the right, twelve to the left, and in the rear as far as to the confines of the world; it was nine leagues high. The protecting deities of the universe took flight, but the Future Buddha remained unmoved beneath the tree" (Campbell, *Hero with a Thousand Faces* [New York: World, 1971], 32). Like the Crow Heyokas, Kama-Mara and his minions fail, defeated by the Future Buddha with the cooperation of the "goddess earth."

44. Norma Rendon, telephone interview by author, 11 October 1992.

According to Lakota tradition, a heyo'ka is a man who has dreamt of a thunderbird whose role becomes one of contradiction, sometimes providing humor. This is consistent with the explanation provided by John Fire Lame Deer, which is the one Oliveros read.

More scholarly sources of information on heyokas can be found in Frances Densmore's *Teton Sioux Music,* Smithsonian Institute Bureau of American Ethnology, Bulletin 61 (Washington, D. C.: Government Printing Office, 1918); John G. Neihardt's *Black Elk Speaks: Being the Life Story of Holy Man of the Oglala Sioux* (Lincoln and London: Univ. of Nebraska Press, 1979); and Harry W. Paige's *Songs of the Teton Sioux* (Los Angeles: Westernlore Press, 1970). Thanks are due to Tara Browner who brought these works to my attention.

45. To be sure, many Native Americans now view themselves as Native Americans as well as members of a tribe; there is a great deal of political power in this kind of affiliation. But the question isn't concerned with Native American self-representations or -affiliations, but white representations of them.

46. Oliveros, telephone interview by author, 20 December 1991.

47. See band member Stuart Dempster's history of the band in "Deep Listening Band: A Concise History," http://www.purplefrog.com/deeplistening/news/DLB.html.

48. Oliveros, telephone interview by author, 20 December 1991.

49. Pictures, sound clips and other D'Cückoo promotional materials can be found on the Internet at http://www.well.com:80/user/tcircus/Dcuckoo/, and http://www.cnet.com/Content/Features/Quick/Cuckoo/index.html.

50. "Virtual Reality Evangelist: Interview with Linda Jacobson," by Loretta L. Lange, *Switch* 1, http://cadre.sjsu.edu/SwitchV1N2/Jacobson/lindaj.html.

51. Back cover note to D'Cückoo's *Umoja*, RGB Records RGB 501–2, 1994.

52. Notes to *Umoja*.

53. Ibid.

54. From http://www.dcuckoo.com.

55. Such a message is behind Laurie Anderson's work as well. See Susan McClary's excellent article on Anderson, "This is not a Story my People Tell: Musical Time and Space According to Laurie Anderson," in *Feminine Endings: Music Gender, and Sexuality* (Minneapolis and London: Univ. of Minnesota Press, 1991).

56. The source to read on heavy metal is Robert Walser's *Running with the Devil: Power, Gender, and Madness in Heavy Metal Music*, Music/Culture, ed. George Lipsitz, Susan McClary, and Robert Walser (Middletown, Conn.: Wesleyan Univ. Press, 1993).

57. From an interview by Gina St. John, aired in the week of 22 July 1995 on C|Net Central. The transcript is available on the Internet at http://www.cnet.com/pub/Cctranscripts/bandchat.text. Ellipsis in original.

58. Maria Johnson, "Women Making World Music Today: Laura Love, D'Cückoo, and Zap Mama," paper delivered at the Society for Ethnomusicology, Northern California Chapter, 17 September 1994.

59. From D'Cückoo's web page at http://www.dcuckoo.com.

60. Interview with Gina St. John.

61. Rolling Stones, *Between the Buttons*, Abkco Music and Records CD 499, 1986.

62. This convention gave its name to Susan McClary's provocative *Feminine Endings*,

which includes a discussion of this technique and its label.

I had originally written that we in music *formerly* called this phenomenon a feminine ending. But I looked it up in the *Harvard Dictionary of Music*, the definitive one-volume source, and discovered the entry: "Feminine cadence. See Masculine, feminine cadence" (*The New Harvard Dictionary of Music*, ed. Don Michael Randel, [Cambridge, Mass. and London: Belknap Press of Harvard Univ. Press, 1986]).

63. The backbeat is a staple of most popular musics in which beats two and four are stressed instead of the usual one and three.

64. Bush, "War with Iraq," *Vital Speeches of the Day* 57 (1 February 1991), 227.

65. This is still available on *Street Jam: Hip-Hop from the Top, Part 1*, Rhino R2 70577, 1992.

66. I would like to thank Adam Mansbach for bringing this song to my attention.

67. Since jungle music depends so much on technology there is a good deal of information (and sound samples and musician photos) available on the Internet. A few of the best sites I have seen are http://web.mit.edu/jcarow/www/breaks.html (DJ Casper's Jungle and Happy Hardcore Web Page); http://www.hooked.net:80/buzznet/03/beats/jungle/index.html (WELCOME TO THE JUNGLE); and http://polestar.fac.mcgill.ca/courses/engl378/socks/jungle/, the only academic site devoted to this music. At this writing there is only one scholarly article in print, Benjamin Noys's "Into the 'Jungle'," *Popular Music* 14 (October 1995): 321–32. There has been a good deal of discussion by the popular press; the most insightful articles are Matthew Collin, "Jungle Fever," *Life* [*The Observer Magazine*] (26 June 1994), 26–30; Dave Hucker, "Jungle Fever Spreads in U.K.: Reggae/Techno Hybrid Growing Quickly," *Billboard* 106 (29 October 1994), 1; Simon Reynolds has several articles, "Above the Treeline," *The Wire* (September 1994), 36, "It's a Jungle out There. . ." *Melody Maker* (15 October 1994), 42–43, "Jungle Boogie," *Rolling Stone* 704 (23 March 23 1995), 38, and "Will Jungle be the Next Craze from Britain?" *New York Times* (6 August 1995), H28; Greg Tate, "Jungle Boogie," *Pulse!* 50

(July 1996), 64; and David Toop, "Jungle Fever Spreads in U.K.: Genre Defies Labels," *Billboard* 106 (29 October 1994), 1. Finally, while jungle is made mainly by DJs and duplicated and distributed by them, a growing number of compilations are available, though they are always out of date when they appear: *Jungle Hits: 100% Jungle*, Street Tuff STRCD 1, 1994, and *Law of the Jungle*, Moonshine Music MM 80016-2, 1994. The beginning of jungle's entry into the mainstream is Goldie's *Timeless*, FFRR 697-124 073-2, 1996. The inevitable appropriations by superstars has already begun, with David Bowie grabbing the spotlight by releasing the first free single over the Internet, a jungle track (he says) that will not be available on the commercial release of the compact disc. This is downloadable from http://www.davidbowie.com, and the track is called "Telling Lies."

Strategic Inauthenticity

The most important thing we own is our culture. Don't trade away your culture for anything in the world.

—Youssou N'Dour (promotional T-shirt)

Kwame Anthony Appiah writes in his important *In My Father's House* that Africans who employ western categories such as "literature" and "nation" and attempt to use them to oppose the west by creating "national literatures" are doomed to failure; for Appiah, acceptance of these concepts means that "the terms of resistance are already given us, and our contestation is entrapped within the western cultural conjuncture we affect to dispute. The pose of repudiation actually presupposes the cultural institutions of the west and the ideological matrix in which they, in turn, are imbricated."[1]

Yet it seems to me that one important way that the oppressed can overthrow their oppressors and their legacy is by beating them at their own game, by writing national literatures that would engage with the west on the very terrain that it affords the most prestige—art and the aesthetic. But such a step may well fail that the best first step toward decolonizing the mind is to make national literatures and musics on the way to a kind of cultural production that is freer from the legacy of colonialization than is currently imaginable. It may well be that such a step may well fail, since, after all, it is racism that has kept African novelists out of the canon of great works, not judgments based on merit.

At the same time, though, I would question Appiah's focus on high cultural forms such as literature. Listening to popular musics from Africa, I hear musicians constantly asserting national, local, and international identities, always attempting to get outside and beyond more traditionally bounded identities. Moreover, many of these musicians are concerned with modernity and modernization and voice in their music the problems of moving quickly into modernity, a modernity in the postcolonial, globalized world that could even be construed as postmodern.

However, given the prestige of high art in western cultures, Appiah's concern is understandable. Popular culture that makes use of traditional or folk cultural forms make it dangerously close to those forms, which means that popular culture may not be permitted out of the "natural culture" slot I discussed in chapter 1 and allowed into the arena of highest prestige. I now want to examine this western notion of the nonwestern natural culture a bit more. Anthropologist Richard Fox writes in *Lions of the Punjab* that the anthropological term culture has been employed historically to denote an essentialized category of identity just as race or ethnicity, or what he terms an "organismic" definition of culture, which is congruent with Edward Said's Orientalism: culture is constructed as organically inherent in individuals and groups.[2] I would further add that culture has gained such legitimacy and currency that any analytical value is just about gone; culture has entered everyday language, but as nothing other than a term that supplants race or blood or ethnicity as an essentialized marker of racial-ethnic difference. As Paul Gilroy also observes, "It is significant that prior to the consolidation of scientific racism in the nineteenth century, the term 'race' was used very much in the way that the word 'culture' is used today."[3]

So what has happened? Westerners—including musicians—now allow others a culture, but it is a culture in the anthropological sense. Western culture is still a culture in the opera house sense—civilization. So the rhetorical/discursive/imperialist moves still prevail. These cultures of other peoples are natural cultures, and naturalizing culture means it can thus be taken. "Culture flows like water," Paul Simon said, generally, and about South African musics in particular. "It isn't something that can just be cut off."[4] And Peter Gabriel can use a ten-year-old recording without compensating or crediting the musicians, but if they tried to do the same with Gabriel's music, they would have to secure copyright permissions. The success of the anthropological culture is merely semantic: it labels the supposed void of places and places that are perceived to have no high culture.

In this chapter, I want to explore these issues as they relate to the music of two musicians from the African continent, Youssou N'Dour from Senegal and Angélique Kidjo from Benin. My argument here is that these musicians are moderns who face constant pressure from westerners to remain musically and otherwise premodern—that is, culturally "natural"—because of racism and western demands for authenticity.[5]

YOUSSOU N'DOUR: "A MODERN GRIOT"

Youssou N'Dour (1959–) is one of a handful but growing number of nonwestern pop stars from the African continent born around or after the independence of their homeland. He is probably the biggest international non-western pop star appearing in this book and his been written about extensively by the U.S. music press. N'Dour sings many of the typical stories of those who are trying to be subjects of modernity and not its objects: stories about the dangers of being overrun by tourism, the degradation of the environment, moving from the country to the city, and nostalgia for the ancestors and their wisdom. This modernization, however, in the form of the colonial machine, left N'Dour and his fellow Senegalese few options. The stories of modernization and colonialism/postcolonialism intersect time and again in his music, as, I have been arguing, they do in the "real world."

N'Dour, like Rhoma Irama, expresses the desire to make a new popular music that incorporates elements of indigenous traditional musics and uses the local language. At the same time, N'Dour acknowledges the influence of musics from around the world on him. "It's just a natural process of evolution," N'Dour says. "My style evolves depending on what other musics I've heard."[6] He explains his mix of musics and sounds in explicitly politico- historical terms.[7]

> The process of modernisation began relatively late in Senegambia. Ghana and Nigeria had developed their hi-life and such styles much earlier. The hit sounds in Senegal in the Fifties and sixties were still the Cuban dance songs of [Orquesta] Aragon and Johnny Pacheco. For those of us who wanted to form a purely Senegalese pop sound, this Cuban music was rhythmically acceptable, but harmonically foreign. And of course there was the problem of language. We wanted to sing in our own Wolof language. The Gambian group, Super Eagles, later called I Fang Bondi, who were pioneering their Afro Manding jazz, and the Senegalese groups, Baobab and Sahel, had already begun to translate local traditional songs and rhythms to the instruments of pop music. Perhaps I had more of what we call in Wolof, *fit*, or courage. When I started with the Star Band, we went even further, developing a dance music which I called mbalax. The dancers at the Miami [a night club in Dakar] were no longer content with the pachanga or the cha cha cha, but followed the tama drum and the other sabars [drums] into their own natural dances.[8]

The traditional stylistic and musical aspects of mbalax, which means "the rhythm of the drum" in Wolof, are mostly concerned with rhythm.

> That drum [mbung mbung], along with others like the talmbeut, ndende, bougarabu, djembe, nder, tunge, gorong and tama, creates the rhythm. When they say in Dakar, '*C'est très mbalax*', they mean it's got a very strong, distinctive rhythm. So the base of mbalax is the drums, collectively known as sabars. There could be up

to eight in any traditional line-up. In my group, I gave some of those drum parts to guitars and keyboards. The rhythms can change within songs—that is always a big attraction. This diversity comes from many tribal sources: Toucouleur, Peul, Bambara, Djola, Serer, as well as Wolof. We could make ten songs and they'd all sound different, unusual to people in the West. So I created this modern style, but the Senegalese quickly recognised it as their own popular music, and when it was recorded in France under favourable conditions it made even better sense to them.[9]

The resulting sound brought N'Dour to the attention of western musicians such as Peter Gabriel and Paul Simon (both of whom recorded with him on some of their albums). N'Dour's album *The Guide* (*Wommat*) of 1994[10] was nominated for a Grammy (ultimately losing to Ali Farka Toure and Ry Cooder) and features guest appearances by black British American pop star Neneh Cherry and American jazz great Branford Marsalis.[11] "Leaving (Dem)" opens *The Guide* and is the most upbeat song on the album, although the melancholy tale of the lyrics might indicate otherwise. The trajectory of "Leaving" isn't much different from a contemporary U.S. rock song: a brief guitar introduction followed by the rhythm track, then the vocals in N'Dour's amazing voice, supple, grainy, high, muscular. But the guitar sound owes more to South African *mbaqanga* than anything else; it may be *très* mbalax, but it makes use of African popular musics from all over, including soukous, highlife, Afrobeat, reggae, salsa, soul, and disco according to one commentator.[12] Once the rhythm starts, the song inhabits an ecstatic groove, emphasized by N'Dour's conversational yet melodic singing style, and the horns (saxophone, trombones, trumpet). N'Dour further adds to the effect produced by the song by stepping down from it with an improvised, metrically free harmonica solo at the song's conclusion—bringing Stevie Wonder's brand of joyous music to mind—and including applause and whistles, even though this song was recorded in a studio without a live audience. There is also a background chorus that vocalizes along with N'Dour near the end of the song, adding to the celebratory sound.

Leaving (Dem)

Leaving
Leaving to go where
Leaving for what
Leaving because of the hard times
The sun is not burning me anymore
The rain is not falling anymore
Leaving because
There's nothing to share anymore
Leaving because
A man's got to be strong
Leaving
Leaving because of freedom

There's no more room for me
Can't look at these trees
That raised me
Every morning
Leaving because
This house seems too dark
Leaving because
I've got to be a man
I'm going to the jungle
I'm going to this big river
To join my friends

Don't go away
Don't go away

Show me your friends
And I'll tell you who you are
Show me your relatives
And I'll tell you where to go
Eh! Do what you want
Eh! Eh! What you need
One only knows his own sorrow
The ones that can make things happen
Never get the chance

The lyrics of the song illustrate the kind of movement in the global postmodern that might take those at the traditional metropoles by surprise. Rather than becoming modern and moving, as did so many European moderns from the country to the city, N'Dour instead tells of wanting to move the other direction: he has had enough of modernity, thank you very much. He is interested in cultivating older ways of interaction, through one's friends and family, rather than the faceless, impersonal postcolonial city. "I am a modern man," he says. "I love traditional things, but I think African music must be popular. We have to go forward."[13] So he built a 24-track recording studio in Dakar, naming it Xippi, or "eyes open," also the title of one of his albums.

With songs such as "Leaving," N'Dour's music mounts a different kind of resistance—or different kinds of resistances—than those we have examined so far. *The Guide* does offer songs that rage against the European colonial machine, such as "How you are (No mele)," which incorporates a rap in English. At the same time, however, N'Dour addresses more local concerns, most of which sound familiar to western listeners: "There is a lot of joblessness here [in Senegal]. Many kids here have dreams, but the opportunities are limited."[14]

Although N'Dour is clearly a modern western musician of sorts, he evidently still views himself as a griot, or, a *gawulo*, literally, "the one who is always singing praises," a Tukulor people version of the better-known griot.[15] One of the most

revealing statements about him wasn't made by the extremely private musician himself, but by an associate who refused to let *Rolling Stone* use his name.

> Remember, he knows how to use power but not how to give it away. That is a very hard thing for anyone, but especially an African, knowing who to trust and who to give responsibility to. The only people Youssou really trusts are members of his family and the friends he's had since childhood. It's a very insular world. And you also have to remember that first and foremost, he's a griot.
>
> Traditionally, griots are always supported by the king and the country and are paid to sing. The idea that he has to pay someone [to do sound or lights or to produce or accompany him] so that he can sing and perform is very confusing.[16]

N'Dour is a Muslim, though, unlike Rhoma Irama, his music and lyrics have not taken on specifically Islamic issues. But his music is still informed by a strong sense of right and wrong. "You know," he told interviewer Brian Cullman, "when you are walking with a girl, you have to make sure you walk along the right path, that you watch your step. You have a certain responsibility to be very proper."[17] The idea of "propriety" recurs throughout his songs, which exhort youths to behave respectfully toward their parents, caution the west to behave respectfully toward its former colonies, and ask tourists to treat his country well.

Because of his fame, N'Dour realizes the extent to which he, as an international star and local *gawulo*, can help his more provincial listeners understand the events in the larger world.[18] "In my society where there are those who cannot read or write, I was able to tell them in song just what was happening in South Africa. My own mother had seen pictures on TV but she didn't fully understand the situation. I could make a link between the situation in South Africa today and a famous, bloody battle in our own history—the battle of N'Der in the nineteenth century."[19]

The international success N'Dour has achieved leaves him mindful of his roots in the family tradition of musicians and *gawulos*. "Before the radio," he says, "griots gathered the people together and gave them the news, the information from the king. He helped them understand the world, he was their voice. That's what I am, a modern griot."[20] Before that he was a premodern griot, singing for various traditional rituals, including circumcision ceremonies. N'Dour's current duties are thus those of a griot: telling stories, giving admonitions, keeping watch.

> I sometimes inform people, give advice that is not perhaps very acceptable because they are hard things. For example, "Toxiques," [on the *Set* album of 1990[21]] is information I'm giving to African people to explain the danger of toxic waste. Because I don't think information is flowing as it should. And then, it is also to talk with people in the West, to say, "Keep your toxic waste. It's you who created it."[22]

One of N'Dour's more political songs on *The Guide (Wommat)*, "How you are," employs a brief rap in Wolof (N'Dour's first language, although he also sings in French and English on this album) that, near as I can tell, quickly recapitulates

the rundown of dates of independence of many African nations, ending with "Youssou N'Dour, African gold!" echoing the praise in the form of applause and whistles at the end of "Leaving (Dem)." N'Dour himself doesn't do this rap, though; it is credited to M'Backe Diou. N'Dour says the dates in the song "signify the times when African countries freed themselves from colonial rule. But it asks the question, 'Are we really liberated in the '90s in our thoughts and actions?'"[23]

How you are (No mele)

Oh God
However you are
God will always be here

July 1947 Liberia
December 1951 Libya
March 1956 Morocco
October 1959 Guinea
January 1960 Cameroon
July 1960 Somalia
August 1960 Burkina Fasso
June 1960 Senegal

Oh God
However you are
God will always be here

Rap

Now that we're independent let's show it
Senegal, we're all in this together
Nigeria, we're all in this together
Somalia, we're all in this together
Ivory Coast, we're all in this together
Youssou N'Dour, African gold!

N'Dour

The help we get from outside
Should not make us forget our duties
Help doesn't last forever
We asked for independence
Let's show it

Never ending fight for freedom Africa
I don't wanna see you fade away Africa

"How you are (No mele)" makes use of some of the most resigned, taught music of the album. A bass starts the song, then rhythm and keyboards, sounding just one harmony over and over. The chorus is more harmonically adventurous, but the song's overall affect is one of immense seriousness and solemnity, a call to responsibility for all the citizens on the African continent.

N'Dour also tries to project a vision for the youth of the African continent; his song "Xale," on *Set* doesn't beat around the bush, lyrically or musically.

Xale (Our Young People)

Young people of our country
This is how I see it
Let's start by asking God
To accept our prayers
To bless all our endeavours
To shield us from the Devil
Who conspires to make us doubt
Who tries to change our ideas
And to divide us

We must come together and show everyone
What we can do
That we can be the backbone
Of our country

We will benefit by talking things over
With our parents
But we must contribute our own ideas
Those of us who are in Senegal
And those of us who are abroad
Can all make an effort

Where am I with my guys?
Well I think we are doing our bit
We all need to work together
For the future of our country.

Hey Thiatl I'm certainly not forgetting you

N'Dour says about "Xale" that "it's a question of reflecting and showing a different image; to be credible; able to work hand in hand to achieve the development of our continent, our country. It's a song to stimulate consciousness and a call for the union of our youth for a new vision."[24]

The music is the most serious he has written in its use of a nearly "classical" sound: his band, Super Etoile de Dakar sits out, so it is all guest strings, giving "Xale" the sound of a string quartet in its instrumentation (though there are string

basses, not part of a classical string quartet lineup). And there are some clearly audible dissonances in the string parts.[25] It is sober music, a sense conveyed by the use of strings, heavy on the bottom, that is, the basses, the lowest instruments; the key, E minor; and the periodic, angry interventions by the basses, such as in measure 7, which I've marked *sfz*.

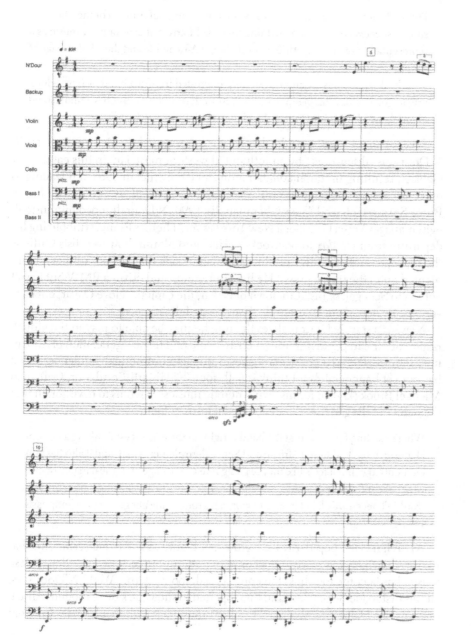

Example 5.1
Youssou N'Dour:
"Xale," opening.

N'Dour doesn't use his status just to educate people from the African conti-nent, however; much of his music is aimed at the west. Just as "Leaving" might turn some westerners' ideas about Africa upside down—it is a song about leaving the city for the country, not the other way around—N'Dour is also bent on demonstrating to his growing worldwide listeners that Africa is modern already.

> I'm really defending a cause: the cause of a new image of Africa. For me, the mea-sure of success is more than anything how well I arrive at exposing my music as a representation of not only African music but of African life and the whole image of Africa.
>
> I think Americans are more and more interested in Africa but they have a long way to go. The day that people in the West understand how much we understand about the workings of the rest of the planet will be a happy day for us.[26]

Like so many stars outside the North American/U.K. rock music circuit, N'Dour was "discovered" by an influential western musician, in this case, Peter Gabriel, resulting in much collaboration since they met in 1984 and leading to other collaborations, such as on Paul Simon's *Graceland*, as well as with Sting, Bruce Springsteen, and Tracy Chapman. By 1990, N'Dour dropped his musicol-ogist manager Verna Gillis for a New York lawyer, Thomas Rome, symbolizing his departure from *mbalax* to pop/rock.[27] (His latest album, however, lists Gillis as the manager and executive producer, a switch back that has not yet been com-mented on in the music press.) He lives in London and drives a BMW but hasn't cut ties to Senegal, or his hometown of Dakar, the capital. "I love Dakar, but I am very visible here, I am an example. Everything I do, it's seen."[28]

Now, as a star, N'Dour realizes the role he may be able to play in the global-ization of African popular musics such as *mbalax*: "The new generation of African musicians really has a chance to have an impact on American audiences. That has not yet happened, but I think it will, soon."[29] His artistic advisor, Canadian Michael Brook (known for his own syncretic musics[30]), seems to have gotten into the habit of filling in the silences of the taciturn N'Dour.

> What's exciting for me is that the band is right on the edge of establishing a person-al music. It has traditional African and Senegalese elements in it, and it also has pop elements in it, but it feels like they're going into a new stage of musical maturity, one where the influences become less relevant. They're Africans making music, but you wouldn't necessarily label it *African music*. It's something altogether new [emphasis in original].[31]

As his fame and popularity have grown, N'Dour has had to face criticisms that his music, which was, early on, a conscious attempt to re-Africanize Senegalese music, has become too slick, too commercial, too western. "Well," N'Dour says, "it was first made Senegalese and then opened to show the side of modern Africa, of towns like Dakar and Abidjan. I think my music has really evolved. It's true that

it's lost a bit for older people but then it's gained popularity with younger people. That's life. I don't make music for such and such a person; I do it because it's me—what I feel."[32] Prominent world music commentator Brooke Wentz devoted an entire article to the subject of whether or not N'Dour had sold out, entitling it "Youssou N'Dour: Is He Shaking the Tree or Cutting it Down?" (referring to "Shaking the Tree," a song by Peter Gabriel that N'Dour joined him on the "Secret World Live" tour and album).[33] Wentz criticized N'Dour for sanitizing his music in *The Guide (Wommat)*, attempting to achieve commercial success at the expense of his authentic *mbalax* music; N'Dour's music, writes Wentz, "is at its most spectacular when soaring over the rhythms of his native country, in his native language, over his native rhythms."[34] N'Dour, in the meantime, continues patiently to explain his position. "In Dakar we hear many different recordings. We are open to these sounds. When people say my music is too Western, they must remember that we, too, hear this music over here. We hear the African music with the modern."[35]

Or the postmodern. Wentz and other critics who would insist that N'Dour be "true" to the music of his culture help demonstrate the ways that Kwame Anthony Appiah's idea of "nativism"—"the claim that true African independence requires a literature [or, I would add, culture] of one's own"[36]—can be used against itself, against Africans, when wielded by westerners looking for traditional, authentic sounds.

For here, we have westerners demanding local, premodern cultures of Africans. Gabriel and Simon (or whoever) are allowed to work with N'Dour and "Africanize" their music, but, it seems, N'Dour is not permitted to work with them and "westernize" his music. His culture is constructed by western critics as pure, while theirs is always already tainted by artifice, voracious by nature. Postcolonial/postmodern attitudes allow N'Dour a culture, as colonialist ideologies did not, but it is a natural culture, while the west's culture is civilization, technological culture, premised on development, expansion, progress, and artifice.

Reggae commentator Kwaku posted to rec.music.reggae a recent interview with N'Dour in which he asks about these criticisms.

> Kwaku: You've been accused of "Westernising" your African music with Western pop and African-American styles. How do you justify it?

> N'Dour: It's very simple, really. When I was young growing up in Dakar and hadn't travelled, my music had a different feel. But when I began to travel and tour around Europe, America and the rest of the world, obviously I was hearing new sounds and mixing new musical ideas, which gives rise to those sort of criticisms.

This exchange demonstrates that N'Dour's impulses are not any different from a western musician who is enough of a star to be able to travel widely and soak up other sounds and influences. Then:

Kwaku: What kind of artist are you?

N'Dour: I wouldn't want to define myself. But there are two ways I see myself. One is to appeal to my African audience and the second is to leave myself open to other influences and other cultures.[37]

And N'Dour, like most contemporary western musicians, doesn't want to be pigeonholed.

It thus seems to me that the classic discourse of the nature/culture binary that has so driven western notions about the west and the rest has begun to shift. The west is no longer so arrogant that it presumes that other cultures are uncivilized, or, indeed, that nonwestern peoples do not have cultures in both the anthropological and aesthetic senses. But as often as these nonwestern peoples' cultures were constructed as akin to nature in the past, they are now viewed as natural cultures; the west is conceived as civilized, but this means postindustrial, technological.[38] I will return to this point at the conclusion of this chapter.

ANGÉLIQUE KIDJO:
"LET'S CREATE A BETTER CONTINENT"

Angélique Kidjo (born in Ouidah, Benin in 1960, the year of independence from France), is less ambivalently modern than N'Dour. Billed by her record company, Island/Mango, as "the African funk diva of world music," she is one of the stars of Afropop, world beat, and Afrobeat, exploding on the music scene in 1991 with *Logozo*, which stayed on *Billboard*'s world music charts for 46 weeks. (Her first solo album, *Parakou*, was released in 1989 but is relatively unknown and currently unavailable[39]; Parakou is a town in central Benin that is a cultural crossroads between the Sahel, a region in northwest Africa, and coastal peoples).[40] Like Djura, she sings about women, in the village, in her country, on the African continent, and in the world. And like Youssou N'Dour, she is a kind of postcolonial critic, exhorting her listeners to pay attention to what is going on in her country and Africa in general and singing mainly in her native Fon language instead of English or French, both of which she grew up speaking (she speaks a half-dozen other languages as well).

Social change is perhaps the most important recurring theme in her lyrics. "People are too sad for me to bring music with a lot of sorrow. I want them to feel happy, but then I want them to say: 'Damn! This person needs some help—I'm going to *do* something'."[41] Kidjo's desire to effect social change is so strong that for a time she thought of becoming a lawyer. "The one thing that drives me crazy is injustice. I hate it so much, but my idea of law was not to study so hard. It was more of going to people and talking to those who need help."[42]

Kidjo's musical upbringing led her to listen to James Brown, Jimi Hendrix, Aretha Franklin, Otis Redding, the Beatles, and Annie Lennox; she even named her daughter Naïma after a composition by John Coltrane ("He blew the shit out

Figure 5.1
Angélique Kidjo.

of that horn," she says[43]). When she was a kid, Kidjo used to hear her brothers' rock band practicing music by these musicians and others. "I'd hear my brothers playing modern music inside, and then I'd hear the drums outside, and I was in between both."[44] One of her brothers was a guitarist who was particularly fond of Carlos Santana, so he and his sister knew Santana's music by heart. Santana appears on a track named for Kidjo's daughter on her latest album, *Fifa* (1996).[45] Kidjo also says that the traditional music of Benin and all over Africa was always already syncretic, so that it was natural to mix styles and sounds from all over.[46]

Kidjo learned from all of these musicians and still others and developed a sensitivity to the problems faced by African Americans, and Africans all over the world.

> The black people in the United States are not as free as they are supposed to be. They were brought from Africa without nobody asking them. And now, what's happening? You want them to get out of your country. "We don't want you, we needed you once when we bring your ancestors to be our slaves. Now we would like to be rid of you, but we can't." The society, the way it's ruled, there's no chance if you are black. There have been a lot of changes but it's still too slow. Just compare the white society and the black society in the United States. The black child face so many more problems than the white child. I definitely believe that the social politics of the United States has to be changed completely. For me, the biggest apartheid is there.[47]

Like Djura, Kidjo emigrated to the colonial capital, France, where she developed ideas about European culture and people. But her childhood was far less traumatic than Djura's, and her European experiences not as intellectual or liberating. In 1983, she moved to Paris. "It was either stay there and shut my mouth

or leave," she says, having gotten in some unspecified trouble with the government.[48] Benin was ruled by a Marxist-Leninist dictatorship from 1972 until 1988, when the government fell as a result of student protests and the beginning of the end of the Soviet Union and its satellites in Eastern Europe; this government tried to coerce artists to make works that support the government, which Kidjo refused to do.[49] It was after the move to France that she toyed with the idea of becoming a lawyer, but she decided to go to music school instead, where she studied western classical music, singing, and jazz; her first recording work was with Alafia and then the jazz band Pili Pili.

But like many African American musicians who were at the forefront of popular musics in the 1950s, Kidjo and others from the African continent coming to European metropoles were often cheated by unscrupulous entrepreneurs. Kidjo took out a bank loan in Benin to record an album in France with another African artist, with whom she expected to cowrite and coproduce. Upon arriving, Kidjo found she was supposed to pay for everything. (*Billboard*'s report on this incident names neither the other artist nor the album title). Kidjo says,

> The album was released and I never got a cent back, although it sold over 40,000 copies. More so, my so-called partner had simply registered all the songs with himself as a sole composer. I discovered this in 1984 when I went back to France and went to SACEM, where I had to prove that I was co-composer and co-author. Then I registered with SACEM in 1985. By the way, I'm still paying back my bank loan![50]

This is not to say that Kidjo and her African compatriots who seek to make careers in Europe are naive and uneducated like many of their less fortunate African American colleagues a generation earlier (even the highly intelligent Chuck Berry unwittingly signed away two-thirds of the rights to his number-one hit of 1955, "Maybellene," saying of the contract thrust in front of him, "I did see the word *copyright* several times as I read through it and thus figured if it was connected with the United States government, it was legitimate and I was likely protected").[51] Kidjo and other recent artists are far more savvy about matters of the music industry. Their problems arise more often because they aren't familiar with local practices outside their home country, or, in Kidjo's case, they are simply deceived by people they thought they could trust—fellow postcolonial immigrants like themselves.[52]

The title song of her second solo album, *Logozo* ("turtle") is about the turtle-like insularity she met with after moving to France. She explains:

> One of my images when I first arrived in France was that animal and seeing how human beings react. As soon as you approach them too close, they all go back in their shells. And they live lonely lives like a turtle with the problems of their housing, their money, their clothes, their kids and everything on their backs. The turtle will communicate with you only when it's really important. It's not an animal that will come up to you and ask for a stroke like a dog. For me, Europeans are turtles

because they don't want to speak. They don't like to be involved in any relationship in case they get hurt. And you can't talk about money problems in your society: it's taboo. When you look at them . . . [here she mimes someone looking the other way not in a stubbing way, simply detached].[53]

The song's lyrics deal with these sentiments.[54]

Kidjo's music is the most pop/rock-oriented of any western musician in this study; *Logozo* was recorded in Miami and produced by Joe Galdo, who also produces Miami Sound Machine. Kidjo makes no apologies for her use of popular musics from the U.S., many of which, of course, come from African Americans. "There isn't much in African music today that is pure. We all have different ways of expressing our music."[55] Nonetheless, her desire to sing in Fon isn't Kidjo's only acknowledgment to the traditional forms of her culture. Her mother worked with a ballet group called Troupe Théâtre et Folklorique du Bénin, helping Kidjo develop a knowledge of the traditional cultural forms of Benin, as well as an intellectual underpinning to that understanding. "With her it was knowing exactly what was going on, what is your tradition and what you could do with it. I wanted to know more by asking questions. Why is this rhythm different from that one? Why can't you dance the same way to both? Why is it a different language? Why, why, why? I was called 'Who-And-Why' when I was a little girl. I wanted to know. And she always explained."[56]

All the influences on Kidjo resulted in a style on *Parakou*, described by Philip Sweeney as "50% standard pan-global funk, 25% vaguely Salif Keita-ish[57] synthesized ornamentation and 25% traditional-crossed-with-jazz vocal lines."[58] You can hear the level of disapproval increasing as the numbers drop. World music reviews of Kidjo's work have been increasingly disapproving across her three solo albums as the audible traditional elements have been replaced by more popular sounds. In *World Music: The Rough Guide*, Richard Trillo writes:

> the Beninoise funk diva more or less dispensed with the quirkier style of songs that made her earlier CDs, *Logozo* and particularly the first, *Parakou*, interesting. On *Parakou*, the songs range from driving dance numbers to sepia-toned laments and a cappella and there's a huge wealth of dramatic and intriguing percussion. By comparison, *Ayé* is straight funk-rock, slickly packaged by a pop producer and, whichever way you look at it—not necessarily with any purist inflection—the songs on it are less engaging.[59]

But it's clearly this "purist inflection" that results in this judgment of *Ayé*.

Branford Marsalis, who contributed sax solos on two of the songs on *Logozo* thought Kidjo had been duped by her *Ayé* producers, Will Mowat, producer of Soul II Soul, and David Z, who worked with the Fine Young Cannibals and The Artist Formerly Known As Prince. "They were trying to make her music western," says Marsalis. "The production sounds good, but it's not her. When the world's greatest rhythms are in your own backyard, why use drum machines and

sequencers?"[60] In other words, why isn't Kidjo an authentic African? (One could ask Marsalis why he doesn't stick with authentic New Orleans jazz styles.) Such criticisms anger Kidjo. "There is a kind of cultural racism going on where people think that African musicians have to make a certain kind of music. No one asks Paul Simon, 'Why did you use black African musicians? Why don't you use Americans? Why don't you make your music?' What is the music that Paul Simon is supposed to do?'"[61] Elsewhere, she said,

> I won't do my music different to please some people who want to see something very traditional. The music I write is me. It's how I feel. If you want to see traditional music and exoticism, take a plane to Africa. They play that music on the streets. I'm not going to play traditional drums and dress like bush people. I'm not going to show my ass for any fucking white man. If they want to see it, they can go outside. I'm not here for that. I don't ask Americans to play country music.[62]

Kidjo rightly perceives criticisms of her music as not authentic enough as being ideologically part of a great western view of African cultures as backward and perennially premodern. Her postcolonial politics take the form of a pan-Africanism—in material, language, and comusicians—and feminism. *Logozo* contains songs from Tanzania in Swahili, from Togo in Ewe, and original material, musicians from all over Africa, and an African American—Marsalis plays solos on "Logozo" and another song. In keeping with this pan-African stance, in "Ewa ka djo," Kidjo sings, "Let's all dance together, let's create a better continent."[63]

Kidjo's voice is extraordinarily supple and powerful; she is really like a female Youssou N'Dour in the range and power of her vocal abilities. Having been on the scene less time than N'Dour, it may be that her music will not be viewed so much in terms of a departure from traditional forms and rhythms (as N'Dour's latest work is), but it is clear that already, such criticism are being leveled at her by listeners seeking the kind of authentic and different music I discussed at length in the first chapter.

Besides, careful listening shows that her music is more complex than her detractors would have it; the sound of synthesizers and other electronic instruments gives a patina of familiarity, but the music underneath is more complex, though not alway complex in the ways that western popular musics are. Listening beyond the surface, more traditionally African approaches to rhythm and phrasing are evident. "Logozo," for example, fades in with drums and Branford Marsalis's sax, and by the time Kidjo enters, it is clear this is not a standard pop/rock/funk song—it is in 6/4 an unusual time signature for a pop song of any genre from anywhere. And by the chorus, it is hard to tell what the meter is because of the syncopation within the bar and over the barline.

What's more, "Logozo" is F♯ major, an extremely unusual key in popular music. Further, Kidjo introduces major/minor ambiguity—the verses in major, the choruses, minor—which is a powerful way of musically treating ambivalence, of refusing to pick one side or another. Here ambivalence can be nothing other

than Kidjo's life in the west: happy to be there, but greatly disliking certain facts of life in Paris, such as meeting human turtles.

"I sing about problems that are not only in Benin or Africa. I write for everybody," she says.[64] Kidjo's embrace of a variety of western popular music sounds means that she likes the world music label, for it is inclusive enough to include someone who doesn't sing in a European language.

> I like world music. It expresses an open outlook, a lack of musical sectarianism. World music is not a genre, like funk or reggae. It is played by musicians who think that artists—especially in Third World countries that are not overrun by the media—can express themselves in a very contemporary and original way, thanks to the richness of their cultures. The only danger of the world-music label is that of being left out of the mainstream, because this music is given the same weight in the market that the Third World is given on the global economic chessboard.[65]

Elsewhere, she said that she felt that it was a musician's duty to cross cultural boundaries. "It is not possible any more for artist to talk to only one audience. Problems, whether it is in Africa or the Caribbean, are world problems. I would like to see African governments come to the realisation that the various forms of arts and culture are important. Although things are desperate in countries, the arts are important."[66]

Kidjo probably adopts western ways more wholeheartedly than N'Dour because they afford her a feminist subject position; she is less concerned with traditional ways of her home country. She attacks western ideas about exotic African women as we have already seen. "I'm not here to fulfill anybody's fantasies. If they [western critics] want to see exotic African women, they have to fly to Africa. And if they're not careful, when they arrive there, they'll get their faces punched in."[67] And she feels that

> the music business is macho. When you are a woman, you have to be at a point in life when your mind is at the same place as a man. You have to fight two times harder because men want the power for themselves and they don't want to share it. The advantage of being a woman is having the pride to do what you do every day. Being there and showing men that because you are a woman you can do it too. That is the only way to gain respect.[68]

While the western women musicians examined in chapter 4 faced some issues similar to Kidjo, at the same time they are freer to make the music they want. In all the writings on Pauline Oliveros and D'Cückoo, no one has criticized their choice of genres or materials; indeed, D'Cückoo's use and mastery of technology has been widely recognized and praised. Contrasting these musicians with Kidjo—and Djur Djura—highlights the kinds of expectations and demands made of musicians of color that don't necessarily transfer to western women.

Kidjo's latest album, *Fifa* (1996) continues the same kinds of Afropop/rock/jazz

fusions as her earlier albums, but with an added element: whatever might have been traditional African music on her first three solo albums is this time augmented by field recordings Kidjo and her husband/producer Jean Hebrail made in a month-long trip back to Benin from Paris in early 1995. "I'd wanted to go back for a long time, I really missed and needed those drums," she says. "So instead of composing the songs first per usual, I decided to wait for the drums to inspire and guide the melodies."[69]

This isn't the first time in these pages that a musician has traveled to Africa to make field recordings to use in his or her own work, of course, but it is the first time that this traveler was originally from the place visited. Again, as Kidjo and N'Dour insist in many of their interviews, they are modern; Kidjo's attitudes toward the traditional musicians whose musics she borrows aren't that different from any other urbanized metropolitan.

Traditional music from Benin makes appearances all over the album, but perhaps the most memorable moment is on the third track, "Welcome," where Kidjo and Hebrail recorded some women singers in a village called Manigri. Kidjo's description of this experience emphasizes her attitude toward these musicians as natural and unencumbered by modernity.

> It's a Muslim village, I don't even speak the language from there. When I arrived all the women came out in their long "boubous" (Muslim gowns), and they sang this song for me. I didn't ask them for it, they just sang it. Wow, it was like they were all my mothers!
>
> Those women, they bring me straight back to gospel. It's the first time in my life I really have had proof that gospel comes from Africa. It's straight from the heart—these women are saying, "Will you allow us to touch your heart?" That's how African women sing. It gives me the same kind of shivers as gospel does.[70]

Here are the song's English lyrics. The French lyrics in the booklet include a French translation of what the village women sang, which is included below.

Welcome

Village singers

We want to greet this daughter,
This girl who comes from Ouidah.
We want to greet this daughter,
This girl who comes from Ouidah.

Kidjo sings in English for the first time on *Fifa*, illustrating her desire to achieve mainstream rock/pop success. But, for whatever reason, *Fifa* is by far her least successful album in the U.S. In fact, her three albums to chart on *Billboard*'s World Music charts have declined steadily, down from *Logozo*'s 47 weeks on the

charts (where it was number 1 for nine weeks), to *Ayé*'s 33 weeks, where it was never number 1, having the misfortune of being released just before Ry Cooder and Ali Farka Toure's blockbuster *Talking Timbuktu* to which *Ayé* played a solid second fiddle for 16 weeks. The success of both these earlier albums earned Kidjo positions on *Billboard*'s year-end list of top-ten World Music Artists in 1992 and 1994. *Fifa*, on the other hand, charted for only five weeks and was never number 1, and indeed never climbed higher than number 10. My main contact in the retail end of the music industry has confirmed *Fifa*'s poor performance. (N'Dour's albums, by contrast, have been somewhat more stable on the charts, though his visibility on the world music scene seems to have waned somewhat.)

WHOSE AUTHENTICITY?

Given western listeners' concern for authenticity and the desire of musicians from around the world to be stars and make it in the global music industry, N'Dour's and Kidjo's clear lack of concern with authenticity is striking at first. It seems to me there are two reasons for the lack of interest in authenticity by these musicians. One, more prevalent in the west, is aesthetic: these musicians, like Peter Gabriel, are artists, they make art, and in art, anything goes: the aesthetic is by its very nature, voracious. But N'Dour and Kidjo view western demands for authenticity as concomitant with demands that they and their countries remain premodern, or modern, while the rest of the globe moves further toward a postindustrial, late capitalist, postmodern culture. N'Dour and Kidjo are concerned with becoming global citizens and do this by showing that their countries and their continent are neither backward nor premodern, that they can make cultural forms as (post)modern as the west's. They hear many sounds—in Kidjo's case, she grew up with lots of sounds, lots of musics—and pull these into their music, to the chagrin of some western critics.

Hand in hand with this observation goes another: It is worth noting that Kidjo actively likes the world music label: from her perspective, it's inclusive. Those who express reservations about the label tend to be those westerners whose desire for the real means that anything smacking of the popular, mass-mediated, or generic is unacceptable.

NOTES

1. Kwame Anthony Appiah, *In My Father's House: Africa in the Philosophy of Culture* (New York and Oxford: Oxford Univ. Press, 1992), 59.

2. Fox, *Lions of the Punjab: Culture in the Making* (Berkeley and Los Angeles: Univ. of California Press, 1985), 2, and Said, *Orientalism* (New York: Vintage, 1979).

3. Gilroy, *The Black Atlantic: Modernity and Double Consciousness* (Cambridge: Harvard Univ. Press, 1993), 8.

For more on the culture concept in the context of globalization, see Frederick Buell, *National Culture and the New Global System*, Parallax: Re-visions of Culture and Society, ed. Stephen G. Nichols, Gerald Prince, and Wendy Steiner (Baltimore: Johns Hopkins Univ. Press, 1994).

4. Quoted by Denis Herbstein, "The Hazards of Cultural Deprivation," *Africa Report* 32 (July–August 1987): 35.

5. My point is similar to Charles Hamm's "first narrative of authenticity," discussed in his "Modernist Narratives and Popular Music" in his *Putting Popular Music in Its Place* (Cambridge: Cambridge Univ. Press, 1995). Here Hamm identifies the European American assumption that African American musics are pure expressions of African American culture.

6. Quoted by Rob Tannenbaum, "Can Youssou N'Dour Score?" *Rolling Stone* 556/557 (13–27 July 1989), 67.

7. Senegambia, below, refers to Senegal and Gambia. In 1982, both countries signed the Confederation of Senegambia, in which both remain sovereign but share defense and foreign and monetary policies.

8. Quoted by Jenny Cathcart, *Hey You! A Portrait of Youssou N'Dour* (Witney, Oxfordshire: Fine Line Books, 1989), 9.

9. Ibid., 13. For more on N'Dour's early career and the genesis of his sound, see also Lucy Duran, "Key to N'Dour: Roots of the Senegalese Star," *Popular Music* 8 (October 1989): 275–84.

10. *The Guide (Wommat)*, Sony Music OK 53828, 1994.

11. The song with Cherry, "7 Seconds," proved to be hugely popular, selling 1.5 million copies outside of the U.S.; MTV Europe gave the song its Best Song award in 1994. See Banning Eyre, "Youssou N'Dour and Neneh Cherry's 7 Second Summer," *Rhythm Music Magazine* 4 (1995), 30–35. Overall, by summer 1995, *The Guide (Wommat)* sold 700,000 copies worldwide, 100,00 of these in the U.S. Since a third of all record sales in the world occur in the U.S., N'Dour's sales record here is not stellar. See Robert La Franco and Michael Schuman, "How Do You Say Rock 'n' Roll in Wolof?" *Forbes* 156 (17 July 1995), 102–3.

12. Larry Birnbaum, "Youssou N'Dour," *Down Beat* 54 (May 1987), 14. Soukous is a Zairian folk music and dance genre now big among fans of Afropop; highlife is a popular, syncretic style of music associated mainly with Ghana.

13. Quoted by Sean Barlow and Banning Eyre, *Afropop! An Illustrated Guide to Contemporary African Music* (Edison, N.J.: Chartwell Books, 1995), 40.

14. Quoted by Gordon Chambers, "Youssou N'Dour: Sound of Senegal," *Essence* 25 (9 January 1995), 56.

15. Cathcart, *Hey You!*, 2.

16. Quoted by Brian Cullman, "World Music's Hope: Can West Africa's Youssou N'Dour Pass the Global Test?" *Rolling Stone* 591 (15 November 1991), 172.

17. Ibid.

18. Cathcart, *Hey You!*, 2.

19. Ibid., 100.

20. Quoted by Cullman, "World Music's Hope," 23.

21. On Virgin V2-86195, 1990.

22. Quoted by Sarah Coxson, "The Complete Set," *Folk Roots* 89 (November 1990), 15.

23. N'Dour, interview with Kwaku, posted on the Internet to rec.music.reggae, 22 November 1995.

24. Ibid.

25. Note that in the following transcription I have not assigned words to N'Dour's and the backup singer's parts; the liner notes to *Set* contain only English translations, not the original Wolof.

26. Quoted by Sheila Rule, "An African Superstar Sings out to the World," *New York Times* (5 September 1992), A11.

27. Gillis is probably best known for her contributions to the Folkways catalog of field recordings, from Afghanistan, Ghana, India, Iran, the Dominican Republic, and more. Near as I can tell, though, she has not published anything scholarly. See "Interview with Verna Gillis—Promoter of World Music," *Review-Latin American Literature and Arts* 40 (January/June 1989): 24–29.

28. Quoted by Brian Cullman, "World Music's Hope," 26.

29. Quoted by Scott Brodeur, "The World of Youssou N'Dour Broadening to Include U.S.," *Billboard* 104 (20 June 1992), 10.

30. Such as *Hybrid*, EG Records EEGCD 41, 1985, an early attempt in popular music to cross boundaries, and more recently, Brook's album with Nusrat Fateh Ali Khan, *Night Song*, Real World CAROL 2354-2, 1996, which has been selling extremely well.

31. Quoted by Cullman, "World Music's Hope," 174.

32. Quoted by Coxson, "The Complete Set," 15.

33. "Shaking the Tree" is on *Secret World Live*, Uni/Geffen 2064 24722 4, 1994.

34. Wentz, "Youssou N'Dour: Is He Shaking the Tree or Cutting it Down?" *RMM* (May/June 1994), 53.

35. Ibid., 39.

36. Appiah, *In My Father's House*, 56.

37. N'Dour, interview with Kwaku.

38. Fox, *Lions of the Punjab*.

39. It's on Mango 848219/2, 1989.

40. According to Graeme Ewens, *Africa O-Ye!: A Celebration of African Music* (Enfield, Middlesex: Guinness Publishing, 1991), 79.

41. Quoted by Michael Azerrad, "Angélique Kidjo: Politics with a Beat," *Rolling Stone* 630 (14 May 1992), 32.

42. Quoted by Wentz, "No Kid Stuff," *The Beat* 12 (1993), 44.

43. Quoted by Kevin Carter and Jonathan Shulman, "Deep African Woman: Angélique Kidjo," *RMM* 3 (1994), 52.

44. Quoted by Azerrad, "Angélique Kidjo," 32.

45. On Mango 162-531 039-2, 1996.

46. Interview with Corny O'Connell, WFUV-FM, New York, N.Y., 26 September 1996.

47. Quoted by Carter and Shulman, "Deep African Woman," *RMM* 3 (1994), 53.

48. Quoted by Azerrad, "Angélique Kidjo," 32.

49. Kidjo, interview with Corny O'Connell. In 1991, the first free presidential election was held in 30 years, in which Mathieu Kérékou was defeated by Nicephore Soglo.

50. Quoted by Emmanuel Legrand, "Legacy of Colonial Rule Shapes Afro-Pop in France," *Billboard* 105 (13 February 1993), 1. SACEM (Syndicat des Auteurs, Compositeurs, et Editeurs de Musique) is the French equivalent to the American music licensing organizations ASCAP (American Society of Composers, Authors and Publishers) and BMI (Broadcast Music, Incorporated).

51. *Chuck Berry: The Autobiography* (New York: Simon & Schuster, 1987), 104.

52. For an examination of recording industry and practices in Paris, see Chris Stapleton's "Paris, Africa," in *Rhythms of the World*, edited by Francis Hanly and Tim May, (London: BBC Books, 1989).

53. Quoted by Ken Hunt, "Fon Thoughts," *Folk Roots* 130 (April 1994), 19. Bracketed passage and ellipsis in original.

54. An enterprising "netizen," David Sauvé, offers complete lyrics in three languages (Fon, French, and English), though not parallel. Sauvé's web site is at http://www.otterspace. com/~dsauve/kidjo/.

55. Quoted by Carter and Shulman, "Deep African Woman," *RMM* 3 (1994), 31.

56. Quoted by Hunt, "Fon Thoughts," 17.

57. Keita is a famous Malian musician.

58. Sweeney, *The Virgin Directory of World Music* (London: Virgin Books, 1991), 37.

59. Simon Broughton et al., eds., *World Music: The Rough Guide* (London: Rough Guides, 1994), 298. *Ayé* is on Mango/Antilles 1625 9934 4, 1994.

60. Quoted by Wentz, "No Kid Stuff," 43.

61. Quoted by Burr, "From Africa," H28.

62. Quoted by Wentz, "No Kid Stuff," 43.

63. David Sauvé has also written out these lyrics in Fon, archived on the Internet at http://www.otterspace.com/~dsauve/kidjo/.

64. Quoted by Barlow and Eyre, *Afropop!*, 51.

65. Quoted by Laurent Aubert, "The World Dances to a New Beat," *World Press Review* 39 (January 1992), 25. This article originally appeared in *Le Monde*.

66. Quoted by Laura Connerly, "Angélique Kidjo," http://www.connect.org.uk/ merseyworld/worldup1/angelique.html.

67. Quoted by Burr, "From Africa," H28.

68. Quoted by Wentz, "No Kid Stuff," 43.

69. Quoted on her unofficial homepage maintained by Emmanuel Attia at http://www. imaginet.fr/~kidjo/bio5.html.

70. Ibid.

6

Anglo-Asian Self-Fashioning

> Nothing is quite as good as the India I invented at Waverly Place, New York.
> —Joseph Campbell[1]

> All interpretations of India are ultimately autobiographical.
> —Ashis Nandy[2]

In this chapter I want to examine two Anglo-Asian musicians, both born in England of South Asian descent: Sheila Chandra and Apache Indian. Both of these musicians have, at one time or another, attempted to construct musical and real selves from the various components of culture and identities available to them. Chandra juxtaposes sounds and songs from all over in an attempt to assimilate her various selves, drawing strength from certain aspects of the feminist movement in the U.K., and Apache Indian borrows sounds and ideas from Jamaican dancehall, rap music, and Anglo-Punjabi bhangra music in order to make what he calls "a very British sound."[3] The central problem for these musicians is identity—identity through belonging, and belonging through place. For Chandra and Apache Indian, it is belonging in England and to India, and how to create a sound and a space of their own.

SHEILA CHANDRA: "FROM ME YOU'VE STOLEN EAST AND WEST"

Asian Indians living in the United Kingdom have only recently begun to make musics that have generated broad public interest in the U.K. and beyond. One of these musicians is Sheila Chandra (1965–), who has cultivated a

worldwide audience of aficionados of acoustic world music. Her concerns are more artistic as well: her words concern musical features that transcend differences and focus instead on supra-national similarities. In this sense she, too, is political, but producing a highly aestheticized music, and perhaps less effective, since she treads close to the border of new age music, which is usually unconcerned with political issues.

When she was 16, already having achieved some fame as a child television actor, Chandra and musician/producer Steve Coe founded Monsoon in 1981, a band that featured east/west fusions that was briefly popular in England, disbanding in 1982 after disagreements with their recording company. Chandra now has a great deal of control over her recordings for Real World.[4] Monsoon made only one public appearance and one recording, *Third Eye*, released in 1983.[5] Their first single, "Ever So Lonely," was a Top Ten hit in the U.K. in 1982 and a version of it appears on Chandra's 1992 album, *Weaving My Ancestors' Voices*.[6] The earlier version made it to Top of the Pops, where Chandra appeared in a sari. After Monsoon broke up, due, Chandra says, to pressures from their company, which wanted the band to adopt a more "hit-making-machine type demeanor,"[7] Chandra and Coe, who had together (with Martin Smith) coined the word "Indipop" to describe the music of Monsoon, founded their own record label of the same name. Chandra has since released seven albums and married Coe.

Chandra has no training in classical Indian music, or any Indian musics, for that matter. She says she has been teaching herself through recordings and attending concerts. "As a child I heard mainly Karnatic music and some Hindi film music but not a great deal of either. It was something that I pretty much ignored."[8] For her, this lack of training in the classical music of her ancestors is a good thing. "I haven't had to overcome rules or had any sense of 'this is slightly wrong,' because with fusion you really have to discover the principles for yourself."[9] And she says that she grew up listening to the same pop music that any English person would, which makes her "oriented towards what the mainstream listener in Europe or America is used to hearing."[10] Chandra does list several Indian musicians among her heroes, however, and says that she employs rāgas in her compositions.[11]

Chandra is well aware of the global musical world she inhabits, saying that it is one of the benefits of living at the end of the twentieth century.

> Not only have we got the technology to access so many different traditions and things from different cultures, but we actually want to! It gives me a sense of myself as a world citizen to be alongside artists from other customs [in the 1993 WOMAD tour]. It's a very enriching time for people, if they're brave enough to go beyond the 'flavor of the month' faddishness that sometimes exists around this kind of scene. If they develop a lasting interest in something that broadens their minds musically, I think that's great.[12]

Of *Weaving My Ancestors' Voices*, Chandra writes that "some people seem to be interested in analysing the *differences* between different cultures and traditions. I'm interested in comparing the *similarities* and weaving them together—to take threads of thought that come from different techniques and singers and weave them into my own pattern."[13] This, for her, constitutes a "we're all one world" kind of stance such as we have encountered before.

> For me, the album is also a statement about going beyond Asian fusion. I do not want to be an Indian living museum piece here in England. Although I'm passionate about Asian music and culture, and though I involve the knowledge I have of Asian structures in my work, this album is more of a statement about me as a 'world citizen'. I believe that my heritage comes not specifically from my own culture. I believe I am a spiritual heir to a universal form of inspiration.[14]

Her music concentrates on commonalities. "Most traditions include the components of drone, either heard or implied, and ornaments for the voice," she writes.[15] Hence, her conglomeration of two songs from far different traditions into "Dhyana and Donalogue," on *Weaving my Ancestors' Voices*, a combined Muslim and Irish song. Many scholars of Irish traditional music have posited some sort of link between "Oriental" music and the music of Ireland; there has been a good deal of scholarly energy directed toward ascertaining the origins of Irish traditional music. Some of this work has resulted in classic publications: James Hardiman's *Irish Minstrelsy* of 1831,[16] Breandán Breathnach's *Folk Music and Dances of Ireland*, Seán Ó Riada's *Our Musical Heritage*, and most importantly, Fanny Feehan's "Suggested Links Between Eastern and Celtic Music."[17] This supposed "Oriental" influence seems to be taken for granted, but no one, however, has provided any evidence, or even much of a discussion, mainly because origins can never be unambiguously known.[18]

But they can be assumed, or, in Sheila Chandra's case, posited in musical practice. The "Donalogue" portion of "Dhyana and Donalogue" (an Anglicized corruption of the Irish "Dónall Óg," which means "Young Donal"[19]) juxtaposes two songs, an Irish one followed by a Muslim one (the title indicates the opposite arrangement from the performance). Chandra writes that "*Donalogue* is an ancient Irish ballad from about 1000 A.D.[20] to which I've added a new verse and changed some of its male-centered lyrics—the sentiment doesn't seem to suffer! The additional weaving of a Muslim style vocal into the piece leaves me wondering where the ornaments of each tradition begin and end."[21]

In the album following *Weaving my Ancestors' Voices*, *The Zen Kiss* (1994), Chandra writes of listening to British folk singers June Tabor and Sandy Denny and discovering that "the key ornaments . . . were exactly the same as the ones used in the north Indian tradition."[22] (Elsewhere, she describes other commonalities: "Then I realized I'd also heard this in Islamic vocals, Andalusian vocals and the music of Bulgaria. Suddenly it became crystal clear."[23]) The ornaments of

some Asian and Irish traditional musics are occasionally similar, although I should point out that her ornamentation of the Irish song is not strictly authentic. She inflects the sixth degree with a raised semitone in a way that no Irish singer ever would, as she does on the third line of "Dhyana and Donalogue." An extended and ornamented word is indicated by an underline; this (and other) ornamentations depart from traditional Irish singing styles and enter the realm of "Dhyana," rather than "Donalogue."

Dhyana and Donalogue

I saw you first, on a Sunday evening
About the old tower as I was kneeling
Upon Christ's passion as I was <u>reading</u>
But my mind was on you and my sore heart pleading.

This is a highly idiosyncratic version of "Donall Óg," not only because of its juxtaposition of two songs from parts of the world geographically distant from one another. Chandra did not grant permission to print my transcription of her version of the song; I'm therefore including a more straightforward version from a collection of Irish songs as Appendix 3.

Such juxtapositions of distant and unrelated pieces characterize the way Chandra and Coe (who works with her in composing) write most of the songs: combining, manipulating, seeing what will happen.

> Someone said to me that it all seemed so worked out, but all the working out happened afterwards. Originally it was me playing around with Irish vocals and my voice automatically going into Islamic vocal and then back again. My following what my voice wanted to do, causing a whole set of connotations to take place and a whole discovery of these gateways in music where a certain vowel sound or a certain tone of voice, a certain vocal ornament will lead you from one tradition to another. In that gateway there's like a nexus where there is pure music, pure vocal music and it could go in any number of directions.[24]

Note how Chandra constructs "Irish" and "Islamic" vocals as monoliths, which she has to do if she is going to adopt them in the way that she does. There are many different vocal styles in Irish traditional music, or, for that matter, in Ireland. Likewise the Islamic world, which if anything has even more kinds of musics and musicking. Chandra also assumes the naturalness of the two musics: "It sort of biologically works. It becomes a fusion within me in an organic way in terms of the mind that I have because of the context that I find myself in."[25]

What is interesting in the juxtaposition of the two songs is that moving from Ireland to the Islamic world is distanced in the production—there is some reverb employed in "Donalogue," but much more appears in "Dhyana," putting it much further back from the listener—mystifying it, in a sense. The switch of languages makes this shift even more striking. Both emphasize the new age tendencies of

Chandra's vocal experimentation, resulting in music that seems to exist for its own sake—not in the sense of art music but as music that doesn't have to mean anything other than pretty sounds.

In *The Rapacious Muse* I describe John Cage's critique of modern and modernist assumptions about music and musicking as antimodern in the sense that Cage used the composerly authority given him by modernity to compel listeners to make music for themselves, or, perhaps more accurately, to hear music around them for themselves without the presence or imposition of the composer. This, I argued, signaled his advocacy of premodern ideas, in which the ideas of "composer," "masterpiece," and "genius" had not yet arisen, and that music was something made by and for everyday people. With Chandra we find some of the same strategy operating, although her reliance on premodern ideologies is more musical than conceptual. Chandra uses folk and traditional musics (like those that rely on drones) as an instrument against modernity/postmodernity. The other musics she uses are all ancient, traditional, or composed.

But Chandra's music only could have arisen in the postmodern, global ethnoscape, where traditions, styles, and practices circulate and juxtapose themselves as never before. And Chandra's music, with its emphasis on acoustic sound production and drones, meets up with the new agers (among whom her music is fairly popular), mainly white European and North American middle-class subjects who seek spiritual and other kinds of identities through the trappings of other cultures, as religion, ritual, and music—almost anything. But in most record stores Chandra's music is usually found in the world music sections, demonstrating that racial/ethnic origins almost always count for classification more than anything else, as we have seen.

In addition to the mix of sounds from many places, Chandra also takes some pains to empower herself as a woman. First, she believes that women can do anything men can do.[26] On both *Weaving My Ancestors' Voices* and *The Zen Kiss*, Chandra includes pieces called "Speaking in Tongues," which are dressed-up versions of the syllables that all tabla players (in the Hindustani tradition) and mridangam players (Karnatic) learn as part of their training. Singing these songs as songs rather than exercises reflects the kind of universalization that Chandra is attempting: she sings these syllables—normally a male domain—aestheticizes them (that is, turns them into a piece, rather than a pedagogical tool), and entitles them with the name of a premodern religious practice.

Also, Chandra, like Djur Djura, makes connections with women around the world, and women in the past. *The Zen Kiss* includes a track entitled "Abbess Hildegard," that proves to be Hildegard von Bingen (1098–1179), nun, abbess, poet, mystic, and musician. Chandra's song is actually Hildegard's *Sequentia de sancto Maximino*, a sequence, a type of medieval plainchant.[27] Chandra's version sticks to the original at the beginning, but moves increasingly into her own sound world, in which sheer timbral beauty and the timeless, ethereal effects supplied by the drone come to the fore. She says that she wanted to include this song for a

simple reason: a plug. "I just felt more people should know about her. . . . She wrote plays and songs and chants, she advised kings and popes and queens—she had an incredible mind. I'd heard of Henry VII but I'd never heard of her! So I just wanted to correct it."[28]

Chandra has been criticized by some white feminists for having been manipulated, or for taking advantage of her clearly Indian looks and dress to attract publicity to Monsoon and herself.[29] Such a position pays insufficient attention to the problems of mimicry widely discussed by postcolonial theorists, the desire by dominant groups for "a reformed, recognizable other, as *a subject of a difference that is almost the same, but not quite* [emphasis in original]."[30] Looking like an Indian woman would ensure that Chandra is constructed as an Indian woman, perhaps exoticized, but dressing as a western woman would still mean that Chandra is constructed as an Indian woman, just as her music is classified as world music more than new age or any other category. Criticizing Chandra's dress also ignores the importance of taking over representations of oneself as much as possible. Hazel Carby and Susan McClary have trenchantly written on the importance of control over representations, and this is something Chandra has clearly thought about herself, having been stung by such criticisms.[31]

> It's a very difficult area. If you wear the best traditional clothes that you have, then you're making a statement. It's very difficult because you're making a non-verbal statement that can be interpreted in several ways. And the way that it was interpreted was in the nature of "Well, this is out of the ordinary". Therefore it must have been a stronger statement than perhaps I meant it to be. I meant it to be a strong statement in the sense that I'm proud of the way my ancestors dressed, of the patterns in the materials and their skills in producing them.
>
> I am proud of the way I look. I mean, I obviously look Indian and I can't hide that. That's the reason I did it. I also am—and was at the time—very aware that India for a lot of people means poor people, means slums; to some degree means extremes. I was trying to say in the way I dressed that I wanted to put forward the positive things about India and one of the positive things about India is its music.[32]

And Chandra has taken pains to exploit white British perceptions of South Asians, South Asian women, and India, saying that early in her career, "there was a very strong connotation that India was Patchouli oil and the Khama Sutra."[33] The cover of *Quiet* (1984) featured Chandra standing before a shadow puppet.[34] But her next album, *The Struggle* (1984), showed a begloved Chandra holding a wrench.[35] And Chandra says that before *Weaving My Ancestors' Voices*, "I haven't done anything overtly sensual, ever."[36]

This is one way of dealing with the preconceptions of a racist public: exploit both ends of the spectrum, the feminine, mysterious, delicate, exotic Asian flower one year, the mannish, handy, tool-wielding the next. In a way, this is much like Madonna's strategy, as McClary has so insightfully commented: Madonna plays

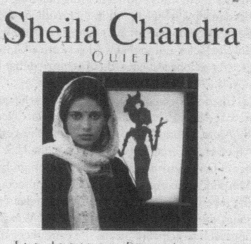

Figure 6.1
Sheila Chandra:
Quiet, cover (reissue).

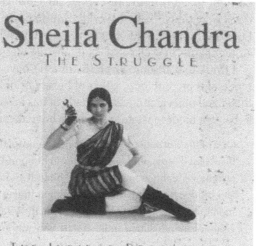

Figure 6.2
Sheila Chandra:
The Struggle, cover
(reissue).

both ends of the virgin/whore dichotomy allotted women by patriarchy, but ultimately refuses to be categorized by either position.[37]

Musically, Chandra's solution was one unique in this book: she sought to make experimental, unusual music—music true to the new directions she had hoped to follow that led to the disagreement with Phonogram (Monsoon's record company)—and ground her ethnic difference in musical difference. Her music, even

in Monsoon, wasn't "just a nothing pop song that had no interest to it and really needed a big image to sell it, that really needed a pretty young singer to sell it. Some people may think it's a novelty, that I was using it for a gimmick, for the novelty factor and so that we'd get noticed. I think, having stayed around in this area for as long as I have, that I've proved that I'm not just doing it because it's a novelty."[38]

Chandra's music, indeed, is proving to be quite popular with world music and new age fans alike; *Weaving My Ancestors' Voices* and *The Zen Kiss* both made *Billboard*'s World Music Chart. Her releases on Peter Gabriel's Real World label, which enjoys excellent distribution in the U.S. by Caroline, means that the number of fans is growing all the time, which probably accounts for the re-release of Monsoon's recording, an early Chandra recording entitled *Nada Brahma*, and the recent appearance of a previously released compilation of Chandra's early songs on an album entitled *Roots and Wings*.[39] Chandra's new age, aesthetic approach to her work means she can successfully sidestep issues of authenticity and cross these market lines. "I don't believe in drawing lines between cultures and between peoples," she says. "We all have the gift of a world heritage, different ways of seeing things, of doing things. . . . The idea of someone saying, 'You have no right to learn from our culture, because you're not one of our tribe'—well, that's ridiculous."[40] Real World's international marketing manager at Virgin in London, though, talks about the ways Chandra's recent music crosses over to ambient and "new classical" and new age markets.[41]

I think that at some level, she doesn't have any particular attachment to any mode of representation, either of herself or of her music. It is music; it is an aestheticized object; and what is made of it is less important. Chandra is committed to being a modern western subject who makes art.

> One of the frustrations I have as a person using these traditions, and being a part of the Asian diaspora but born and brought up in England, is what people see of my own individuality is marked by that filter. It comes before me into a room, I almost feel hidden behind it: this is a woman of Indian descent living in Britain. But I'm much more than that. I am an individual. What I'm trying to do musically is the vision of an individual, and that's the only way good art gets made.[42]

At the same time, Chandra universalizes through the voice: The ancestors she refers to on *Weaving My Ancestors' Voices* are spiritual, not cultural, she says, adding that "they're the threads of thought that have come to me from singers all over the world who have just been incredibly emotional and ornate and skillful with their voices. And what I'm trying to say is that this is a vocal heritage which is everyone's, and I'd really like people who listen to the record to feel that they can claim all this amazing vocal heritage for themselves."[43]

APACHE INDIAN'S *NO RESERVATIONS:*
"A VERY BRITISH SOUND"

More than anyone else in this study, Apache Indian (1968–), an English-born Punjabi from Handsworth, near Birmingham, exploits the free-floating signifiers so evident in Appadurai's ethnoscape. For this reason (and because of the abundance of sources) I will spend some time with him.

Apache Indian uses the name "Apache" (after the reggae star Supercat, the "Wild Apache") even though he is a different kind of Indian; he entitled his first album *No Reservations,* and the style he performs is a contemporary Anglo-Indian blend of dancehall and Punjabi traditional music called bhangra, combined into a music known in England as "bhangramuffin."[44] Apache Indian sings of issues relevant to his community in England, but so important to young Indians all over that he is among a handful of pop superstars in India; he found on his first visit there in 1993 that he was treated like a world superstar: "I was asked to meet the Prime Minister, which I did. I met Sonia Gandhi, Rajiv Gandhi's widow . . . nobody meets her." "By the time I left India," he says, "they were calling me the 'Gandhi Of Pop'."[45]

Apache Indian's music falls between the cracks of bhangra and dancehall, but closer to dancehall; he is the only South Asian musician to cross over and find listeners among reggae fans; his music is usually found in the reggae sections of record stores; his music is reviewed in newspapers and magazines usually catering to African American and Afro-Caribbean readers[46]; and he is discussed more fre-

Figure 6.3
Apache Indian.

quently on rec.music.reggae than on any Indian music newsgroup on the Internet. His fan base among South Asians is therefore due more to his ethnicity and his subject matter, as well as much of the publicity that considers him a bhangra musician because of his ethnicity. For example, this recent post from rec.music.indian.music about Apache's second CD, *Make Way for the Indian* (1995)[47]:

> True it wasn't bhangra but the reggae was jammin. . . . he had some really dope beats. . . . If you are not into reggae I can understand, but if you are, or at least like it a bit, this cs [cassette] was great . . . in fact I liked it better than the last one. . . though Arranged Marriage was stilled the dopest and hippest song I have heard in a while.

Another post credits Apache with encouraging Indians to listen to reggae.

> Peace to yal out der, Apache indian must get respect for all that he did for raggae music in general. He has brought reggae music into the homes of people that would never have had the chance to actually listen to raggae. India has 800 million people of which many now have become raggae music listeners.

Whether classified as bhangra or reggae, the success of Apache Indian has focused attention on bhangra and it's worth outlining its history briefly. Since the mid–1980s, bhangra was hugely popular among Asians in the U.K. and India before Apache Indian; it was the first music in this community to help promote and solidify a unified Anglo-Asian identity. It now has its own chart and weekly newspaper, *Ghazal and Beat*, the first publication devoted to any Asian music — popular or otherwise — in the U.K.[48] Even though part of the mix of musics that contribute to the bhangra come from the Punjab in India, it is fast becoming the most popular music among all Indians in the U.K., whether Sikh, Hindu, Muslim, Jain, or Christian, and it is being exported out of the U.K. to India, east Africa, Australasia, and to South Asian communities in the North America.[49] The popularity of bhangra has helped young Anglo-Asians, in Dick Hebdige's words, break up "imaginary Britishness," that is, bhangra makes available new identities, even new kinds of identities, postcolonial, and transnational, at the same time Britain is becoming part of a unified European market and identity.[50] "Through the patterns of belonging and distancing established in these forms of cultural production," Hebdige writes, "new forms of 'British' identity become available which circulate along with the records themselves in the clubs and casette [sic] players and on the pirate radio stations."[51]

Some of Apache's Anglo-Asian fans identify with his ethnicity and achievements. "They are happy and proud that Asian music is in the charts because that hasn't really happened before," Apache says. "When I was a kid I remember Monsoon, but the difference here is that it's Indian subjects with a street element. What was lacking was that street vibe."[52] Elsewhere he talks about hearing the different musics around him. "On the videos and all the films from India, you'd hear the music and learn the names of all the bhangra artists. On the street it was a dif-

ferent vibe again. On the playground you hear the reggae sound."[53] Apache also talks about being the only Indian he knew who was interested in reggae.

> There was something about the music. Regardless of what anybody said, it was for me. I just wanted to be part of it, get close to it and I did by buying reggae records in the reggae shops. Someone might say, "Look, here comes the Indian man!" or if I went to a dance, "What's he doing here?" but that was nothing really. At 16 I had dreadlocks. My bedroom was red, gold and green. As an Asian you can understand it caused a few problems. Most older Asians see reggae as a violent, drug related thing. They would hear about black people mugging Asian women . . . that was all blown up. My parents were always there but my aunties and uncles couldn't under-stand. People said that I was forgetting my own roots and culture but that wasn't it, I just loved reggae music.[54]

The U.K.'s position as a former colonial power with many of its colonialized now living in the U.K. makes possible this kind of identity and self-fashioning.

Apache elsewhere talked about the great influence of black culture on young Asians.

> I was from a new generation of Asian kids who were brought up alongside black kids, but we had no street culture or heroes to relate to—all we had were videos from India. We were discouraged from talking about things like sex or contraception or arranged marriages.
>
> The new generation of Asian kids wanted to talk about these things and we want-ed a street culture of our own.[55]

Apache believes that his single "Movie over India," which went to number 1 in both the Asian and the reggae charts in 1990, helped solidify young Asian attitudes.

> Asian kids had already brought the street fashion clothes they had seen their black pals wearing at school—but because of all the prejudices our parents' generation had about black people the clothes stayed in their wardrobes. It took "Movie over India" before the kids had the confidence to wear it . . . we grew up with black kids, went to school with them, had black friends. The new generation of Asian kids have a new culture that consists of a lot of different things—an Asian thing, a white thing and a black thing. The Asian thing is still very important to them, but I want to put all these things together to take our culture forward.[56]

Apache credits his success to his appearances on MTV, which have generated requests for him from all over Asia, saying that "Without MTV, I'd probably be still DJ-ing or singing some form of reggae in Birmingham. The whole thing about discovering my ethnic background and putting it into my music comes from media exposure."[57] His point here isn't clear, though he appears to be saying that without his Anglo-Asian fans prompting him to take up certain themes in his lyrics, he would still be primarily a reggae musician.

Apache, whose real name is Steve Kapur,[58] makes social meanings the primary focus of his music, saying, "There's a lot more than the music involved here."[59] Brooke Wentz's article about him describes Apache traveling to India in June of 1993, listening intently to Indians telling him of social problems there. He takes notes. He also consults his parents.

> I had people writing to me admitting almost that they had AIDS and didn't know what to do or how to deal with it. I had to re-write the AIDS song ["AIDS Warning"] for the EP. It's a lot more meaningful now. Who ever addresses these things—problems of caste—must take on board the hassle. Do you know how much hassle I got from the older generation for the last line of "Arranged Marriage" ["Me want arrange marriage from me mum and daddy"]? But now they have to face up to the reality. You're explaining to them what's happening on the street.[60]

Elsewhere he said, "I want to speak on things that haven't been talked about before. Because of our religious upbringing, we found that there are a lot of subjects that need to be discussed among the Asian community—like arranged marriages, and AIDS. . . . I'm not saying that we're going to solve the problem, I just want to bring them out in the open for discussion."[61] His political proselytizing has made him unpopular among some sectors. "I've faced a lot of criticism," he told Wentz. "Some people tell me I shouldn't be talking about these issues. I have to carry security wherever I go."[62] And he recognizes that taking on controversial issues could result in violence: "Mahatma Gandhi ended up getting shot so you have to be prepared to face the negativity that will come from certain people. I'm prepared for that."[63] This is the Rushdie problem again, as we saw in the case of Djur Djura in chapter 3.

Even though he tries to sing about what his fans want to hear, he usually plays an active role as social critic himself. Following the local election victory on 17 September 1993 of a British National Party candidate, Derek Beackon, who ran on a platform of "rights for whites," Apache was "bombarded with phone calls asking him to do something," according to Rachel Iyer of Island Records U.K., Apache Indian's record company. The singer himself said, "It's the scariest news I've heard, and I can only hope it isn't a spreading virus."[64] He responded with a single, "Movin' On," in which he explicitly criticizes Beackon and his party, and describes recent racist attacks on an Anglo-Asian, Quaddas Ali. Apache Indian is donating proceeds of the single to aid Ali's family, nine people arrested in antiracist demonstrations, and youth organizations in Beackon's district.

Apache recognizes that his stardom in a European metropolitan center—in particular, the seat of the erstwhile Empire—gives him a unique perspective on his ancestral home. Whereas an Indian might not be able to find the distance necessary to critique his or her own culture, a geographical outsider with an insider's interest might get the job done. "People seem to underestimate Asians and do not recognize that we can be artists. Being on the Top of the Pops and MTV is big

news to them," he tells some local journalists in New Delhi. Later, to Wentz, "India is the country, and the whole world is the audience. That's the way we're looking at it. We are here to put India on the map." [65] India has long been on the map, of course, but not as a place that produces stars popular in India and elsewhere.

"ARRANGED MARRIAGE"

First released as a single, "Arranged Marriage" on *No Reservations* debuted at sixteenth place on the U.K. singles chart upon its release in January, 1993. It is among the most fascinating songs of the subsequent album not just because of the lyrics (included below) but the range of sounds employed. The narrator (presumably Apache himself, since the introduction and later verses refer to him by name; he also goes by Don Raja), is a hip young gangsta in need of a wife. She shows up in the narrative but does not speak. She does, however, speak in the song itself: above the almost-rapped lines Apache sings, a woman's voice soars occasionally, singing in a style out of Indian film music. This line alternates with a synthesized line that sounds like a harmonium, an instrument introduced by missionaries and now often used in accompanying religious music in South Asia.

Other traditional sounds appear as well. The song opens with a brief splash of rhythm on the *dhol* drum, a quick sonic nod to traditional bhangra. Then flute-like music starts, with the percussion playing a steady beat, *dhol* and tabla drums (found throughout the musics of North India, including film music) barely audible in the background. This music lasts throughout the introduction.

Not appearing in the printed accompanying lyrics is a barely intelligible background chorus, sung by a woman most prominently, and a man more in the background, who sings with her an octave lower. This fragment of music sounds closest to more mainstream U.S. pop and some rap in its more lyrical moments. But the woman, like Apache, occupies more than one cultural identity: she also sings in English and sings with a man—she has a boyfriend, as Apache has a girlfriend, and her marriage was arranged as well. Moreover, the lines "I'm lookin' for love" are sung in American English, as if to point out the European/American ideology of the love marriage espoused in the background. While these lines are being sung, another woman sings a vocalise (an untexted line) in a style closer to Indian film music, even more in the background, as if she is the woman back in India who is waiting for Apache to come home.

Example 6.1
Apache Indian:
"Arranged Marriage,"
background chorus.

The music is remarkable, but it is the words that have captured the attention of most listeners, the words in English, anyway.

Arranged Marriage[66]

intro.

Well the time has come fe the original, Indian to get married—
And you done no, already when the Indian get married a pure, tradi-
 tional business—
so all the people that, say them no too love the arrange marriage thing,
 catch this one here now—
beca when we come we, come to educate the people them everytime

verse 1

Now the time has come mon fe Apache,
Fe find one gal and to get marry,
But listen when me talk tell everybody,
Me want me arranged marriage from me mum & daddy

chorus

Me wan gal from Jullunder City,
Me wan gal say a soorni curi [beautiful girl],
Me wan gal mon to look after me,
Me wan gal that say she love me

verse 2

Nough gal a thema come mon from all over,
And who find them no the Buchular [matchmaker],
Say that a the mon we call the matchmaker,
And fe him job a to find no the right partner,
Him have to trod go a East and trod go a West,
And the North and the South fe find which gal best,
But a no lie say me lie me have to confess,
Say the Don Raja me want a Princess

chorus

Me wan gal a fee me Don-Rani,
Me wan gal dress up in a sari
Me wan gal say soorni logthi [looks pretty],
Me wan gal sweet like jelebee

verse 3

Now nough of them a sweet and some a ugly,
And some of them a marga [skinny] mean she puthlee [skinny],
And some of them a mampee [fat] that a muttee curi [fat girl],
And some too English talk no Punjabi,
Say the gal me like have the right figure and,
In she eyes have the surma [a kind of eyeliner] and,
Wear the chunee [scarf], kurtha [blouse] pujamer,
And talk the Indian with the patwa,
Ca the time has come mon fe the Indian,
To find the right gal say a pretty woman,
But listen when me talk tell each and everyone,
Say me arrange marriage are the tradition

chorus Me wan gal fe me arrange marriage,
 Me wan gal a say me can manage,
 Me wan gal from over India,
 Me wan gal take a fe me lover

[background *I'm lookin' for love, or just a lover*
chorus] *'Cause I can be one or the other*
 I'm lookin' for love, or just a lover
 'Cause I can be one or the other

verse 4 Say the engagement that are the Kurmai [engagement],
 Where me have fe make sure me is satisfy,
 Two family them a meet is called the Milhni [meeting with prospec-
 tive bride],
 Pure sugan [gift] where them bring mon fe Apache,
 Then you have fe me wife mon called the Bortee [wife],
 And me have to tell she about Apache,
 Me no mind where you do from you respect me,
 And after the roti [bread] bring me the sensi [affection]

chorus Me wan gal respect Apache,
 Me wan gal go bring me sensi,
 Me wan gal o meri [mine] serva curee,
 Me wan gal respect me mum & daddy

verse 5 Doli are the time everyone start cry,
 Ca the wife she a leave and have fe wave bye,
 Go to the inlaws called the sora [father-in-law],
 To start she a new life in a next somewhere,
 So next time you a pass a see Apache,
 Just say buthia [congratulations] to congratulate me,
 But if me yard you a pass and you want greet me,
 Bring the Ludu [Indian sweet], the beson [Indian sweet] and the
 burfee [Indian sweet handed out at weddings]

chorus Me wan gal from Jullunder City,
 Me wan gal say a soorni curi,
 Me wan gal that say she love me,
 Me wan gal sweet like jelebee,
 Now me done get marry but me start to worry,
 Me have to tell you something mon would you help me,
 About me arrange marriage me have a problem,
 When is the right time to tell me girlfriend!,
 Beca the time has come mon fe Apache, Fe find one gal and to get
 marry,

But listen raggamuffin tell everybody,
Me want arrange marriage from me mum and daddy

double Me wan gal a fe me Don-Rani,
chorus Me wan gal dress up in a sari,
 Me wan gal say soorni logthi,
 Me wan gal sweet like jelebee,
 Me wan gal from, Jullunder City,
 Me wan gal say soorni curi,
 Me wan gal man to look after me,
 Me wan gal to make me roti

Apache's lyrics talk about himself, his fame, just as a rapper's words would. But the language is a heady mixture of English, Jamaican English, and Punjabi, a "patwa" (as the third verse says) whose meanings are sometimes obscure, but which come through most of the time thanks to Apache's reggae-like style of syllabic declamation, more sung than rap lyrics, but not really sung either.

The line "When is the right time to tell me girlfriend!" makes the song for his listeners, Apache says. "You go through a system where you have girlfriends and boyfriends, you go through another system at home where you have to have an arranged marriage. It's like a double life. You love and respect both lives but you're faced with a problem. . . . The new generation of kids are well aware of these things and the music is filling a gap."[67] Apache says that people asked him to write a song about arranged marriage. "Girls have asked me to sing about how they have to run away from home because their parents can't accept the kind of life they want to live."[68]

The lyrics of the song clearly speak to concerns of Apache's immediate fan base, though I would argue that he is ultimately ambivalent about arranged marriage and the world of two cultures—Indian and English—in which he finds himself.[69] He does, after all, want an Indian wife. Kathleen Hall's study of young Sikhs in Leeds, England, reveals that young Sikhs speak of their feelings over arranged marriages versus "love matches"; given the divorce rate, Hall says that they would "trust their parents to 'assist' their marriages before the would trust an English love match. . . ."[70]

South Asians I have interviewed, musicians and nonmusicians both, dislike Apache Indian's music. "Not very interesting harmonies," a well-known Indian novelist living in New York City told me. "Very clever but . . ." a professional tabla (paired drums) player living in Washington, D.C. said (who, by the way, has recently released his own world fusion CD and has appeared on more obscure "world fusion" recordings for years). South Asian listeners seem to find the music too clever to be good, or, admit that the words might be clever but the music has little to offer. Perhaps this is because, as Apache himself explains, his music represents "a very British sound." "You'd never get this in Jamaica because you

wouldn't have the bhangra element. You wouldn't get it in India because you wouldn't have the reggae or the pop element. The music is everything around me."[71]

What is interesting about "Arranged Marriage" and many of the songs on the recording is the way that Apache spatializes and choreographs the various places and positions that make up his self-conception, and those of the women characters; this arrangement of positionalities is scarcely evident in the lyrics, which look like a more straightforward hybrid of Punjabi and English, with a little "patwa" as spice. In the music, the reggae sound predominates, but flitting around the edges are the distant sounds of India, either in the vocalise of Indian film music, the *dhol* and tabla, or more folklike ululations. Note how this observation—which I take to be crucial—is not available through examination of the nonmusical signs. George Lipsitz examines Apache Indian in his provocative *Dangerous Crossroads* and makes a similar point about Apache's identities, but I would like to add that the music itself demonstrates the ways that Apache juggles and juxtaposes identity conceptions, with India sometimes far, sometimes near, reggae up front one moment and gone the next, and with Apache's supposed intended in the background making her own arrangement with her boyfriend.[72] The fact of the multiple subject positions newly available in the global postmodern is only part of the picture; equally important is the way they are lived and deployed, negotiated and renegotiated. "Bangra [*sic*] and Indi pop," writes Dick Hebdige,

> the vibrant trademarks of a growing number of second-generation British Asians, are played across the gaps and tensions not just between the "home" and the "host culture," with their different language, behavior norms, belief systems, and cuisines, not just between *two* cultures (the "traditional" East, the "permissive" or "progressive" West), but between many *different* south Asian cultures, between the multiple boundaries which for centuries have marked off different religions, castes, ethnic traditions with a "community" which appears homogeneous only when viewed from the outside [emphasis in original].[73]

I agree thoroughly with Hebdige's analysis of the fluidities and solidarities made in and around music by different South Asians. Nonetheless, there is still racism, and there are still old binary oppositions at work, as Hall's essay on Sikh youth culture in northern England helps demonstrate. Apache himself isn't a Sikh, but the pressures that operate on Hall's informants aren't any different than those Apache confronts. Hall wonders why Sikh youths feel pulled in many different directions for their identities and affiliations, but ultimately feel torn between only two identities: British and Asian. Drawing on Paul Gilroy's *There Ain't no Black in the Union Jack*, Hall argues that the two most powerful ideologies in Britain shape subjects as white—British—or Black, in impermeable, mutually exclusive ways. Hall identifies five "cultural fields" in which Sikh youths commonly operate, the Sikh *gurdwara* or temple, home, town, school, and "Eng-

lish nightlife," listed in order from most Indian to most English. Any young English Sikh moves fluidly through each of these, an individual adopting whatever mode of behavior is appropriate to the situation.

Hall argues that the poles—the temple, where her informants are most authentically Sikh, and "English nightlife," where they are least—define a cultural field that allows Sikh youths to "play with identities that lie somewhere in between."[74] One of her informants speaks of these tensions in remarkable language: *"You can't have both of two worlds,"* while she goes on to say that she tries [emphasis in original].[75] Or as Apache himself observes, "Because kids . . . go out to schools and colleges; they go out with boys and girls and stuff but they come home and it's almost like a double life and this is what was lacking on the Indian [popular music] scene."[76] The binarized dialectic of Indian versus English is expressed in every aspect of self-conception, which I have summarized below in a table derived from Hall:

Table 6.1
Dualities in "Indian" and
"English" self-conceptions.

Indian	English
black	white
traditional	modern
backward	modern
backward	educated
backward	western
religious	not religious

Apache's music exemplifies the room for "symbolic play" that Hall's findings identify.[77] But there's clearly more than that, as Apache Indian himself shows us. White and black, yes, but black can also mean South Asian, or even, as Apache is trying to tell us, blacks and South Asians and even Native Americans across the water can come together. And what's English about "Arranged Marriage," or any of the songs on his recordings? The English language, to be sure, but this is employed in a thick "patwa." His music could only happen in Britain, as he tells us, but at the same time, it provides a way of escaping the Englishness of the place, escaping the dialectic of black or white. Apache's music provides a new identity that does function in both worlds.

I have delayed theorizing identity and music until this point because I wanted to make the case of identity as something both fluid and stable: fluid because it audibly is, sometimes, and stable because stability is what many subjects say that want. Conceptions of identity do flow, but they ebb as well, and sometimes they even rest. This observation may not seem all that profound, but there is a tendency in theories of identity, and theories of musicalized identities, to go for the flow, because it is a model that seems to work. Simon Frith's provocative "Music and Identity," for example, asserts that "identity is not a thing but a process."[78] I'm saying, it's a process both toward and away from a thing—a stable identity—that many musicians and fans hold on to. These musicians and fans often speak in

other ways. Sasha, an Anglo-Indian woman bhangra musician in the U.K., says that "I always want people to know that this girl is Asian" when they listen to her music.[79] Asian, pure and simple, not (in this moment) female, young, black, Punjabi, Hindu, whatever: just Asian.

Gayatri Gopinath also discusses bhangra and identity in a recent article, shedding much light on conceptions of gender and nation, and the ways in which bhangra articulates different positions at the same time but ultimately reinforces patriarchal values. She writes, for example, that "Arranged Marriage" "quite transparently reinserts women into a standard role as bearers of 'tradition,' even while, in his disruption of claims to origination or racial authenticity, Apache undermines the very notion of 'tradition' as a pure or recuperable space."[80]

I think Apache's strategy is a little different, though. The musical signs Apache wields undermine his claims to patriarchy as much as tradition. The line that Gopinath quotes from the chorus, "Me wan gal," is not said/sung by Apache himself; it is performed by background voices in an extremely guttural, aggressive way and helps highlight the several kinds of male desires evident in this song: sexual, old cultural, new cultural, desires to please one's parents. But the point is that the way the lines are uttered ironizes them, as if Apache knows they shouldn't be said while at the same time finding a way to get away with it. Other words are sung/spoken in ways that similarly invert their literal meanings, such as "serva curee," where Apache's voice soars high at the end of each word, as if asking a question. Feminism has been far too influential in Apache's generation—and mine—for such words to be written, said, or sung without some consciousness of their possible reception. Such ironization of patriarchal or traditional male sentiments has become a noticeable feature of much post–1980s popular music (the Beastie Boys are the great virtuosi of this kind of irony that isn't quite irony—or is it?). Whether or not this is postmodern (as the phenomenon has been identified by some theorists[81]), Apache's lyrics are further called into question by the background vocalists singing, "I'm lookin' for love." Apache's musics and lyrics together demarcate an ambivalent position between arranged married=tradition=patriarchy, to which he is partly drawn, and love marriage=modern=(more) egalitarian, to which he is also partly drawn.

BHANGRA IN THE U.S.

While bhangra is hugely popular in the U.K. among South Asians, and, as we have seen, while some of this popularity has traveled back to India and to other South Asian communities around the world, bhangra has not caught on as much in South Asian communities in the U.S., though it is big in New York City and growing in some other communities.[82] This raises an important point: analysis of lyrics and even music can go only so far. These can tell us that hybridization happens, that new selves and alliances are being proposed. But they cannot tell us about reception.

Occasional postings to newsgroups on the Internet make it clear that there is an small but active bhangra scene in America.[83] These postings also indicate that Indians in America seem to be more caught up in American ideas about what makes popular music worth listening to, for discussions on rec.music.indian.misc display all the same issues that American pop and rock fans espouse: authenticity (either to rock, or to "real" bhangra from the Punjab), accusations of selloutism, and identity politics.[84] A few excerpts and discussions will help clarify this.

Given the ephemerality of postings on the Internet it is difficult to say when the "bangra [*sic*] sucks!!" postings started.[85] The first I saw appeared in late February 1995:

Why does bangra suck so badly?

Bangra is a music for off-the-boat immigrants who are trying so hard to fit in with our American culture. They want to be like Americans so badly that they are willing to show shame towards their own culture. I really don't like Indian music either, but I have respect for it because it is a display of Indian culture. If y'all start listening to bangra, y'all are giving up on your own culture.

The Indian children of today seem to dislike their culture. Why don't you guys classify yourselves as White? It's no different than listening to bangra.

While it would be easy to pick apart this statement for its lapses in consistency of logic (the writer talks about "our American culture" but also refers to Americans in the third person, and he criticizes bhangra lovers for betraying Indian culture, but then says that he himself doesn't like Indian music), it is more important to uncover the premises: that for this person, bhangra isn't Indian, but (white) American. Also, he contends that Indians in America should stick with their own culture, without ever saying what that is—certainly not one that includes listening to Indian (classical?) music.

These sentiments understandably elicited a number of heated replies. Some users pointed out that western artists who make hybrid musics are usually praised and that listening to bhangra can be a way of recalling one's roots, not running from them, as a netter in Philadelphia points out:

I think listening to bhangra is a way to go back to your cultural roots, not a way to pull you away from them. I hate it when the young adult crowd turn their noses away from bhangra, but then they end up listening to rap, hip-hop, top-40, alternative, new wave, etc. They don't even give bhangra a chance! But these same people would think that it's cool if some Western artists started using dhols, tabla beats, and harmonium breaks in their songs! Give me a break! You should be more upset at these people, not the bhangra listeners!

Other responses focused on the music's authenticity (or lack thereof): "Bhangra is good to listen *IF* it is in its original Punjabi form," wrote one user, arguing that if it is popularized into "punjabi pop," then it "well and truly sucks." And an Anglo-Indian user wrote in to say that "I was born in England. I speak

Punjabi. Bangra is the folk music of the Jats of Punjab. If he thinks we are trying to be white by listening to Bangra, then I guess every other Punjabi in Punjab is also trying to be white."

As in all popular musics, some listeners make judgments solely (or principally) on aesthetic grounds. So a recent post to rec.music.indian.misc excoriates Apache Indian for not being original enough. This Canadian user's slang speaks to his involvement in reggae and hip hop culture, and he has a South Asian surname, but, while he makes many recommendations of other reggae recordings to listen to, he never refers to any South Asian musicians but Apache and Bally Sagoo, a Birmingham, England DJ.

> are you on some fucked up shit? the apache indian is finished soundbwoy! every thing he releases is a carbon of lyrics and beats that already exist. check this shit— on his last album he chats with Tim Dog, (yeah Dog was safe when he was with the Ultramagnetic MC's but now that punk gets dissed by all MC's) on that track "make way for the indian", make way for you? eat a dick! then he has a track with YAMMI BOLO. BOLO is butta, but the track is a rip off, of NINJAMANS' old shit. then he's got that jungle cut, half the lyrics are from SHABBA, the other half is from one of his own old songs and the tune is from GENERAL LEVY'S "incredible". then to top off the album he has 2 messed up disco/60's shit in "raggamuffin girl" and that played out shit "boomshakalak". on the first album, the track "chok there" (nigga can't even spell that shit) was a compilation of rip offs—the beats from SHABBA, some lyrics from CAPLETON, some from SUPER CAT, and the rest from APACHE SCRATCHIE. what does he call himself?—don raja, thiefed it from SUPER CAT the DOD DADA. if you listin to some of SUPER CATs albums "BOOPS", "SWEETS FOR MY SWEETS", "CABBIN STABBIN", "DON DADA", "THE GOOD THE BAD THE UGLY AND THE CRAZY" and "THE STRUGGLE CONTINUES" you'll see that the apache indian ripped off alot of lyrics. i'll admit the second album did have some decent beats and so did the first but they sounded like it took a week to produce and mix. listin to some true dancehall, BEENIE, BOUNTY, CAPLETON, MEGA, MAD LION, RICKSTA, RAYVON, SUPER CAT, SPRAGGA, FRANKIE SLY, LITTLE LENNY, BUJU, STITCHIE, TOP CAT, SILVER CAT, LOUIE CULTURE, the list goes on rudie. educate yourself in the dancehall and you too will lose any respect you had for the apache indian. as for that bally sagoo, who the fuck knows? who the fuck cares?

Bhangra's visibility is increasing slightly in the U.S., though, but it is still hovering around the fringes of the world music and world beat clientele, where it will probably never be successful since it sounds too slickly popular to make it as a world music genre. Rec.music.indian.misc does list an occasional announcement of a bhangra party, and South Asian students at some universities have bhangra parties occasionally though they are mainly for insiders.[86]

Without this virtual ethnography we might not have learned of the differential

popularity of bhangra among diasporic South Asians. Hybridization happens, as we knew from Lipsitz's *Dangerous Crossroads*. And this hybridization and its meanings don't work equally in all the places the diaspora has reached. South Asians in different locales and situations have different histories and forge different musical and political alliances locally. Lipsitz's interpretation of Apache Indian's texts as political and liberatory must also be understood in conjunction with Apache's own admission that he injected his music with political concerns and signs of his ethnicity based on his reception on MTV in England and that his popularity among Indians outside the U.K. is quite contested. Likewise, Apache's music, with the insights gained from Kathleen Hall, helps show that the "imaginary Britishness" that Dick Hebdige writes about isn't what these musicians are escaping, but what they are creating and inhabiting.

NOTES

1. Campbell, letter to his wife Jean Erdman, 19 October 1954, quoted by Stephen and Robin Larsen, *A Fire in the Mind: The Life of Joseph Campbell* (New York: Doubleday, 1991), 373.

2. Nandy, *The Intimate Enemy: Loss and Recovery of Self under Colonialism* (Delhi: Oxford Univ. Press, 1983), 80.

3. Amanda Whittington, "A very British Sound," *New Statesman & Society* 6 (26 February 1993), 35.

4. See Dominic Pride's "Chandra's Harmonic Drones Come Together on Real World," *Billboard* 108 (22 June 1996), 9.

5. *Third Eye*, Phonogram PIPCD 001, 1983. With the growing popularity of Chandra and her music, *Third Eye* was re-released by Mercury, a large American label, in 1995, Mercury 314 526 527-2.

6. On Real World/Caroline 2322-2, 1992.

7. Chandra, interview with Charley Cvercko and Vickie (no surname given), 11 September 1993; this interview, as far as I can determine, has not been published and exists solely on the Internet, appearing in the newsgroups alt.music.world and alt.music.alternative in the spring of 1995.

8. Quoted by Ken Hunt, "Sheila Chandra: Weaving Musical Traditions," *The Beat* 12 (1993), 54.

9. Chandra, interview with Jonathan Shulman, *Rhythm Music Monthly* 2 (August 1993), 6.

10. Ibid.

11. A rāga is a scalar melody form in the classical music system of India.

12. Shulman, *Rhythm Music Monthly*, 7.

13. Chandra, liner notes to *Weaving my Ancestors' Voices*, Real World Records, 2322-2, 1992.

14. Ibid.

15. Ibid.

16. According to Marie McCarthy, "Music Education and the Quest for Cultural Identity in Ireland, 1831–1989," Ph.D. diss., University of Michigan, 1990.

17. Breathnach, *Folk Music and Dance of Ireland* (Cork: Mercier, 1977); Ó Riada, *Our Musical Heritage*, edited by Thomas Kinsella and Tomás Ó Canainn (Portaloise, Ireland: Dolmen, 1982); and Feehan, in *The Celtic Consciousness*, edited by Robert O'Driscoll (New York: George Braziller, 1981). See also Alwyn and Brinley Rees, *Celtic Heritage: Ancient Tradition in Ireland and Wales* (London: Thames and Hudson, 1961); and, most recently, Bob Quinn, *The Atlantean* (London and New York: Quartet Books, 1986). Thanks are due to Stephen Lessard for bringing that last book to my attention.

18. Discussions of Irish traditional music have been largely confined to examinations of particular tunes or styles; methodologies from musicology or ethnomusicology have often not been used. Harry White has called for new approaches to Irish traditional music — particu-

larly a sociological one—but none, as he has noted, have been forthcoming (White, "The Need for a Sociology of Irish Music," *International Review of the Aesthetics and Sociology of Music* 15 [1984]: 3–14). See also White's "Music and the Perception of Music in Ireland," *Studies* 79 (Spring 1990): 38–44.

19. A more traditional, Irish version can be found on *Muintir Catháin* (*The Keane Family*), gael-linn CEF 107, 1985.

20. I don't know where she gets her information. "Dónall Óg," is tonal, and tonality in Ireland did not precede tonality on the European continent, which began roughly at the beginning of the seventeenth century. Since most traditional music—in Ireland and everywhere else—was not written down, if at all, until the eighteenth century, questions of dating are so problematic as to be impossible.

21. Chandra, liner notes to *Weaving My Ancestors' Voices*. In an interview with Ken Hunt, she says the song is about 800 years old (Hunt, "Sheila Chandra," 55).

22. Chandra, liner notes to *The Zen Kiss*, Real World/Caroline 2342-2, 1994.

23. Quoted in Simon Broughton et al., eds., *World Music: The Rough Guide* (London: Rough Guides, 1994), 40.

24. Quoted by Lois Darlington, "Fusion Vocal," *Folk Roots* 134/5 (August/September 1994), 31.

25. Quoted by Hunt, "Sheila Chandra," 55, 71.

26. See Darlington, "Fusion Vocal."

27. See Hildegard von Bingen, *Sequentia de sancto Maximino*, transcribed, ed., and trans. Pozzi Escot (Bryn Mawr, Penn.: Hildegard Publishing Company, n.d.).

28. Quoted by Darlington, "Fusion Vocal," 29.

29. In *Signed, Sealed, and Delivered*, Sue Steward and Sheryl Garratt comment on Chandra's appearance at Top of the Pops in a sari: "When British-born actress Sheila Chandra tried for the UK charts with the Indi-pop group Monsoon, she projected an . . . image to a public who still largely saw Indian dress as exotic. She was an opulent exaggeration of Western ideas of the East, looking like a Turkish delight ad, in richly coloured saris, dark eye make-up and wearing (along with the men in the band) a red dot in the middle of the forehead. This kind of exotic packaging is a seductive marketing ploy—another stereotype for women to be shaped by." Steward and Garratt, *Signed Sealed and Delivered: True Life Stories of Women in Pop* (Boston: South End Press, 1984), 40.

30. Homi K. Bhabha, "Of Mimicry and Man: The Ambivalence of Colonial Discourse," *October* 28 (Spring 1984): 126.

31. See Carby, "It Just Be's Dat Way Sometime: The Sexual Politics of Women's Blues," *Radical America* 20 (1986): 9–22 and McClary, "Living to Tell: Madonna's Resurrection of the Fleshly," in *Feminine Endings: Music, Gender, and Sexuality* (Minneapolis and Oxford: Univ. of Minnesota Press, 1991).

32. Quoted by Kate Hickson, "The Indi Chart," *Folk Roots* 83 (May 1990), 25.

33. Quoted by Darlington, "Fusion Vocal," 28.

34. *Quiet* is on Indipop 2, 1984.

35. *The Struggle* is on Caroline 1704 1781 4, 1984.

36. Quoted by Darlington, "Fusion Vocal," 28.

37. McClary, "Living to Tell."

38. Quoted by Hickson, "The Indi Chart," 25.

39. *Nada Brahma*, Caroline Carol 1780-2, 1995; *Roots and Wings*, Caroline Carol 1779-2, 1995.

40. Quoted by Kenny Berkowitz, "FYI: Sheila Chandra," *Option* 68 (May/June 1996), 24. Ellipsis in original.

41. Pride, "Chandra's Harmonic Drones," 96.

42. Quoted by Berkowitz, "FYI," 24.

43. Chandra, interview with Linda Wertheimer, National Public Radio, *All Things Considered* (7 June 1993).

44. *No Reservations* is on Mango 162-539 932-2, 1992.

45. Quoted by Paul Bradshaw, "Handsworth Revolutionary," *Straight No Chaser* 23 (Autumn 1993), 29. Ellipsis in original.

46. For example, B. Petrie, "Apache Indian: *Make Way for the Indian*" [review], *Everybody's: The Caribbean-American Magazine* 19 (30 June 1995), 27.

47. On Mango 162-539 948-2, 1995.

48. For more on bhangra, see Sabita Banerji, "Ghazals of Bhangra in Great Britain," *Popular Music* 7 (May 1988): 207–13; Gerd Baumann, "The Re-Invention of Bhangra—Social Change and Aesthetic Shifts in a Punjabi Music in Britain," *World of Music* 32 (1990): 81–98; and Peter Manuel's *Popular Musics of the Non-Western World* (New York and Oxford: Oxford Univ. Press, 1988), and *Cassette Culture: Popular Music and Technology in North India*, Chicago Studies in Ethnomusicology, ed. Philip V. Bohlman and Bruno Nettl (Chicago: Univ. of Chicago Press, 1993). Less scholarly articles chronicling bhangra's rise in popularity among Asian Indian communities include Vaughan Allen, "Bhangramuffin," *The Face* 44 (May 1992), 104–8; Kevin J. Aylmer, "British Bhangra: The Sound of a New Community," *Rhythm Music Magazine* 4 (1995), 14–17; and David Stanley, "Bhangra Music Comes Stateside via Multitone," *Billboard* 106 (18 June 1994), 17. A new e-zine devoted to hip hop musics (including bhangra) recently appeared on the Internet: http://streetsound.clever.net/bha.html; other important bhangra sites on the Internet are http://www.brad.ac.uk:80/~szia/Bhangra/; Bhangra Central, at http://www.geocities.com/ SunsetStrip/6746/bhangra.htm; the Bhangra Network, at http://www.zensys.co.uk/home/ page/s.rattan/; Nachda Punjab Bhangra Homepage, http://www.golden.net/~jheeta/ bhangra.htm; and an excellent page in Canada, http://yucc.yorku.ca/home/sanraj/bhangra.html. The largest record company specializing in bhangra recently started a homepage on the Internet at http://www.omnium.com/pub/multitone/. Finally, a useful compilation recording entitled *What is Bhangra?* can be found on IRS Records 7243 8 29242 27, 1994.

49. Sabita Banerji and Gerd Baumann, "Bhangra 1984–8: Fusion and Professionalization in a Genre of South Asian Dance Music," in *Black Music in Britain: Essays on the Afro-Asian Contribution to Popular Music*, ed. Paul Oliver (Buckingham: Open Univ. Press, 1990). See also a National Public Radio report on bhangra in which the reporter goes to a London club and interviews young people waiting to get in. There are Punjabis, Pakistanis, Sikhs, and others. Several say that if their parents knew they were there they would be angry (Neva Grant, National Public Radio, *Weekend Edition* [21 August 1993]).

50. Hebdige, "After the Masses," in *Culture/Power/History: A Reader in Contemporary Social Theory*, ed. Nicholas B. Dirks, Geoff Eley, and Sherry B. Ortner, Princeton Studies in Culture/Power/History, ed. Nicholas B. Dirks, Geoff Eley, and Sherry B. Ortner (Princeton, N.J.: Princeton Univ. Press, 1994), 234.

51. Ibid.

52. Whittington, "A Very British Sound," 34.

53. Quoted by Jeff Chang, "On the Warpath," *A. Magazine* 2 (Fall 1993), 66.

54. Quoted by Bradshaw, "Handsworth Revolutionary," 26. Ellipsis in original.

55. Quoted by Mary McCaughey, "An Apache from Handsworth," *Living Marxism* 52 (February 1993), available on the Internet at http://www.junius.co.uk/LM/LM52/LM52_Living.html#1.

56. Ibid.

57. Quoted by Jerry D'Souza, and Mike Levin, "Indian Artists benefiting from MTV Asia Exposure," *Billboard* 105 (4 December 1993), 42.

His work on MTV has been successful. Apache's video, "Boom Shak-a-lak" won the prize for best reggae video at the 1994 U K. Black Music Awards in London, and is featured in the opening credits of the otherwise aptly titled film *Dumb and Dumber*.

58. I have seen his surname listed as "Kapul" several times, though I am assured by Punjabis that this name makes no sense.

59. Quoted by Thom Duffy, "Apache Indian's Asian-Indian Pop Scores U.K. Hit," *Billboard* 105 (20 February 1993), 14.

60. Bradshaw, "Handsworth Revolutionary," 29.

61. Quoted by Brooke Wentz, "Apache Come Home," *Vibe* 1 (November 1993), 86.

62. Ibid.

63. Quoted by Bradshaw, "Handsworth Revolutionary," 29.

64. Quoted by Thom Duffy, "U.K. Politician Draws Fire from Apache Indian," *Billboard* 105 (2 October 1993), 107.

65. Wentz, "Apache Come Home," 87.

66. Not being a Punjabi speaker I put out a

plea on the Internet to soc.culture.punjab, which was answered by Hiren Chandiramani and Pardeep Singh Mann, who helped with the Punjabi words. I would like to thank them both, and Pardeep in particular, for their time and insights.

67. Quoted by Whittington, "A Very British Sound," 35.

68. Ibid.

69. See also Hanif Kureishi's *The Buddha of Suburbia* (New York: Viking, 1990), which includes an important subplot about an arranged marriage.

70. Hall, "'There's a Time to Act English and a Time to Act Indian': The Politics of Identity among British-Sikh Teenagers," in *Children and the Politics of Culture*, ed. Sharon Stephens, Princeton Studies in Culture/Power/History, ed. Nicholas B. Dirks, Geoff Eley, and Sherry B. Ortner (Princeton, N.J.: Princeton Univ. Press, 1995), 259.

71. Quoted by Whittington, "A Very British Sound," 35.

72. Lipsitz, *Dangerous Crossroads: Popular Music, Postmodernism and the Poetics of Place* (London and New York: Verso, 1994).

73. Hebdige, "Digging for Britain: An Excavation in Seven Parts," in *Black British Cultural Studies: A Reader*, edited by Houston A. Baker Jr., Manthia Diawara, and Ruth H. Lindeborg, Black Literature and Culture, ed. Houston A. Baker Jr. (Chicago and London: Univ. of Chicago Press, 1996), 139.

74. Hall, "'There's a Time to Act English and a Time to Act Indian'," 254.

75. Ibid., 247.

76. Apache Indian, interview with Katie Davis, National Public Radio, *All Things Considered* (18 July 1993).

77. Hall, "'There's a Time to Act English and a Time to Act Indian'," 255.

78. Frith, "Music and Identity," in *Questions of Cultural Identity*, ed. Stuart Hall and Paul du Gay (London and Thousand Oaks, Calif.: Sage, 1996), 110.

79. Quoted by David Stansfield, "More Labels Bang Drum for Euro-Asian Bhangra Beat," *Billboard* 106 (1 October 1994), 20. Sasha's *Cultural Vibes* on Multitone DMUT 1294, 1995 is well worth listening to.

80. Gopinath, "'Bombay, U.K., Yuba City':

Bhangra Music and the Engendering of Diaspora," *Diaspora* 4 (Winter 1995): 315.

81. Most prominently by Linda Hutcheon in *The Politics of Postmodernism*, in which she writes that postmodernism "takes the form of self-conscious, self-contradictory, self-undermining statement. It is rather like saying something whilst at the same time putting inverted commas around what is being said." Hutcheon, *The Politics of Postmodernism* New Accents, ed. Terence Hawkes (London and New York: Routledge, 1989), 1.

82. Bhangra is popular in Canada, though not as widespread as the U.K. See Larry LeBlanc, "Bhangra's Bubbling under Toronto Radio and Dance," *Billboard* 105 (6 March 1993), 49.

83. See Jasbir K. Puar, "Home, Hybridity, and Nationalism: South Asians and Bhangra Music," paper presented to the Association for Asian American Studies Conference, Oakland, California, 1 June 1995. Thanks are due to Jasbir for giving me a copy of this paper. For reports of bhangra events, see "Indian American Youth in the Dock," *Little India* 4 (31 August 1994), 60; and Sridhar Tallapragada, "No Doldrums Amidst the Dholdrums," *Little India* 4 (30 September 1994), 23.

84. For treatments of these issues, see Philip V. Bohlman, *The Study of Folk Music in the Modern World*, Folkloristics, ed. Alan Dundes (Bloomington and Indianapolis: Indiana Univ. Press, 1988); Lawrence Grossberg, *We Gotta Get Out of This Place: Popular Conservatism and Postmodern Culture* (New York and London: Routledge, 1992); Barry Shank, *Dissonant Identities: The Rock 'n' Roll Scene in Austin, Texas*, Music/Culture, ed. George Lipsitz, Susan McClary, and Robert Walser (Hanover and London: Wesleyan University Press, University Press of New England, 1994), and my own "David Byrne's *Rei Momo* and the Politics of Authenticity" (in preparation).

85. The "bhangra sucks" postings appear to be semiregular. Another campaign began in November 1995, though it was a cruder episode than the one I am describing here. This later one was mainly bhangra fans versus Indian film music fans and did not touch on the issues of origin and identity that the conversation detailed above did.

86. Since the rise of Apache Indian, some musicians have combined bhangra with another U.K. dance music craze called jungle, resulting in yet another hybrid called "bhangle." To my knowledge, nothing has yet been written on bhangle, though there is an excellent web page, http://www.state51.co.uk/state51/hottips/bhangle.html.

Apache Indian is cutting a jungle/bhangle track, "The New Style," for Outcaste Records, and his recording after *No Reservations, Make Way for the Indian*, includes a jungle track, "Who Say?" DJ and Outcaste employee DJ Ritu told *Billboard*, "Jungle has drawn together all kinds of British youth, including British Asians, which accounts for the wide popularity of jungle on the Asian club scene. It seemed fitting for Outcaste to produce a jungle track featuring a high-profile Asian artist such as Apache Indian" (quoted by Dave Hucker, "Jungle Fever Spreads in U.K.: Reggae/Techno Hybrid Growing Quickly," *Billboard* 106 [29 October 1994], 1). Apache himself says that "jungle is a sound that comes from London, and I wouldn't say that I'm a big fan. . . . Jungle is a form of reggae and brings back some of the old reggae vibes and bass lines and samples, but I couldn't listen to it all night. It's big with the kids" (quoted by Russell Gerlach, "Birmingham's Indyian," *ClubLife* 2 [1995], 20).

For a collection of bhangle music, see *Deep into Jungle Territory: A Jungle-Bhangra Fusion*, Multitone DMUTA 1314, 1994, which was reviewed by Mark Kemp, *Option* 65 (November/December 1995), 99.

Toward a More Perfect Union

Cross-Cultural Collaborations

Last vestiges of colonial-imperialist mentality cause us to mistake other peoples' culture for the raw material of our eclectic postmodern "mix." But in fact we're guilty of cultural appropriation—or in less fancy terms, stealing from friends. . . . "Multiculturalism" means that your little bit of "folk art" will look nice in my living room. Well, fuck that shit. We're interested now in de-centering the discourse and constructing a cross-cultural synergy. No more pyramids with Euro-males on top and "anonymous" voices from some distant Turkish radio on the bottom. Collaboration—not appropriation. Translation— not interpretation. Life—not "lifestyle." Plagiarism as a cultural tactic should be directed at putrid capitalists, not potential comrades. "World" culture is either true co-creation, or it is nothing. Or worse than nothing:—a sin against the holy spirit. There is no exotic other. Planet Earth—love it or leave it.

—Hakim Bey[1]

In *The Communist Manifesto*, Karl Marx and Friedrich Engels write, using startlingly utopian language, that, with the eventual demise of capitalism,

> in place of the old wants, satisfied by the production of the country, we find new wants, requiring for their satisfaction the products of distant lands and climes. In place of the old local and national seclusion and self-sufficiency, we have intercourse in every direction, universal interdependence of nations. And as in material, so also in intellectual production. The intellectual creations of individual nations become common property. National one-sidedness and narrow mindedness become more and more impossible, and from the numerous national and local literatures there arises a world literature.[2]

Or a world music.

In a sense this vision has been realized, since western popular music travels more and further than any other music, resulting in the new sounds and hybridities I have been examining in this book. But, as Steven Feld has written, no matter how collaborative and syncretic a musical style sounds, we should always remember the musicians' relationship to the means of production.[3] In the case of Peter Gabriel and the musicians discussed in chapter 2, the relationship was skewed in favor of Gabriel, who, despite stated good intentions, remained firmly

within the existing structures of control in production that emphasizes individual achievement over group participation and that values the activities of stars.

Even though I am setting out to discuss collaboration in this chapter, I nonetheless don't want to forget the inevitable inequities in cross-cultural production. In looking for a way around these inequities, I'm not arguing for separatism or authenticity, but rather new modes of production in collaboration, such as Marvin Winans and Ladysmith Black Mambazo's version of "Leaning on the Everlasting Arm" discussed in chapter 3.

JOHNNY CLEGG, SIPHO MCHUNU, AND JULUKA

The ambivalent success of Paul Simon's *Graceland* has ensured that most listeners outside South Africa have some notion of what some South African popular musics sound like. But westerners were involved in making and making known African music long before Simon; the white South African Johnny Clegg is one of these. Born in 1953 in Rochdale, England, he and his mother moved to Zimbabwe (then Rhodesia), his mother's birthplace, then moved again with his mother and stepfather to Johannesburg when Clegg was seven years old. Clegg's mother was a cabaret singer, his stepfather a liberal journalist who was strongly anti-apartheid and who had an interest in black culture.

From his early teen years, Clegg sought out Zulu musicians to learn from and says that it was his interest in the music that first prompted his cross-cultural for-

Figure 7.1
Johnny Clegg and
Sipho Mchunu.

ays. His first teacher was Mntonganazo Mzila, a Zulu apartment cleaner who played street music near Clegg's home when Clegg was a teenager. "My entry into Zulu music," says Clegg, "was not a political statement, it was a cultural journey, an adventure in the context of a crazy political system, and politics caught up with *me*. I never wanted to be with black people to show anyone anything about politics. I went in there because I loved the music and I wanted to be there and to play it" (emphasis in original).[4]

Clegg also discusses the early lure of the music. "It was as if some very powerful disclosure was being made to me and I didn't understand it. And that freaked me out. Those songs seemed to be from another place, another time. And yet they were discussing something about the world. There was a secret locked in there. And then I knew that I had to know that secret."[5] So in "Heart of the Dancer" on *African Litany* (1982), he, Sipho Mchunu, and their band Juluka sing:

> I want to look into the heart of the dancer
> His movements have a magic mystery
> They must have a message and a meaning
> 'Cause he's doing something to me
> Please don't let the drum stop beating
> I have to understand
> How he dances our future and our destiny
> And how we became part of this land[6]

A POLITICIZED MUSIC

Clegg's interest in Zulu music and other aspects of Zulu culture led him, professionally, to an M.A. in Social Anthropology and a junior lectureship in the Social Anthropology Department of the University of Witwatersrand in Johannesburg, a leading university in South Africa with a strong liberal history. Clegg's academic career resulted in his learning the Zulu language and dance and publishing several articles on Zulu music and dance. But Clegg left the university in the 1970s to pursue a career in music. To continue his musical education, he approached Sipho Mchunu, a migrant worker employed as a gardener in Johannesburg who was also a street musician. Mchunu says that he was at first puzzled by a white man's interest in him, but Clegg eventually won him over; Mchunu taught Clegg traditional Zulu music (having taught himself to play on a tin guitar made from a gasoline can) and instruments, and in 1970, they formed a duo called Johnny and Sipho, which lasted until 1976.[7] In 1979, they released a new album entitled *Universal Men*, under the new name Juluka, Zulu for "sweat." Along the way Clegg learned the Zulu language and an athletic style of Zulu traditional dance called *indlamu* that he performs as part of his act.

Clegg spoke about the early days of Juluka in Jeremy Marre's film *Rhythm of Resistance*. "Originally, it was very difficult to play together in public, the laws being as they are: a black and a white not being allowed to play on a stage, or to a

mixed audience. Things are starting to ease up slowly, as you see tonight at the market. We've got a few sort of little hidden venues where everybody can come together and enjoy each others' music."[8]

Clegg said that he and Mchunu were "not revolutionaries, we're not a protest group. We have certain general principles that are fundamental human values. It's basically, 'I want to be able to play to everybody.' That's all. I mean, it's a simple thing. But in South Africa, it's a political issue."[9] Mchunu says much the same thing: that when they first started playing together, "We didn't care about politics, because we didn't know about politics. I was just happy with a friend."[10] But some of their early songs as Johnny and Sipho were quite political. In introducing a Zulu song to a small audience at one of their hidden venues, Clegg explained how the song's story gave rise to a Zulu proverb: "The bull does not stab with his horns but with his fighting knowledge. It is the spirit that counts, not superior weaponry." Clegg's gloss on the proverb brings it into the realm of the political struggle he and Mchunu had embarked on, saying that the proverb symbolized "the victory of the underdog over his oppressor."[11]

Eventually, inevitably, Clegg's interest in Zulu traditional music and dance and his work with Sipho Mchunu collided with the apartheid government. According to Jeremy Marre and Hannah Charlton, the government succeeded in banning a record that featured a song because it was "an incitement against work" and questionable for its use of slang, with words such as "sweetie" and "heavy."[12] Other songs banned were "Africa" on *Universal Men*, a number one hit before being banned[13] and "Asimbonanga," a tribute to Nelson Mandela and Steve Biko on *Third World Child*.[14] Robin Denselow writes that Clegg and his band after Juluka, Savuka, were often in trouble with the South African police: their van was regularly searched, and problems with their concert licenses were commonplace.[15]

Johnny and Sipho, then Juluka, are usually credited with being the first interracial band in South Africa. Clegg says that is not the case.

> Well, I don't think we were the first mixed group. I think if we look back to the fifties, there was quite a strong multi-racial tradition, especially in the African jazz music scene. It was the sixties when the cultural segregation really became serious. I think we were the first multi-racial group, if you want to call it that, experimenting with culture in the sense of looking at the roots of Zulu culture and, say, Celtic folk music and trying to find threads of similarity, trying to weave them somehow into a meld or mix. The band Juluka was the first band in South Africa to effect a full mix of tribal music and Celtic folk music. Later we mixed in general western pop, from jazz to blues and reggae.[16]

In an interview with Chris Stapleton Clegg reflected on the success of Juluka, linking it to black South Africans' growing interest in African American popular musics. "Juluka appeared at a time when black people were buying up records by the O'Jays in the hundreds and thousands. We went back to our roots. A cult fashion began, with people playing roots music. You had something similar in 1970,

and again in 1976 with the black-consciousness movement, an attempt to recapture and to stress African roots and origins."[17] The impetus for this attempt was African Americans' search for social justice and roots.

This search for roots music was by and large a solution to the paradox caused by the white-controlled media. Millions of black South Africans listened to African American musics on the radio, to which they had no administrative access. At the same time, the apartheid government fostered any adherence to tribal customs as a way of dividing black South Africans. "Thus," Charles Hamm writes, "black radicals of the 1970s, within the country and in exile, largely rejected contemporary commercial, mass-disseminated music in favor of older syncretic genres less contaminated by government appropriation," such as jazz and choral "freedom songs."[18] Here is an instance where "authenticity," in this case, fidelity to the oldest remaining forms of musicking, is explicitly rejected for political reasons in favor of syncretisms, not authentic in and of themselves, but believed to be more authentic than the commercial music propogated by the apartheid government.

Juluka went on from playing in small clubs and markets to become a hot band, popular with both blacks and whites. Clegg and Mchunu's music started as fairly traditional Zulu music with a political edge, but as they produced and as other musicians joined them, their music began to show a more western pop orientation; by the *Scatterlings* album of 1983, several other musicians had joined the band. Most of Juluka's albums, however, still show the influence of *mbaqanga* music.[19] Clegg told Chris Stapleton that his music, township pop, is "a new genre. It's a genre where reggae and *mbaqanga* meet, where soul and *mbaqanga* meet, where funk and *mbaqanga* meet."[20]

In 1985, weary of being a musician on the road, Mchunu left Juluka to return to KwaZulu, one of the black homelands, retiring on the money he had made from his work as a musician; he wanted to concentrate on building his homestead and family. He now has five wives and twenty-five children.[21] Clegg then formed a new band, Savuka—Zulu for "awakening"—a group consisting of three blacks and three whites, some of whom had occasionally worked with Juluka. The members on the most recent incarnation of Savuka, on the album *Heat, Dust & Dreams*, are Derek de Beer, drums, backing vocals, percussion; Keith Hutchinson, keyboards; Solly Letwaba, bass guitar, backing vocals; and Steve Mavuso, keyboards.[22] (Another member, Mntowaziwayo "Dudu" Ndlovu, died in 1992.) Savuka's music is more electronic than Juluka's ever was, but Clegg doesn't feel that authentic traditional styles should be preserved as museum pieces. He thinks that musicians should feel free to experiment with styles and come up with new musics, arguing, as an anthropologist might, that music itself isn't intrinsically political: "Culture by itself isn't 'liberal' or 'conservative.' It's what you *do* with it" (emphasis in original).[23]

As Clegg says, the politics of apartheid South Africa caught up with his love of the music and dance, so that now his music and liberatory political ideals are

inseparable. And Clegg has much to say on the political impetus behind his constructed identity as the "white Zulu." His discussion of this identity comes out of a cultural anthropologist's understanding of the workings of race and culture.

> Apartheid is both a racial *and ethnic* system, so race and culture, white and black, Afrikaner and Zulu, these represent its two primary features. When you can take race and culture and meld them subconsciously within an apartheid psyche, you make a very powerful statement. What you are saying is that race and culture are manifestations of the same thing, so a "white Zulu" is a complete contradiction of that. Against the discourse of apartheid during those years, it was a very hip thing: the guy is white but he is Zulu. This became a township joke; people would say *uZulu mhlope nam'*, "that white Zulu." Both blacks *and* whites would come to me and say, "What do you see in this?" and not in a nasty way, but genuinely . . . really wanting to know [emphasis in original].[24]

Clegg's analysis of apartheid makes it clear that this separatist view of the world is a kind of colonialism, a colonizing of the mind. "Apartheid isn't just something outside. It's something in the brain. It's something that divides you from a greater whole. For me, Mandela was a link pin toward wholeness. He held the key to bringing together different groups, to bringing unity. Not a cynical political unity, but a psychic, spiritual, intellectual, cultural unity. Because apartheid fragments those levels."[25]

Clegg wasn't interested only in ousting the apartheid government, but looking and cultivating awareness and understanding beyond the current prejudices. For example, in the late 1980s, Clegg and Savuka decided to give a concert in Pretoria for young Afrikaner children. This required some delicate maneuvering, since few venues would permit blacks, musicians or not, to enter. There were the inevitable threats of violence, but the band played to full houses. "At the end of each show," Clegg recounts, "there was a pile of letters, some of them written in Afrikaans by 15-year-old kids, saying: 'Thank you for showing us something that we didn't even know could exist in this country'. For me it was a great reward."[26]

Whites like Clegg who are involved in using or making music by black South Africans are often criticized from a variety of angles, so despite his political activism and accomplishments, Clegg's music has received all kinds of negative reviews. *Melody Maker*, for example, attacked Clegg for plundering African music, calling him a "cultural transvestite"[27]; *Rolling Stone* criticized him for not being original enough.[28]

Some of the same confusion engendered by Paul Simon and the *Graceland* musicians' appearance in London in 1992 (when anti-apartheid protesters demonstrated outside a concert hall in London, while inside Simon and the members of the tour sang "Nkosi Sikelel' iAfrika") affected Clegg earlier. In 1988, Clegg, ironically, was expelled from the British Musicians' Union for performing in South Africa. Clegg had had run-ins with the union before, as well as problems with civil-rights organizations outside South Africa. He thinks that people outside

South Africa view the racial issues in an overly simple way. "The exile community," he says, "has done the struggle a disservice by trying to present the issue simply in terms of black and white."[29] Clegg and Savuka thus were not allowed to play in a giant concert in London's Wembley Stadium honoring Nelson Mandela's 70th birthday, despite a letter from Winnie Mandela (in those days, still a powerful figure) in support of the band.

THE MUSIC

One of the ways Clegg and Mchunu attempt to articulate musically their view of a post-apartheid South Africa is by pointing out that South Africans have all suffered the disruptions and the fractured identities caused by the colonialization of South Africa and apartheid.[30] "Scatterlings of Africa," which was just voted as the favorite song (tied with "Kwela Man," also on the *Scatterlings* album) by the readers of the Scatterlings mailing list on the Internet, tells a story of the hungry, the searching, all trying to make a better South Africa, at the same time employing rocking, upbeat music. But this music, nonetheless, subtly indicates the scattered, fractured, anxious tone of the lyrics by employing a meter rare in popular musics, 7/4, which would never allow most listeners to find a metrical "home," that is, a reliable, recurring downbeat.[31] All of this, however, following a straight eight-bar introduction in 4/4.

Example 7.1
Juluka:
"Scatterlings of Africa,"
first chorus.

Here are the complete lyrics, modified slightly from those included in the liner to match the performance.

Scatterlings of Africa

Copper sun sinking low
Scatterlings and fugitives
Hooded eyes and weary brows
Seek refuge in the night

Chorus

They are the scatterlings of Africa
Each uprooted one
[They're] On the road to Phelamanga[32]

Where the world began
I love the scatterlings of Africa
Each and every one
In their hearts a burning hunger
Beneath the copper sun

Broken wall, bicycle wheel
African song forging steel, singing
Magic machine cannot match
Human being human being
African ideas, African ideas—make the future clear
Make the future clear

Chorus

They are the scatterlings of Africa
Each uprooted one
[They're] On the road to Phelamanga
Where the world began
And for the scatterlings of Africa
The journey has begun
Future find their hungry eyes
Beneath the copper sun

Ancient bones from Olduvai[33]
Echoes of the very first cry
"Who made me, here and why?—
Beneath the copper sun."
My very first beginnings
Beneath the copper sky
Lie deeply buried
In the dust of Olduvai

Chorus

And we are scatterlings of Africa
Both you and I
We're on the road to Phelamanga
Beneath this copper sky
And we are scatterlings of Africa
On a journey to the stars
Far below we leave forever
Dreams of what we were

Hawu beke Mama-ye! Mama-ye!

Spoken

In the beginning
Beneath the copper sky
Ancient bones
In the dust of Olduvai
Who made us, here, and why
Remember!
Scatterlings of Africa (repeat)

"Scatterlings" oscillates between E♭ major and its closely related key, C minor, giving evidence of the kind of ambivalence and unwillingness to be confined to a particular tonal space and identity that Susan McClary described in her analysis of two songs by Madonna. For McClary, Madonna's refusal to adhere to a single tonal area in "Like a Prayer"[34] signaled a move away from the traditional virgin/whore dichotomy imposed by patriarchal western culture into a space in which Madonna refuses to attach herself to either of those subject positions, while playing with both. "Tonal structures," McClary says, "are organized teleologically, with the illusion of unitary identity promised at the end of each piece."[35] Likewise, I would argue, Clegg/Mchunu's tonal ambivalence here is an attempt to escape the usual black/white oppositional formulation of social life in South Africa and the usual codes associated with major and minor tonalities, with major as the more positive of the two. Everyone is a scatterling, everyone is displaced by apartheid, everyone is "decivilized," use Aimé Césaire's word,[36] left without a stable home or identity.

Clegg himself admits that the culture of resistance in South Africa is a huge jumble of ideologies, some of which conflict. Such ambivalence is not confined to South Africa, as the London stories of Paul Simon and the *Graceland* musicians' experience and Savuka illustrate.

> In 1969, in a full-blown apartheid society [Zulu concepts of life and death expressed in music and dance] amounted to an organic form of . . . "the culture of resistance," which South Africans talk about in completely incoherent ways, as if it is a conscious attempt by a group of people to create expressive forms which will resist. These people were at the bottom of the pile. Most of them were illegal here. They were considered to be backward, rural, tribal, pagan, uneducated people, even by black people in the townships; and here they were saying, "We live." And when you hear the concertina being played in the street at night, and it bounces off the walls, that's what that crying concertina says: "I will be heard." The Zulu have a saying, *Inqanye mpile*, "There is nothing left except the stubborn determination to live" . . . This is not a political consciousness, but a resistance to the world, a resistance to what the world throws against you. Stubborn determination, commitment, all these ideas and values are very important.[37]

Clegg and the other musicians do not simply create nontonal or post-tonal musics; rather, they want to make a new space with the musical materials at hand.

Clegg's style with Savuka has moved further and further away from the traditional music he learned from and performed with Sipho Mchunu; the music on *Cruel, Crazy, Beautiful World*[38] reflects his knowledge and synthesis of contemporary popular musics in North America and the U.K. particularly the highly sophisticated funk of The Artist Formally Known As Prince and the politically charged, angry vocals of Sting. Clegg said in 1993 that

> I don't want to *be* the Great White Hope, but I want to give people hope, realistic hope. Black people don't have to be told about one man, one vote. [Clegg took on the issue of one man, one vote in "One (Hu)'man on Vote" on *Cruel, Crazy, Beautiful World*.] Black people don't need to be told about searching for an African identity. But white people, especially young white people, do. I understand their fears. I understand their problems. I try to make them feel this is their time—they are the ones who for better or worse will make an impact. I try to tell them not to be victims of history. Because they're excited by the prospect of change but not sure they can deal with it. There's a lot of paralysis to overcome. What they see is the picture of something that when we started out was of the future. And now it can be the present [emphasis in original].[39]

Prescient words, perhaps, but Clegg has not stopped his activism since the demise of the apartheid government. (He has not, however, released a new album since the election of Nelson Mandela as president.) One of his current battles concerns the paucity of local musics on the South African Broadcasting Corporation. Clegg, ever the anthropologist, makes a point about the inseparability of cultural production and reception. "Radio is not merely a reflection of the market's tastes. It also shapes tastes and influences our aesthetic preconceptions."[40]

Post-apartheid Clegg interviews are few thus far; one shows Clegg caught up in political issues as much as ever. "You know, it's the best and the worst of times. It's the most incredible social, economic, political and cultural pudding."[41] Clegg notes that problems of unemployment and lawlessness are there, but at the same time there are some signs of positive change. "In some schools, we have these experiments going on where you have all the various cultures and races together. It might be a Ramadan holiday where the Muslims don't come to school. Then the children at that school learn all about Ramadan that day."[42]

Since the end of apartheid, Clegg says, with some perplexed pleasure, that he has had to drop from his active repertoire some of his more political songs. "Resistance themes [are] out of vogue," says a recent report on post-apartheid culture in South Africa.[43]

> The thing for me is I look out to a sea of facades and I realize that there is a whole generation of young people who are discovering my music in a different context.

They're first-year students four years after Mandela was released, and I'm playing them songs from a previous era. It takes some ability for a writer to transcend those two epochs and for the songs to still have some kind of meaning. I've had to drop songs because they were too issue-based. . . . One about a township bus boycott, or "Missing" [on *Third World Child* of 1987] about political detainees being abducted by the apartheid regime. Those songs are now locked in an era. But that's only about 30 or 40% of my repertoire. The other stuff has transcended that period for me.[44]

Most notable in Clegg's recent activities is that Savuka seems to be falling apart. Their drummer moved to Canada, and Clegg fired the keyboard player, leaving only two of the original members of Savuka besides Clegg himself. He is thus working again with Sipho Mchunu; they toured together in the summer of 1996, and talk of a reunion is in the air.[45] At the very least, a new album is in the works. He has formed his own record label, Look South Records; he is becoming involved in multimedia projects. And he is still being political, more as a community activist than ever, working for the Community Law Center and anticipating becoming involved in youth empowerment.

And he and others are discovering that the kind of music Clegg and Juluka made is becoming a kind of model for post-apartheid cultural production. "Crossover is really beginning to happen," says playwright Athol Fugard. "That is the one thing that is going to replace apartheid as the motor in terms of the new artistic wave in this country. It's the rich, abrasive contact between different cultures rubbing up against each other that is going to spread all sorts of creative sparks."[46]

At the same time, Clegg realizes there are problems with a post-apartheid world; South Africa's apartheid insularity protected musicians and other artists from competition with artists from the rest of the world. "We're coming out of 30 years of cultural, political and economic isolation. South African culture has developed in an unnatural vacuum, and the standards achieved in musicianship, performance and composition have not really been tested against international competition. Musicians are struggling with the idea and reality that they have to compete with UB40, Sting, Whitney Houston and Phil Collins. There's a sense that we are second-class in our own country."[47]

Perhaps most interestingly, given Clegg's past work and this new focus on crossover, his own interest in unifying the various forces in apartheid seems to have waned. In a recent interview, Clegg acknowledges that perhaps a kind of unified self isn't possible. "When I was lecturing in the anthropology department at Wits [the University of Witwatersrand], there was this expectation that, as a progressive person, one would be capable of uniting all the conflicting sides of oneself and becoming a truly integrated adult. But, for me, that is impossible. I have learnt, rather, to accept the fragments and the changes."[48]

THE SONGCATCHERS: "HISTORY 101"

While collaborations between blacks and whites in politically-charged South Africa may be the most dramatically interesting, there are some less visible collaborations that are doing some important cultural work. Long before the founding of the SongCatchers,[49] Native American musicians were making recordings and making bids for popular music stardom: Buffy Sainte-Marie (who has recently released an album after a hiatus of 15 years), Patrick Sky, A. Paul Ortega, Robbie Robertson (who has recently returned to his roots to record music for the PBS series *The Native Americans*[50]), and others. But to use Native American sounds, words, or instruments invited immediate marginalization, removal from the rock category and into the folk or ethnic, and it is the rock niche where the real money and prestige are.

At the same time in American culture, the roots movement of the 1970s, the New Age movement of the 1980s (and beyond), the men's movement, and the rise of interest by the late 1980s in world music, mainstream American interest in Native Americans grew. Kevin Costner's 1990 film *Dances with Wolves* registered this interest. Not long after *Dances with Wolves*, a new conglomeration of Native American musicians (and other Americans) formed a band called SongCatchers, a band that credits Costner with raising media consciousness, calling him, half-jokingly, "the Great White Costner God."[51] The name SongCatchers refers to the belief of some tribes, particularly the Pima of the Southwest, that music isn't "composed" in the western European sense, but exists already, and is caught or "untangled" by the musician.[52] The music captured by the SongCatchers is a mixture of pop, rock, jazz, and Native American musics and language that works in innovative ways.

Arlie Nekashi, leader of the White Eagle Singers and one of the founding members of the SongCatchers, says that, "We tried really hard to create Native

Figure 7.2
The SongCatchers.

music first and then build the Western music around it. We have some pieces that are driven by a Native core and the rest of the band plays modern music around it. My goal with the music was to highlight the Indian vocal style in a real traditional sound and form. I don't think that has been explored in this way before."[53] The result is something other than the "ethnotechno" kind of electronic manipulations that have proliferated in the last few years, with Deep Forest's (the "project" that became a "band," to recall Michael Whitaker's words in the epigraph to chapter 2) *Deep Forest* as the most salient example.[54] Most of these have avoided Native American musics until the 1994 release of *Sacred Spirits* by Virgin, which topped the national sales charts in France in the summer of 1995, selling nearly a million units; it has fared far less well in the U.S., selling only 8,000 units in its first five months.[55]

The lyrics of "History 101" from the SongCatchers' *Dreaming in Color* album tell a familiar story, but with a twist one finds only in this global postmodern.[56] History is not being told here by the victors, but the victimized. But notice how they tell it: the narrator in this mainly Native American band isn't a Native American, he is an African American, Charles Neville, of the Neville Brothers, whose involvement with Native American cultures is well known.[57] Neville says that his interest in the SongCatchers began after a powwow outside New Orleans in the early 1990s, simultaneous with an African American celebration in the same neighborhood.

> There was a little stream and a line of trees separating the two areas. The black people could hear the drumming and dancing, but their reaction was to crank up the rap music they were playing and try to drown out the drums. The people on the two sides of the trees saw the two things as opposing things. That started me thinking about how African Americans and Native Americans don't really know each other and their history.[58]

Neville's story in "History 101" unites African Americans and Native Americans, as the music unites jazz and Native American musics. This selection is reminiscent both of jazz and a Gil Scott Heron kind of 1960s political/musical radicalism, most memorable in his "The Revolution will not be Televised": hard riffs in the background of make-no-bones-about-it spoken lyrics, by Charles Neville. Neville's words demonstrate the double play of generality and particularity apparent in the new kinds of identity formation. His words decry the subsumption of a multiplicity of tribes into a single word—"Indian"—while at the same time making overarching connections between Native Americans and African Americans. Neville's words also make use of a lyrical device in many of the musics of transnationalism or globalization: there are lists, lots of lists, which detail the particularities of groups before the arrival of Europeans. The Australian aboriginal rock group Yothu Yindi makes use of such lists in "Tribal Voice" on the album of the same name, as does Youssou N'Dour in "How you are (No mele)" on *The Guide (Wommat)*, discussed in chapter 5.[59]

In the example below, Native American musics commingle with jazz, and with the sound of an accordion insinuating itself into the background at the moment the Europeans enter this tale; even further in the background is the sound of a harpsichord. But unlike Europeans in the history of colonialism and subjugation, these sounds do not gain the upper hand in this history 101.

History 101

This is our history. This is the way it was. This is History 101.

A great civilization existed in this land we call America.
Long before the people who came to colonize even knew
that the world was round. Pima, Dine, Mohawk, Ojibwa,
Lakota, Creek, Seminole, Cree, Mikasuki, Homas,
Choctaw, Nisqually, Suquamish, Duwamish, Pawnee,
Cheyenne, Apache, Arapaho, Navajo, Mohican, Seneca,
Tunica, Shoshone, the people now called "Indian."

There were varied cultures, all with traditions that
involved guarding and nurturing and keeping the Earth,
our mother, honoring all other living creatures. But the
colonialists from a far land beyond the ocean arrived here,
seeking to own, to conquer and subdue the wilderness
and its inhabitants, to subdue the earth, to conquer
nature!

This would require a lot of work. More work than the
colonists could do themselves. More work than the
colonists were willing to do themselves, more work than
the colonists were capable of doing themselves.

And so, another ancient civilization was called upon to
supply the labor. Uruba [Yoruba], Mandinka, Zulu, Eboh, Princes
from Dahome, Princes from the Congo, Kings from
Kikuyu, Masai, Africans. These people were brought in
chains under duress forced to work under pain of death.

This is history. This the way it was. This is History 101.

There were cultural similarities and similarities in the attitudes
of the colonists toward both of these groups of
people and this gave these two groups common cause.
Together, maybe they could successfully resist, but the
colonial officials saw this danger and they took steps to
prevent an alliance. Hire Indians as slave hunters. Force
the slaves to fight the Indians. Create fear, hatred,
distrust. Subjugate both peoples. Divide and conquer.

Now this strategy worked to a certain extent. But in
some areas Seminoles and Africans joined forces and
fought to the bitter end; Homas and Choctaws and
Africans joined each other in the southern swamps and
fought. And in New Orleans in Congo Square, Choctaws,
Homas, Africans got together to express similarities in
their culture in music and dance and to this day in New
Orleans there are people known as Mardi Gras Indians
who honor and commemorate the cooperation, respect
and alliance of the African and the Indian, the Indian and
the African, African and Indian, Indian and African.

This is our history. This is the way it was. This is History 101.

African Americans and Native Americans are strangers to
each other today. We are brothers and sisters of the
same blood, brothers and sister from the same spirit,
brothers and sisters from the same mud, our mother, the
Earth. We must know each other. We must learn from
each other. The thing that separates us today is lack of
knowledge and understanding.

This is history. This is the way it was. This is History 101.

There is no room for ambivalence in the lyrics: the arrival of the Europeans
was an invasion. But what about that accordion? While it would seem that the
SongCatchers are making a statement about people of color uniting in word and
sound—at the same time that they maintain their identities as members of par-
ticular tribes—it is possible to hear the accordion as not so much European as
Mexican. The accordion, after all, features in many musics in Mexico and in
Mexican America: *conjunto*, *Norteño*, and many others. We could go further back
in history and recall that the accordion was brought to the American southwest by
immigrants from central Europe. The function of the accordion here, beyond sig-
nifying "European" or perhaps "Mexican" isn't clear, and this very ambivalence
marks the same kind of ambivalence faced by all people of color in contemporary
America, as the lyrics themselves demonstrate: a tension between ethnic speci-
ficity versus hybridization, ethnic specificity versus a pan-Native American, pan-
black and brown solidarity that might provide the political power necessary for
progressive social change.

ZAP MAMA: THE SOUND
OF CHANNEL SURFING

So far we have examined collaborations across races and places.
This next collaboration is between women across races and places. Much of the

Figure 7.3
Zap Mama.

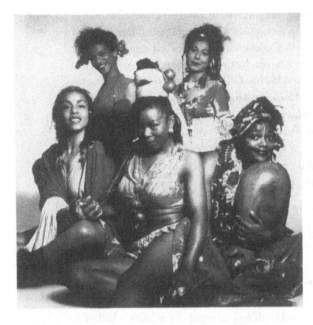

feminist movement has focused on achieving for women the kind of agency pre-
viously available only to men. Another collaborative, cross-cultural group that is
beginning to make a name for itself is Zap Mama, five women who hail from
European and African countries. Led by Marie Daulne, born in Zaire but raised
in Belgium, Zap Mama endeavors, in Daulne's words, to "participate in bringing
people closer through understanding and respect for each culture—with, of
course, a special attention to the people threatened by the triumphant material-
ism of the modern world."[60] Most of the other women in the group are also of
racially mixed heritage; the current lineup, in addition to Daulne, includes the
core members Sabine Kabongo (Belgian and Zairian) and Sylvie Nawasadio (also
Afro-Belgian); Sally Nyolo (from Cameroon) and Marie Afonso (from Portugal)
have replaced Cécilia Kankonda and Marie Cavenaile; Céline 'T Hooft also left
the group.[61]

Daulne was born in Zaire to a Zairian mother and a white Belgian father who
was killed in a political revolt in 1960; Daulne and her mother, a Bantu, escaped
to the forest, for the revolutionaries were killing everyone of mixed parentage.
Eight months later, Daulne and her mother moved to Belgium; the soldiers took
Daulne's skin for black and allowed her and her mother to escape. While recov-
ering from an injury in 1986, she happened to listen to some field recordings of
Zairian music that prompted her to rediscover her roots.

She formed Zap Mama. Zap Mama accomplishes Daulne's stated goals by
recording music from all over: some is original, some is covered/arranged from
field recordings of music from around the world, and some is composed by oth-

ers. Daulne says that the group's name comes from the word "mama," which she says everyone knows; and "zap," because "zapping is change. Zapping is how people change TV."[62] A list of titles and origins from their eponymous first album, released in 1993, gives an idea of the eclecticism and range of their music.

Title	Source
Mupepe	central African pygmy chant
Bottom	composed by Jean-Louis Daulne; in English; spiritual in the style of Sweet Honey in the Rock
Brrrlak!	Panpipe-like vocables
Abadou	from a Syrian song
Take me Coco	composed by Céline 'T Hooft
Plekete	"motor-car polyrhythm"
Mizike	original recorded near Isiro, Zaire
Babanzélé	traditional chant of the pygmies of central Africa, originally released on Folkways 4457, *The Pygmies of the Ituri Forest*[63]
Din Din	by an anonymous Spanish composer from the sixteenth century
I Ne Suhe	[n/a]
Guzophela	composed by Marie Daulne, an anti-apartheid song translated into Zulu
Nabombeli Yo	[n/a]
Marie-Josée	popular Zairian song
Ndje Mukanie	mix of nursery rhyme from Rwanda, Zairian young women's chant, and a Tanzanian song
Son Cubano	Cuban rhythm

Table 7.1
Zap Mama, songs and sources.[64]

While the above table indicates that Zap Mama uses sounds from all over, they also employ styles and techniques from various parts of the globe. Daulne says that "I just follow my instincts. I love vocal techniques and vocal music."[65] In this statement, Daulne recalls Sheila Chandra; it would be possible to view each musician's interest in musical techniques as a kind of aestheticization, but Daulne and the other musicians in Zap Mama rarely lose sight of a political or social message.

One of the loyal followers to the Zap Mama newsgroup on the Internet posted a fall 1994, Nashville, radio interview with Rusty Miller that contains some information about how the group formed. I've edited it slightly from the literal transcription provided by Zap Mama fan Marsha Patterson.

Marie Daulne: The story of Zap Mama begins in 1989 . . . right after the trouble in Africa [presumably the growing tide against Sese Seko Mobutu, ruler of Zaire from 1965]. I go back to visit my family and there the idea right when I see the situation

of Africa, they enjoy, without instrument and just with mouths and feet, no matter it is just the natural . . . the heart, the spirit and the body. And when I see this I say "Wow, this can afford something for the modern time," and when I write, I write all of the song and the composition and the idea and after I am looking for sister and I ask to Sabine [Kabongo] and Sylvie [Nawasadio] to come in with me and there is the group beginning at this moment and until now and after we meet Sally [Nyolo] and Marie [Afonso] in Paris and get them to star with us.

[Interviewer]: So were any of you friends before all this happened?

M.D.: Yes, Sylvie and me, but not really friends, meeting together all the time, but our brothers play music together and I know Sylvie; Sylvie knows me and Sabine. We see us in a party, we have a friend in common. We know each other.

Sylvie Nawasadio was studying anthropology and sociology in Brussels at the time Daulne asked her to join the group. She agreed, because, she said, "Yes, I think the way you do is my way too, the *sociologique* way."[66] Like Clegg, Zap Mama takes ideas about cultural production and puts them to social and aesthetic purposes.

Perhaps more than any other group or musician in this study, Zap Mama exemplifies the global postmodern. With the success of *Zap Mama*, the group toured extensively for two years in the early 1990s, resulting in the album *Sabsylma* (1994), which Daulne says is "more urban" as a result.[68] "The reason is that we've traveled a lot since then. And we wanted to reflect the many different sounds we heard, at festivals and on streets around the world."[69] "I expanded what I searched for," Daulne explained elsewhere. "Australia, Pakistan—all these sounds I absorbed were the results of informal contacts, meeting people like Pakistani cab drivers, for instance."[70] But Daulne's research is more than serendipity. "I go to the *bibliothèque*; I buy record and video, and I see *reportage*. And I meet a man that live in Australia in WOMAD festival. He sell didjeridu, and I discover aboriginal music, and I have the idea to do that."[71] Still, we should recall that not everyone can afford to be a tourist.[67] Just as Arjun Appadurai can assume that the world's people and cultures are mixing it up more than ever, one has to ask, Who can afford to travel? International recording stars, among others.

Daulne also has a good deal of conventional musical training, having attended the Antwerp School of Jazz; and a couple of press reports credit her with a Ph.D. in music.[72] So Zap Mama's music is, as one might expect, is highly virtuosic, making use of all kinds of extended vocal techniques, onomatopoeic sounds, and almost no instruments.

We are different from other a cappella groups because we play with all aspects of the voice. Coughing, clearing the throat—we play with that. We want to share the pleasure of human possibilities. If you put a finger in your ear and it makes a sound, we will use that. We knock on our breasts and make a sound with our mouth at the same time, what happens is like a real big drum![73]

Daulne and the other members of the group take the natural, nontechnological aspect of much of their music to posit a kind of universality that we have seen throughout this study. Nowhere is this discourse invoked more often than in discussions of cross-cultural collaborations; in his introduction to the compilation *Planet Soup*, W. A. Mathieu writes of musicians, "What is it about their language that carries a collective message so well? What makes music a universal language?"[74] In interviews, Daulne constantly compares African and European ways of looking at the world, usually constructing the African as natural and the European as materialistic and violent. "A *cappella* music has always been there. In the '60s, you had doo-wop groups. Today, everything has become very electronic. But we mustn't forget that the earth was here before us—the sun, the wind, the essentials of nature. I am happy to see people responding to Zap Mama. It means they want to rediscover their natural blood."[75] This naturalness means that everyone can understand her music. "I think everywhere they can understand Zap Mama. When we are onstage we move a lot, and imitate with our bodies what we sing. So if nobody can understand our language we speak, then sometimes [we sing] not with language, just sound. And if we move onstage to imitate what we sing, then people can understand it."[76]

Daulne's comments, coming as they do from a woman, a half-African, half-European woman, demonstrate that the European Enlightenment myth of universalism can be accepted, but turned on its head and used by subalterns as a way of intervening in a discourse that historically has favored Europeans. Now, in the global postmodern, the meaning of universalist discourse depends on who is talking. At the same time, though, the homogenizing aspects of universalism come through. The members of the group speak of Daulne's research into various musics of the world and her quest to "find a common point between the world's musics."[77]

Zap Mama's music has proved to be quite popular, their first album providing Luaka Bop with its biggest seller to date. *Zap Mama* enjoyed the number 1 position on *Billboard*'s World Music chart for 11 weeks; appeared on the *New York Times* popular music critic Jon Pareles's top ten list of 1993[78]; there is a Zap Mama newsgroup on the Internet; and, according to one of the postings to that newsgroup, a World Wide Web page in progress, a Coca-Cola commercial, and a documentary about the group, *Mizike Mama*.[79]

Zap Mama's songs are clearly concerned not only with condemning the materialism Daulne wrote of but of liberation in general, and the liberation of women in particular, although Daulne denies that Zap Mama is a group of feminists. "We are not feminists, absolutely not. We're for men and children, too. We are political no, humanist yes."[80] Many of the songs concern women, or were written by women. Their song "Les Mamas des Mamas," on *Sabsylma*, is about a song Daulne's mother sang, a song that was sung in her Zairian village whenever a woman had twins. Daulne decided to record it, and invited "my mother, my aunt, my grandmother, the whole family" to contribute.[81]

Another selection, "Mizike," is based on a young girls' song from Zaire. "Mizike" begins with a catchy percussion (presumably the *boîte à rythme humaine* ["human beat box"] of the credits, played by Jean-Louis Daulne). This rhythm, which Daulne's liner notes tell us is derived from the girls beating the river water, goes throughout the song; above it, most of the women sing a recurring line, the title—Mizike—while a soloist, Daulne, sings the lyrics above the ostinati of the other musicians.

Despite the rhythmic complexity (not very evident from the transcription, partly because I have omitted some of the mouth music percussion) and the sheer catchiness and vitality, "Mizike," takes on quite serious subjects, as the lyrics demonstrate.

Mizike

This is the story of those invaded by materialism, machinism,
 capitalism
Those whose limbs, soul, instincts and, worst of all, conscience are
 eaten up, friend
Listen to your head, listen to your spirit inside
There's a friend, it's called melody
Hey! Mr. Music come dance with me.

Since recording that song, Zap Mama teamed up with producer Chris Cuban (who produces the rap musician Me Phi Me) to record some James Brown covers.[82] Cuban evidently told the maintainer of the Zap Mama Internet mailing list that he worked with Zap Mama in Nashville to come up with a seven-minute track that paired the group with six different rappers and that there will be two more versions, one without the rappers and one on which the Zaps just sing backup.

Zap Mama's second album, *Sabsylma* (a word derived from the three names of group's three principals, *Sab*ine Kabongo, *Syl*vie Nawasadio, and *Ma*rie Daulne), released on Luaka Bop in 1994, continues many of the same themes, although some relate more directly to Zap Mama's growing fame. Explaining "For No One," on the *Sabsylma* album, Daulne says, "When I sing this song, I remember certain artists who change their direction. They have good direction

and then they change. Or people I grew up with as a child. I meet them again as adults, and they follow a very strange way. My vision is not their vision."[83]

Zap Mama's music is liberationist more than anything else; the European parts of the selves in the group do not override the African halves; Europeans and Africans collaborate. But the European training and orientation of the musicians have allowed them to make popular music that travels, spreading their message.

I opened this chapter with an epigraph by the South Asian activist and polemicist Hakim Bey calling for—demanding—collaborations, not appropriations. I have been making the same demand, though perhaps more gently. While many popular musicians in the North American/British world of popular music are busy making well-publicized collaborations, such as Paul Simon on *Graceland* and *The Rhythm of the Saints*, Peter Gabriel on *Us*, David Byrne on *Rei Momo*, Jimmy Page and Robert Plant on *No Quarter*, and others, we need collaborations in which the western stars don't override their lesser-known, nonwestern partners.[84] The first step toward a truly collaborative world music begins at home.

NOTES

1. Quoted by Peter Wetherbee, Axiom History, http://hyperreal.com/music/labels/axiom/axibook1.html.

2. Karl Marx and Friedrich Engels, *The Communist Manifesto* (New York: Monthly Review, 1964), 8.

3. Feld, "Notes on World Beat," in Feld and Charles Keil, *Music Grooves: Essays and Dialogues* (Chicago and London: Univ. of Chicago Press, 1994).

4. Interview with David B. Coplan, "A Terrible Commitment: Balancing the Tribes in South African National Culture," in *Perilous States: Conversations on Culture, Politics, and Nation*, ed. George E. Marcus, Late Editions: Cultural Studies for the End of the Century, no. 1 (Chicago and London: Univ. of Chicago Press, 1993), 312.

5. Quoted by Samuel G. Freedman, "Johnny Clegg's War on Apartheid," *Rolling Stone* 574 (22 March 1990), 60.

6. *African Litany* is on Rhythm Safari CDL 57145, 1991.

7. Clegg's official press release says that Mchunu "pass[ed] by Johnny Clegg's house and what started out as a friendly challenge from one musician to another ended up as one of the biggest groups South Africa has known." From the official Johnny Clegg home page at http://www.teleport.com/~sheilam/.

8. Marre, *The Rhythm of Resistance*, Harcourt Films, produced by Jeremy Marre, directed by Chris Austin and Jeremy Marre (Newton, N.J.: Shanachie, 1988).

9. Quoted by Rob Tannenbaum, "Johnny Clegg Battles Union," *Rolling Stone* 536 (6 October 1988), 17.

10. Quoted by Freedman, "Johnny Clegg's War on Apartheid," 64.

11. Jeremy Marre and Hannah Charlton, *Beats of the Heart: Popular Music of the World* (New York: Pantheon, 1985), 39.

12. Ibid.

13. *Universal Men* is on Rhythm Safari P2 57144, 1984. "Africa" is a circumspect tale about the young life of a black man; to my ears

there is nothing inflammatory about it, though perhaps this young man was taken by authorities to be Nelson Mandela or another black leader.

14. "Asimbonanga" begins with the words (in Zulu but translated in the liner notes): "We have not seen him/We have not seen Mandela.../in the place where he is.../in the place where he is kept" (*Third World Child*, Capitol CDP 7 46778 2, 1987), 1.

15. Denselow, *When the Music's Over: The Story of Political Pop* (London and Boston: Faber and Faber, 1989), 200.

16. Tom Schnabel, *Stolen Moments: Conversations with Contemporary Musicians* (Los Angeles: A Books, 1988), 42–43.

17. Chris Stapleton and Chris May, *African All-Stars: The Pop Music of a Continent* (London: Paladin, 1987), 209.

18. Hamm, *Afro-American Music, South Africa, and Apartheid*, I.S.A.M. Monographs, no. 28 (Brooklyn: Institute for Studies in American Music, 1988), 33.

19. *Mbaqanga*, which means "money" in Zulu, can also mean "dumpling," and this usage refers to the homemade quality of this main popular music of South Africa since the 1960s, also known as township jive.

20. Stapleton and May, *African All-Stars*, 210.

21. See David Herndon, "A Valley Deep in Another World to Visit the Hardscabble Zululand is to step out of Modern Life," *Newsday* (5 February 1995), 17.

22. *Heat, Dust & Dreams* is on Capitol CDP 0777 7 98795 2 6, 1993.

23. Quoted by Samuel Freedman, "Johnny Clegg's War on Apartheid," 64.

24. Coplan, "A Terrible Commitment," 321. Ellipsis in original.

25. Quoted by Freedman, "Johnny Clegg's War on Apartheid," 120.

26. Quoted by Michael A. Lerner, "Clegg Fuses Pop with Politics," *Newsweek* 112 (12 September 1988), 72.

27. Paul Oldfield, review of Johnny Clegg and Savuka *Cruel, Crazy Beautiful World, Melody Maker* 66 (10 March 1990), 37.

28. Jimmy Guterman, review of Johnny Clegg and Savuka, *Shadow Man, Rolling Stone* 536 (6 October 1988), 142.

29. Marre, *The Rhythm of Resistance*.

30. J. M. Coetzee's novel *Waiting for the Barbarians* (Harmondsworth: Penguin, 1982) makes the inverse point: if apartheid brutalized black South Africans and turned white South Africans into brutes, then a fictive post-apartheid South Africa may well turn black South Africans into brutes, the whites the brutalized. Coetzee's point isn't just that everyone has the capacity to become a barbarian, but that apartheid, like colonialism, does not discriminate.

31. Juluka, *Scatterlings*, Warner Bros. 9 23898-2, 1982.

32. In Zulu, "Impelamanga," evidently a related word, literally translated, would mean "the end of lies"—although while this would obviously be a metaphorically interesting interpretation of the song, it doesn't seem to have any obvious referent. I am told that a creation myth, perhaps East African, refers to a mountain of a similar name, which would explain the references to Olduvai Gorge and the line "where the world began" (E. Tom Thomas, personal communication, 7 February 1996).

33. Olduvai Gorge in Tanzania, the site of early hominid bones discovered by the Leakey family in 1959.

34. Also the title of the album, on Sire 9 25844-2, 1989.

35. McClary, "Living to Tell: Madonna's Resurrection of the Fleshly," in *Feminine Endings: Music, Gender, and Sexuality* (Minneapolis and Oxford: Univ. of Minnesota Press, 1991), 155.

36. Césaire, *Discourse on Colonialism*, translated by Joan Pinkham (1955; reprint, New York: Monthly Review Press, 1972).

37. Quoted by Coplan, "A Terrible Commitment," 318–19. Ellipsis in original.

38. *Cruel, Crazy, Beautiful World*, Capitol CDP 7 93446 2, 1989.

39. Quoted by Freedman, "Johnny Clegg's War on Apartheid," 62.

40. Quoted in Hazel Friedman, "Time to Face the *Mbaqanga*," *Weekly Mail* (2 December 1994), downloaded from http://www.is.co.za/services/wmail/wmail.html.

41. Quoted by Banning Eyre, "Citizen Clegg," *Rhythm Music Magazine* 4 (1995), 28.

42. Ibid.

43. Sudarsan Raghavan, "'Crossover' is new Buzzword in South Africa," *Los Angeles Times* (11 July 1995), 2.

44. Eyre, "Citizen Clegg," 29.

45. See "People," *Weekly Mail and Guardian* (2 June 1995).

46. Raghavan, "'Crossover' is new Buzzword in South Africa," 2.

47. Quoted by Judith Matloff, "A New Threat to S. Africa's Musicians," *Los Angeles Times* (29 December 1994), 13.

48. Quoted by Hazel Friedman, "Another Chapter in the Full Story," *Weekly Mail and Guardian* (n.d.), http://pubweb.is.co.za/mg/art/rvclegg.html.

49. A video clip of the SongCatchers can be found on the Internet at http://www.eden.com/music/songctch.html.

50. See Joe Compton "Robbie Robertson's Red Road Home," *Rhythm Music* 4 (1995), 30–35.

51. Quoted in Carrie Borzillo, "Major Labels Find Market for Native American Sounds," *Billboard* 106 (6 August 1994), 1.

52. Bruno Nettl, *Folk and Traditional Music of the Western Continents*, 2d ed., Prentice-Hall History of Music Series, ed. H. Wiley Hitchcock (Englewood Cliffs, N.J.: Prentice Hall, 1973), 163. See also Richard Keeling, "The Sources of Indian Music—an Introduction and Overview," *World of Music* 34 (1992): 3–21 for some vivid examples, as well as Judith Vander's *Songprints: The Musical Experience of Five Shoshone Women*, Music in American Life (Urbana: Univ. of Illinois Press, 1988).

53. "Multi-Ethnic Musicians Blend Powwow with Pop," *Los Angeles Sentinel* 60 (18 January 1995), B6. For more on the formation of the band, see Jill O'Brien, "The SongCatchers Merge Music and Dreams," *Indian Country Today* 14 (26 October 1994), D-6.

54. *Deep Forest*, 550 Music/epic BK-57840, 1992. For more on "ethnotechno," see Erik Goldman, "Ethnotechno: A Sample Twist of Fate," *Rhythm Music* 4 (July 1995): 36–39; and Jon Pareles, "A Small World after All. But is that Good?" *New York Times* (24 March 1996), H34. For more on Deep Forest, see Carrie Borzillo, "Deep Forest Growing in Popularity; 550's World Music-Dance Hybrid Climbs Charts," *Billboard* 106 (19 February 1994), 8;

and Al Weisel, "Deep Forests's Lush Lullaby," *Rolling Stone* (21 April 1994), 26. Nothing scholarly has yet been written, though there are doubtless projects in the works, including my own "Free Samples: Ghosts in the Tape Machine," in preparation.

55. *Sacred Spirits* is on Virgin 7243 8 40352 2 8, 1994. See Emmanuel Legrand, "French Hit Invokes Native U.S. Spirit," *Billboard* 107 (4 November 1995), 1.

56. The album is on Horizon/A&M 31454 0247 2, 1994.

57. See George Lipsitz's discussion of the Neville Brothers in "Mardi Gras Indians: Carnival and Counter-Narrative in Black New Orleans," in *Time Passages: Collective Memory and American Popular Culture*, American Culture, ed. Stanley Aronowitz, Sandra M. Gilbert, and George Lipsitz (Minneapolis: Univ. of Minnesota Press, 1990), and more recently in "That's my Blood Down There," in *Dangerous Crossroads: Popular Music, Postmodernism and the Poetics of Place* (London and New York: Verso, 1994).

58. "Multi-Ethnic Musicians Blend Powwow with Pop," B6.

59. *Tribal Voice*, Hollywood Records HR-61288-2, 1992; N'Dour, *The Guide (Wommat)*, Sony Music OK 53828, 1994.

60. Marie Daulne, liner notes to *Zap Mama*, Adventures in Afropea 1, Luaka Bop 9 45183-2, 1993.

61. Since this writing Sally Nyolo left the group to embark on a solo career.

62. Quoted by Matthew Dietrich, "Eclectic Sounds Merge in Group's Unique Music," *Springfield, Ill. State Journal-Register* (29 September 1994), included in the press kit from Luaka Bop.

63. *The Pygmies of the Ituri Forest*, Ethnic Folkways Library, Folkways FE 4457, 1958, pointed out by Maria Johnson, "Women Making World Music Today: Laura Love, D'Cückoo, and Zap Mama," paper delivered at the Society for Ethnomusicology, Northern California chapter, 17 September 1994. There is a new release of this recording, retitled *Mbuti Pygmies of the Ituri Rainforest*, Smithsonian Folkways SF CD 40401, 1992.

64. Information drawn from *Zap Mama*, liner notes, and listening.

65. Quoted by Thom Duffy, "Zap Mama Rides World Wave: Afro-European Quintet Bridges Cultural Gaps," *Billboard* 105 (7 August 1993), 1.

66. Daulne, quoted by Jeff Kaliss, "A Joyous Journey across many Borders," *San Jose Mercury News Eye* (17 June 1994), 28.

67. Quoted by Victor Bains Marshall, "Zap Mama: Extraterrestrial Sistahs!!" *Exclaim Magazine* (July 1994), included in the press kit from Luaka Bop. *Sabsylma* is on Luaka Bop 9 45537-2, 1994.

68. Quoted by N. J., "Zap Mama find a Global Voice," *Eye Magazine* (30 June 1994), included in the press kit from Luaka Bop.

69. Quoted by Gene Santoro, "Zap Mama of Invention," *Daily News* (11 July 1994), included in the press kit from Luaka Bop.

70. Quoted by Kaliss, "A Joyous Journey," 28.

71. See also James Clifford, "Traveling Cultures," in *Cultural Studies*, ed. Lawrence Grossberg, Cary Nelson, and Paula Treichler (New York and London: Routledge, 1992).

72. Susan Weitz, review of *Zap Mama*, *Ithaca Times* (16 September 1993); and an unattributed review in the *Des Moines Register* (8 July 1993), both included in the press kit from Luaka Bop.

73. Quoted by K. L., "Zaps!" *Columbus Alive* (22 June 1994), included in the press kit from Luaka Bop.

74. Mathieu, liner notes to *Planet Soup*, Ellipsis Arts... CD3450, 1995.

75. Quoted by Banning Eyre, "Tops Vox," *Boston Phoenix* (1 July 1994), included in the press kit from Luaka Bop.

76. Quoted by J. D. Considine, "Language is No Barrier When Zap Mama Celebrates Humanity," *Baltimore Sun* (1 June 1994), included in the press kit from Luaka Bop.

77. Sabine Kabongo, quoted by Marshall, "Zap Mama."

78. Pareles, "The Pop Life," *New York Times* (5 January 1994), C17.

79. Directed by Violaine de Villers, 1992.

80. Quoted by Kaliss, "A Joyous Journey," 28.

81. Ty Burr, "From Africa, Three Female Rebels with a Cause," *New York Times* (10 July 1994), H26.

82. This news traveled fast and furiously over the Internet in 1995, though there has been no other public announcement of it that I am aware of.

83. Quoted by Melinda Newman, "Luaka Bop Hopes to Make Zap Mama's World Go Pop," *Billboard* 106 (2 April 1994), 12.

84. Simon, *Graceland*, Warner Bros. W2-25447, 1986 and *The Rhythm of the Saints*, Warner Bros. 9 26098-2, 1990; Gabriel, *Us*, Real World GEFD 24473, 1992; Byrne, *Rei Momo*, Luaka Bop/Sire 9 25990-2, 1989; and Page and Plant, *No Quarter*, WEA LR-3169, 1994.

Conclusions

We Are the World, and the World Is Us

American culture is a complex thing
I want to know the secret
Now listen to me sing
—Zulu Spear, "Welcome to the USA"[1]

Even though musics and musicians have been mixing it up for a long time, globalization is providing musicians all over the world with new ways of making hybrid sounds and hybrid selves. But the ways in which they do this have at least partially changed from older modes of cultural interaction in modernity. The dynamics of collaboration, representation, and appropriation create new, complicated political and subject positions that shift with increasing frequency.

This global/cultural mixing in this global postmodern, these new ethno-/mediascapes result in some new musics, many of which sound increasingly North American. But it's equally true that some things aren't changing. The opening to Rhoma Irama's "Qur'an dan Koran," for example, sounds as if it could be an North American/British pop/rock song, but when his voice starts, there is no question: The language and vocal style make it Irama's own. Rather than cultural imperialism simply wiping out indigenous musicking and indigenous sounds, new popular musics are being made, old ones altered or maintained, sometimes museumized and sometimes lost altogether.

If cultural imperialism happens, sort of, in many places, modern ideas about preservation and authenticity ensure in many places that more traditional forms of musicking are being retained. Since the sea-change in politics in South Africa,

for example, Joseph Shabalala of Ladysmith Black Mambazo in 1994 founded a conservatory of music in South Africa, the Mambazo Academy of South African Music and Culture, whose mission is to "educate a new generation of South Africans. Using the unique philosophy of culture-based Education coupled with an immersion in traditional, indigenous South African music, dance and ritual."[2] The creation of such institutions as schools and conservatories will doubtless present new problems of the maintenance and dissemination of traditional musics — it isn't my purpose here to outline them — but it is clear that, again, Africa and Africans are modern, despite demands by some western listeners that both remain premodern.

BINARIES? YES/NO

Throughout this study I have taken pains to complexify many of the simple binaries that drive western understandings of other peoples and their music: binaries of domination/resistance, self/other, traditional/modern, nature/culture. This is the typical poststructuralist concern, but less common is the cultural critic's examination of a series of texts to see just how structures of any binary can be simultaneously circumvented, maintained, ignored, or dealt with in many other ways. Apache Indian's "very British sound," his "imaginary British- ness" marks him both as a self and an Other; Djur Djura explicitly embraces both France and Algeria, rejecting any notion of hybridity or halfness: "My culture is double," she says.[3]

Another binary opposition that has come into question here concerns eco- nomic cores and peripheries. Just as second- and third-world places begin to take control of the processes of modernization and begin to be economic cores, they are told that cores and peripheries are gone. So it strikes me that much of the the- orizing of the new global world is Americocentric. North American cultural forms do span the globe, but the centers of the production and distribution of those forms have moved, too. Some writers, such as Arjun Appadurai, have said that the Wallersteinian trope of cores and peripheries needs to be replaced or rethought,[4] but it seems to me that cores and peripheries aren't disappearing as much as the traditional cores are dispersing and diluting and thus centering and peripheralizing new spaces. For example, capitals of music recording aren't in the United States anymore — they are mainly in Europe and Japan. Historically, all but one of the largest music companies were located in the United States; now there is only one U.S.-owned record company, WEA (Warner/Elektra/Atlantic). Some cores have relocated out of the U.S., but also there are more, so that we can now speak of polylateral markets.[5] At the same time, there is still a very small num- ber of major players.[6] These companies, BMG, EMD, PolyGram, Sony, UNI, and WEA, own around 80% of the market share of sales of recordings, which also means that they control a similar portion of radio time.[7] And we should never for-

get the desires of the real, on-the-ground people, for most working musicians would still rather sign a contract with a major label than minor one in a new poly-lateral market. Besides, most critics of Wallerstein's model seem to have forgotten that he didn't posit a binarized core/periphery system, but one with more flexibility, for there was a semi-periphery in his model.

Even if economic cores are shifting out of the U.S., or, perhaps more accurately, the U.S. is beginning to share its core status with other areas, the globally influential *cultural* cores remain largely in the U.S. It is mainly U.S. musicians who can sell the most recordings, not musicians from anywhere else, though non-North American stars can do quite well in the local and/or regional markets, or what Mark Slobin has called a "transregional" markets.[8] And it was the United States that invented music television, some form of which is now received in over 30 countries, including those in Asia and Latin America. Likewise, it was the U.S. that invented most of the musics that now travel the world: pop, rock, and rap in particular. And these forms, we should remember, come out of a dominant and subordinate dynamic that is still with us. We would not have what we think of as popular music without African Americans and their constant struggle against white America to achieve some kind of power—what Stuart Hall has so eloquently described as the "double movement of containment and resistance."[9] This struggle constantly produces new musics, whether blues, jazz, rhythm and blues, rock and roll, rock, soul, Motown, funk, disco, or, most recently, rap. And we have seen the struggle of formerly marginalized groups to achieve control over representations and to prevent appropriation and sanitization throughout this study. As Hall writes, "Our lives have been transformed by the struggle of the margins to come into representation."[10]

To give an idea of who and what sells, below is a table of the best-selling recordings of all time, courtesy of the Recording Industry Association of America (RIAA); I'll present the table in the same way RIAA does, with the numbers first (which, after all, indicates nicely their primary concern).

Table 8.1
Best-Selling Albums
of All Time.[12]

Units sold (millions)	Musician	Album Title	Date
24	Michael Jackson	*Thriller*	1982
17	Fleetwood Mac	*Rumours*	1976
15	Boston	*Boston*	1976
14	Eagles	*Eagles/Their Greatest Hits 1971–1975*	1976
	Bruce Springsteen	*Born in the U.S.A.*	1984
13	Garth Brooks	*No Fences*	1990
	Guns N' Roses	*Appetite for Destruction*	1987
	Whitney Houston/ Various	*Bodyguard* soundtrack	1992

Units sold (millions)	Musician	Album Title	Date
	Pink Floyd	*The Dark Side of the Moon*	1973
12	Meat Loaf	[*Bat Out of Hell*][11]	1978
	Bruce Springsteen & the E Street Band	*Bruce Springsteen & the E Street Band Live 1975–1985*	1986

There you have it: mostly North American (save Fleetwood Mac and Pink Floyd), mostly male (except Whitney Houston), mostly white (but not Michael Jackson or Whitney Houston). And if you add Springsteen's two top-selling albums together, he wins. Who would have thought any different? Americans win, but it is mainly white Americans, yet all these musicians could not do what they do without African American musics.[13]

Even though cultural cores, as I am arguing, are still largely in the U.S., the relocating of cores of production will nonetheless affect how widely consumed cultural forms are made. Just as the real money in television is now in syndication, not first-run programs, and just as the real money in movies isn't in ticket purchases but in video rentals, music produced in Asia—home to CBS/Sony—isn't made for live performances, or even recorded ones, but rather, karaoke. "If you can't sing it in karaoke, it won't be a hit," says the Asia regional managing director of EMI Music (now EMD), one of the world's biggest record companies.[14] Karaoke sales in Japan have reached such huge proportions—$10 billion annually—that karaoke has become the test application for many of the most advanced electronic technologies being developed in Japan.[15] So CBS Records' move to Japan will have consequences. Japan, also, is the second-biggest world market for recording sales, with 16.7% of the $35.5 billion expanded on recordings in 1994 spent there; the U.S. was number 1, with 33.3% of the sales; in other words, nearly twice as much. I should also note that third in sales was Germany, with 8.1%, less than half of Japan's share of the market.[16] In other words, just over half of the world's sales of recordings are in the U.S. and Japan.

While the Wallersteinian economic core/semi-periphery/periphery model has been widely re-theorized, it is less apparent that researchers grasp that these *cultural* cores still exercise powerful influences. Stuart Hall has argued that global postmodern cuisine is found in London and New York, not Calcutta. Musically speaking, though, South Asian popular musics show a profoundly global pop aesthetic at play, whether music by Baba Sehgal (who has an astonishing album entitled *I'm Madonna Too*, in which he appears on the cover dressed in drag[17]), Remo, Shimiak, Najma, Sharon Prabhakar, or, most recently, a new genre called "Goa" (or "Goatrance") emanating from that Indian state and described by a fan on the newsgroup alt.music.techno as "a form of techno or trance that has a lot of psychedelic influences to it. Lots of New Age samples—Tangerine Dream, etc., with

a good 4/4 beat."[18] And all of this is before mentioning the mammoth Indian film-music industry, which produces a globally syncretic music if there ever was one.

Besides, recordings such as Sehgal's demonstrate that, if anything, the global postmodern is disseminating more out of the cultural cores and to the traditional margins than vice-versa; Sehgal and many other South Asians hear far more North American and British popular musics than we hear Indian musics in the western metropoles. I know this from the experiences of trying to audition musics for this book: I could read about something on the Internet, perhaps even hear a short sound clip, but laying my hands on the actual recordings proved to be an insurmountable problem all too often. Because of large multinational corporations and, more recently, MTV and its knockoffs—western popular musics are available as never before at the traditional peripheries, but not the reverse: it is much easier to buy, say, Madonna in China than Cui Jian, the leading Chinese rock musician, in the U.S.[19]

WHOSE HYBRIDITY?

Even though I have been tacitly praising the salutary effects of these cross-cultural collaborations, the workings of the music industry and assumptions of listeners betoken old forms of racism, and long-standing western views of nonwestern peoples and cultures. It is worth wondering who is asked to be authentic and whose music is labeled as hybridized.[20]

Paul Simon, Peter Gabriel, and other western musicians who collaborate with musicians from other parts of the world are never described as makers of hybrids, and demands of authenticity are not made of them and their music. Their music is categorized as the most prestigious of popular musics—"rock"—while the musicians with whom they work are called world beat, or something else outside the rock category. Rock music is allowed to take whatever music it wants, not always without controversy, but nonetheless, a kind of voracious aesthetic is the norm.

Musicians from the margins of the global economy, however, have demands of authenticity made of them by western listeners, even if these third world musicians grew up listening to the same popular musicians as any western kid. Recall, for example, Youssou N'Dour's rejoinder to his western critics who complain that he is becoming too western: "In Dakar we hear many different recordings. We are open to these sounds. When people say my music is too Western, they must remember that we, too, hear this music over here. We hear the African music with the modern."[21] N'Dour adroitly inverts the containing binary of the west here: His popular music, even with some traditional sounds and instruments, is *modern*, not traditional.

And Angélique Kidjo's response to Branford Marsalis:

There is a kind of cultural racism going on where people think that African musicians have to make a certain kind of music. No one asks Paul Simon, "Why did you

use black African musicians? Why don't you use Americans? Why don't you make your music?" What is the music that Paul Simon is supposed to do?[22]

Answer: Any music he wants.

THE "GLOBAL POSTMODERN"

Clearly, musics and musicking are proliferating faster than we can conceptualize the processes of musical/cultural change, and so there is a good deal of slippage in current discussions about what to call this contemporary moment. I have been using Stuart Hall's "global postmodern" and Arjun Appadurai's various "-scapes," but it is now time to own up to what these terms might mean.

Since the essays by Stuart Hall that I have found so useful were written, Hall has said that he hates the term "the global postmodern," as noted in the introduction.[23] Hall objects to its all-encompassing quality, but he still feels a fascination for the term. While I too think it has its up and down sides, it is useful enough in capturing the notion of the global flow and mix. But I would nonetheless shy away from calling all of these resulting musics postmodern in stylistic terms; I do think there is such a thing as postmodern cultural production—and postmodern music—but I would limit this to, largely, the traditional metropoles. Fred Pfeil argues cogently that postmodern cultural forms are mostly made and consumed by the PMC, that is, the professional-managerial class, who have the time, education, money, and power—educational and cultural capital—to play with meaninglessness and non-referentiality that are thought to be characteristic of postmodern cultural production.[24] It is middle-class musicians and artists with large amounts of cultural capital who are the most free to play with other identities, sounds, and instruments, and make the kinds of pastiches that are well characterized by Fredric Jameson's and others' accounts of postmodernism.

Recently, some scholars have begun to discuss world musics such as I have been examining here as postmodern musics, because of their hybridity and cut-and-paste aesthetics. Veit Erlmann, for example, writes in "The Politics and Aesthetics of Transnational Musics" of the Jamesonian[25] pastiche as the central feature of an aesthetic of world music.[26] More recently, Erlmann consolidated and deepened these arguments, and, again, pastiche emerges as "the key principle of world music."[27] Erlmann writes that his pastiche, unlike Jameson's, isn't empty, but "is more an attempt at coating the sounds of the fully commodified present with the patina of use value in some other time and place."[28] Even so, as we have seen, much of the music and musicians in this book are concerned with more than surfaces, more than patinas, and sometimes critique commodification. While Erlmann steps back from Jameson's pastiche as a play of empty signifiers, it nonetheless seems perilously close to saying that there isn't much below the surface.

Another prominent scholar has pursued much the same tack. Peter Manuel identifies Apache Indian (and many subcultural musicians generally) as something of a quintessential postmodern musician whose lyrics "exhibit a relatively consistent postmodern flavour in their non-judgmental presentation of Indianness in a distinctly un-Indian musical style."[29] Throughout his article, Manuel discusses postmodernism-as-style, as though it were a mask that musicians could put on and take off as they pleased. And he subsumes his informants' ideas on their own music under this postmodern rubric. His informants, he writes, "acknowledge the sense of ironic play in such collages, and yet they don't regard their music as a postmodern joke, but rather as a significant expression of their own sense of identity."[30] Manuel's informants talk about postmodernism-as-style, but for them there is no waning of affect here, no meaningless play of signifiers, which, I would argue, requires more subtle theorizing than Manuel provides here.

Other aspects of postmodern theory have been used to discuss world musics. Erlmann believes that cross-cultural musical collaborations obliterate difference and sameness: "the interactive, transversal subject is not the product of some new form of exchange, but of the wholesale disappearance of the social and of otherness as such."[31] His example here is Paul Simon and Ladysmith Black Mambazo's work on *Graceland*. They do collaborate in some sense—they work together, some songs are credited to Simon and Joseph Shabalala—and their center/peripheral subject positions are in some ways effaced, at least, perhaps, for the duration of the songs. But in the end, it is Simon who profits: his position in a powerful economic center—the United States, a major corporation—means that he cannot escape his centrality, despite his assertion that he works "outside the mainstream . . . where I always enjoyed being."[32] Erlmann's historical and ethnographic scholarship are exemplary and I have learned much from them. But the unproblematic omission of the economic realities of this "collaboration" between Simon and black South African musicians means that his analysis falls short. Erlmann asks "*Quo vadis?*" without wondering "*Cui bono?*"[33]

While there is some value to the idea of postmodernism-as-style, it is the postmodernity-as-moment that I want to hang on to, and here we all agree: different musics come together in new ways all over the world. But I've tried to show that the resulting polystylistic works are anything but vacant, empty of meaning, and so I would refrain from using the influential, Jamesonian facet of postmodernism-as-style for these musics. It *may* be true for certain subject positions in certain global and class locations, but even here we would have to look very carefully at the music in question, and the people making it.[34] In the production of the musics we have encountered in this book, different sounds are mobilized for a vast array of reasons, but, perhaps most often, as a way of constructing and/or solidifying new identities.

The musicians in this study are constantly finding new sounds to project their new selves, selves that often find commonalities all over the globe, but at the same

time they are also critiquing some of the politics and policies of the west, even sometimes their home countries. Metanarratives of progressive political change may be dead in the west as (postmodern) theory, they may be dead, even, in practice, but musicians around the world are telling us that it's not so.[35] Just as the subordinate groups in U.S. culture have always done more than the dominant groups to make radical positions available through new sounds, new forms, new styles, it looks as though it is the subordinate groups around the world who are doing the same, perhaps even showing us how to get along on this planet. If we would only listen.

NOTES

1. Zulu Spear, *Welcome to the USA*, Liberty Records CDP-7-97457-2, 1992.

2. From http://www.best.com/~rlai/Paul-Simon/Collab/Ladysmith.txt.

3. Djur Djura, interview with David Byrne, *Bomb* 47 (Spring 1994), 10.

4. See Arjun Appadurai, "Disjuncture and Difference in the Global Cultural Economy," *Public Culture* 2 (Spring 1990): 1–24; Reebee Garofalo, "Whose World, What Beat: the Transnational Music Industry, Identity, and Cultural Imperialism," *World of Music* 35 (1993): 16–32; and Jocelyne Guilbault, "On Redefining the 'Local' through World Music," *World of Music* 35 (1993): 33–47.

5. See "People," *Weekly Mail and Guardian* (2 June 1995).

6. See Guilbault, "On Redefining the 'Local' through World Music."

7. This figure is constantly changing. See the weekly "The Times Music Index" published on Fridays in the *Los Angeles Times* for charts of album sales and a table of the market share of the six majors.

8. In *Subcultural Sounds: Micromusics of the West*, Music/Culture Series, ed. George Lipsitz, Susan McClary, and Robert Walser (Hanover and London: Wesleyan Univ. Press, 1993).

9. Hall, "Notes on Deconstructing 'The Popular'," in *People's History and Socialist Theory*, ed. Raphael Samuel (London and Boston: Routledge and Kegan Paul, 1981), 228.

10. Hall, "The Local and the Global: Globalization and Ethnicity," and "Old and New Identities, Old and New Ethnicities," in *Culture, Globalization and the World-System*, ed.

Anthony D. King, Current Debates in Art History, no. 3 (Binghamton, N.Y.: Department of Art and Art History, State Univ. of New York at Binghamton, 1991), 34.

11. RIAA lists an eponymous album as the best-seller, but this must be an error, for there is no such album. I assume that they are probably referring to *Bat Out of Hell*, which did sell extremely well.

12. From the *1994 Annual Report of the Recording Industry Association of America* (Washington, D.C.: Recording Industry Association of America, 1995). RIAA's 1995 report does not list the best-selling recordings of all time.

13. Such figures leave out the sales of pirated (unauthorized duplication), bootlegged (unauthorized recording), and counterfeit (unauthorized duplication of sounds and artwork) recordings. RIAA says that there were about 1,300,000 seizures of counterfeit and pirate recordings in 1995 in the U.S., the lowest figure in five years (*Annual Report of the Recording Industry Association of America* [Washington, D.C.: Recording Industry Association of America, 1996]). Global figures are much harder to come by, for these are based not on actual seizures but estimates. In 1994, the International Federation of the Phonographic Industry estimated that the number of pirated recordings topped the one-billion mark worldwide, with an estimated retail value of $2.25 billion (Jeff Clark-Meads, "World Piracy Breaks Billion-Unit Mark," *Billboard* 107 [3 June 1995], 70). Their 1995 figure was slightly lower—955 million units—which means that one in every five recordings is a pirate copy

(Jackie Rodgers, "Pirate sales of Pre-Recorded Music Sailing High," Reuters, 10 May 1996, from http://newspage.yahoo.com/.

14. Quoted by Andrew Tanzer, "Sweet Chinese Siren," *Forbes* 152 (20 December 1993), 78.

15. According to Andrew Pollack, "For a Lot More Than a Song, Karaoke is Put on the Block," *New York Times Cybertimes* (11 March 1996), at http://www.nytimes.com/web/docsroot/library/cyber/week/0311karaoke.html.

16. These statistics are from the RIAA *1994 Annual Report*. The 1995 report does not contain such statistics.

17. I would like to thank Lawrence Cohen for bringing this album to my attention.

18. From a posting on 2 September 1995. For music by these and other South Asian artists, see Bally Sagoo, *Bollywood Flashback*, Sony Music 477697 2, 1994; Sehgal, *I'm Madonna Too, & Other Hits*, OMI Music, D4-Q0660, 1993; Remo, *Politicians Don't Know to Rock 'n' Roll*, OMI Music D4-P0591, 1992; [various], *Rap & Disco–93*, Melody International, 227, n.d., an unbelievable collection; Shiamak, *Survive*, EMI CDNF 154020, 1995; Najma, *Atish*, Shanachie 64026, 1990; and Prabhakar, *The Best of Sharon Prabhakar*, Music India CDNF 030, 1988. And there is a recent collection of music from Goa called *Return to the Source:–Deep Trance & Ritual Beats*, RTTS CD 1, 1995. Finally, see Jerry D'Souza and Mike Levin, "Indian Artists Benefiting from MTV Asia Exposure," *Billboard* 105 (4 December 1993), 42; Edward Gargan, "Vanilla Ice in Hindi," *New York Times* (23 August 1992), H22; and the redoubtable Peter Manuel, *Cassette Culture: Popular Music and Technology in North India*, Chicago Studies in Ethnomusicology, ed. Philip V. Bohlman and Bruno Nettl (Chicago: Univ. of Chicago Press, 1993).

19. I suspect that, as discussed in the first chapter, this is due to the problem of classification. Cui Jian's music sounds like rock music, but not like rock lyrics. It therefore isn't considered world music, and also cannot participate in the overlapping nature of the categories and discourses that world music does: Cui Jian's rock does not allow new agers to listen and bliss out to timbres and rhythms; it does not provide

listeners concerned with questions of authenticity authentic Chinese music, and it doesn't provide the average listener of rock music rock music because its lyrics aren't in English.

For more on Cui Jian, see Tim Brace and Paul Friedlander, "Rock and Roll on the New Long March: Popular Music, Cultural Identity, and Political Opposition in the People's Republic of China," in *Rockin' the Boat: Mass Music and Mass Movements*, ed. Reebee Garofalo (Boston: South End Press, 1992); Robert Delfs, "The Controversial fame of China's first Rock Star," *Far Eastern Economic Review* (26 December 1985): 40; Hans Ebert, "Cui Jian's Rock Resonates in Hearts of China's Youth," *Billboard* 104 (May 2, 1992), 1; Matei P. Mihalca, "Chinese Rock Stars: New Generation Emerging Following Political Liberalisation," *Far Eastern Economic Review* 155 (19 November 1992): 34–35; and Matt Peters, "Rock 'n' Revolt," *Far Eastern Economic Review* 151 (28 March 1991): 30–31.

20. I am indebted to Jasbir K. Puar, whose work on bhangra helped raise these issues. For a similar and thoughtful critique, see Nicholas Thomas, "Cold Fusion," *American Anthropologist* 98 (March 1996): 9–16.

21. Quoted by Wentz, "Youssou N'Dour: Is He Shaking the Tree or Cutting it Down?" *RMM* 2 (May/June 1994), 39.

22. Quoted by Ty Burr, "From Africa, Three Female Rebels With a Cause," *New York Times* (10 July 1994), H28.

23. Hall, "What is this 'Black' in Black Popular Culture?" *Social Justice* 20 (Spring-Summer 1993): 105.

24. Pfeil, "'Makin' Flippy-Floppy': Postmodernism and the Baby-Boom PMC," in *Another Tale to Tell: Politics and Narrative in Postmodern Culture* (London and New York: Verso, 1990).

25. As discussed in *Postmodernism, or, the Cultural Logic of Late Capitalism*, Post-Contemporary Interventions, ed. Fredric Jameson and Stanley Fish (Durham: Duke Univ. Press, 1991).

26. Erlmann, "The Politics and Aesthetics of Transnational Musics," *World of Music* 35 (1993): 3–15.

27. Erlmann, "The Aesthetics of the Global Imagination: Reflections on World Music in the

1990s," *Public Culture* 8 (Spring 1996): 482.

28. Erlmann, "The Politics and Aesthetics of Transnational Musics," 13.

29. Manuel, "Music as Symbol, Music as Simulacrum: Postmodern, Pre-Modern, and Modern Aesthetics in Subcultural Popular Musics," *Popular Music* 14 (May 1995): 236.

See also George Lipsitz's "Cruising Around the Historical Bloc: Postmodernism and Popular Music in East Los Angeles," in *Time Passages: Collective Memory and American Popular Culture*, American Culture, ed. Stanley Aronowitz, Sandra M. Gilbert, and George Lipsitz (Minneapolis: Univ. of Minnesota Press, 1990), in which he argues that Chicano musicians in east Los Angeles exhibited some stylistic features akin to those Michael M. J. Fischer outlined in his "Ethnicity and the Post-Modern Arts of Memory," in *Writing Culture: The Poetics and Politics of Ethnography*, ed. James Clifford and George E. Marcus (Berkeley: Univ. of California Press, 1986).

30. Manuel, "Music as Symbol," 237.

31. Erlmann, "'Africa Civilised, Africa Uncivilised': Local Culture, World System and South African Music," *Journal of Southern African Studies* 20 (June 1994): 179. See also his "The Politics and Aesthetics of Transnational Musics."

32. Quoted by Erlmann, "'Africa Civilised, Africa Uncivilised'," 176. Ellipsis in original.

33. See also Armand Mattelart, "Unequal Voices," *UNESCO Courier* (February 1995): 11–14, for a discussion of this last question.

34. For an excellent series of caveats about the term 'postmodern' and music, see Andrew Goodwin's typically acute "Popular Music and Postmodern Theory," *Cultural Studies* 5 (May 1991): 174–90.

35. There is some irony here, and it's the same one that some feminist scholars and others have pointed out: just as subalterns begin to have some degree of agency, they are told by some gurus of theory that there is no such thing as an agent. On this point, see Nancy Hartsock, "Postmodernism and Political Change: Issues for Feminist Theory," *Cultural Critique* 14 (Winter 1989–90): 15–33. See also Abdul R. JanMohamed and David Lloyd, eds., *The Nature and Context of Minority Discourse* (New York and Oxford: Oxford Univ. Press, 1990).

Appendices

Appendix 1: *Billboard* World Music Charts, Arranged Chronologically

#	Artist	Album Title	Label	Debut Date/ Position	Wks. On Chart	Region/Genre[1]
1.	various	*Grooveyard*	Mango	90/05/19(10)	3	Reggae collection
2.	Miriam Makeba	*Welela*	Mercury	90/05/19(6)	11	Africa: Southern Africa: South Africa
3.	Johnny Clegg and Savuka	*Cruel, Crazy, Beautiful World*	Capitol	90/05/19(11)	43	Africa: Southern Africa: South Africa
4.	Hugh Masekela	*Uptownship*	Novus	90/05/19(4)	9	Africa: Southern Africa: South Africa: jazz
5.	Thomas Mapfumo	*Corruption*	Mango	90/05/19(15)	3	Africa: Southern Africa: Zimbabwe
6.	Black Uhuru	*Now*	Mesa	90/05/19(2)	23	Caribbean: Jamaica: reggae
7.	Le Mystère des Voix Bulgares	*Volume Two*	Nonesuch	90/05/19(3)	5	Europe: Baltic/Balkans: Bulgaria
8.	Le Mystère des Voix Bulgares	*Volume One*	Nonesuch	90/05/19(5)	5	Europe: Baltic/Balkans: Bulgaria
9.	Caetano Veloso	*Estrangeiro*	Elektra	90/05/19(13)	1	Latin America: Brazil
10.	various	*Brazil Classics 2: O Samba*	Luaka Bop	90/05/19(14)	15	Latin America: Brazil
11.	Gipsy Kings	*Mosaique*	Elektra	90/05/19(1)	39	Mediterranean and Maghreb: Flamenco: France
12.	Gipsy Kings	*Gipsy Kings*	Elektra	90/05/19(8)	68	Mediterranean and Maghreb: Flamenco: France
13.	various	*Passion–Sources*	Real World	90/05/19(7)	7	North Africa/Middle East: fusion

[1]Region designations adapted from *World Music: The Rough Guide*, ed. Simon Broughton et al. (London: Rough Guides, 1994).

14.	Beausoleil	*Live! from the Left Coast*	Rounder	90/05/19(9)	3	North America: Cajun
15.	Nusrat Fateh Ali Khan	*Shahen Shah*	Real World	90/05/19(12)	1	South Asia: Pakistan
16.	various	*Brazil Classics 1: Beleza Tropical*	Luaka Bop	90/06/02(5)	1	Latin America: Brazil
17.	Ben Tavera King	*Coyote Moon*	Global Pacific	90/06/02(12)	15	North America: Native American
18.	Ladysmith Black Mambazo	*Two Worlds One Heart*	Warner Bros.	90/06/16(4)	35	Africa: Southern Africa: South Africa
19.	The Bhundu Boys	*Pamberi!*	Mango	90/06/16(15)	1	Africa: Southern Africa: Zimbabwe
20.	3 Mustaphas 3	*Heart of Uncle*	Ryko	90/06/16(13)	3	Europe: Western Europe: England/fusion
21.	Les Negresses Vertes	*Mlah*	Sire	90/06/16(14)	7	Europe: Western Europe: France
22.	Mahlathini and the Mahotella Queens	*Paris-Soweto*	Polydor	90/06/30(11)	9	Africa: Southern Africa: South Africa
23.	Mahlathini and the Mahotella Queens	*Rhythm and Art*	Shanachie	90/06/30(13)	7	Africa: Southern Africa: South Africa
24.	Bunny Wailer	*Time Will Tell*	Shanachie	90/06/30(15)	11	Caribbean: Jamaica: reggae
25.	Burning Spear	*Mek We Dweet*	Mango	90/07/14(5)	35	Caribbean: Jamaica: reggae
26.	Margareth Menzes	*Elegibo*	Mango	90/07/14(8)	31	Latin America: Brazil
27.	Djavan	*Puzzle of Hearts*	Columbia	90/07/28(14)	13	Latin America: Brazil
28.	Shankar	*Pancha Nadai Pallavi*	ECM	90/07/28(15)	11	South Asia: India
29.	Lee Perry	*From the Secret Labratory*	Mango	90/08/11(15)	11	Caribbean: Jamaica: reggae
30.	Lucky Dube	*Prisoner*	Shanachie	90/08/25(15)	10	Africa: Southern Africa: South Africa: reggae
31.	Barefoot	*Barefoot*	Global Pacific	90/08/25(11)	17	fusion
32.	Ladysmith Black Mambazo	*Classic Tracks*	Shanachie	90/09/08(14)	13	Africa: Southern Africa: South Africa

	Artist	Title	Label	Date		Region
33.	Alpha Blondy	The Best of Alpha Blondy	Shanachie	90/09/08(12)	3	Africa: West Africa: Ivory Coast
34.	Black Uhuru	Now Dub	Mesa	90/09/22(14)	11	Caribbean: Jamaica: reggae
35.	Ravi Shankar/Philip Glass	Passages	Private Music	90/09/22(11)	19	Fusion
36.	Youssou N'Dour	Set	Virgin	90/10/20(7)	27	Africa: West Africa: Senegambia
37.	Arrow	Soca Dance Party	Mango	90/10/20(13)	17	Caribbean: Trinidad: soca
38.	Strunz & Farah	Primal Magic	Mesa	90/11/03(13)	35	fusion
39.	Ketama	Y Es Ke Me Han . . .	Mango	90/11/17(15)	6	Mediterranean and Maghreb: Flamenco
40.	Najma	Atish	Shanachie	90/11/17(14)	15	Europe: Western Europe: England: Anglo-Indian
41.	Fela Anikulapo-Kuti	O.D.O.O.	Shanachie	90/12/01(15)	7	Africa: West Africa: Nigeria
42.	Aswad	Too Wicked	Mango	90/12/01(11)	19	Caribbean: Anglo-African: reggae
43.	3 Mustaphas 3	Soup of the Century	Ryko	91/01/12(8)	19	Europe: Western Europe: England/fusion
44.	Edi	Edi	Bons Ritmos	91/01/26(14)	7	[unknown]
45.	Gipsy Kings	Allegria	Elektra	91/01/26(4)	15	Mediterranean and Maghreb: Flamenco: France
46.	Tom Zé	Brazil Classics 4: The Best of Tom Zé	Luaka Bop	91/02/09(15)	7	Latin America: Brazil
47.	Amina	Yalil	Mango	91/02/09(1)	11	Mediterranean and Maghreb: Tunisia
48.	Les Têtes Brulées	Hotheads	Shanachie	91/02/23(12)	1	Africa: Central and East Africa: Cameroon
49.	The Ousmane Kouyaté Band	Domba	Mango	91/02/23(13)	5	Africa: Central and East Africa: Guinea

	Artist	Title	Label	Date	No.	Region
50.	Bunny Wailer	*Gumption*	Shanachie	91/02/23(10)	7	Caribbean: Jamaica: reggae
51.	Ali Farka Toure	*The River*	Mango	91/03/09(14)	11	Africa: West Africa: Mali
52.	Bob Marley and the Wailers	*Talkin' Blues*	Tuff Gong	91/03/09(7)	23	Caribbean: Jamaica: reggae
53.	Mouth Music	*Mouth Music*	Ryko	91/03/09(8)	17	Europe: Celtic: Scotland
54.	Muungano National Choir	*Missa Luba: An African Mass*	Philips	91/03/23(9)	17	Africa
55.	Daniel Ponce	*Chango te Llama*	Mango	91/03/23(12)	7	Caribbean: Cuba: salsa
56.	Jai Uttal	*Footprints*	Triloka	91/03/23(11)	7	North America: fusion
57.	Le Mystère des Voix Bulgares	*Three*	Fontana	91/04/06(11)	11	Europe: Baltic/Balkans: Bulgaria
58.	various	*Brazil Classics 3: Forro Etc.*	Luaka Bop	91/04/06(14)	9	Latin America: Brazil
59.	Juluka	*The Best of Juluka*	Rhythm Safari	91/04/20(12)	19	Africa: Southern Africa: South Africa
60.	Thomas Mapfumo	*Chamunorwa*	Mango	91/04/20(10)	19	Africa: Southern Africa: Zimbabwe
61.	Mory Kanté	*Touma*	Mango	91/05/04(15)	15	Africa: Central and East Africa: Guinea
62.	Milton Nascimento	*Txai*	Columbia	91/05/04(8)	13	Latin America: Brazil
63.	Silvio Rodriguez	*Los Clasicos de Cuba 1*	Luaka Bop	91/05/18(13)	3	Caribbean: Cuba
64.	Boukman Eksperyans	*Vodou Adjae*	Mango	91/05/18(10)	19	Caribbean: Haiti
65.	Annabouboula	*Greek Fire*	Shanachie	91/05/18(14)	9	Mediterranean and Maghreb: Greek-American
66.	Ali Akbar Khan	*Journey*	Triloka	91/06/01(14)	7	South Asia: India
67.	Nusrat Fateh Ali Khan	*Mustt Mustt*	Real World	91/06/01(14)	5	South Asia: Pakistan
68.	Rita Marley	*We Must Carry On*	Shanachie	91/06/15(12)	15	Caribbean: Jamaica: reggae
69.	Black Uhuru	*Iron Storm*	Mesa	91/06/15(15)	25	Caribbean: Jamaica: reggae
70.	Baaba Maal	*Baayo*	Mango	91/06/29(14)	8	Africa: West Africa: Senegambia
71.	various	*Cuba Classics 2: Dancing with the Enemy*	Luaka Bop	91/07/13(12)	19	Caribbean: Cuba

72.	Ziggy Marley and The Melody Makers	*Jahmekya*	Virgin	91/07/13(15)	31	Caribbean: Jamaica: reggae
73.	Outback	*Baka*	Hannibal	91/07/13(10)	7	Oceania: Australia/fusion
74.	Chuck Jonkey	*New Worlds*	Jonkey Music	91/07/27(15)	1	North America: fusion
75.	Steel Pulse	*Victims*	MCA	91/07/27(12)	11	Caribbean: Anglo-African: reggae
76.	Gipsy Kings	*Este Mundo*	Elektra	91/07/27(14)	47	Mediterranean and Maghreb: Flamenco: France
77.	Miriam Makeba	*Eyes on Tomorrow*	Polydor	91/08/10(10)	9	Africa: Southern Africa: South Africa
78.	Marisa Monte	*Mais*	World Pacific	91/08/10(9)	27	Latin America: Brazil
79.	Beausoleil	*Cajun Conja*	Rhino	91/08/10(14)	35	North America: Cajun
80.	Salif Keita	*Amen*	Mango	91/08/24(4)	35	Africa: West Africa: Mali
81.	various	*Axé-Brazil: The Afro-Brazilian Music of Brazil*	World Pacific	91/08/24(11)	17	Latin America: Brazil: Afro-Brazilian
82.	Kanda Bongo Man	*Zing Zong*	Hannibal	91/09/07(13)	13	Africa: Central and East Africa: Zaire
83.	Burning Spear	*Jah Kingdom*	Mango	91/09/07(8)	25	Caribbean: Jamaica: reggae
84.	The Itals	*Easy to Catch*	Rhythm Safari	91/09/21(14)	5	Caribbean: Jamaica: reggae
85.	Judy Mowatt	*Look at Love*	Shanachie	91/09/21(15)	17	Caribbean: Jamaica: reggae
86.	Lucky Dube	*Captured Live*	Shanachie	91/10/05(8)	27	Africa: Southern Africa: South Africa: reggae
87.	Burning Flames	*Dig*	Mango	91/10/05(14)	5	Caribbean: St. Vincent: reggae
88.	Patricia Kaas	*Scene de Vie*	Columbia	91/10/19(14)	21	Europe: Western Europe: France
89.	Mickey Hart	*Planet Drum*	Ryko	91/10/19(9)	41	North America: fusion

	Artist	Album	Label	Date		Region
90.	Aster Aweke	*Kabu*	Columbia	91/11/16(13)	17	Africa: North Africa: Ethiopia
91.	Bob Marley and the Wailers	*One Love*	Heartbeat	91/12/14(15)	21	Caribbean: Jamaica: reggae
92.	Margareth Menezes	*Kindala*	Mango	91/12/14(8)	19	Latin America: Brazil
93.	Edi	*Arte Amada*	Bons Ritmos	92/01/11(12)	7	[unknown]
94.	Flor de Caña	*Dancing on the Wall*	Flying Fish	92/01/25(14)	11	Latin America: various
95.	Hassan Hakmoun and Adam Rudolph	*Gift of the Gnawa*	Flying Fish	92/02/08(13)	13	Mediterranean and Maghreb: Morocco: fusion
96.	Mahlathini and the Mahotella Queens	*Mbaqanga*	Verve	92/02/22(14)	13	Africa: Southern Africa: South Africa
97.	Outback	*Dance the Devil Away*	Hannibal	92/02/22(9)	27	Oceania: Australia: fusion
98.	Juluka	*African Litany*	Rhythm Safari	92/03/07(13)	11	Africa: Southern Africa: South Africa
99.	The Chieftains	*An Irish Evening*	RCA	92/03/07(15)	15	Europe: Celtic: Ireland
100.	Lucky Dube	*House of Exile*	Shanachie	92/03/21(14)	19	Africa: Southern Africa: South Africa: reggae
101.	Paco de Lucia	*Zyryab*	Verve	92/03/21(15)	11	Mediterranean and Maghreb: Spain
102.	various/Kronos Quartet	*Pieces of Africa*	Nonesuch	92/04/04(7)	29	Africa: various
103.	Angélique Kidjo	*Logozo*	Mango	92/04/04(6)	47	Africa: West Africa: Benin
104.	Rara Machine	*Break the Chain*	Shanachie	92/04/18(15)	1	Caribbean: Haiti
105.	Zulu Spear	*Welcome to the USA*	Liberty	92/05/02(13)	9	Africa: Southern Africa: South Africa
106.	Ismael Lo	*Ismael Lo*	Mango	92/05/02(14)	7	Africa: West Africa: Senegambia
107.	Márta Sebestyén	*Apocrypha*	Hannibal	92/05/02(10)	17	Europe: Baltic/Balkans: Hungary
108.	Bahia Black	*Ritual Beating System*	Axiom	92/05/16(11)	11	Latin America: Brazil

#	Artist	Title	Label	Date	No.	Region/Genre
109.	Master Musicians of Jajouka	Apocalypse Across the Sky	Axiom	92/05/16(10)	29	Mediterranean and Maghreb: Morocco
110.	Henry Kaiser and David Lindley	A World Out of Time	Shanachie	92/05/30(13)	39	North America: fusion: Madagascar
111.	Yothu Yindi	Tribal Voice	Hollywood	92/05/30(14)	19	Oceania: Australia: aboriginal
112.	Strunz & Farah	Americas	Mesa	92/06/13(9)	39	fusion
113.	Youssou N'Dour	Eyes Open	40 Acres and a Mule	92/06/27(13)	37	Africa: West Africa: Senegambia
114.	Sergio Mendes	Brasileiro	Elektra	92/06/27(12)	29	Latin America: Brazil
115.	various	Dance Raja Dance	Luaka Bop	92/06/27(15)	9	South Asia: India
116.	Altan	Harvest Storm	Green Linnet	92/07/11(15)	15	North America: Canada: Celtic
117.	Airto Moreira	The Other Side of This	Ryko	92/07/25(10)	13	Latin America: Brazil
118.	Wailing Souls	All Over the World	Chaos	92/08/08(13)	13	Caribbean: Jamaica: reggae
119.	Talip Özkan	The Dark Fire	Axiom	92/08/22(14)	1	Mediterranean and Maghreb: Turkey
120.	various	Duke Reid's Treasure Chest	Heartbeat	92/09/05(14)	15	Caribbean: Jamaica: reggae
121.	Jimmy Cliff	Breakout	JRS	92/09/05(15)	7	Caribbean: Jamaica: reggae
122.	Ofra Haza	Kirya	Shanachie	92/09/05(12)	39	Nile and Gulf: Israel
123.	Flaco Jimenez	Partners	Reprise	92/09/05(13)	11	North America: Mexican
124.	Gipsy Kings	Live	Elektra Musician	92/10/17(13)	23	Mediterranean and Maghreb: Flamenco: France
125.	The Tahitian Choir	Rapa Iti	Triloka	92/10/17(9)	31	Oceania: Tahiti
126.	Bob Marley	Songs of Freedom	Tuff Gong	92/10/31(13)	35	Caribbean: Jamaica: reggae
127.	Khaled	Khaled	Cohiba	92/10/31(12)	11	Mediterranean and Maghreb: Algeria: rai

128.	Jai Uttal	*Monkey*	Triloka	92/11/14(14)	13	North America: fusion
129.	The Pahinui Brothers	*The Pahinui Bros.*	Private Music	92/11/14(15)	5	Oceania: Hawai'i
130.	Zakir Hussain	*Zakir Hussain and the Rhythm Experience*	Moment	92/11/28(14)	23	South Asia: India
131.	Kevin Burke	*Open House*	Green Linnet	92/12/12(15)	7	Europe: Celtic: Ireland
132.	Boukman Eksperyans	*Kalfou Danjere*	Mango	92/12/26(9)	27	Caribbean: Haiti
133.	The Klezmatics	*Rhythm and Jews*	Flying Fish	92/12/26(15)	15	North America: Jewish
134.	various	*Cuba Classics 3: Diablo al Infierno*	Luaka Bop	93/01/23(15)	11	Caribbean: Cuba
135.	Sweet Honey in the Rock	*In This Land*	Earth Beat	93/01/23(14)	21	North America: African American: spirituals
136.	various	*Global Meditation*	Ellipsis Arts . . .	93/02/06(15)	33	collection
137.	Tarika Sammy	*Fanafody*	Green Linnet	93/02/20(15)	7	Africa: Central and East Africa: Madagascar
138.	Big Mountain	*Wake Up*	Quality	93/03/06(13)	19	Caribbean: Jamaica: reggae
139.	Le Mystère des Voix Bulgares	*From Bulgaria with Love*	Mesa	93/03/06(14)	7	Europe: Baltic/Balkans: Bulgaria
140.	Mouth Music	*Mo-Di*	Rykodisc	93/03/20(8)	13	Europe: Celtic: Scotland
141.	Buckwheat Zydeco	*Menagerie: The Essential Collection*	Mango	93/03/20(14)	13	North America: African American: zydeco
142.	Black Uhuru	*Mystical Truth*	Mesa	93/04/03(13)	17	Caribbean: Jamaica: reggae
143.	The Chieftains	*The Celtic Harp*	RCA Victor	93/04/03(11)	9	Europe: Celtic: Ireland
144.	Ry Cooder and V. M. Bhatt	*A Meeting by the River*	Waterlily Acoustics	93/04/03(8)	61	South Asia: India: fusion
145.	Zap Mama	*Adventures in Afropea 1*	Luaka Bop	93/04/17(13)	41	Europe/Africa: fusion
146.	Clannad	*Anam*	Atlantic	93/04/17(14)	55	Europe: Celtic: Ireland
147.	Sheila Chandra	*Weaving My Ancestors' Voices*	Real World	93/04/17(15)	33	Europe: Western Europe: England: fusion
148.	Burning Spear	*The World Should Know*	Heartbeat	93/05/15(15)	21	Caribbean: Jamaica: reggae

149.	Baaba Maal	*Lam Toro*	Mango	93/05/29(7)	25	Africa: West Africa: Senegambia
150.	Värttinä	*Seleniko*	Green Linnet	93/06/12(15)	11	Europe: Baltic/Balkans: Finland
151.	Nicky Skopelitis	*Ekstasis*	Axiom	93/06/12(14)	5	fusion
152.	Obo Addy and Kukrudu	*Let Me Play My Drums*	Burnside	93/06/26(15)	3	Africa: West Africa: Ghana
153.	various	*Putumayo: World Music Vol. 1*	Rhino	93/06/26(14)	7	collection
154.	Clannad	*Banba*	Atlantic	93/07/10(14)	85	Europe: Celtic: Ireland
155.	Bachir Attar	*The Next Dream*	CMP	93/07/10(15)	11	Mediterranean and Maghreb: Morocco
156.	Lucky Dube	*Victims*	Shanachie	93/07/24(11)	17	Africa: Southern Africa: South Africa: reggae
157.	Ali Farka Toure	*The Source*	Hannibal	93/07/24(13)	37	Africa: West Africa: Mali
158.	Ziggy Marley and the Melody Makers	*Joy and Blues*	Virgin	93/08/07(14)	17	Caribbean: Jamaica: reggae
159.	various	*Global Celebration*	Ellipsis Arts . . .	93/08/21(297)	29	collection
160.	Willie and Lobo	*Gypsy Boogaloo*	Mesa	93/08/21(15)	33	fusion
161.	Johnny Clegg and Savuka	*Heat, Dust & Dreams*	Capitol	93/09/04(15)	7	Africa: Southern Africa: South Africa
162.	Conjunto Céspedes	*Una Sola Casa*	Green Linnet	93/10/02(13)	21	Caribbean: Cuba: Afro-Cuban
163.	Henry Kaiser and David Lindley	*A World Out of Time Vol. 2*	Shanachie	93/10/02(11)	13	North America: fusion: Madagascar
164.	Le Mystère des Voix Bulgares	*Melody Rhythm & Harmony*	Mesa	93/10/16(14)	9	Europe: Baltic/Balkans: Bulgaria
165.	various	*Plus from Us*	Real World	93/10/30(15)	1	various
166.	Black Uhuru	*Liberation: The Island Anthology*	Mango	93/11/13(13)	7	Caribbean: Jamaica: reggae
167.	Altan	*Island Angel*	Green Linnet	93/11/13(15)	39	Europe: Celtic: Ireland

168.	Sweet Honey in the Rock	Still on the Journey	Earth Beat	93/11/27(11)	23	North America: African American: spirituals
169.	Ali Akbar Khan	Garden of Dreams	Triloka	93/11/27(15)	19	South Asia: India
170.	Gipsy Kings	Love & Liberté	Elektra Musician	93/12/11(7)	97	Mediterranean and Maghreb: Flamenco: France
171.	various	The Story of Jamaican Music	Mango	93/12/25(12)	5	Caribbean: Jamaica: reggae
172.	various	The World Sings Goodnight	Silver Wave	94/01/08(10)	27	collection
173.	Baka Beyond	Spirit of the Forest	Hannibal	94/01/08(14)	13	fusion
174.	Geoffrey Oryema	Beat the Border	Real World	94/01/22(15)	11	Africa: Central and East Africa: Uganda
175.	Uakti	I Ching	Point Music	94/03/05(12)	7	fusion
176.	Hugh Masekela	Hope	Triloka	94/03/19(14)	29	Africa: Southern Africa: South Africa: jazz
177.	Inti-Illimani	Andadas	Xenophile/Green Linnet	94/03/19(13)	13	Latin America: Chile
178.	Milton Nascimento	Angelus	Warner Bros.	94/04/02(11)	19	Latin America: Brazil
179.	Khaled	N'ssi N'ssi	Mango	94/04/02(6)	21	Mediterranean and Maghreb: Algeria: rai
180.	various	Africa: Never Stand Still	Ellipsis Arts...	94/04/16(15)	17	Africa: collection
181.	Angélique Kidjo	Ayé	Mango	94/04/16(7)	33	Africa: West Africa: Benin
182.	Salif Keita	The Mansa of Mali–A Retrospective	Mango	94/04/30(10)	31	Africa: West Africa: Mali
183.	Ladysmith Black Mambazo	Gift of the Tortoise	MFLP	94/05/14(13)	24	Africa: Southern Africa: South Africa
184.	Nusrat Fateh Ali Khan	Last Prophet	Real World	94/05/14(15)	3	South Asia: Pakistan
185.	various	Best of Both Worlds	Hannibal	94/05/28(15)	7	collection
186.	Talitha Mackenzie	Solas	Shanachie	94/06/11(12)	1	Europe: Celtic: Scotland
187.	Ladysmith Black Mambazo	Liph' Iqiniso	Shanachie	94/06/25(13)	13	Africa: Southern Africa: South Africa

188.	Zap Mama	*Sabsylma*	Luaka Bop	94/06/25(6)	25	Europe/Africa: fusion
189.	Sheila Chandra	*Zen Kiss*	Real World	94/06/25(11)	21	Europe: Western Europe: England: fusion
190.	Manu Dibango	*Wakafrika*	Giant	94/07/23(7)	19	Africa: Central and East Africa: Cameroon: jazz
191.	Youssou N'Dour	*The Guide (Wommat)*	Chaos	94/07/23(10)	31	Africa: West Africa: Senegambia
192.	MC Solaar	*Prose Combat*	Cohiba	94/08/06(10)	16	Europe: Western Europe: France: rap
193.	various	*Trance Planet*	Worldly Music	94/08/20(14)	13	collection
194.	various	*Africa Fête*	Mango	94/09/03(12)	5	Africa: various
195.	Willie and Lobo	*Fandango Nights*	Mesa	94/09/03(13)	13	fusion
196.	Keola Beamer	*Wooden Boat*	Dancing Cat	94/09/17(15)	3	Oceania: Hawai'i
197.	various	*Soca Carnival '94*	Ice	94/10/01(10)	5	Caribbean: Soca
198.	various	*Duende*	Ellipsis Arts . . .	94/10/01(12)	5	Mediterranean and Maghreb: Flamenco
199.	Ismael Lo	*Iso*	Mango	94/10/15(11)	9	Africa: West Africa: Senegambia
200.	I. K. Dairo	*Ashiko*	Green Linnet	94/10/29(15)	5	Africa: West Africa: Nigeria
201.	Tabu Ley Rochereau	*Muzina*	Rounder	94/11/12(14)	3	Africa: Central and East Africa: Zaire
202.	Shakti with John McLaughlin	*The Best of Shakti*	Moment	94/11/12(12)	1	North America/South Asian: fusion
203.	Le Mystère des Voix Bulgares	*Ritual*	Nonesuch	94/11/26(11)	1	Europe: Baltic/Balkans: Bulgaria
204.	Marisa Monte	*Rose and Charcoal*	Metro Blue	94/11/26(10)	2	Latin America: Brazil
205.	Jai Uttal	*Beggars and Saints*	Triloka	94/11/26(12)	1	North America: fusion
206.	various	*Lullaby*	Music for Little People	94/12/10(10)	9	collection

207.	Clannad	Magical Ring	RCA	94/12/10*2	12	Europe: Celtic: Ireland
208.	Beausoleil	L'Echo	Rhino	94/12/10*	14	North America: Cajun
209.	Ledward Kaapana	Led Live Solo	Dancing Cat	94/12/24(15)	1	Oceania: Hawai'i
210.	Buckwheat Zydeco	Five Card Stud	Mango	95/01/07*	2	North America: Cajun
211.	Baaba Maal	Firin' in Fouta	Mango	95/01/21*	8	Africa: West Africa: Senegambia
212.	various	Taste of Soca	Ice	95/01/21*	4	Caribbean: Soca
213.	Nomad	Nomad	Australian Music International	95/01/21(14)	1	Oceania: Australia: fusion
214.	various	Latcho Drom	Caroline	95/02/04*	6	Mediterranean and Maghreb: gypsy: various
215.	Mary Black	By the Time it gets Dark	Gifthorse	95/02/18*	2	Europe: Celtic: Ireland
216.	various	Celtic Legacy: A Global Celtic Journey	Narada	95/03/04(2)	52	Europe: Celtic
217.	Los Lobos with Lalo Guerrero	Papa's Dream	Music for Little People	95/03/04(4)	13	North America: Mexican
218.	Lebo M	The Lion King: Rhythm of the Pride Lands	Walt Disney	95/03/18(1)	79	Africa: Southern Africa: South Africa/fusion
219.	Ali Farka Toure and Ry Cooder	Talking Timbuktu	Hannibal	95/03/18(11)	63	Africa: West Africa: Mali/fusion
220.	various	Celtic Odyssey	Narada	95/03/18(13)	18	Europe: Celtic
221.	various	Celtic Heartbeat Collection	Celtic Heartbeat	95/03/18(6)	27	Europe: Celtic
222.	The Chieftains	The Long Black Veil	RCA Victor	95/03/18(2)	86	Europe: Celtic: Ireland
223.	Clannad	Clannad Themes	Celtic Heartbeat	95/03/18(4)	48	Europe: Celtic: Ireland
224.	various	Celtic Graces—A Best of Ireland	I.R.S.	95/03/18(9)	4	Europe: Celtic: Ireland
225.	Mouth Music	Shorelife	Rykodisc	95/03/18(14)	3	Europe: Celtic: Scotland
226.	Loreena McKennitt	The Mask and Mirror	Warner Bros.	95/03/18(5)	96	North America: Canada: Celtic

227.	Cirque du Soleil	*Alegria*	RCA	95/03/18(7)	63	North America: French-Canadian
228.	Cirque du Soleil	*Mystère*	RCA	95/03/18(15)	18	North America: French-Canadian
229.	Mary Black	*Looking Back*	Curb	95/04/01(6)	17	Europe: Celtic: Ireland
230.	Anína	*Anína*	Celtic Heartbeat	95/04/01*	2	Europe: Celtic: Ireland: ancient/classical
231.	Johnny Clegg and Savuka	*In My African Dream*	Rhythm Safari	95/04/15*	7	Africa: Southern Africa: South Africa
232.	Gipsy Kings	*Best Of*	Nonesuch	95/04/15(3)	77	Mediterranean and Maghreb: Flamenco: France
233.	Beau Jocque and the Zydeco Hi-Rollers	*Git it, Beau Jocque!*	Rounder	95/05/13(10)	1	North America: African American: zydeco
234.	Dr Didg	*Out of the Woods*	Hannibal	95/05/27(12)	3	Oceania: Australia
235.	Nightnoise	*A Different Shore*	Windham Hill	95/06/10*	20	Europe: Celtic: Ireland: new age
236.	various	*Hawaiian Slack Key Guitar Masters: Instrumental Collection*	Dancing Cat	95/06/10(11)	19	Oceania: Hawai'i
237.	various	*The Soul of Black Peru*	Luaka Bop	95/06/24(15)	5	Latin America: Peru Afro-Peruvian
238.	Papa Wemba	*Emotion*	Real World	95/08/05*	2	Africa: Central and East Africa: Zaire
239.	Ry Cooder	*Music by Ry Cooder*	Warner Bros.	95/08/05*	10	North America: America
240.	Robi Kahakalau	*Robi Kahakalau*	Kana'i'a	95/08/05(15)	1	Oceania: Hawai'i
241.	Cesaria Evora	*Cesaria Evora*	Nonesuch	95/08/19(15)	47	Africa: West Africa: Cape Verde
242.	various	*Celtic Voices: Women of Song*	Narada	95/09/16(7)	25	Europe: Celtic

243.	various: soundtrack	The Brothers McMullen	Arista	95/09/16*	53	Europe: Celtic: Ireland: Irish America
244.	Keali'i Reichel	Kawaipunahele	Punahele	95/09/30*	6	Oceania: Hawai'i
245.	various	Celtic Twilight 2	Hearts of Space	95/10/14*	24	Europe: Celtic
246.	various	Celtic Christmas	Windham Hill	95/10/28*	14	Europe: Celtic
247.	Loreena McKennitt	A Winter Garden	Warner Bros.	95/11/25(5)	7	Europe: Celtic: fusion
248.	Strunz & Farah	Heat of the Sun	Selva	95/11/25(14)	19	fusion
249.	various	Women of the World: Celtic	Putumayo	95/12/09(11)	42	Europe: Celtic
250.	Keali'i Reichel	Lei Hali'a	Punahele	95/12/23*	16	Oceania: Hawai'i
251.	Hapa	Holidays	Coconut Grove	95/12/23*	2	Oceania: Hawai'i
252.	The Chieftains	Film Cuts	RCA Victor	96/03/02(2)	29	Europe: Celtic: Ireland
253.	James Galway	The Celtic Minstrel	RCA Victor	96/03/02*	24	Europe: Celtic: Ireland
254.	Clannad	Lore	Celtic Heartbeat	96/03/16(1)	23	Europe: Celtic: Ireland
255.	various	Ireland's Greatest Hits	RCA	96/03/16(11)	3	Europe: Celtic: Ireland
256.	Nusrat Fateh Ali Khan and Michael Brook	Night Song	Real World	96/03/16*	28	South Asia: Pakistan/fusion
257.	Bill Whelan	Riverdance	Celtic Heartbeat	96/03/30(1)	16	Europe: Celtic: Ireland
258.	Phil Coulter	Celtic Horizons	Shanachie	96/03/30(13)	1	Europe: Celtic: Ireland
259.	Seamus Egan	When Juniper Sleeps	Shanachie	96/03/30(15)	1	Europe: Celtic: Irish American
260.	Gipsy Kings	Tierra Gitana	Nonesuch	96/03/30(2)	27	Mediterranean and Maghreb: Flamenco: France
261.	Angélique Kidjo	Fifa	Mango	96/04/13(11)	5	Africa: West Africa: Benin
262.	various	Celtic Treasure–The Legacy of Turlough O'Carolan	Narada	96/05/11(11)	21	Europe: Celtic: Ireland
263.	various	Flamenco: Fire & Grace	Narada	96/05/11(15)	5	Mediterranean and Maghreb: Flamenco

264.	various	Common Ground	Capitol	96/07/06*	8	Europe: Celtic: Ireland
265.	Altan	Blackwater	Virgin	96/07/06*	4	Europe: Celtic: Ireland
266.	Madre Deus	O Espirito da Paz	Metro Blue	96/07/06(10)	1	Mediterranean and Maghreb: Portugal
267.	various	One World	Putumayo	96/07/20(5)	11	collection
268.	various	Celtic Collection	Putumayo	96/07/20*	2	Europe: Celtic
269.	various	Green Linnet Records The 20th Anniversary Collection	Green Linnet	96/08/03(14)	9	collection
270.	Johnny Clegg and Juluka	A Johnny Clegg & Juluka Collection	Putumayo	96/08/17(15)	1	Africa: Southern Africa: South Africa
271.	Dead Can Dance	Spiritchaser	4AD	96/08/31*	6	Oceania: Australia: fusion
272.	Mychael Danna and Jeff Danna	A Celtic Tale	Hearts of Space	96/08/31(15)	1	Europe: Celtic

Appendix 2: History of the Folk, Ethnic, and World Music Grammy Awards

1959
Best Performance, Folk
- •Kingston Trio: *The Kingston Trio at Large*
 Eddy Arnold: "Tennessee Stud"
 Harry Belafonte: *Belafonte at Carnegie Hall*
 Jimmy Driftwood: *The Wilderness Road*
 Ralph Hunter Choir: *The Wild Wild West*

1960
Best Performance, Folk
- • Harry Belafonte: "Swing Dat Hammer"
 Alan Lomax: *Southern Folk Heritage Series*
 Belafonte Singers: "Cheers"
 Brothers Four: "Greenfields"
 Ewan MacColl: *Songs of Robert Burns*
 Jimmy Driftwood: *Songs of Billy Yank and Johnny Reb*
 Kingston Trio: "Here we Go Again"
 Miriam Makeba: *Miriam Makeba*

1961
Best Folk Recording
- • Belafonte Folk Singers: *Belafonte Folk Singers at Home and Abroad*
 Alan Lomax: *Folk Songs of Britain, Vol. 1*
 Bill Broonzy: *The Big Bill Broonzy Story*
 Clancy Brothers and Tommy Makem: *The Clancy Brothers and Tommy Makem*
 Limeliters: *The Slightly Fabulous Limeliters*

1962
Best Folk Recording
- • Peter, Paul & Mary: "If I had a Hammer"
 Bob Dylan: *Bob Dylan*
 Flatt & Scruggs: "The Ballad of Jed Clampett"

Harry Belafonte: *The Midnight Special*
Joan Baez: *Joan Baez*
Kingston Trio: *Something Special*
New Christy Minstrels: *Presenting the New Christy Minstrels*

1963
Best Folk Recording
- • Peter, Paul & Mary: "Blowin' in the Wind"
 Judy Collins: *Judy Collins No. 3*
 Miriam Makeba: *The World of Miriam Makeba*
 New Christy Minstrels: *Green, Green*
 Odetta: *Odetta Sings Folk Songs*
 Pete Seeger: *We Shall Overcome*
 Rooftop Singers: *Walk Right In*

1964
Best Folk Recording
- • Gale Garnett: *We'll Sing in the Sunshine*
 Bob Dylan: *The Times, They Are A-Changin'*
 Harry Belafonte: *Belafonte at the Greek Theatre*
 Miriam Makeba: *The Voice of Africa*
 New Christy Minstrels: *Today*
 Peter, Paul & Mary: *Peter, Paul & Mary in Concert*
 Woody Guthrie: *Woody Guthrie: Library of Congress Recordings*

1965
Best Folk Recording
- • Harry Belafonte, Miriam Makeba: *An Evening with Belafonte/Makeba*
 Joan Baez: *There But for Fortune*
 Miriam Makeba: *Makeba Sings*
 Pete Seeger: *Strangers and Cousins*
 Peter, Paul & Mary: *A Song Will Rise*
 Roscoe Holcomb: *Roscoe Holcomb: The High Lonesome Sound*
 Womenfolk: *The Womenfolk at the Hungry I*

1966
Best Folk Recording
- Cortelia Clark: *Blues in the Street*
 Leadbelly: *Leadbelly*
 Mimi & Richard Farina: *Reflections in a Crystal Wind*
 Mitchell Trio: *Violets of Dawn*
 Oliver Smith: *Oliver Smith*
 Pete Seeger: *God Bless the Grass*
 Peter, Paul & Mary: "Hurry Sundown"
 Ravi Shankar: *Sound of the Sitar*

1967
Best Folk Performance
- John Hartford: "Gentle on My Mind"
 Arlo Guthrie: *Alice's Restaurant*
 Janis Ian: *Janis Ian*
 Judy Collins: *In My Life*
 Pete Seeger: "Waist Deep in the Big Muddy"
 Peter, Paul & Mary: *Album 1700*

1968
Best Folk Performance
- Judy Collins: "Both Sides Now"
 Bob Dylan: "John Wesley Harding"
 Gordon Lightfoot: "Did She Mention My Name"
 Incredible String Band: "The Hangman's Beautiful Daughter"
 Irish Rovers: "The Unicorn"
 Peter, Paul & Mary: "Late Again"

1969
Best Folk Performance
- Joni Mitchell: *Clouds*
 Donovan: "Atlantis"
 Joan Baez: "Any Day Now"
 Judy Collins: "Bird on a Wire"
 Pete Seeger: "Young vs. Old"
 Peter, Paul & Mary: "Day is Done"

1970
Best Ethnic or Traditional Recording (Including Traditional Blues)
- T-Bone Walker: "Good Feelin'"
 Ali Akbar Khan, Shankar Ghosh: "Shree Rag"
 Bjorn Stabi, Ole Hjorth: *Folk Fiddling from Sweden*
 David Lewisohn: *Black Music of South America*
 Mississippi Fred McDowell: *I Do Not Play No Rock and Roll*
 Muddy Waters: *Sail On*

1971
Best Ethnic or Traditional Recording (Including Traditional Blues)
- Muddy Waters: *They Call Me Muddy Waters*
 Esso Trinidad Steel Band: *The Esso Trinidad Steel Band*
 Howlin' Wolf: *Message to the Young*
 Javanese Players: *Javanese Court Gamelan*
 Keiko Matsuo: *18th Century Traditional Music of Japan*
 Mississippi Fred McDowell: *Mississippi Fred McDowell*
 T-Bone Walker: *Stormy Monday Blues*

1972
Best Ethnic or Traditional Recording (Including Traditional Blues)
- Muddy Waters: *The London Muddy Waters Session*
 John Lee Hooker: *Walking the Blues*
 Lightnin' Hopkins: *Lightnin' Strikes*
 Little Brother Montgomery, Roosevelt Sykes, Sunnyland Slim, Speckled Red, Otis Spann, Curtis Jones: *Blues Piano Orgy*

1973
Best Ethnic or Traditional Recording
- Doc Watson: *Then and Now*
 John Lee Hooker: *John Lee Hooker's Detroit (1948-1952)*
 King Curtis, Champion Jack Dupree: *Blues at Montreux*
 Leadbelly: *Leadbelly (Live in Concert)*
 Muddy Waters: *Can't Get No Grindin'*

1974
Best Ethnic or Traditional Recording (Including Traditional Blues and Pure Folk)
- Doc and Merle Watson: *Two Days in November*

Bukka White: *Big Daddy*
Howlin' Wolf: *The Back Door Wolf*
Muddy Waters: *London Revisited*
Willie Dixon: *Catalyst*

1975
Best Ethnic or Traditional Recording
(Including Traditional Blues and Pure Folk)
• Muddy Waters: *The Muddy Waters
 Woodstock Album*
 Black Convict Work Songs: *Wake Up
 Dead Man*
 Koko Taylor: *I Got What It Takes*
 Memphis Slim: *Memphis Blues*
 San Lucas Band: *Music of Guatemala*

(Best Latin Recording category added)

1976
Best Ethnic or Traditional Recording
• John Hartford: *Mark Twang*
 Arliene Nofchissey Williams, Chief Dan
 George, Rick Brosseau: *Proud Earth*
 Hound Dog Taylor: *Beware of the Dog*
 Michael Bloomfield: *If You Love These
 Blues, Play 'em as You Please*
 Shotts & Dykehead Caledonia Pipe
 Band: *Bagpipe Marches and Music of
 Scotland*

1977
Best Ethnic or Traditional Recording
• Muddy Waters: *Hard Again*
 Joe Turner: *Things That I Used to Do*
 Junior Wells: *Blues Hit Big Town*
 Otis Rush: *Right Place, Wrong Time*
 Willie Dixon: *What Happened to My
 Blues*

1978
Best Ethnic or Traditional Recording
• Muddy Waters: *I'm Ready*
 Clifton Chenier: *Clifton Chenier and
 His Red Hot Louisiana Band in New
 Orleans*
 Fenton Robinson: *I Hear Some Blues
 Downstairs*
 Louis Myers, John Littlejohn, Eddie
 Taylor, Jimmy Rogers, Johnny Shines,

Homesick James Williams, and Bob
 Myers: *Chicago Blues at Home*
 Memphis Slim & His House Rockers,
 featuring Matt "Guitar" Murphy:
 U.S.A.

1979
Best Ethnic or Traditional Recording
• Muddy Waters: *Muddy "Mississippi"
 Waters Live*
 Albert Collins: *Ice Pickin'*
 Chieftains: *The Chieftains 7*
 Eubie Blake, Charles Mingus, Roosevelt
 Sykes, and Clifton Chenier: *New
 Orleans Jazz & Heritage Festival*
 Jimmy Johnson Blues Band, Eddie Shaw
 & the Wolf Gang, Left Hand Frank &
 his Blues Band: *Living Chicago Blues*,
 Vol. 1
 Lonnie Brooks Blues Band, Pinetop
 Perkins & Sons of the Blues: *Living
 Chicago Blues*, Vol. 3
 Otis Rush: *So Many Roads*
 Paul F. Wells, producer: *New England
 Traditional Fiddling*
 Uncle Dave Macon: *Laugh Your Blues
 Away*

1980
Best Ethnic or Traditional Recording
• Dr. Isaiah Ross, Maxwell Street Jimmy,
 Big Joe William, Son House, Rev.
 Robert Wilkins, Little Brother Mont-
 gomery, and Sunnyland Slim: *Rare
 Blues*
 Blind Willie McTell, Curley Weaver,
 and Buddy Moss: *Atlanta Blues:
 1933*
 Chieftains: *Boil the Breakfast Early*
 Eddie "Cleanhead" Vinson: *Kidney
 Stew Is Fine*
 Queen Ida: *Queen Ida & the Bon Temps
 Zydeco Band in New Orleans*

1981
Best Ethnic or Traditional Recording
• B. B. King: *There Must Be a Better World
 Somewhere*
 A. C. Reid & the Spark Plugs, Scotty &

the Rib Tips, Lovie Lee with Carey
Bell: *Living Chicago Blues* Vol. IV
Albert Collins: *Frozen Alive!*
Koko Taylor: *From the Heart of a
Woman*
Lonnie Brooks Blues Band, the Son
Seals Blues Band, Mighty Joe Young,
Muddy Waters, Koko Taylor & Her
Blues Machine, and Willie Dixon &
the Chicago Blues All Stars: *Blues
Deluxe*

1982
Best Ethnic or Traditional Recording
• Queen Ida: *Queen Ida and the Bon
Temps Zydeco Band on Tour*
Boys of the Lough: *In the Tradition*
John Renbourn Group: *Live in America*
Klezmorim: *Metropolis*
Various artists: *Reggae Sunsplash '81: A
Tribute to Bob Marley*
Various artists: *Tennessee: Folk Her-
itage—The Mountains*

(Best Traditional Blues Recording category added)

1983
Best Ethnic or Traditional Recording
• Clifton Chenier & His Red Hot
Louisiana Band: *I'm Here*
Alan Stivell: *Renaissance of the Celtic
Harp*
Chieftains: *The Grey Fox*
King Sunny Ade: *Synchro System*
Ravi Shankar and Ali Akbar Khan: *Raga
Mishra Piloo*

(Best Tropical Latin Performance category added;
**Best Mexican/American Performance category
added;**
Best Latin Pop Performance category added)

1984
Best Ethnic or Traditional Recording
• Elizabeth Cotten: *Elizabeth Cotten
Live!*
Boys of the Lough: *Open Road*
Buckwheat Zydeco: *100% Fortified
Zydeco*

Queen Ida: *On a Saturday Night*
Rockin' Dopsie: *Good Rockin'*

(Best Reggae Recording category added)

1985
Best Ethnic or Traditional Recording
• Rockin' Sidney: "My Toot Toot"
Beausoleil: *Zydeco Girls*
Buckwheat Zydeco: *Turning Point*
Clifton Chenier: *Live at the San Fran-
cisco Blues Festival*
Dewey Balfa: *Souvenirs*

(Best Polka Recording category added)

1986
Best Traditional Folk Recording
• Doc Watson: *Riding the Midnight Train*
Buckwheat Zydeco: *Waitin' for My Ya Ya*
New Lost City Ramblers with Elizabeth
Cotten, Pete Seeger, and the High-
wood String Band: *20th Anniversary
Concert*
Queen Ida: *Caught in the Act*
Rockin' Sidney: *Hot Steppin' with
Rockin' Sidney*

(Best Contemporary Folk Recording category added;
Best New Age Recording category added)

1987
Best Traditional Folk Recording
• Ladysmith Black Mambazo: *Shaka Zulu*
Bantu Glee Singers, Crocodiles, Shoot-
ing Stars, and others: *Mbube Roots,
Zulu Choral Music from South Africa*
Chieftains: *Celtic Wedding*
Michael Doucet, Beausoleil: *Belizaire
the Cajun*
Various artists: *Zulu Men's Singing Com-
petition*

**(Best Contemporary Blues Recording category
added)**

1988
Best Traditional Folk Recording
• Various: *Folkways: A Vision Shared—A*

Tribute to Woody Guthrie and
Leadbelly
Bob Dylan: "Pretty Boy Floyd," track
from Folkways: A Vision Shared
Bulgarian State Radio & Television
Female Vocal Choir: Le Mystère des
Voix Bulgares
Ladysmith Black Mambazo: Journey of
Dreams
Van Morrison and the Chieftains: Irish
Heartbeat

1989
Best Traditional Folk Recording
• Bulgarian State Radio & Television
Female Choir: Le Mystère des Voix
Bulgares, Volume II
Cajun Tradition: À la Vieille Façon
Masters of Traditional Missouri Fid-
dling: Now That's a Good Tune
Norman & Nancy Blake: Blind Dog
Various American Indian Tribes: Ameri-
can Indian Dance Theatre

1990
Best Traditional Folk Recording
• Doc Watson: On Praying Ground
Basin Brothers: Let's Get Cajun
Ladysmith Black Mambazo: Classic
Tracks
Toinho de Alagoas, Duda da Passira,
Jose Orland, and Heleno Dos Oito
Baixos: Brazil Forro: Music for Maids
and Taxi Drivers
Various artists: Partisans of Vilna:
Songs of World War II Jewish Resis-
tance
Whitstein Brothers: Old Time Duets

1991
Best Traditional Folk Recording
• Various artists: The Civil War (Original
Soundtrack Recording)
Doc Watson: My Dear Old Southern
Home
Jimmy C. Newman and Cajun Country:
Alligator Man
Mike Seeger: Solo–Oldtime Country
Music

Various Soloists and Choirs: Le Mystère
des Voix Bulgares, Vol. 3

Best World Music Album
• Mickey Hart: Planet Drum
Dori Caymmi: Brazilian Serenata
Gipsy Kings: Este Mundo
Milton Nascimento: Txai
Salif Keita: Amen

1992
Best Traditional Folk Recording
• Chieftains: An Irish Evening Live at the
Grand Opera House, Belfast
D. L. Menard, Eddie LeJeune, and Ken
Smith: Le Trio Cadien
David Holt: Grandfather's Greatest Hits
Norman and Nancy Blake: Just Gimme
Somethin' I'm Used To
Volker Steppat: A Cathedral Concert

Best World Music Album
• Sergio Mendes: Brasileiro
Gipsy Kings: Gipsy Kings Live
Ofra Haza: Kirya
Strunz and Farah: Americas
Youssou N'Dour: Eyes Open

1993
Best Traditional Folk Recording
• Chieftains: The Celtic Harp
Greg Brown and Bill Morrissey: Friend
of Mine
Kate Brislin and Jody Stecher: Our Town
R. Carlos Nakai and William Eaton:
Ancestral Voices
Steve Riley & The Mamou Playboys:
Trace of Time
Uli Balls and Vladimir Ivanoff: Melody,
Rhythm & Harmony

Best World Music Album
• Ry Cooder and V. M. Bhatt: A Meeting
by the River
Deep Forest: Deep Forest
Henry Kaiser: A World Out of Time, Vol.
2: Henry Kaiser & David Lindley in
Madagascar

Johnny Clegg and Savuka: *Heat, Dust & Dreams*
Ulrich Balls and Vladimir Ivanoff: *From Bulgaria with Love*

1994
Best Traditional Folk Album
• Bob Dylan: *World Gone Wrong*
Chieftains: *The Celtic Harp*
Le Mystère des Voix Bulgares: *Melody, Rhythm & Harmony*
Bill Morrissey and Greg Brown: *Friend of Mine*
R. Carlos Nakai and William Eaton (with the Black Lodge Singers): *Ancestral Voices*
Steve Riley and the Mamou Playboys: *Trade of Time*
Jody Stecher and Kate Brislin: *Our Town*

Best World Music Album
• Ali Farka Toure and Ry Cooder: *Talking Timbuktu*
Gipsy Kings: *Love & Liberté*
Milton Nascimento: *Angelus*
Youssou N'Dour: *The Guide (Wommat)*
Zap Mama: *Sabsylma*

1995
Best Traditional Folk Album
• Ramblin' Jack Elliott: *South Coast*
Ali Akbar Khan: *Then and Now*
Dave Van Ronk: *From . . . Another Time & Place*
Laurie Lewis and Tom Rozum: *The Oak and the Laurel*
Norman and Nancy Blake: *While Passing Along This Way*

Best World Music Album
• Deep Forest: *Boheme*
Baaba Maal: *Firin' in Fouta*
Cesaria Evora: *Cesaria Evora*
Shankar with Zakir Hussain & Vikku Vinayakram: *Raga Aberi*
The Splendid Master Gnawa Musicians of Morocco: *The Splendid Master Gnawa Musicians of Morocco Featuring Randy Weston*

Compiled from Thomas O'Neil, *The Grammys for the Record* (New York and London: Penguin, 1993) and the Grammy awards web site, http://www.grammy.com/.

Appendix 3: "Dónall Óg"[1]

Donall Óg

A Dhónaill Óig, má théir thar farraige
Beir mé féin leat 's ná deán dom
dear(a)mad
Beidh agat féirín lá aonaigh 'gus
mar(a)gaidh
Agus níon Rí Gréige mar chéile leapa 'gat

Gheall tú dom-sa ní nach dearn tú
Fáinne óir a chur ar 'ach méar domh
Seisreach óir fána hanlaí airgid
Agus muileann siúchra ar 'ach
struth in Éirinn

B'fhurast dom aithne nach tú
bhí i ndán dom
Chuir tú amach mé oíche na báistí
Bhain truisle dom-sa ag giall na bearnadh
Char dhúirt tú Dia liom 's char
chraith tú lámh liom

Bhain tú soir 'gus bhain tú siar dom
Bhain tú romham is bhain tú mo
dhiaidh dom
Bhain tú 'n ghealach is bhain tú an
ghrian dom
'S is ró-mhór m'eagla gur bhain tú
Dia dom

Young Donald

Young Donald, mine, if you should go away
Then take me too, don't leave me here to wait

A gift I'll give at the fair on market day

And the Greek king's daughter with you to stay

The promise made you never did uphold
That on every finger you would place a ring of gold
A golden plough with shafts of bright silver
On every Irish stream to stand a sugar-mill

'Twas soon I saw that you were not my maid

You sent me out at night in all the rain
I almost tumbled on entering the land
Not even: Bless you, did you say or shake my hand

From me you've stolen East and West likewise
You took my past and my future besides

The sun and moon, you've taken them away

To take my God from me I'm most afraid

[1] In Peter Kennedy, ed., *Folksongs of Britain and Ireland* (London: Oak, 1984).

References

DISCOGRAPHY

Addy, Obo. *Let Me Play My Drums*. Burnside Records: BCA-0010-2, 1993.

———. *Okopong*. EarthBeat! 42508, 1990.

———. *The Rhythm of which a Chief Walks Gracefully*. WEA/Warner Bros. 7599 42561 4, 1994.

The African Mbira: Music of the Shona People of Rhodesia. Nonesuch Explorer Series. Nonesuch H 72043, 1971.

Apache Indian. *Make Way for the Indian*. Mango 162-539 948-2, 1995.

———. *No Reservations*. Mango 162-539 932-2, 1992.

Baka Beyond. *Spirit of the Forest*. Rykodisc HNCD 1377, 1993.

Banig. *Can You Feel My Heart*. Del-Fi 70013-2, 1994.

Benedictine Monks of Santo Domingo de Silos. *Chant*. Angel/EMI CDC 7243 5 55138 2 3, 1994.

———. *The Soul of Chant*. Milan 35703, 1994.

Bringing it All Back Home. BBC CD 844, 1991.

Brook, Michael. *Hybrid*. EG Records EEGCD 41, 1985.

Byrne, David. *Rei Momo*. Luaka Bop/Sire 9 25990-2, 1989.

Chandra, Sheila. *Nada Brahma*. Caroline Carol 1780-2, 1995.

———. *Quiet*. Indipop 2, 1984.

———. *Roots and Wings*. Caroline Carol 1779-2, 1995.

———. *The Struggle*. Caroline 1704 1781 4, 1984.

———. *Weaving My Ancestors' Voices*. Real World/Caroline 2322-2, 1992.

———. *The Zen Kiss*. Real World/Caroline 2342-2, 1994.

Clegg, Johnny, and Savuka. *Cruel, Crazy, Beautiful World*. Capitol CDP 7 93446 2, 1989.

———. *Heat, Dust & Dreams*. Capitol CDP 0777 7 98795 2 6, 1993.

———. *Third World Child*. Capitol CDP 7 46778 2, 1987.

Copeland, Stewart. *The Rhythmatist*. A&M CD 5084, 1985.

D'Cückoo. *Umoja*. RGB Records RGB 501-2, 1994.

Dead Man Walking. Columbia CK 67522, 1995.

Deep Forest. *Boheme*. 550 Music/Epic BK 67115, 1995.

———. *Deep Forest*. 550 Music/Epic BK-57840, 1992.

Deep into Jungle Territory: A Jungle-Bhangra Fusion. Multitone DMUTA 1314, 1994.

Del Santo, Dan. *Off Your Nyash*. Flying Fish Records FF 70551, 1990.

———. *World Beat*. Pleasure Records PLP 1002, 1983.

Djur Djura. *The Best of Djur Djura*. Adventures in Afropea 2. Luaka Bop/Warner Bros. 9 45211-2, 1993.

El-Din, Hamza. *Escalay*. Nonesuch Explorer Series. Nonesuch H 72041, 1971.

Ethnotechno: Sonic Anthropology. Vol. 1. Wax Trax! Records TVT 7211-2, 1994.

Gabriel, Peter. *Passion: Music for* The Last Temptation of Christ. Geffen Records M5G 24206, 1989.

———. *Plus from Us*. Real World Carol 2327-2, 1993.

———. *Secret World Live*. Uni/Geffen 2064 24722 4, 1994.

———. *Us*. Real World GEFD 24473, 1992.

Global Celebration: Authentic Music from Festivals & Celebrations Around the World. Ellipsis Arts... CD 3230, [1992].

Global Meditation: Authentic Music from Meditative Traditions of the World. Ellipsis Arts... CD 3210, 1992.

Goldie. *Timeless*. FFRR 697-124 073-2, 1996.

Gyuto Monks. *Freedom Chants from the Roof of the World*. Rykodisc RCD 20113, 1989.

———. *Tibetan Tantric Choir*. Windham Hill WD-2001, 1987.

Jùjú Roots: 1930s-1950s. Rounder CD 5017, 1993.

Juluka. *African Litany*. Rhythm Safari CDL 57145, 1991.

———. *Scatterlings*. Warner Bros. 9 23898-2, 1982.

———. *Universal Men*. Rhythm Safari P2 57144, 1984.

Jungle Hits: 100% Jungle. Street Tuff STRCD 1, 1994.

Keane Family. *Muintir Catháin (The Keane Family)*. gael-linn CEF 107, 1985.

Khan, Ali Akbar. *Garden of Dreams*. Triloka/Worldly Music 7199-2, 1993.

Khan, Nusrat Fateh Ali, and Michael Brook. *Night Song*. Real World CAROL 2354-2, 1996.

Kidjo, Angélique. *Ayé*. Mango/Antilles 1625 9934 4, 1994.

———. *Fifa*. Mango 162-531 039-2, 1996.

———. *Logozo*. Mango 162-539 918-2, 1991.

———. *Parakou*. Mango 848219/2, 1989.

Kronos Quartet. *Pieces of Africa*. Elektra Nonesuch 9 79275-2, 1992.

Ladysmith Black Mambazo. *Two Worlds One Heart*. Warner Bros. 9 26125-2, 1990.

Lanois, Daniel. *Acadeie*. WEA/Warner Bros. 7599 25969 2, 1989.

———. *For the Beauty of Wynona*. WEA/Warner Bros. 7559 45030, 1993.

Law of the Jungle. Moonshine Music MM 80016-2, 1994.

Madonna. *Like a Prayer*. Sire 9 25844-2, 1989.

Maraire, Dumisani. *African Story-Songs*. Univ. of Washington Press UWP 901, 1969.

———. *Chaminuka: Music of Zimbabwe*. Music of the World CDC-208, 1989.

———. *Mbira Music from Rhodesia*. University of Washington Ethnic Music Series. Seattle: Univ. of Washington Press, UWP-1001, 1971.

Mbube Roots: Zulu Choral Music from South Africa, 1930s-1960s. Rounder CD 5025, 1988.

Mbuti Pygmies of the Ituri Rainforest. Smithsonian Folkways 40401, 1992.

Monsoon. *Third Eye*. Phonogram PIPCD 001, 1983.

Music of Indonesia 2: Indonesian Popular Music: Kroncong, Dangdut, and Langgam Jawa. Smithsonian/Folkways SF 40056, 1991.

Musical Traditions of St. Lucia, West Indies: Dances and Songs from a Caribbean Island. Smithsonian/Folkways SF 40416, 1993.

Najma. *Atish*. Shanachie 64026, 1990.

N'Dour, Youssou. *The Guide (Wommat)*. Sony Music OK 53828, 1994.

———. *Set.* Virgin V2-86195, 1990.

Page, Jimmy, and Robert Plant. *No Quarter.* WEA LR-3169, 1994.

Planet Soup. Ellipsis Arts... CD3450, 1995.

Prabhakar, Sharon. *The Best of Sharon Prabhakar.* Music India CDNF 030, 1988.

Prophets of Da City. *Never Again.* Nation NAT 45T, 1994.

———. *Universal Souljaz.* Nation Records NATCD 54, 1996.

The Pygmies of the Ituri Forest. Ethnic Folkways Library. Folkways FE 4457, 1958.

Rap & Disco—93. Melody International, 227, n.d.

Remo. *Politicians Don't Know to Rock 'n' Roll.* OMI Music D4-P0591, 1992.

Return to the Source:—Deep Trance & Ritual Beats. RTTS CD 1, 1995.

Rolling Stones. *Between the Buttons.* Abcko Music and Records CD 499, 1986.

Sacred Spirits. Virgin 7243 8 40352 2 8, 1994.

Sagoo, Bally. *Bollywood Flashback.* Sony Music 477697 2, 1994.

Sasha. *Cultural Vibes.* Multitone DMUT 1294, 1995.

Sehgal, Baba. *I'm Madonna Too, & Other Hits.* OMI Music D4-Q0660, 1993.

Shiamak, Davar. *Survive.* EMI CDNF 154020, 1995.

Shoukichi Kina. Asia Classics 2: *The Best of Shoukichi Kina: Peppermint Tea House.* Luaka Bop/Warner Bros. 9 45159-2, 1994.

Simon, Paul. *Graceland.* Warner Bros. W2-25447, 1986

———. *The Rhythm of the Saints.* Warner Bros. 9 26098-2, 1990.

SongCatchers. *Dreaming in Color.* Horizon/A&M 31454 0247 2, 1994.

Street Jams: Hip-Hop from the Top, Part 1. Rhino R2 70577, 1992.

This Land is Mine: South African Freedom Songs. Folkways FH 5588, 1965.

Throat Singers of Tuva. *Huun-Huur-Tu.* Shanachie 64050, 1993.

The Virgin Directory of World Music. Virgin Records VDWM1, 1991.

Vision: The Music of Hildegard von Bingen. Angel CDC 7243 5 55246 21, 1994.

Voices of Forgotten Worlds. Ellipsis Arts... CD 3252, 1993.

Voices of the Rainforest. Rykodisc RCD 10173, 1991.

What is Bhangra? IRS Records 7243 8 29242 27, 1994.

Yothu Yindi. *Tribal Voice.* Hollywood Records HR-61288-2, 1992.

Zap Mama. *Sabsylma.* Luaka Bop 9 45537-2, 1994.

———. *Zap Mama.* Adventures in Afropea 1. Luaka Bop 9 45183-2, 1993.

Zulu Spear. *Welcome to the USA.* Liberty Records CDP-7-97457-2, 1992.

MUSICAL SCORES

Addy, Obo. *Wawshishijay.* Photocopy.

Adzinyah, Abraham Kobene, Dumisani Maraire, and Judith Cook Tucker, eds. *Let Your Voice be Heard! Songs from Ghana and Zimbabwe: Call-and-Response, Multipart, and Game Songs.* Danbury, Conn.: World Music Press, 1986.

Hildegard von Bingen. *Sequentia de sancto Maximino.* Transcribed, edited, and translated by Pozzi Escot. Bryn Mawr, Penn.: Hildegard Publishing Company, n.d.

Howard, V. E., and Broadus E. Smith, eds. *Church Gospel Songs & Hymns.* West Monroe, Louisiana, and Texarkana, Texas: Central Printers and Publishers, 1983.

Kennedy, Peter, ed. *Folksongs of Britain and Ireland.* London: Oak, 1984.

Oliveros, Pauline. *Crow Two.* Pauline Oliveros Foundation, n.d.

— — —. *Sonic Meditations*. Baltimore: Smith Publications, 1974.

Stockhausen, Karlheinz. *Aus den Sieben Tagen*. Vienna: Universal Edition, 1970.

FILMOGRAPHY

All About Us, Michael Coulson, 1993.

Dances with Wolves. Kevin Costner. 1990.

Dumb and Dumber. Peter Farrelly. 1994.

Mizike Mama. Violaine de Villers. 1992.

Paul Simon: Born at the Right Time, Susan Lacy, 1992.

The Rhythm of Resistance: The Black Music of South Africa. Chris Austin and Jeremy Marre. 1988.

INTERVIEWS

Oliveros, Pauline. Telephone interview by author, 20 December 1991.

Rendon, Norma. Telephone interview by author, 11 October 1992.

UNPUBLISHED MATERIALS

Addy, Obo. Press kit, 1993.

Apache Indian. Interview with Katie Davis. National Public Radio, *All Things Considered* (18 July 1993).

Becker, A. L. Personal communication. Ann Arbor, Mich. 20 October 1992.

Chandra, Sheila. Interview with Charley Cvercko and Vickie. 11 September 1993. Distributed on the Internet in the newsgroups alt.music.world and alt.music.alternative.

— — —. Interview with Linda Wertheimer. National Public Radio, *All Things Considered* (7 June 1993).

EMI/Angel Records. Press kit for *Vision: The Music of Hildegard von Bingen*, 1994.

Gabriel, Peter. Interview with John di Liberto. National Public Radio, *Morning Edition* (29 September 1992).

Grant, Neva. Report on bhangra. National Public Radio, *Weekend Edition* (21 August 1993).

Johnson, Maria. "Women Making World Music Today: Laura Love, D'Cückoo, and Zap Mama." Paper presented at the Society for Ethnomusicology, Northern California Chapter. 17 September 1994.

Kidjo, Angélique. Interview with Corny O'Connell. WFUV-FM, New York, N.Y. (26 September 1996).

Ladysmith Black Mambazo. Interview with Ray Suarez. National Public Radio, *Talk of the Nation* (12 January 1995).

Maraire, Dumisani. "The Position of Music in Shona Mudzimu (Ancestral Spirit) Possession." Ph.D. diss., the University of Washington, 1990.

— — —. Interview with Julie Burstein. National Public Radio, *Morning Edition* (28 February 1992).

McCarthy, Marie. "Music Education and the Quest for Cultural Identity in Ireland, 1831–1989." Ph.D. diss., the University of Michigan, 1990.

McCaw, Heather. "The Origins, Use and Appeal of Karaoke." Department of Japanese Studies, Monash University, 1990.

Oliveros, Pauline. Personal communication. 15 February 1993.

Puar, Jasbir K. "Home, Hybridity, and Nationalism: South Asians and Bhangra Music." Paper presented at the Association for Asian American Studies Conference, Oakland, Calif. 1 June 1995.

Simon, Paul. Interview with Bob Edwards. National Public Radio, *Morning Edition* (18 October 1990).

Taylor, Timothy D. "David Byrne's *Rei Momo* and the Politics of Authenticity." In preparation.

———. "Free Samples: Ghosts in the Tape Machine." In preparation.

———. "Paul Simon, *Graceland*, and the Continuation of Colonialist Ideologies." In preparation.

———. *The Rapacious Muse: Selves and Others in Music from Modernity through Postmodernity*. In preparation.

———. "The String Quartets of Kevin Volans." M.A. thesis, Queen's University of Belfast, 1990.

———. "The Voracious Muse: Contemporary Cross-Cultural Musical Borrowings, Culture, and Postmodernism. Ph.D. diss., University of Michigan, 1993.

Thomas, E. Tom. Personal communication. 7 February 1996.

Von Gunden, Heidi. "The Music of Pauline Oliveros: A Model for Feminist Criticism." Paper presented at the Music and Gender Conference, London, July 1991.

CD-ROMS

Supreme Beats: A Percussion Library by Bashiri Johnson. Burbank, Calif.: Grand Street Records & Filmworks, 1995.

Xplora1: Peter Gabriel's Secret World. London: Real World Multi Media, 1994.

INTERNET SITES

Note: As most users know, Internet addresses change with alarming rapidity. I have tried to ensure that these are up to date, but by the time you read this, many pages will be gone, and many will be changed. Point your web browser to the Global Pop *web site for a reasonably up-to-date list of links* (http://www.columbia.edu/~tt327/Global_Pop/Global_Pop.html).

ftp://ftp.best.com/pub/quad/deep.forest/DeepForest-FAQ.txt
 Deep Forest FAQ.
ftp://ftp.uwp.edu/pub/music/lyrics/j/juluka/
 Lyrics to Johnny Clegg/Juluka's *Work for All*.
ftp://ftp.uwp.edu/pub/music/lyrics/c/clegg.johnny/
 Lyrics to Johnny Clegg/Savuka's *Third World Child* and *Heat, Dust & Dreams*.
http://fileroom.aaup.uic.edu/FileRoom/documents/Mmusic.html
 Fileroom, a censorhip archive.
http://geffen.com/gabriel.html
 Peter Gabriel page on Geffen Records' site.
http://www.golden.net/~jheeta/bhangra.htm
 Nachda Punjab Bhangra Homepage.
http://home.sprynet.com/sprynet/djembe/youssou.htm
 Unofficial Youssou N'Dour homepage.
http://k12.cnidr.org:90/kronos.html
 Kronos Quartet page.
http://mkn.co.uk/help/extra/people/goatrance
 Goatrance, page devoted to Goa music.

http://newalbion.com
 New Albion Records homepage; contains information on New Albion artists such as
 Pauline Oliveros.
http://polestar.fac.mcgill.ca/courses/engl378/socks/jungle/
 Academic jungle page in Canada.
http://pt-pc40.massey.ac.nz/johnny/johnny.html
 Unofficial Johnny Clegg homepage.
http://pubweb.acns.nwu.edu/~flip/pop.html
 The Philippine Popular Music Page, with information on Banig and other musicians.
http://realworld.on.net/home.html
 Page on Real World Records, WOMAD, and Peter Gabriel.
http://siegelgate.com/~lisa/cantopop.html
 David Seubert's brief but useful introduction to cantopop.
http://streetsound.clever.net/bha.html
 Bhangra page.
http://sunpath.stanford.edu:3007/bands/DCuckoo/DCuckoo.html
 D'Cückoo information.
http://sunsite.unc.edu:80/pub/multimedia/pictures/asia/hongkong/hkpa/popstars/
 Pictures and information on Southeast Asian pop stars.
http://web.mit.edu/jcarow/www/breaks.html
 DJ Casper's Jungle and Happy Hardcore Web Page
http://wmf.oso.com/
 World Music Festival homepage.
http://www.addict.com
 Addicted to Noise, an online music magazine.
http://www.algonet.se/~arfc/goa.html
 Tempel of GoaTrance! Swedish Goa music page.
http://www.allmusic.com/
 Internet version of the *All Music Guide*.
http://www.bart.nl/~tracey/luakabop.html
 Luaka Bop homepage.
http://www.brad.ac.uk:80/~szia/Bhangra/
 Bhangra Fever homepage.
http://www.brad.ac.uk/~agcatchp/pg/92us.html
 Peter Gabriel page.
http://www.cityscape.co.uk/froots/
 Folk Roots magazine homepage.
http://www.cnet.com/Content/Features/Quick/Cuckoo/index.html
 A recent D'Cückoo page at C|Net.
http://www.cs.berkeley.edu/~zyang/cuijian/
 Page devoted to Chinese rock star Cui Jian.
http://www.cs.clemson.edu/~junderw/pg.html
 And Through The Wire—Peter Gabriel.
http://www.davidbowie.com/
 David Bowie page.
http://www.dcuckoo.com/
 D'Cückoo's homepage.

http://www.demon.co.uk/drci/shamen/misc/angelique.html
 Angélique Kidjo information.
http://www.disney.com/records/Disney_Records_Pages/Rhythm.html
 Walt Disney Records page for information on Lebo M and *The Lion King: Rhythm of the Pride Lands*.
http://www.dmn.com/Shanachie/
 Shanachie Records home page.
http://www.eden.com/music/songctch.html
 The SongCatchers homepage.
http://www.engr.wisc.edu/~tlee/hkidol.html
 Asian Popstars homepage with Cantopop stars.
http://www.foresight.co.uk/warnerclassics/kronos/
 Official Kronos Quartet home page.
http://www.geocities.com/SunsetStrip/6746/bhangra.htm
 Bhangra Central page.
http://www.grammy.com/
 Grammy award information.
http://www.lochnet.com/client/gs/kq.html
 Kronos Quartet homepage.
http://www.hooked.net:80/buzznet/03/beats/jungle/index.html
 WELCOME TO THE JUNGLE page.
http://www.imaginet.fr/~kidjo/
 Official Angélique Kidjo homepage.
http://www.ina.fr/Music/Styles/Mbalax.html
 Mbalax page.
http://www.inria.fr/robotvis/personnel/dlingran/
 Kronos Quartet information.
http://www.island.co.uk/island/cat/cat_a/apache.html
 Island Records' Apache Indian web site.
http://www.mg.co.za/mg/
 South Africa's *Weekly Mail & Guardian*.
http://www.iuma.com/GMO/music/Clegg,_Johnny/Juluka/
 Johnny Clegg and Juluka information at the Internet Underground Music Archive.
http://www.lib.ox.ac.uk/internet/news/faq/archive/tuva-faq.html
 FAQ about Tuvan culture, with much information on throat singing.
http://www.otterspace.com/~dsauve/kidjo.html
 Unofficial Angélique Kidjo homepage.
http://www.sony.com/Music/Artistinfo/DeepForest.html
 Sony Music's page on Deep Forest.
http://www.music.sony.com/Music/ArtistInfo/YoussouNDour.html
 Sony Music's page on Youssou N'Dour.
http://www.nd.edu/~sborman/didjeridu/
 Didjeridu page.
http://www.omnium.com/pub/multitone/
 Multitone Records homepage, specialists in bhangra.
http://www.pix.za/cactus/GMO/Clegg_Johnny-S.html
 Official Johnny Clegg homepage.

http://www.polity.org.za/misc/nkosi.html
 Discussion of and lyrics to "Nkosi Sikelel' iAfrika," one of the national anthems of
 South Africa.
http://www.rahul.net/hrmusic/artists/scart.html
 Closest thing to a Sheila Chandra homepage at this writing.
http://www.rhythmroots.com/rhythm/apache.htm
 Apache Indian site.
http://www.roughguides.com/RG_WWW/W_music/wor_con.html
 World Music: The Rough Guide, on the World Wide Web.
http://www.singnet.com.sg/~skyeo/tower.html
 Tower Records in Singapore.
http://www.state51.co.uk/state51/hottips/bhangle.html
 Bhangle music information.
http://www.streetsound.com/zone/
 Streetsound page, with bhangra information.
http://www.teleport.com/~flyheart/oboaddy.htm
 Obo Addy page.
http://www.teleport.com/~sheilam/
 Scatterlings (the Johnny Clegg newslist) homepage.
http://www.tmn.com/0h/Artswire/www/pof/pof.html.
 Pauline Oliveros, Deep Listening Foundation page.
http://www.well.com/user/gyuto/
 Rykodisc page on the Gyuto Monks of Tibet.
http://www.well.com:80/user/tcircus/Dcuckoo/
 D'Cückoo page.
http://www2.khm.de/~oblaum/you/you_menue_d.html
 German Youssou N'Dour page.
http://www.zensys.co.uk/home/page/s.rattan/
 The Bhangra Network.
http://yucc.yorku.ca/home/sanraj/bhangra.html
 The Bhangra Page, in Canada.

INTERNET NEWSGROUPS

alt.culture.tuva
alt.exotic-music
 "Exotic" music—overlaps with alt.music.world, but isn't as active.
alt.music.african
alt.music.karaoke
alt.music.peter-gabriel
alt.music.world
alt.postmodern
 Discussions of postmodernism; occassionally on music and/or MTV.
alt.tv.mtv
rec.music.indian.classical
rec.music.indian.misc

Nonclassical Indian music (classical Indian music has its own newsgroup, rec.music.indian.classical); mostly film music; some bhangra.

rec.music.newage

rec.music.reggae

soc.culture.indian

Aspects of Indian culture.

soc.culture.punjab

Punjabi culture; occasional some bhangra discussions.

PUBLICATIONS/INTERVIEWS/MATERIALS AVAILABLE ONLY ON THE INTERNET

"American Recordings owner Rick Rubin is pleased to announce the signing of Pakistani singer Nusrat Fateh Ali Khan." *Entertainment Wire*. 25 June 1996. http://newspage.yahoo.com/newspage/yahoo2/960625/00305.html.

Carvin, Andy. "Classical Aghast: The Avant-Garde Musings of Kronos Quartet." http://k12.cnidr.org:90/kronos.html.

Connerly, Laura. "Angélique Kidjo." http://www.connect.org.uk/merseyworld/worldup1/angelique.html.

Copeland, Stewart. "A Chat with Stewart Copeland." 12 June 1995. http://rocktropolis.com/sting/stewartchat.html.

Dempster, Stuart. "Deep Listening Band: A Concise History." http://www.purplefrog.com/deeplistening/news/DLB.html.

Eddy, Chuck. "Rock and Madison Avenue." http://www.glyphs.com/millpop/95/inbed/html#chuck.

"The Effect of Music on Society." http://wmf.oso.com/.

Eyre, Banning. "Shona Spirit: Passing on the Ancestral Music." http://kiwi.futuris.net/rw/motw/shona.html.

Gabriel, Peter. Radio interview with Bob Coburn. Transcribed by Wendy Katz. http://www.cs.clemson.edu/~junderw/pg/interviews/swl.html.

Lange, Loretta L. "Virtual Reality Evangelist: Interview with Linda Jacobson. *Switch* 1. http://cadre.sjsu.edu/SwitchV1N2/Jacobson/lindaj.html.

"More Americans Listen to Exotic Beat of World Music." Reuters. 18 September 1996. http://newspage.yahoo.com/.

N'Dour, Youssou. Interview with Kwaku. rec.music.reggae. 22 November 1995.

Pacheco, Candice, and Tina "Bean" Blaine. Interview by Gina St. John. C|Net Central. July 1995. http://www.cnet.com/pub/Cctranscripts/bandchat.text.

poet, j. "Worldbeat." *All-Music Guide*, http://www.allmusic.com/.

Pollack, Andrew. "For a Lot More than a Song, Karaoke is Put on Block." *The New York Times Cybertimes*. 11 March 1996. http://www.nytimes.com/web/docsroot/library/cyber/week/0311karaoke.html.

Rodgers, Jackie. "Pirate Sales of Pre-Recorded Music Sailing High." Reuters. 10 May 1996. http://newspage.yahoo.com/.

Shabalala, Joseph. Description of the Mambazo Academy of South African Music and Culture. http://www.best.com/~rlai/Paul-Simon/Collab/Ladysmith.txt.

Wynn, Ron. Entry on Obo Addy. *All-Music Guide*, http://www.allmusic.com/.

BOOKS AND ARTICLES

Alba, Richard D. *Ethnic Identity: The Transformation of White America*. New Haven and London: Yale Univ. Press, 1990.

Alcoff, Linda. "Cultural Feminism versus Poststructuralism: The Identity Crisis in Feminist Theory." *Signs* 13 (Spring 1988): 405–36.

Alejandro, Reynaldo G. "Fil-Ams Troop to AC for Banig's Concert." *Filipino Reporter* (9 November 1995), PG.

Allen, Jennifer. "The Apostle of Angst." *Esquire* 107 (June 1987), 210.

Allen, Vaughan. "Bhangramuffin." *The Face* 44 (May 1992), 104–8.

Angel, Johnny. "Born to Lose: Fear and Self-Loathing in the Ostrich Generation." *San Francisco Bay Guardian* (17 August 1994), 41–43.

Appadurai, Arjun. "Disjuncture and Difference in the Global Cultural Economy." *Public Culture* 2 (Spring 1990): 1–24.

— — —. "Global Ethnoscapes: Notes and Queries for a Transnational Anthropology." In *Recapturing Anthropology: Working in the Present*, edited by Richard Fox. School of American Research Advanced Seminar Series, ed. Douglas W. Schwartz. Santa Fe: School of American Research Press, 1991.

Appiah, Kwame Anthony. *In My Father's House: Africa in the Philosophy of Culture*. New York and Oxford: Oxford Univ. Press, 1992.

"Are Friends Eclectic?" *Q Magazine* (March 1992). Downloaded from http://www.nwu. edu/music/kronos.

Armstrong, Larry. "What's That Noise in Aisle 5? Karaoke' May be Coming Soon to a Supermarket or Mall Near You." *Business Week* (8 June 1992), 38.

Aubert, Laurent. "The World Dances to a New Beat." *World Press Review* 39 (January 1992), 24-25.

Aylmer, Kevin J. "British Bhangra: The Sound of a New Community." *Rhythm Music Magazine* 4 (1995), 14–17.

Azerrad, Michael. "Angélique Kidjo: Politics with a Beat." *Rolling Stone* 630 (14 May 1992), 32.

— — —. "P.M. Dawn gets Real." *Option* 65 (November/December 1995), 60.

Ballantine, Christopher. *Marabi Nights: Early South African Jazz and Vaudeville*. Johannesburg: Ravan Press; Athens, Ohio: Ohio Univ. Press, 1993.

Banerji, Sabita. "Ghazals of Bhangra in Great Britain." *Popular Music* 7 (May 1988): 207–13.

Banerji, Sabita, and Gerd Baumann. "Bhangra 1984–8: Fusion and Professionalization in a Genre of South Asian Dance Music." In *Black Music in Britain: Essays on the Afro-Asian Contribution to Popular Music*, ed. Paul Oliver. Milton Keynes, U.K., and Philadelphia: Open Univ. Press, 1990.

Barlow, Sean, and Banning Eyre. *Afropop! An Illustrated Guide to Contemporary African Music*. Edison, N.J.: Chartwell Books, 1995.

Baron, Robert, and Nicholas R. Spitzer, eds. *Public Folklore*. Washington and London: the Smithsonian Institution Press, 1992.

Barthes, Roland. *Image-Music-Text*. Trans. Stephen Heath. New York: Noonday, 1977.

Baumann, Gerd. "The Re-Invention of Bhangra—Social Change and Aesthetic Shifts in a Punjabi Music in Britain." *World of Music* 32 (1990): 81–98

Baxter, John. Review of *The Best of Djur Djura*. *Option* (March/April 1994), 98.

Becker, A. L. "Text-Building Epistemology and Aesthetics in Javanese Shadow Theatre." In *The Imagination of Reality: Essays in Southeast Asian Coherence Systems*, ed. A. L. Becker and Aram A. Yengoyan. Norwood, N.J.: Ablex Publishing, 1979.

Bellah, Robert N., Richard Madsen, William M. Sullivan, Ann Swidler, and Steven M. Tipton. *Habits of the Heart: Individualism and Commitment in American Life*. Berkeley: Univ. of California Press, 1985.

Bennett, Tony. "Popular Culture and 'the Turn to Gramsci'." In *Popular Culture and Social Relations*, ed. Tony Bennett, Colin Mercer, and Janet Woollacott. Milton Keynes and Philadelphia: Open Univ. Press, 1986.

Bennett, Tony, Simon Frith, Lawrence Grossberg, John Shepherd, and Graeme Turner, eds. *Rock and Popular Music: Politics, Policies, Institutions*. Culture: Policies and Politics, ed. Tony Bennett, Jennifer Craik, Ian Hunter, Colin Mercer, and Dugald Williamson. London and New York: Routledge, 1993.

Bergeron, Katherine. "The Virtual Sacred: Finding God at Tower Records." *New Republic* 212 (27 February 1995), 29–34.

Berkowitz, Kenny. "FYI: Sheila Chandra." *Option* 68 (May/June 1996), 24–25.

Berlant, Lauren. "The Female Complaint." *Social Text* 9 (Fall 1988): 237–59.

Berliner, Paul. *The Soul of Mbira*. Berkeley and Los Angeles: Univ. of California Press, 1981.

Berman, Marshall. *All That is Solid Melts Into Air: The Experience of Modernity*. New York: Penguin, 1988.

Berry, Chuck. *Chuck Berry: The Autobiography*. New York: Simon & Schuster, 1987.

Berry, Colin. "The Sound of Silence: San Francisco's Ambient Music Labels Find their Groove." *SF Weekly* 14 (17–23 May 1995), 16–18.

Bhabha, Homi K. "Of Mimicry and Man: The Ambivalence of Colonial Discourse." *October* 28 (Spring 1984): 125–34.

"*Billboard* Bows Reggae Albums Chart." *Billboard* 106 (5 February 1994), 7.

"*Billboard* Debuts World Music Album Chart." *Billboard* 102 (19 May 1990), 5.

Birnbaum, Larry. "Youssou N'Dour." *Down Beat* 54 (May 1987), 14.

Blank-Edelman, David N. "Hamza el Din: Looking Out from the Inside." *RMM* (May/June 1994), 14.

———. "Stewart Copeland: The Rhythmatist Returns." *RMM* 3 (February 1994), 38–39.

Blumenfeld, Larry. "My Week in the Real World." *Rhythm Music* 4 (October 1995), 30–35.

———. "Promo Item of the Week Department." *Rhythm Music* 4 (August 1995), 59.

Bohlman, Philip V. *The Study of Folk Music in the Modern World*. Folkloristics, ed. Alan Dundes. Bloomington and Indianapolis: Indiana Univ. Press, 1988.

Borzillo, Carrie. "Deep Forest Growing in Popularity; 550's World Music-Dance Hybrid Climbs Charts." *Billboard* 106 (19 February 1994), 8.

———. "Major Labels Find Market for Native American Sounds." *Billboard* 106 (6 August 1994), 1.

———. "U.S. Ad Use Adds to Commercial Success of *Deep Forest*." *Billboard* 106 (11 June 1994), 44.

Brace, Tim, and Paul Friedlander. "Rock and Roll on the New Long March: Popular Music, Cultural Identity, and Political Opposition in the People's Republic of China." In *Rockin' the Boat: Mass Music and Mass Movements*, ed. Reebee Garofalo. Boston: South End Press, 1992.

Bradshaw, Paul. "Handsworth Revolutionary." *Straight No Chaser* 23 (Autumn 1993), 26–29.

Breathnach, Breandán. *Folk Music and Dance of Ireland.* Cork: Mercier, 1977.

Bridger, John, and Susan Nunziata. "Real World Project Boasts Wide Universe of Talent." *Billboard* 103 (21 September 1991), 41.

Brodeur, Scott. "The World of Youssou N'Dour Broadening to Include U.S." *Billboard* 104 (20 June 1992), 10–11.

Brooman, Thomas. "Peter Gabriel in Conversation." *RMM* (September 1993), 12–15.

Broughton, Simon, Mark Ellingham, David Muddyman, and Richard Trillo, eds. *World Music: The Rough Guide.* London: Rough Guides, 1994.

Buell, Frederick. *National Culture and the New Global System.* Parallax: Re-visions of Culture and Society, ed. Stephen G. Nichols, Gerald Prince, and Wendy Steiner. Baltimore: Johns Hopkins Univ. Press, 1994.

Burnett, Robert. *The Global Jukebox: The International Music Industry.* Communication and Society, ed. James Curran. London and New York: Routledge, 1996.

Burr, Ty. "From Africa, Three Female Rebels With a Cause." *New York Times* (10 July 1994), H26.

Bush, George. "War with Iraq." *Vital Speeches of the Day* 57 (1 February 1991), 226–27.

Campbell, Joseph. *Hero with a Thousand Faces.* New York: World, 1971.

Carby, Hazel. "It Just Be's Dat Way Sometime: the Sexual Politics of Women's Blues." *Radical America* 20 (1986): 9–22

Cardew, Cornelius. *Stockhausen Serves Imperialism and Other Articles.* London: Latimer, 1974.

Carroll, Rebecca. "Rodriguez Meets Byrne." *Mother Jones* 16 (July/August 1991), 9.

Carter, Kevin, and Jonathan Shulman. "Deep African Woman: Angélique Kidjo." *RMM* 3 (1994), 28.

Cathcart, Jenny. *Hey You! A Portrait of Youssou N'Dour.* Witney, Oxfordshire: Fine Line Books, 1989.

Césaire, Aimé. *Discourse on Colonialism.* Trans. Joan Pinkham. 1955. Reprint. New York: Monthly Review Press, 1972.

Chambers, Gordon. "Youssou N'Dour: Sound of Senegal." *Essence* 25 (9 January 1995), 56.

Chambers, Iain. *Migrancy, Culture, Identity.* Comedia, ed. David Morley. New York and London: Routledge, 1994.

Chandra, Sheila. Interview with Jonathan Shulman. *Rhythm Music Monthly* 2 (August 1993), 6–8.

———. Liner notes to *Weaving My Ancestors' Voices.* Real World Records Ltd, 2322–2, 1992.

———. Liner notes to *The Zen Kiss.* Real World/Caroline 2342-2, 1994.

Chang, Jeff. "On the Warpath." *A. Magazine* 2 (Fall 1993), 65–66.

Cheyney, Tom. "The Real World of Peter Gabriel." *The Beat* 9 (1990), 22–25.

Christgau, Robert. "South African Romance." *Village Voice* (23 September 1986), 71.

Clark-Meads, Jeff. "World Piracy Breaks Billion-unit Mark." *Billboard* 107 (3 June 1995), 70.

Clifford, James. "On Collecting Art and Culture." In *Out There: Marginalization and Contemporary Cultures,* ed. Russell Ferguson, Martha Gever, Trinh T. Minh-ha, and Cornel West. Cambridge, Mass., and London: MIT Press, 1990.

— — —. *The Predicament of Culture: Twentieth-Century Ethnography, Literature, and Art.* Cambridge, Mass. and London: Harvard Univ. Press, 1988.

— — —. "Traveling Cultures." In *Cultural Studies*, ed. Lawrence Grossberg, Cary Nelson, and Paula Treichler. New York and London: Routledge, 1992.

Clifford, James, and George Marcus, eds. *Writing Culture: The Poetics and Politics of Ethnography.* Berkeley and Los Angeles: Univ. of California Press, 1986.

Cockrell, Dale. "Of Gospel Hymns, Minstrel Shows, and Jubilee Singers: Toward Some Black South African Musics." *American Music* 5 (Winter 1987): 417–32.

Coetzee, J. M. *Waiting for the Barbarians.* Harmondsworth: Penguin, 1982.

Collin, Matthew. "Jungle Fever," *Life* [*The Observer Magazine*] (26 June 1994), 26–30.

Compton, Joe F. Review of *The Best of Djur Djura. Dirty Linen* 50 (February/March 1994). Included in press kit from Luaka Bop.

— — —. "Robbie Robertson's Red Road Home." *Rhythm Music* 4 (1995), 30–35.

Considine, J. D. "Language is No Barrier When Zap Mama Celebrates Humanity." *Baltimore Sun* (1 June 1994). Included in press kit from Luaka Bop.

Consul, Wilma B. "Brave and Beautiful Banig." *Filipinas Magazine* 3 (30 June 1995), 15.

— — —. "Filipino Americans in the U.S. Music Industry." *Filipinas Magazine* 3 (31 July 1994), 38.

Copeland, Stewart. Liner notes to *The Rhythmatist*. A&M CD 5084, 1985.

Coplan, David B. "A Terrible Commitment: Balancing the Tribes in South African National Culture." In *Perilous States: Conversations on Culture, Politics, and Nation*, ed. George Marcus. Late Editions: Cultural Studies for the End of the Century. Chicago: Univ. of Chicago Press, 1993.

— — —. *In Township Tonight! South Africa's Black City Music and Theatre.* London and New York: Longman, 1985.

Coronil, Fernando. "Can Postcoloniality be Decolonized? Imperial Banality and Postcolonial Power." *Public Culture* 5 (Fall 1992): 89–108.

Cosgrove, Stuart. "Music Global Style?" *New Statesman & Society* 1 (9 September 1988), 50.

Cott, Jonathan. "Talking (Whew!) to Karlheinz Stockhausen." *Rolling Stone* 86 (8 July 1971), 36–40.

Courtney-Clarke, Margaret. *African Canvas: The Art of West African Women.* New York : Rizzoli, 1990.

Coxson, Sarah. "The Complete Set." *Folk Roots* 89 (November 1990), 13–15.

Cullman, Brian. "World Music's Hope: Can West Africa's Youssou N'Dour Pass the Global Test?" *Rolling Stone* 591 (15 November 1991), 21.

Darlington, Lois. "Fusion Vocal." *Folk Roots* 134/135 (August/September 1994), 28–31.

— — —. "Solo Nyolo." *Folk Roots* 156 (June 1996), 49–51.

Darroch, Lynn. "Obo Addy: Third-World Beat." *Northwest Magazine* (20 August 1989), 4.

Daulne, Marie. Liner notes to *Zap Mama*. Adventures in Afropea 1. Luaka Bop 9 45183-2, 1993.

Davis, Fred. "I Want my Desktop MTV." *Wired* (July/August 1993), 4–11.

Davis, Stephen. "The Wild Woman of the Barbary Coast." *The Beat* 12 (1993), 42–45.

D'Cückoo. Liner notes to *Umoja*. San Francisco: RGB Records RGB 501-2, 1994.

Delfs, Robert. "The Controversial Fame of China's First Rock Star." *Far Eastern Economic Review* (26 December 1985): 40.

Denselow, Robin. *When the Music's Over: The Story of Political Pop*. London and Boston: Faber and Faber, 1989.

Densmore, Frances. *Teton Sioux Music*. Smithsonian Institute Bureau of American Ethnology, Bulletin 61. Washington, D. C.: Government Printing Office, 1918.

Dietrich, Matthew. "Eclectic Sounds Merge in Group's Unique Music." *(Springfield, Ill.) State Journal-Register* (29 September 1994). Included in press kit from Luaka Bop.

DiMaggio, Paul. "Cultural Entrepreneurship in Nineteenth-Century Boston: The Creation of an Organizational Base for High Culture in America." In *Rethinking Popular Culture*, edited by Chandra Mukerji and Michael Schudson. Berkeley: Univ. of California Press, 1991.

Djur Djura. *The Veil of Silence*. Trans. Dorothy S. Blair. London: Quartet, 1992.

— — —. Interview with David Byrne. *Bomb* 47 (Spring 1994), 8–11.

D'Souza, Jerry, and Mike Levin. "Indian Artists Benefiting from MTV Asia Exposure." *Billboard* 105 (4 December 1993), 42.

Duckworth, William. *Talking Music: Conversations with John Cage, Philip Glass, Laurie Anderson, and Five Generations of American Experimental Composers*. New York: Schirmer Books, 1995.

Duffy, Thom. "Apache Indian's Asian-Indian Pop Scores U.K. Hit." *Billboard* 105 (20 February 1993), 14.

— — —. "U.K. Politician Draws Fire from Apache Indian." *Billboard* 105 (2 October 1993), 107.

— — —. "Zap Mama Rides World Wave: Afro-European Quintet Bridges Cultural Gaps." *Billboard* 105 (7 August 1993), 1.

Duran, Lucy. "Key to N'Dour: Roots of the Senegalese Star." *Popular Music* 8 (October 1989): 275–84.

Ebert, Hans. "Cui Jian's Rock Resonates in Hearts of China's Youth." *Billboard* 104 (May 2, 1992), 1.

Echols, Alice. "The New Feminism of Yin and Yang." In *Powers of Desire: The Politics of Sexuality*, ed. Ann Snitow, Christine Stansell, and Sharon Thompson. New York: Monthly Review Press, 1983.

El Din, Hamza. Liner notes to *Pieces of Africa*. Elektra Nonesuch 9 79275-2, 1992.

Elliott, J. H. *The Old World and the New: 1492–1650*. Cambridge and New York: Cambridge Univ. Press, 1970.

Erlmann, Veit. "The Aesthetics of the Global Imagination: Reflections on World Music in the 1990s." *Public Culture* 8 (Spring 1996): 467–87.

— — —. "'Africa Civilised, Africa Uncivilised': Local Culture, World System and South African Music." *Journal of Southern African Studies* 20 (June 1994): 165–79.

— — —. *African Stars: Studies in Black South African Performance*. Chicago and London: Univ. of Chicago Press, 1991.

— — —. "A Conversation with Joseph Shabalala of Ladysmith Black Mambazo: Aspects of African Performers' Life Stories." *World of Music* 31 (1989): 31–57.

— — —. "A Feeling of Prejudice: Orpheus M. McAdoo and the Virginia Jubilee Singers in South Africa, 1890–1898." *Journal of Southern African Studies* 14 (April 1988): 1–35.

— — —. "Migration and Performance: Zulu Migrant Workers' *Isicathamiya* Performance in South Africa, 1890–1950." *Ethnomusicology* 34 (Spring/Summer 1990): 190–220.

— — —. *Nightsong: Performance, Power, and Practice in South Africa*. Chicago Studies in

Ethnomusicology, ed. Philip Bohlman and Bruno Nettl. Chicago: Univ. of Chicago Press, 1996.

— — —. "The Past is Far and the Future is Far": Power and Performance among Zulu Migrant Workers." *American Ethnologist* 19 (November 1992): 688–709.

— — —. "The Politics and Aesthetics of Transnational Musics." *World of Music* 35 (1993): 3–15.

Ewens, Graeme. *Africa O-Ye!: A Celebration of African Music*. Enfield, Middlesex: Guinness Publishing, 1991.

Eyre, Banning. "Becoming an Insider: Louis Sarno's Life Among the Pygmies." *Rhythm Music Magazine* 3 (1994) / 4 (1995), 40–43.

— — —. "Bringing it All Back Home: Three Takes on Producing World Music." *Option* (November 1990), 75–81.

— — —. "Citizen Clegg." *Rhythm Music* 4 (1995), 28.

— — —. "Microphone in Hand: David Lewiston's World Recordings." *Rhythm Music Magazine* 3 (1994) / 4 (1995), 36–39.

— — —. "Tops Vox." *Boston Phoenix* (1 July 1994). Included in press kit from Luaka Bop.

— — —. "Youssou N'Dour and Neneh Cherry's 7 Second Summer." *Rhythm Music Magazine* 4 (1995), 30–35.

Fanon, Frantz. *The Wretched of the Earth*. Trans. Constance Farrington. New York: Grove Weidenfeld, 1968.

Feehan, Fanny. "Suggested Links Between Eastern and Celtic Music." In *The Celtic Consciousness*, edited by Robert O'Driscoll. New York: George Braziller, 1981.

Feld, Steven. "From Schizophonia to Schismogenesis: Notes on the Discourses of World Music and World Beat." In Charles Keil and Steven Feld, *Music Grooves: Essays and Dialogues*. Chicago and London: Univ. of Chicago Press, 1994.

— — —. "Notes on 'World Beat'." In Charles Keil and Steven Feld, *Music Grooves: Essays and Dialogues*. Chicago and London: Univ. of Chicago Press, 1994.

Fischer, Michael M. J. "Ethnicity and the Post-Modern Arts of Memory." In *Writing Culture: The Poetics and Politics of Ethnography*, edited by James Clifford and George E. Marcus. Berkeley: Univ. of California Press, 1986.

Foucault, Michel. *The Foucault Reader*. Edited by Paul Rabinow. New York: Pantheon, 1984.

— — —. *The History of Sexuality: An Introduction*. Trans. Robert Hurley. Harmondsworth: Penguin, 1987.

— — —. *Power/Knowledge: Selected Interviews and Other Writings, 1972–77*. Ed. Colin Gordon. Trans. Colin Gordon, Leo Marshall, John Mephan, and Kate Soper. New York: Pantheon, 1980.

— — —. "Two Lectures." In *Culture/Power/History: A Reader in Contemporary Social Theory*. Ed. Nicholas B. Dirks, Geoff Eley, and Sherry B. Ortner. Princeton Studies in Culture/Power/History, ed. Nicholas B. Dirks, Geoff Eley, and Sherry B. Ortner. Princeton: Princeton Univ. Press, 1994.

Fox, Richard. *Lions of the Punjab: Culture in the Making*. Berkeley and Los Angeles: Univ. of California Press, 1985.

Fraser, Steven, ed. *The Bell Curve Wars: Race, Intelligence, and the Future of America*. New York: Basic Books, 1995.

Frederick, William H. "Rhoma Irama and the Dangdut Style: Aspects of Contemporary Indonesian Popular Culture." *Indonesia* 34 (October 1982): 102–30.

Freedman, Samuel G. "Johnny Clegg's War on Apartheid." *Rolling Stone* 574 (22 March 1990), 58.

Fricke, David. "Peter Gabriel: The Ethnic Shocks the Electronic." *Musician* 51 (January 1983), 20.

Friedman, Hazel. "Another Chapter in the Full Story." *Weekly Mail and Guardian* n.d. http://pubweb.is.co.za/mg/art/rvclegg.html.

— — —. "Time to Face the *Mbaqanga*." *Weekly Mail* (2 December 1994). Downloaded from http://www.mg.co.za/mg/.

Frith, Simon. "Art versus Technology: The Strange Case of Popular Music." *Media, Culture and Society* 8 (July 1986): 263–79.

— — —. "Introduction." In *World Music, Politics and Social Change*, ed. Simon Frith. Music and Society, ed. Peter Martin. Manchester and New York: Manchester Univ. Press, 1989.

— — —. "Music and Identity." In *Questions of Cultural Identity*, ed. Stuart Hall and Paul du Gay. London and Thousand Oaks, Calif.: Sage, 1996.

— — —. *Sound Effects: Youth, Leisure, and the Politics of Rock 'n' Roll*. Communication and Society Series, ed. Jeremy Tunstall. London: Constable, 1983.

Gabriel, Peter. Liner notes to *Plus from Us*. Real World Carol 2327-2, 1993.

Gagne, Cole. *Soundpieces 2: Interviews with American Composers*. Metuchen, N.J. and London: Scarecrow Press, 1993.

Gamson, Joshua. *Claims to Fame: Celebrity in Contemporary America*. Berkeley: Univ. of California Press, 1994.

Gardner, Elysa. "Peter Gabriel's *Us*." *Rolling Stone* 639 (17 September 1992), 27.

Gargan, Edward. "Vanilla Ice in Hindi." *New York Times* (23 August 1992), H22.

Garofalo, Reebee. "Whose World, What Beat: The Transnational Music Industry, Identity, and Cultural Imperialism." *World of Music* 35 (1993): 16–32.

Gates, David. "The Marketing o' the Green." *Newsweek* 121 (5 April 1993), 60.

Gates, Henry Louis Jr. *The Signifying Monkey: A Theory of African-American Literary Criticism*. New York: Oxford Univ. Press, 1988.

Gerlach, Russell. "Birmingham's Indyian." *ClubLife* 2 (1995), 20–21.

Giddens, Anthony. *The Consequences of Modernity*. Stanford: Stanford Univ. Press, 1990.

Gilroy, Paul. *The Black Atlantic: Modernity and Double Consciousness*. Cambridge: Harvard Univ. Press, 1993.

Goldman, Erik. "Ethnotechno: A Sample Twist of Fate." *Rhythm Music* 6 (July 1995), 36–39.

— — —. "Get Innuit!" *Rhythm Music Magazine* 3 (1994) / 4 (1995), 44–46.

Goodwin, Andrew. "Popular Music and Postmodern Theory." *Cultural Studies* 5 (May 1991): 174–90.

Goodwin, Andrew, and Joe Gore. "World Beat and the Cultural Imperialism Debate." *Socialist Review* 20 (July–September 1990): 63–80.

Gopinath, Gayatri. "'Bombay, U.K., Yuba City': Bhangra Music and the Engendering of Diaspora." *Diaspora* 4 (Winter 1995): 303–21.

Gordon, Diane. "African Music for String Quartet." *Strings* (July/August 1994), 30–31.

Gould, Stephen Jay. *The Mismeasure of Man*. New York: W. W. Norton, 1981.

Gramsci, Antonio. *Selections from the Prison Notebooks*, ed. and trans. Quintin Hoare and Geoffrey Nowell Smith. New York: International, 1971.

Grossberg, Lawrence. *We Gotta Get out of This Place: Popular Conservatism and Postmodern Culture*. New York and London: Routledge, 1992.

Guilbault, Jocelyne. "On Redefining the 'Local' Through World Music." *World of Music* 32 (1993): 33–47.

Guterman, Jimmy. Review of Johnny Clegg and Savuka, *Shadow Man*. *Rolling Stone* 536 (6 October 1988), 142.

Hall, Kathleen. "'There's a Time to Act English and a Time to Act Indian': The Politics of Identity among British-Sikh Teenagers." In *Children and the Politics of Culture*, ed. Sharon Stephens. Princeton Studies in Culture/Power/History, ed. Nicholas B. Dirks, Geoff Eley, and Sherry B. Ortner. Princeton, N.J.: Princeton Univ. Press, 1995.

Hall, Stuart. "Culture, the Media and the 'Ideological Effect'." In *Mass Communication and Society*, ed. James Curran, Michael Gurevitch, and Janet Woollacott. Beverly Hills: Sage, 1979.

— — —. "The Local and the Global: Globalization and Ethnicity." In *Culture, Globalization and the World-System*, ed. Anthony D. King. Current Debates in Art History, no. 3. Binghamton, N.Y.: Department of Art and Art History, State Univ. of New York at Binghamton, 1991.

— — —. "Notes on Deconstructing 'The Popular'." In *People's History and Socialist Theory*, ed. Raphael Samuel. London and Boston: Routledge and Kegan Paul, 1981.

— — —. "Old and New Identities, Old and New Ethnicities." In *Culture, Globalization and the World-System*, ed. Anthony D. King. Current Debates in Art History, no. 3. Binghamton, N.Y.: Department of Art and Art History, State Univ. of New York at Binghamton, 1991.

— — —. "What is this 'Black' in Black Popular Culture?" *Social Justice* 20 (Spring–Summer 1993): 104–14.

Hamm, Charles. *Afro-American Music, South Africa, and Apartheid*. ISAM Monographs, no. 28. Brooklyn: Institute for Studies in American Music, 1988.

— — —. "*Graceland* Revisited." *Popular Music* 8 (October 1989): 299–304.

— — —. *Putting Popular Music in Its Place*. Cambridge: Cambridge Univ. Press, 1995.

Hart, Mickey, with Jay Stevens. *Drumming at the Edge of Magic: A Journey into the Spirit of Percussion*. San Francisco: HarperSanFrancisco, 1990.

Hart, Mickey, with Fredric Lieberman. *Planet Drum: A Celebration of Percussion and Rhythm*. San Francisco: HarperSanFrancisco, 1991.

Hartsock, Nancy. "Postmodernism and Political Change: Issues for Feminist Theory." *Cultural Critique* 14 (Winter 1989–90): 15–33.

Hatch, Martin. "Popular Music in Indonesia." In *World Music, Politics, and Social Change*, edited by Simon Frith. Music and Society, ed. Peter Martin. Manchester and New York: Manchester Univ. Press, 1989.

Hebdige, Dick. "After the Masses." In *Culture/Power/History: A Reader in Contemporary Social Theory*, ed. Nicholas B. Dirks, Geoff Eley, and Sherry B. Ortner. Princeton Studies in Culture/Power/History, ed. Nicholas B. Dirks, Geoff Eley, and Sherry B. Ortner. Princeton, N.J.: Princeton Univ. Press, 1994.

— — —. "Digging for Britain: An Excavation in Seven Parts." In *Black British Cultural Studies: A Reader*, ed. Houston A. Baker Jr., Manthia Diawara, and Ruth H. Lindeborg. Black Literature and Culture, ed. Houston A. Baker Jr. Chicago and London: Univ. of Chicago Press, 1996.

Henderson, Richard. "Dead Men Walking, Tibetans Chanting & Cubans Smoking Cigars." *Billboard* 108 (25 May 1996), 35.

Herbstein, Denis. "The Hazards of Cultural Deprivation." *Africa Report* 32 (July/August 1987): 33–35.

Herndon, David. "A Valley Deep in Another World to Visit the Hardscabble Zululand is to Step Out of Modern Life." *Newsday* (5 February 1995), 17.

Herrnstein, Richard J., and Charles Murray. *The Bell Curve: Intelligence and Class Structure in American Life*. New York: Free Press, 1994.

Hickson, Kate. "The Indi Chart." *Folk Roots* 83 (May 1990), 25–27.

Holiday, Billie, with William Dufty. *Lady Sings the Blues*. London and New York: Penguin, 1992.

Hopkins, Simon. Liner notes to *The Virgin Directory of World Music*. Virgin Records: VDWM1, 1991.

Hucker, Dave. "Jungle Fever Spreads in U.K.: Reggae/Techno Hybrid Growing Quickly." *Billboard* 106 (29 October 1994), 1.

Humphries, Patrick. *The Boy in the Bubble: A Biography of Paul Simon*. London: Sidgwick and Jackson, 1988.

Hunt, Ken. "Fon Thoughts." *Folk Roots* 130 (April 1994), 17–19.

— — —. "Sheila Chandra: Weaving Musical Traditions." *The Beat* 12 (1993), 54.

Hutcheon, Linda. *The Politics of Postmodernism*. New Accents, ed. Terence Hawkes. London and New York: Routledge, 1989.

"Indian American Youth in the Dock." *Little India* 4 (31 August 1994), 60.

Infusino, Divina. "Singer Peter Gabriel Reveals his Inner Journey." *Christian Science Monitor* (3 August 1993), 13.

"Interview with Verna Gillis—Promoter of World Music." *Review-Latin American Literature and Arts* 40 (January/June 1989): 24–29.

J., N. "Zap Mama find a Global Voice." *Eye Magazine* (30 June 1994). Included in press kit from Luaka Bop.

Jacoby, Russell, and Naomi Glauberman, eds. *The Bell Curve Debate: History, Documents, Opinions*. New York: Times Books, 1995.

Jameson, Fredric. *Postmodernism, or, the Cultural Logic of Late Capitalism*. Post-Contemporary Interventions, ed. Fredric Jameson and Stanley Fish. Durham: Duke Univ. Press, 1991.

JanMohamed, Abdul R., and David Lloyd, eds. *The Nature and Context of Minority Discourse*. New York and Oxford: Oxford Univ. Press, 1990.

Jeffrey, Don. "Monks Lift EMI Music to Double-digit Gains." *Billboard* 106 (3 September 1994), 6.

Jones, LeRoi. *Blues People: Negro Music in White America*. New York: Morrow, 1963.

Jowers, Peter. "Beating new Tracks: WOMAD and the British World Music Movement." In *The Last Post: Music After Modernism*, ed. Simon Miller. Music and Society, ed. Peter Martin. Manchester and New York: Manchester Univ. Press, 1993.

Jung, C. G. *Mandala Symbolism*. Trans. R. F. C. Hull. Bollingen Series. Princeton, N.J.: Princeton Univ. Press, 1972.

Kaliss, Jeff. "A Joyous Journey Across Many Borders." *San Jose Mercury News Eye* (17 June 1994), 28–29.

Keeling Richard. "The Sources of Indian Music—An Introduction and Overview." *World of Music* 34 (1992): 3–21.

Keil, Charles. "Music Mediated and Live in Japan." In Charles Keil and Steven Feld, *Music Grooves: Essays and Dialogues*. Chicago and London: Univ. of Chicago Press, 1994.

Kemp, Mark. Review of *Deep Into Jungle Territory*. *Option* 65 (November/December 1995), 99.

Kivnick, Helen Q. *Where is the Way: Song and Struggle in South Africa*. New York: Penguin, 1990.

Kun, Josh. "Too Pure?" *Option* 68 (May/June 1996), 54.

Kureishi, Hanif. *The Buddha of Suburbia*. New York: Viking, 1990.

L., K. "Zaps!" *Columbus Alive* (22 June 1994). Included in press kit from Luaka Bop.

La Franco, Robert, and Michael Schuman. "How Do You Say Rock 'n' Roll in Wolof?" *Forbes* 156 (17 July 1995), 102–3.

Laing, Dave. "The Music Industry and the 'Cultural Imperialism' Thesis." *Media, Culture and Society* 8 (July 1986): 331–41.

Lambert, Stu. "The Angel Gabriel." *New Statesman & Society* 6 (25 June 1993), 34.

Lame Deer, John (Fire), and Richard Erdoes. *Lame Deer: Seeker of Visions*. New York: Washington Square Press, 1972.

Larlham, Peter. *Black Theater, Dance, and Ritual in South Africa*. Ann Arbor; UMI Research Press, 1985.

Larsen, Stephen, and Robin Larsen. *A Fire in the Mind: The Life of Joseph Campbell*. New York: Doubleday, 1991.

Lash, Scott, and John Urry. *The End of Organized Capitalism*. Madison: Univ. of Wisconsin Press, 1987.

LeBlanc, Larry. "Bhangra's Bubbling Under Toronto Radio and Dance." *Billboard* 105 (6 March 1993), 49.

Legrand, Emmanuel. "French Hit Invokes Native U.S. Spirit." *Billboard* 107 (4 November 1995), 1.

— — —. "Legacy of Colonial Rule Shapes Afro-pop in France." *Billboard* 105 (13 February 1993), 1.

LeGuin, Elisabeth. "Uneasy Listening." *Repercussions* 3 (Spring 1994): 5–21.

Lerner, Michael A. "Clegg Fuses Pop with Politics." *Newsweek* 112 (12 September 1988), 12.

Letter to the Editor. *Spin* 10 (March 1995), 16.

Levin, Mike. "Cuttin' Loose in Concert." *Billboard* 105 (27 November 1993), 83.

— — —. "Southeast Asia Talking up Chinese Music." *Billboard* 105 (30 January 1993), 1.

Levine, Lawrence W. *Black Culture and Black Consciousness: Afro-American Folk Thought from Slavery to Freedom*. Oxford: Oxford Univ. Press, 1977.

— — —. *Highbrow/Lowbrow: The Emergence of Cultural Hierarachy in America*. Cambridge: Harvard Univ. Press, 1988.

Linden, Amy. "Djura: Making Gorgeous, Liberating Music out of a Brutal Past." *Mirabella* (April 1994), 66.

Liner notes to Ofra Haza, *Fifty Gates of Wisdom*. Shanachie 64002, 1989.

Lipsitz, George. *Dangerous Crossroads: Popular Music, Postmodernism and the Poetics of Place*. London and New York: Verso, 1994.

— — —. *Time Passages: Collective Memory and American Popular Culture*. American Culture, ed. Stanley Aronowitz, Sandra M. Gilbert, and George Lipsitz. Minneapolis: Univ. of Minnesota Press, 1990.

Llewellyn, Howell. "Meet the Monks: EMI's Next Hit?" *Billboard* 106 (29 January 1994), 1.

———. "Monk's New Chant: 'Get off Our Cloud'." *Billboard* 106 (25 June 1994), 11.

———. "Timeless Success Story: New Age Music Experiences Growing Gains in Popularity." *Billboard* 106 (9 July 1994), 54.

Malm, Krister, and Roger Wallis. *Media Policy and Music Activity*. London and New York: Routledge: 1992.

Manuel, Peter. *Cassette Culture: Popular Music and Technology in North India*. Chicago Studies in Ethnomusicology, ed. Philip V. Bohlman and Bruno Nettl. Chicago: Univ. of Chicago Press, 1993.

———. "Music as Symbol, Music as Simulacrum: Postmodern, Pre-Modern, and Modern Aesthetics in Subcultural Popular Musics." *Popular Music* 14 (May 1995): 227–39.

———. *Popular Musics of the Non-Western World*. New York and Oxford: Oxford Univ. Press, 1988.

Maraire, Dumisani. Liner notes to *Pieces of Africa*. Elektra Nonesuch 9 79275-2, 1992.

Marre, Jeremy, and Hannah Charlton. *Beats of the Heart: Popular Music of the World*. New York: Pantheon, 1985.

Marshall, Victor Bains. "Zap Mama: Extraterrestrial Sistahs!!" *Exclaim Magazine* (July 1994). Included in press kit from Luaka Bop.

Marx, Karl, and Friedrich Engels. *The Communist Manifesto*. New York: Monthly Review, 1964.

Mathieu, W. A. Liner notes to *Planet Soup*. Ellipsis Arts... CD3450, 1995.

Matloff, Judith. "A New Threat to S. Africa's Musicians." *Los Angeles Times* (29 December 1994), 13.

Mattelart, Armand. "Unequal Voices." *UNESCO Courier* (February 1995): 11–14.

Mattelart, Herbert. "Life as Style: Putting the 'World' in the Music." *Baffler* (1993): 103–9.

McCaughey, Mary. "An Apache from Handsworth." *Living Marxism* 52 (February 1993). Available on the Internet at http://www.junius.co.uk/LM/LM52/LM52_Living.html#1.

McClary, Susan. *Feminine Endings: Music, Gender, and Sexuality*. Minneapolis and Oxford: Univ. of Minnesota Press, 1991.

———. "Same as it Ever Was: Youth Culture and Music." In *Microphone Fiends: Youth Music and Youth Culture*, ed. Andrew Ross and Tricia Rose. New York and London: Routledge, 1994.

———. "Terminal Prestige: the Case of Avant-Garde Music Composition." *Cultural Critique* 12 (Spring 1989): 57–81.

McClary, Susan, and Robert Walser. "Start Making Sense! Musicology Wrestles with Rock." In *On Record: Rock, Pop, and the Written Word*, ed. Simon Frith and Andrew Goodwin. New York: Pantheon, 1990.

McGowan, Chris. "Market Report: Can Karaoke Take Root in America?" *Billboard* 104 (30 May 1992), K1.

McLane, Daisann. "The Global Beat." *Rolling Stone* 670 (25 November 1993), 108.

Meintjes, Louise. "Paul Simon's *Graceland*, South Africa, and the Mediation of Musical Meaning." *Ethnomusicology* 34 (Winter 1990): 37–73.

Mihalca, Matei P. "Chinese Rock Stars: New Generation Emerging Following Political Liberalisation." *Far Eastern Economic Review* 155 (19 November 1992): 34–35.

Miller, Jim. "Pop Takes a Global Spin." *Newsweek* 111 (13 June 1989), 72–74.

Mitchell, Tony. "World Music and the Popular Music Industry: An Australian View." *Ethnomusicology* 37 (Fall 1993): 309–38.

Montague, Jim. "Sister Act." *Hospitals & Health Networks* 69 (20 May 1995), 54.

Mouquet, Eric, and Michel Sanchez. Liner notes to *Boheme*. 550 Music/epic BK 67115, 1995.

"Multi-Ethnic Musicians Blend Powwow with Pop." *Los Angeles Sentinel* 60 (18 January 1995), B6.

"Music Man." *Forbes* 155 (13 March 1995), 164.

Nandy, Ashis. *The Intimate Enemy: Loss and Recovery of Self under Colonialism*. Delhi: Oxford Univ. Press, 1983.

Negus, Keith. *Producing Pop: Culture and Conflict in the Popular Music Industry*. London and New York: Edward Arnold, 1992.

Neihardt, John G. *Black Elk Speaks: Being the Life Story of Holy Man of the Oglala Sioux*. Lincoln and London: Univ. of Nebraska Press, 1979.

Nelson, Havelock. "Ice Cube, K-Dee Launch Lench Mob Label; Grand Street Releases a Big Box of Beats." *Billboard* 106 (25 June 1994), 36.

Nettl, Bruno. *Folk and Traditional Music of the Western Continents*. 2d ed. Prentice-Hall History of Music Series, ed. H. Wiley Hitchcock. Englewood Cliffs, N.J.: Prentice Hall, 1973.

— — —. *The Western Impact on World Music: Change, Adaptation, and Survival*. New York: Schirmer Books, 1985.

Newman, Melinda. "Luaka Bop Hopes to Make Zap Mama's World Go Pop." *Billboard* 106 (2 April 1994), 12.

Ngũgĩ wa Thiong'o. *Writers in Politics*. Studies in African Literature. London: Heinemann, 1981.

Noys, Benjamin. "Into the 'Jungle'." *Popular Music* 14 (October 1995): 321–32.

O'Brien, Jill. "The SongCatchers Merge Music and Dreams." *Indian Country Today* 14 (26 October 1994), D–6.

O'Connor, Karen. "Grammy Adds 3 Categories: World Music Among New Awards." *Billboard* 103 (8 June 1991), 87.

Oldfield, Paul. Review of Johnny Clegg and Savuka: *Cruel, Crazy Beautiful World*. *Melody Maker* 66 (10 March 1990), 37.

Oliveros, Pauline. *Software for People: Collected Writings 1963–80*. Baltimore: Smith Publications, 1984.

Olsher, Dean. Review of *The Best of Djur Djura*. *(Raleigh, N. C.) News and Observer* (16 January 1994). Included in press kit from Luaka Bop.

O'Neil, Thomas. *The Grammys for the Record*. New York and London: Penguin, 1993.

Ó Riada, Seán. *Our Musical Heritage*. Ed. Thomas Kinsella and Tomás Ó Canainn. Portaloise, Ireland: Dolmen, 1982

Ortner, Sherry B. "Resistance and the Problem of Ethnographic Refusal." *Comparative Studies in Society and History* 37 (January 1995): 173–93.

Paige, Harry W. *Songs of the Teton Sioux*. Los Angeles: Westernlore Press, 1970.

Paredes, Américo. *With His Pistol in His Hand: A Border Ballad and Its Hero*. 1958. Reprint, Austin: Univ. of Texas Press, 1971.

Pareles, Jon. "For Peter Gabriel, This Time it's Personal." *New York Times* (27 September 1992), H30.

———. "Music Without Frontiers: Peter Gabriel." *Musician, Player & Listener* 27 (September/October 1983), 40–44.

———. "The Pop Life." *New York Times* (5 January 1994), C17.

———. "A Small World After All. But is That Good?" *New York Times* (24 March 1996), H34.

Parkhill, Peter. "Of Tradition, Tourism and the World Music Industry." *Meanjin* 52 (Spring 1993): 501–8.

"People." *Weekly Mail and Guardian* (2 June 1995).

Peters, Matt. "Rock 'n' Revolt." *Far Eastern Economic Review* 151 (28 March 1991): 30–31.

Petrie, B. "Apache Indian: *Make Way for the Indian*" (review). *Everybody's: The Caribbean-American Magazine* 19 (30 June 1995), 27.

Pfeil, Fred. *Another Tale to Tell: Politics and Narrative in Postmodern Culture.* London and New York: Verso, 1990.

Phillips, Dom. "U.K. Fray: Trip or Trance, Tech or Tribal, House Rules." *Billboard* 105 (25 September 1993), 34.

Pollak, Michael. "Medieval Mystic and a Nun Ascend the Music Charts." *New York Times* (11 June 1995), 21.

Pond, Steve. "Grammys Look for Hipness in New Rules." *New York Times* (25 February 1996), H34.

Prendergast, Mark. "Background Story." *New Statesman & Society* 6 (29 October 1993), 34–35.

———. "The Chilling Fields." *New Statesman & Society* 8 (13 January 1995), 32–33.

Price, Sally. *Primitive Art in Civilized Places.* Chicago and London: Univ. of Chicago Press, 1989.

Pride, Dominic. "Chandra's Harmonic Drones Come Together on Real World." *Billboard* 108 (22 June 1996), 9.

———. "U.K.'s Nation of 'Ethno-Techno'." *Billboard* 105 (16 January 1995), 1.

———. "WOMAD's Future Appears Wobbly." *Billboard* 105 (16 January 1993), 87.

Przybylowicz, Donna. "Toward a Feminist Cultural Criticism: Hegemony and Modes of Social Division." *Cultural Critique* 14 (Winter 1989–90): 259–301.

Quinn, Bob. *The Atlantean.* London and New York: Quartet Books, 1986.

Raghavan, Sudarsan. "'Crossover' is New Buzzword in South Africa." *Los Angeles Times* (11 July 1995), 2.

Randel, Don Michael, ed. *The New Harvard Dictionary of Music.* Cambridge, Mass., and London: Belknap Press of Harvard Univ. Press, 1986.

Rawick, George P. *The American Slave: A Composite Biography.* Vol. 1, *From Sundown to Sunup: The Making of the Black Community.* Contributions in Afro-American and African Studies, no. 11. Westport, Conn.: Greenwood, 1972.

Recording Industry Association of America. *1994 Annual Report of the Recording Industry Association of America.* Washington, D.C.: Recording Industry Association of America, 1995.

———. *Annual Report of the Recording Industry Association of America.* Washington, D.C.: Recording Industry Association of America, 1996.

Rees, Alwyn, and Brinley Rees. *Celtic Heritage: Ancient Tradition in Ireland and Wales.* London: Thames and Hudson, 1961.

Review of *Zap Mama. Des Moines Register* (8 July 1993). Included in press kit from Luaka Bop.

Reynolds, Simon. "Above the Treeline." *The Wire* (September 1994), 36.

———. "It's a Jungle out There. . ." *Melody Maker* (15 October 1994), 42–43.

———. "Jungle Boogie." *Rolling Stone* 704 (23 March 23 1995), 38.

———. "Will Jungle be the Next Craze from Britain?" *New York Times* (6 August 1995), H28.

Ringer, Benjamin B., and Elinor R. Lawless. *Race-Ethnicity and Society*. London and New York: Routledge, 1989.

Robertson, Roland. "Social Theory, Cultural Relativity and the Problem of Globality." In *Culture, Globalization and the World-System*, ed. Anthony D. King. Current Debates in Art History, no. 3. Binghamton, N.Y.: Department of Art and Art History, State Univ. of New York at Binghamton, 1991.

Robinson, Deanna Campbell, Elizabeth B. Buck, and Marlene Cuthbert. *Music at the Margins: Popular Music and Global Cultural Diversity*. Communication and Human Values, ed. Michael A. White and Michael Traber. Newbury Park, Calif., and London: Sage Publications, 1991.

Root, Deborah. *Cannibal Culture: Art, Appropriation, and the Commodification of Difference*. Boulder and Oxford: Westview Press, 1996.

Rule, Greg. Review of *Supreme Beats: A Percussion Library by Bashiri Johnson*. *Keyboard* 21 (March 1995), 97–98.

Rule, Sheila. "An African Superstar Sings Out to the World." *New York Times* (5 September 1992), A11.

Rushdie, Salman. "In Defense of the Novel, Yet Again." *New Yorker* (24 June and 1 July 1996), 48–55.

Russell, Warne. "The Throat Singers of Tuva." *RMM* (February 1994), 10–12.

Said, Edward. *Orientalism*. New York: Vintage, 1979.

———. "The Politics of Knowledge." *Raritan* 11 (Summer 1991): 17–31.

Santoro, Gene. "Zap Mama of Invention." *Daily News* (11 July 1994). Included in press kit from Luaka Bop.

Sarno, Louis. *Song from the Forest: My Life Among the Ba-Benjellé Pygmies*. Boston and New York: Houghton Mifflin 1993.

Schiff, David. "Scanning the Dial: Searching for Authenticity in High-Art and Popular Music." *Atlantic* 272 (November 1993), 138–44.

Schnabel, Tom. *Stolen Moments: Conversations with Contemporary Musicians*. Los Angeles: Acrobat Books, 1988.

Scott, James C. *Domination and the Arts of Resistance: Hidden Transcripts*. New Haven and London: Yale Univ. Press, 1990.

———. *Weapons of the Weak: Everyday Forms of Peasant Resistance*. New Haven and London: Yale Univ. Press, 1985.

Sexton, Paul. "WOMAD Back for 2nd U.S. Tour; Western, World Music Acts Team Again." *Billboard* 106 (21 May 1994), 1.

Shank, Barry. *Dissonant Identities: The Rock 'n' Roll Scene in Austin, Texas*. Music/Culture, ed. George Lipsitz, Susan McClary, and Robert Walser. Hanover and London: Wesleyan Univ. Press, Univ. Press of New England, 1994.

Shepherd, John. *Music as Social Text*. Cambridge: Polity Press, 1991.

Shuhei Hosokawa. "Fake Fame Folk: Some Aspects of Japanese Popular Music in the 1980s." *Art & Text* 40 (September 1991): 78–81.

———. *Japanese Popular Music of the Past Twenty Years—Mainstream and Underground*. Trans. Larry Richards. Tokyo: Japan Foundation, 1994.

Sieburth, Stephanie. *Inventing High and Low: Literature, Mass Culture, and Uneven Modernity in Spain*. Durham and London: Duke Univ. Press, 1994.

Sinclair, David. "Peter Gabriel's Secret World." *Rolling Stone* 663 (19 August 1993), 9.

— — —. "World Music Fests Flourish in U.K." *Billboard* 104 (8 August 1992), 12.

"Singer 'Banig' Relocates to Los Angeles." *Heritage* 8 (June 1994), 22.

Sison-Paez, Marites. "The Banig Invasion." *Filipino Express* (12 November 1995), PG.

Slobin, Mark. *Subcultural Sounds: Micromusics of the West*. Music/Culture, ed. George Lipsitz, Susan McClary, and Robert Walser. Hanover and London: Wesleyan Univ. Press, 1993.

Small, Christopher. *Music • Society • Education*. London: John Calder, 1980.

Smith, Geoff and Nicola Walker Smith. *New Voices: American Composers Talk about Their Music*. Portland: Amadeus Press, 1995.

"So What About Us?" *Vox* 25 (October 1992), 22. Downloaded from http://www.cs.clemson.edu/~junderw/pg/interviews/vox.

Spencer, Peter. *World Beat: A Listener's Guide to Contemporary World Music on CD*. Pennington, N.J.: A Cappella Books, 1992.

Stabler, David. "Different Drummer." *Oregonian* (1 March 1992), D2.

Stallybrass, Peter and Allon White. *The Politics and Poetics of Transgression*. Ithaca: Cornell Univ. Press, 1986.

Stanley, David. "Bhangra Music comes Stateside via Multitone." *Billboard* 106 (18 June 1994), 17.

Stansfield, David. "More Labels Bang Drum for Euro-Asian Bhangra Beat." *Billboard* 106 (1 October 1994), 1.

Stapleton, Chris. "Paris, Africa." In *Rhythms of the World*, edited by Francis Hanly and Tim May. London: BBC Books, 1989.

Stapleton, Chris, and Chris May. *African All-Stars: the Pop Music of a Continent*. London: Paladin, 1987.

Steward, Sue, and Sheryl Garratt. *Signed, Sealed, and Delivered: True Life Stories of Women in Pop*. Boston: South End Press, 1984.

Stockhausen, Karlheinz. *Stockhausen on Music*. Compiled by Robin Maconie. London and New York: Marion Boyars, 1989.

— — —. "World Music." *Dalhousie Review* 69 (1989): 318–26.

Stokes, Martin. "Introduction: Ethnicity, Identity and Music." In *Ethnicity, Identity and Music: The Musical Construction of Place*, ed. Martin Stokes. Berg Ethnic Identities Series, ed. Shirley Ardener, Tamara Dragadze, and Jonathan Webber. Oxford and Providence: Berg, 1994.

— — —. Review of *World Music: The Rough Guide*. *Popular Music* 15 (May 1996): 243–45.

Sutton, R. Anderson. "Asia/Indonesia." In *Worlds of Music: An Introduction to the Music of the World's Peoples*, edited by Jeff Todd Titon. 2d ed. New York: Schirmer Books, 1992.

Sweeney, Philip. *The Virgin Directory of World Music*. London: Virgin Books, 1991.

Tallapragada, Sridhar. "No Doldrums Amidst the Dholdrums." *Little India* 4 (30 September 1994), 23.

Tannenbaum, Rob. "Can Youssou N'Dour Score?" *Rolling Stone* 556/557 (13–27 July 1989), 67.

— — —. "Johnny Clegg Battles Union." *Rolling Stone* 536 (6 October 1985), 17.

Tanzer, Andrew. "Sweet Chinese Siren." *Forbes* 152 (20 December 1993), 78.

Tate, Greg. "Jungle Boogie." *Pulse!* 50 (July 1996), 64.

Taylor, Charles. *Multiculturalism: Examining the Politics of Recognition*. Edited by Amy Gutmann. Princeton, N.J.: Princeton Univ. Press, 1994.

Taylor, Timothy D. "When We Think about Music and Politics: The Case of Kevin Volans." *Perspectives of New Music* 33 (Winter and Summer 1995): 504–36.

Thomas, Nicholas. "Cold Fusion." *American Anthropologist* 98 (March 1996): 9–16.

Thornton, Sarah. *Club Cultures: Music, Media and Subcultural Capital*. Music/Culture, ed. George Lipsitz, Susan McClary, and Robert Walser. Middletown, Conn. Wesleyan Univ. Press, 1996.

Thigpen, David E. Review of *The Soul of Chant*. *Time* 145 (22 May 1995), 72.

Tomlinson, John. *Cultural Imperialism: A Critical Introduction*. Parallax: Re-Visions of Culture and Society, ed. Stephen G. Nichols, Gerald Prince, and Wendy Steiner. Baltimore: Johns Hopkins Univ. Press, 1991.

Toop, David. "Jungle Fever Spreads in U.K.: Genre Defies Labels." *Billboard* 106 (29 October 1994), 1.

———. *Ocean of Sound: Aether Talk, Ambient Sound and Imaginary Worlds*. London and New York: Serpent's Tail, 1995.

Torgovnick, Marianna. *Gone Primitive: Savage Intellects, Modern Lives*. Chicago and London: Univ. of Chicago Press, 1990.

Trilling, Lionel. *Sincerity and Authenticity*. New York: W. W. Norton, 1969.

Tucci, Giuseppe. *The Theory and Practice of the Mandala*. Trans. Alan Houghton Brodrick. London: Rider and Company, 1961.

Vander, Judith. *Songprints: The Musical Experience of Five Shoshone Women*. Music in American Life. Urbana: Univ. of Illinois Press, 1988.

Vanderknyff, Rick. "Beating a Path from Village to City to Globe." *Los Angeles Times* (22 July 1995), 3.

Varty, Alexander. "Real World Problems and Otherworldly Music." *Georgia Straight* (1–8 October 1993). Downloaded from http://www.cs.clemson.edu/~junderw/pg/reviews/real.world.

Vergnani, Linda. "Rapping for Democracy in South Africa." *Chronicle of Higher Education* 40 (3 November 1993), A43.

Von Gunden, Heidi. *The Music of Pauline Oliveros*. Metuchen, N.J. and London: Scarecrow Press, 1983.

Walker, Alice. *The Color Purple*. New York: Harcourt Brace Jovanovich, 1982.

Wall, Anthony. "Introduction." In *Rhythms of the World*, ed. Francis Hanly and Tim May. London: BBC Books, 1989.

Wallerstein, Immanuel. *Historical Capitalism*. London: Verso, 1983.

———. *The Modern World-System: Capitalist Agriculture and the Origins of the European World-Economy in the Sixteenth Century*. Studies in Social Discontinuity, ed. Charles Tilly and Edward Shorter. New York and London: Academic Press, 1974.

Wallis, Roger, and Krister Malm. *Big Sounds from Small Peoples: The Music Industry in Small Countries*. Communication & Society Series, ed. Jeremy Tunstall. London: Constable, 1984.

Walser, Robert. "Highbrow, Lowbrow, Voodoo Aesthetics." In *Microphone Fiends: Youth Music and Youth Culture*, ed. Andrew Ross and Tricia Rose. New York and London: Routledge, 1994.

———. "Rhythm, Rhyme and Rhetoric in the Music of Public Enemy." *Ethnomusicology* 39 (Spring 1995): 193–217.

———. *Running with the Devil: Power, Gender, and Madness in Heavy Metal Music.* Music/Culture, ed. George Lipsitz, Susan McClary, and Robert Walser. Middletown, Conn.: Wesleyan Univ. Press, 1993.

Waters, Mary C. *Ethnic Options: Choosing Identities in America.* Berkeley and Los Angeles: Univ. of California Press, 1990.

Watrous, Peter. "The Pop Life." *New York Times* (23 September 1992), C14.

Weber, Max. *The Rational and Social Foundations of Music.* Trans. and ed. Don Martindale, Johannes Riedel, and Gertrude Neuwirth. Carbondale: Southern Illinois Univ. Press, 1958.

Weitz, Susan. Review of *Zap Mama. Ithaca Times* (16 September 1993). Included in press kit from Luaka Bop.

Weisel, Al. "Deep Forests's Lush Lullaby." *Rolling Stone* (21 April 1994), 26.

Wentz, Brooke. "Apache Come Home." *Vibe* 1 (November 1993), 86.

———. "It's a Global Village out There." *Down Beat* 58 (April 1991), 22–25.

———. "No Kid Stuff." *The Beat* 12 (1993), 42–45.

———. "Youssou N'Dour: Is He Shaking the Tree or Cutting it Down?" *RMM* 2 (May/June 1994): 38.

White, Harry. "Music and the Perception of Music in Ireland." *Studies* 79 (Spring 1990): 38–44.

———. "The Need for a Sociology of Irish Music." *International Review of the Aesthetics and Sociology of Music* 15 (1984): 3–14

Whittington, Amanda. "A Very British Sound." *New Statesman & Society* 6 (26 February 1993), 34–35.

Wilson, Peter Niklas. "'Zwischen 'Ethno-Pop' und 'Weltmusik'." *Neue Zeitschrift für Musik* 148 (May 1987): 5–8

"World Music: Year to Date Charts." *Billboard* 108 (25 May 1996), 44.

"The Year in Music, 1990." *Billboard* 102 (22 December 1990), YE–36.

"The Year in Music, 1991." *Billboard* 103 (28 December 1991), YE–34.

"The Year in Music, 1992." *Billboard* 104 (19 December 1992), YE–45.

"The Year in Music, 1993." *Billboard* 105 (25 December 1993), YE–45.

"The Year in Music, 1994." *Billboard* 106 (24 December 1994), YE–63.

"The Year in Music, 1995." *Billboard* 107 (23 December 1995), YE–78.

Young, La Monte, and Marian Zazeela. *Selected Writings.* Munich: Heiner Friedrich, 1969.

Young, La Monte, and Jackson Mac Low, eds. *An Anthology of Chance Operations.* 2d ed. New York: Heiner Friedrich, 1970.

Young, Robert. *Colonial Desire: Hybridity in Theory, Culture and Race.* London and New York: Routledge, 1995.

Zimmermann, Walter. *Desert Plants: Conversations with 23 American Musicians.* Vancouver: A.R.C. Publications, 1976.

Permissions

Every effort has been made to contact copyright holders for the materials appearing in this volume. If copyright permission is not acknowledged, please contact the publisher.

Copyright information follows for the lyrics and/or music quoted in this volume, and permission to reprint them is gratefully acknowledged.